stone canoe A Journal of Arts and Ideas from Upstate New York

W9-BWZ-815

SPRING 2008 | NUMBER 2

EDITOR: Robert Colley

POETRY EDITORS: Paul Aviles, Michael Burkard

FICTION EDITOR: David Lloyd

VISUAL ARTS EDITOR: Marion Wilson

ART DIRECTOR: E.L. Cummings Serafini

PRODUCTION MANAGER: Karen Nadolski

COPY EDITORS: Lois Gridley, Martha Zvonik

ASSISTANT EDITOR: Allison Vincent

EDITORIAL COORDINATOR: Tiffany Bentley

PROOFREADER: Nancy Miller

WEB DESIGNER: Denise Heckman

DESIGN CONSULTANT: Adam Rozum

SYRACUSE
UNIVERSITY
University College
Continuing education since 1918

Stone Canoe, a Journal of Arts and Ideas from Upstate New York, is published annually by University College of Syracuse University, 700 University Avenue, Syracuse, New York 13224-2530. E-mail: *stonecanoe@uc.syr.edu.* Phone: 315-443-3225/4165. Fax: 315-443-4174. Web: *stonecanoejournal.org.*

Stone Canoe showcases the work of a diverse mix of emerging and well-established artists and writers with ties to Upstate New York. In so doing, the journal supports Syracuse University's ongoing commitment to nurture creative community partnerships, and seeks to promote greater awareness of the cultural and intellectual richness of the region.

The views expressed in the contents of this journal are solely those of the contributors, and do not necessarily reflect the views of Syracuse University, its trustees, staff, faculty, or students.

Stone Canoe considers for inclusion previously unpublished short fiction and nonfiction, short plays, poems, and works of visual art in any medium. Unsolicited submissions are welcome from March 1 through July 31 of each year. Submissions must be sent via our web page, and must include a short biographical statement and contact information. Complete submission instructions and forms are available at *stonecanoejournal.org/submission.* No additional application or fee is required in order to be considered for our annual prizes for emerging writer and artists (see page 388).

All rights for individual works revert to contributors upon publication, though *Stone Canoe* may seek permission to feature submitted work on its web site.

Stone Canoe is available at Syracuse University Bookstores, at most regional commercial and college bookstores, and at Amazon.com. Individual copies are $20. For subscriptions ($36 for 2 years/2 issues and $52 for 3 years/3 issues), send a check or money order to *Stone Canoe* at the address above. *Stone Canoe* is also available at the educational rate of $12 for classroom use.

Stone Canoe is printed by Quartier Printing, 5795 Bridge Street, East Syracuse, New York, 13057. *Stone Canoe* is set in Bembo, a trademark font of the Monotype Corporation, based on a typeface designed by Francesco Griffo in 1495. *Stone Canoe* is distributed by Syracuse University Press, 621 Skytop Road, Syracuse, New York 13244-5160, *www.SyracuseUniversityPress.syr.edu.*

Stone Canoe is a member of the Council of Literary Magazines and Presses (CLMP).

ISSN: 1934-9963 ISBN: 978-0-9791944-1-2

ABOUT THE COVER

Joy Adams, *The Flying Lesson,* oil on linen, 65"x60" (detail), 2003

The Flying Lesson is a flight of fantasy and imagination. It conjures up something reminiscent of Dorothy and the Wizard of Oz, or a stained glass window, or a grand finale smile during the rapture of an ascension. The painting also yields deeper truths, and is suggestive of a yearning for another culture and time from long ago.

The Flying Lesson belongs to an evolving series of paintings called **Mad Sally's Marvelous Adventures** that falls into the traditional category of figurative representation. Painted in a deliberate manner and with a reverence for the legacy and history of art, these works are, at the same time, contemporary narratives. Each of the works celebrates a negative stereotype. They reveal an alter identity in an audacious character contained within an imperfect body. In a cultural climate that rejects age and imperfection, Mad Sally holds her ground as she postures, ever ready to abandon her dignity and defy all the standards of proper comportment and behavior. Sally is a strong-willed and visual affirmation of mature woman as Super Hero, a lone feminine ego who lives in a mythic world. Her scenarios oscillate between truth and fantasy and are set into fabricated landscapes where feeling takes precedence over actuality.

Mad Sally opens passageways to a wellspring of ideas that trigger memories of my working class British roots, and the immigrant experience in America. The journey is an engrossing and deeply felt one, as Sally continues to strike out in ever-evolving directions. Whether she is introspective, edgy, or comically tinted, Mad Sally is my muse—an incarnation of splendid individuality.

Joy Adams

The full painting can be seen on page 225.

Raised in London and educated at the Maryland Institute of Art, Joy Adams has had a long and successful career in Upstate New York, teaching art at SUNY Brockport, SUNY Potsdam, and Ithaca College. Since retiring from academe, she has devoted herself full time to her painting, with shows at Binghamton's Roberson Museum and Science Center, Buffalo's Albright-Knox Museum, the Memorial Art Gallery of the University of Rochester, and SUNY Oswego's Tyler Art Gallery.

Acknowledgements

This issue of *Stone Canoe* is dedicated to the memory of Philip Booth, esteemed poet and co-founder of the Syracuse University Creative Writing Program, who taught at Syracuse from 1963-87.

Special thanks to the following people whose support and encouragement have helped keep Stone Canoe afloat this past year.

Rob Aronson, Aronson Media Group

Nancy Cantor, Chancellor and President, Syracuse University

John Dowling, John Dowling Photography

Florence Eichen, Penguin Group (USA) Inc.

John L. Gann, Gann Associates

Karen Gissony, Helen B. Bernstein Librarian for Periodicals and Journals,
 The New York Public Library

Bea González, Dean, University College of Syracuse University

Raymond Hammond, Editor, *The New York Quarterly*

Jeffrey Lependorf, Jay Baron Nicorvo, and Jamie Schwarz,
 Council of Literary Magazines and Presses

Grace Matthews, Faith Ringgold, Inc.

William Patrick, Director, New York State Summer Young Writers' Institute

Joseph Stoll, Manager, Cartographic Lab, Department of Geography,
 Syracuse University

Steven F. Zdep, D.D.S. and Stephen R. Zdep, D.D.S. P.C.

Thanks to the *Stone Canoe* advisory board for their continued wise counsel and support:

Omanii Abdullah-Grace, Paul Aviles, Peter Blanck, Michael Burkard, Carol Dandridge Charles, William Delavan, Stephen Dunn, Brad Edmonson, Arthur Flowers, Wendy Gonyea, Kenneth Hine, Jeffrey Hoone, Elizabeth Kamell, Johanna Keller, Christopher Kennedy, Robin Wall Kimmerer, David Lloyd, David MacDonald, Timothy Mahar, Pamela McLaughlin, Philip Memmer, Elizabeth O'Rourke, Francis Parks, Minnie Bruce Pratt, Maria Russell, Carol Terry, Suzanne Thorin, Silvio Torres-Saillant, John von Bergen, Marion Wilson.

Thanks to Bill Delavan, Caroline Szozda McGowan, and Courtney Rile of the Delavan Art Gallery for hosting the annual Stone Canoe Art Exhibition and the Stone Canoe Writer's Series.

Finally, thanks to our loyal sponsors, whose individual pages appear at the back of the journal.

We are pleased to have a number of Constance Saltonstall Foundation for the Arts grant awardees among our contributors for this issue: Joy Adams, Kath M. Anderson, Daniel Donaghy, Douglas Dubois, Sara Eichner, Eric Gansworth, Holly Greenberg, Christopher Kennedy, Jonathan Kirk, Sarah McCoubrey, Fred Muratori, Linda Tomol Pennisi, Linda Price, Sylvia de Swann, Ed Taylor, Michael Paul Thomas, and Leah Zazulyer.

Images of Janet Biggs's installations are provided courtesy of Claire Oliver Gallery, New York City.

Images of Ada Jacques' pottery are provided courtesy of Dawn Van Hall, Director, Fine Arts Gallery, SUNY Cortland, Cortland, New York.

Images of Faith Ringgold's art are provided courtesy of Faith Ringgold, Inc, copyright © by Faith Ringgold.

"Eaton's Boatyard," "First Lesson," "Not to Tell Lies" from *Lifelines* by Philip Booth, copyright © 1999 by Philip Booth. Used by permission of Viking Penguin, a division of Penguin Group (USA) Inc. 1999.

This publication has been awarded a regrant from the Council of Literary Magazines and Presses, supported by public funds from the New York State Council on the Arts, a state agency.

EDITOR'S NOTES

Welcome to the second issue of *Stone Canoe,* significantly bigger this year—an attempt to accommodate the enthusiastic response to our call for submissions. 350 individuals submitted work for consideration (over 800 individual pieces), and 98 are represented in this issue. As the accompanying map shows, most of our contributors are fairly well distributed across Upstate New York, with a few from New York City or elsewhere who have ties to the region.

What the collective work demonstrates is that the arts are alive and well in Upstate New York—not that those of us who pay attention to such things had any doubts. Yet we citizens of the region are used to being somewhat defensive about its reputation as "the land that time forgot," to quote Lewis Menand from a recent *New Yorker* review of Richard Russo's *Bridge of Sighs.* Russo's novel is set in a small upstate town, the "sort of place" says Menand, "where people think of moving to Schenectady as making it." How benighted they must be! Even Russo's protagonist, with a certain amount of self-awareness and a good upstate sense of humor, admits that his natural inclination is toward "inertia rationalized," and acknowledges that his memoir might appropriately be titled "The Dullest Story Ever Told." Henry Allen, *Washington Post* writer and contributor to this issue, admits that, as a young New Englander, he thought of Upstate New York as essentially devoid of culture, "the hell to which Dick Diver was condemned in Fitzgerald's *Tender is the Night.*" Then there is the variation on the old joke about what Americans think of Canada, courtesy of a *New York Times* writer who shall remain anonymous. Question: "What do people from New York City think of upstate?" Answer: "They don't."

So *Stone Canoe's* editorial stance may admittedly be a bit combative. We see ourselves as awakening the general reading public to the news that the art and writing produced in our corner of the world is second to none, and deserves a larger audience than it has historically enjoyed. We try to pick work that "makes the local place nationally available," as Paul Gray says Philip Booth's poems were always able to do. The reception to our first

issue has so far been encouraging. A bronze medal in the 2007 Independent Book Publishers competition brought us wider recognition, and two *Stone Canoe* readings at the New York Public Library, sponsored by the Council of Literary Magazines and Presses, yielded critical praise from audiences as well as from fellow journal editors.

That said, however, *Stone Canoe* faces the same challenge all arts journals face: finding a good audience. The cliché is that Americans in general have not much interest in the arts or literature. Certainly book sellers will tell you that literary journals are not a big inventory item. But this then becomes a self-fulfilling prophecy, since the same book sellers will often not feature these prominently on their shelves. Readers of the *New York Times Book Review* may remember an essay on the subject this past fall by Stephen King, who talks of literally having to get on his hands and knees in the aisle of a large bookstore to unearth the few literary journals in stock from under piles of commercial magazines.

Fred Muratori, poet and bibliographer at Cornell, congratulates *Stone Canoe* on making it to issue number two, which he says puts us ahead of 90 percent of the literary journals produced in this country since WWII. His tongue is in his cheek here, of course, but I take his point. Those who put out journals that do manage to survive have an obstinate faith, with Saul Bellow, that "there are millions of literate Americans in a state of separation from others of their kind...a crowd of (serious readers) too large to be hidden in the woods." It is heartening to see a small but growing number of *Stone Canoe* readers emerging from the upstate woods, so to speak, as well as from the larger urban forests. Our mission is to continue to offer them not only good things to read, but also an enhanced sense of community, a chance to come out into the open, as it were, and compare notes.

This enhanced sense of community hopefully extends to our contributors as well, particularly the less experienced ones who may be working in relative isolation, perhaps unsure of their audience, perhaps unable to establish the sorts of networks enjoyed by their more established colleagues. One writer offers "heartfelt thanks for giving the artists of our area such a splendid forum," one that gives him "an encouraging sense of belonging to a chorus of voices here in Upstate New York." He also singles out certain contributors to our

first issue as people he would like to meet. What could be better? Another writes to say how much he has longed for a community-based outlet for his work, and is excited at the prospect of "contributing to a journal that celebrates Upstate New York's plentiful creative talents." We think there are lots of these folks in the woods also, and look forward to getting to know them better as they respond to future calls for submissions.

As with our first issue, the range of theme and subject matter in *Stone Canoe* Number 2 is impressive. Some contributors do indeed have a regional focus—the pulse of daily life in upstate urban centers and small towns, the look of our road signs, back yards, train tracks, and woods, the effect of place on personality—yet manage to wrest universal significance from their materials. Others tell us firsthand what it is like to be incarcerated; to cope with suburban life after combat in Iraq; to undergo rehabilitation from war injuries; to lose a best friend to AIDS; to be of mixed heritage and unsure of one's rightful place in the world; to triumph over the challenges of autism, to name just a few of the pieces found here. Still others remind us of the implications of our global citizenship, connecting us in new ways with the lives of Holocaust survivors, West Bank villagers, residents of rural India, or recent immigrants to the U.S., trying to make sense of their new and utterly alien surroundings.

At this stage in our development, it is hard to predict what *Stone Canoe's* ultimate legacy will be. For the moment, though, Henry Allen's reaction to our first issue is worth quoting briefly:

"I began reading *Stone Canoe,* whose mission seems to be in considerable part the reviving of the thereness and placeness of Upstate New York, which I could never quite understand when I was young, since I was from New England with all its sly self-consciousness. Anyway, *Stone Canoe* made me think of Upstate, and shows me hints of a very different self-consciousness. Good luck with it."

Might there be a unique Upstate New York sensibility, one that can perhaps be distilled from the best writing and art to come out of the region? It is a tempting thought. In his final book, *Upstate,* the distinguished scholar and critic Edmund Wilson struggles to articulate his feelings for Talcottville, his chosen place of retirement. Despite complaints about the harsh weather and "cultural poverty," he admits the area has captivated him since childhood,

and talks of "a certain romantic attachment which the North Country generates for its addicts." Edward Root, the distinguished art collector and historian based in Clinton, has described the Mohawk Valley as "a country to be born in, to live in, to die in; to arouse indeterminable desires and bestow sensuous delights—the proper nursery for the poet, the artist, and the man of thought." The poet Susan Deer Cloud describes her surprise at how she misses her upstate home when she is away, "for who hasn't cursed the darkness in Binghamton, or Syracuse, or Ithaca?" How, if at all, are these disparate observations related? To steal a metaphor from James Joyce, the snows of upstate have fallen on all of us. What are we to make of this? Perhaps cumulative issues of *Stone Canoe* will begin to suggest some answers.

Thanks to all our contributors for sharing their artistic gifts with the rest of us, and congratulations to the 2008 *Stone Canoe* prize winners, who impressed the editors as deserving special merit. Thanks to our distinguished editors, Paul Aviles, Michael Burkard, David Lloyd, and Marion Wilson, without whose expertise and selflessness *Stone Canoe* would not exist. Their profiles and comments can be found on pages 361–362. Finally, thanks to the *Stone Canoe* staff, whose insistence on precision and adherence to deadlines triumphed over countless small disasters and my own worst administrative impulses.

Robert Colley
Editor, *Stone Canoe*
Syracuse, New York
December, 2007

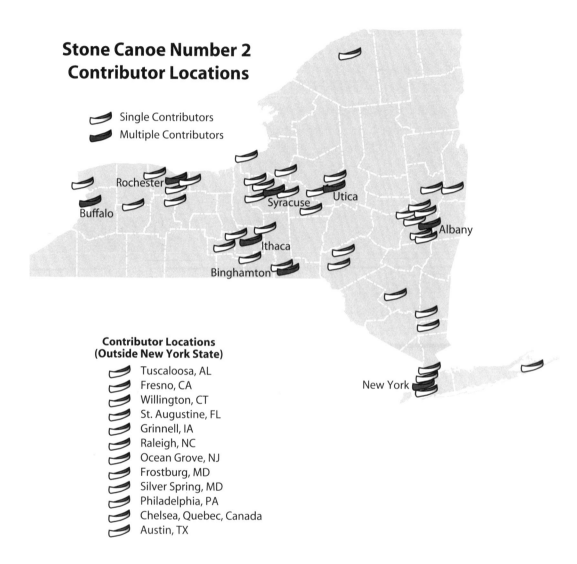

**Stone Canoe Number 2
Contributor Locations**

Single Contributors
Multiple Contributors

Rochester
Buffalo
Syracuse
Utica
Albany
Ithaca
Binghamton
New York

**Contributor Locations
(Outside New York State)**

Tuscaloosa, AL
Fresno, CA
Willington, CT
St. Augustine, FL
Grinnell, IA
Raleigh, NC
Ocean Grove, NJ
Frostburg, MD
Silver Spring, MD
Philadelphia, PA
Chelsea, Quebec, Canada
Austin, TX

stone canoe SPRING 2008 | NUMBER 2

CONTENTS

FICTION

NONFICTION

DRAMATIC MONOLOGUE

POETRY

VISUAL ARTS

Mark Budman

Keep Sawing, Shura

From all the colors of the palette, I like the gold and the red the most, especially when they are combined. Nothing pleases my aesthetics more than a drop of blood on a golden ring.

One busy day, my uncle in my former homeland of Moldova sends me pig-iron utensils. Two large pots and a frying pan packaged in two big cardboard boxes. They probably weigh a ton when I carry them from the post office to the car and from the car to my house. I curse in two languages when no one can hear me.

Moldova used to be a crown jewel in the Soviet Union's proletarian cap. It was a place with a relatively mild climate, great music, cheap wine, and plentiful fruits. Now, it's probably the poorest country in Europe. In Moldova, they have heat, water, and electricity just a few hours a day. In the winter, ice covers the sidewalks and no one removes it. We sent my uncle slip-on cleats to attach over his shoes. He's in his seventies and fragile like an icicle. He mustn't fall.

In Moldova, bandits break into people's apartments and rob them of their money and possessions. If you are a bit richer than the average, you are in trouble. It only pays to be very rich, but not everyone has enough money for that.

Now, my uncle sends us utensils. It's a puzzle. We don't need puzzles. We are Americans now. We are too busy for headaches.

When my uncle let us know about them in the mail, a month ago, I told my wife, "They are made out of gold."

"Gold?" she said while examining the letter again, perhaps searching for some secret code.

"Yes, gold. Like the metal in this Chinese proverb: 'An inch of time cannot be bought with an inch of gold.'"

"A Chinese proverb? Are you wasting my time with another one of your sick jokes?"

"It's not a joke. I really think it's gold. Unless it's platinum. Painted to resemble pig iron. Remember Ilf and Petrov's 'The Golden Calf'?"

Of course, she remembered "The Golden Calf." In that Russian novel, two characters thought that the dumbbells of a rich man were made out

of gold and painted to resemble iron. They stole them and cut them. One character kept telling the other, "Keep sawing, Shura, keep sawing!"

It was iron through and through, after all, so Shura sawed for nothing. I always pitied him.

"Why would he send us utensils made of gold?" my wife said. "He always seemed a sane man."

"Because he wants to transfer his money out of the country. You know how the banking system works in Moldova. They steal everything. He wants us to have the money."

"Even so, where would he get gold in the first place?"

It's a good question. It was illegal to own any substantial quantities of precious metals in the old Soviet Union besides a few personal jewelry items or perhaps a dozen silver spoons. I don't know the current Moldavian laws, but even if gold were legal to own now, where would a piss-poor old man get it?

"Maybe he had the gold since the Romanian times?" I said. "It was legal to own gold in Romania before World War II. Or maybe he received a large inheritance."

My wife shrugged. "You're making things up. Even if he had gold, how would he melt it to make utensils? It's not even literature. It's either science fiction or syrupy romance."

Now, I bring the boxes to the basement. My wife is not home, so there is no need to defend myself against her. Our family cat follows. She probably hopes for handouts though she's in need of a diet, but I hope she wants to keep me company. Hope is cheap.

I unpack the boxes and the cat and I examine the utensils together. They look brand-new. What would I do with the gold? Strike coins with my portrait? Sell it to a jeweler? Hide it in the basement for the rainy day?

The cat finishes sniffing the utensils, and settles nearby, her paws tucked in neatly under her chest. Her eyes suck in all light so I have to watch out. Despite her age, she has great eye-to-neck coordination.

I take a file and begin to scratch. The paint comes off easily but the underlying metal resists me. The cat gets up and bangs her head against my knee. The sharp tool catches my finger and a drop of blood falls on the blackness of the pig iron. I pause to admire it. Red against black. It's the second most beautiful thing in the world. But I'm an American now. I have to go on. I shoo away the cat, take the file, and resume my work. The cat hisses. She's also an American but born and raised. She also has to go on.

When I am done, I stare at the filings. They are pure, uncontaminated Russian iron.

"I guess the coins with my portrait are out of the question now," I say to my cat. Her eyes are full of wisdom as if she's a Himalayan guru.

"You have to make it on your own, Shura," they say. I have no choice but to agree. ≋

Joseph Lee

My-You-Me

Bhing!

Ladies and Gentlemen, this is your Captain speaking. We are currently attempting our flight over the beautiful black abyss of the Pacific Ocean en route to our final destination, Tokyo, Japan. Our current cruising altitude is forty-thousand feet. We are experiencing a little bumpiness so I'm going to ask that you please fasten your seatbelts for the time being. If you happen to still be awake out there, our lovely hostesses, Mayumi and Soo, will be serving a mid-evening snack and beverages, followed by a complimentary Japanese massage during which your submissive needs will be utterly absorbed by porcelain-smooth, exotically eager, and lusty hands... my, my God, that sounds great. My, my—

"Mayumi!"

Here.

I am here.

But not there. Not just yet.

The first thing that I bring with me is the sound. It is comforting, it is loud. It is the hum of engines that seemed so exciting when I first heard them, and then annoying until I eventually became sick of them entirely — but then decided that I could live with them anyway. The second thing I bring is the smell; it is soft vegetables, hard rice, cold sauce, and chicken with faux grille marks, as if every turntable microwave in the world is dancing in unison while emitting comic-book waves of flatulence. But, perhaps, I'm used to it. This is my job. This is my *career.* I wonder how much I could make in tips, if only —

"Mayumi-chan! Get up! Quickly, quickly!"

I curse quietly, politely. I open my eyes.

Focus.

In the dim shading of miniature bulbs I see Soo. Soo is Korean. Men like Soo because they can remember her name. Because in English it sounds exactly like *Sue,* and in Korean it means *Excellence.* My name is *a possessive-pronoun followed by two consecutive pronouns,* and Japanese men say I'm not "giving" enough. Soo looks at me with a smile of disbelief.

"Daijobu?" she asks.

"Yes, I'm OK" I say. Soo's Japanese is good, it's *excellent* in fact. Soo was born to a Korean mother and Japanese father and grew up in Osaka. Soo showed me a picture of her mother once. I told her that they looked alike; same pretty dark hair, and eyes, and lips. She giggled and covered her pretty smile with her hand and said, "That's what everyone says, but I don't really think so. My mother is much prettier." Soo is very modest.

Her hand is now gently placed on mine and I am awake. I am sitting in a faded purple chair that folds up, like the seats in a movie theater, except this one has a seatbelt with the strap secured firmly to my waist. Soo is crouched in front of me and we are completely surrounded by stale silver panels, and handles, and hooks, and shelves, except for two curtains that are the same faded purple as my seat. Behind Soo sits the hulking metal food cart, like King Kong's paperweight. I contemplate why they can't make it more stylish. Perhaps a few ergonomic curves, some color: perhaps beige, maybe even peach?

The plane hiccups, and Soo gets up and says we should start serving the passengers. I unbuckle my seatbelt, and mechanically slip my heels back on. I stand up—but a little too slowly—the chair bats my bum.

<center>• • •</center>

I slide the faded purple curtain with a *whskkkkk.* Under the heavily dimmed corridor of lights I see a cabin full of floating faces. Most are sleeping, hypnotized by the whine of turbines, or half-worn headphones that have come loose while they try to get comfortable in econo-class egg cartons.

Deep breath.

Soo and I proceed to walk down the plane aisle. It's my turn to walk forwards so Soo gets to pull the cart. I admire her flawlessly backwards walk. She begins to offer drinks.

"Excuse me, would you like a beverage?" I say in English, to a Middle Eastern looking man. A young Japanese couple is sleeping in the two seats beside him. He looks up at me. He is handsome.

Sharp chin.

He holds a serious expression as he looks up from a book. His eyes are watery.

"Yes, please. Um...," he looks up at the metropolis of bottles and cans that inhabit the food cart. He clears his throat and *asks,* "Maybe...water?"

I pour bottled water into a fragile plastic cup, already filled with mouth-sized bergs of ice, and place it on the open the tray in front of him. Without

drinking from it, he slides it into the shallow crater situated at the top-right of the tray, where cups rest between sips. He doesn't thank me. He continues to read his book.

I ask: "Are you OK?" because I don't know what else to say.

He looks up and says, "Pardon me?" He is sad. His book is sad. His eyes are still watery.

"Would you like a snack?" I say innocently. I hold up something green and vacuum-sealed.

"No thank you," he says without looking at it. He clears his throat and says, "I would just like to read my book."

The tug of the food cart tells me that it is time to move on. I quickly glance over the man's shoulder before we sink deeper into the beverage abyss. I look at the book for the first time and read from the page that he is reading from. It says: *I do not like green eggs and ham.*

I serve more people, more drinks: Sprite, ginger ale, green tea, black tea, black coffee, tomato juice no ice, orange juice no pulp, apple juice no can, Coca Cola whole can, Sapporo 500 yen, red wine, white wine, whine wine, whine. Some people accept the green shrink-wrapped snacks, but slide them into the pregnant magazine holder where they will be retrieved and thrown away after the flight.

• • •

I used to babysit the Yonekura children for a few hours after school. Being a flight attendant is kind of like babysitting. I administer blankets and pillows and headphones. I provide the illusion of comfort while people endure thirteen hours on sore cheeks. When I first started, I convinced myself that I would be doing an important service. During my interview I even used the words "born to do..." not *actually* because my conception was bound to the glorious servitude of altitudinal patronage, but because it was a strategy I read on the Internet.

My father once told me that I would make a good wife someday, like my mother was to him. My mother was already 43 when I was born and my father was a decade older than she. People would say that their age would be an advantage for me because they would spoil me like grandparents. I'm not sure if there were any advantages, but I noticed at an early age that my parents were different from the other children's parents. Everything was slower at my house; instead of playing softball, I learned the card game

babanuki, instead of hiking in the mountains during the new spring blooms, I learned how to perform a traditional tea ceremony. My father didn't even walk like other fathers. He favored a peaceful shuffle with clasped hands behind his back, with a sort of fluid elegance. I never saw him run.

• • •

Bhing!

Now I am running from the front of economy class to the back. I hear an agonized scream and the floating heads awaken like frightened baby chicks. A man in his late 40s tries to yell for help but he chokes on his own adrenaline and lets out a feeble bark as I pass him. I race through the emergency procedures in my head:

- Put the oxygen mask on your face and pull,
- Use the bottom of your seat as a flotation device,
- Latch the seat-table in an upright position.

A woman shoots up from her seat and yells, "Oh my God!" In the dim light I see that she is covered with dripping dark liquid. I am scared. She holds a something in her hand and drops it quickly. She looks at me with urgent eyes and says, "Please help me!!! A napkin!"

I prefer to call a doctor but agree to a "napkin" because I am still afraid. About two minutes later I realize that there is no emergency, and that we will not need to open the pressurized doors. The woman is ok. The liquid is dripping, dark, scalding, coffee.

We are in the kitchen at the back of the plane and I am holding a roll of paper towels. I try not to stare as the woman brushes a handful of them along the front of her blouse. She uses a quick downward stroke with nervous concentration. I can see the outline of her bra behind the window of semi-dry coffee.

"Do you have something else to wear?" I ask while tearing three giant paper towel squares and handing them to her. She looks up. She smiles. I try to smile back.

"No, I'm sorry," she says. "I didn't mean to make such a fuss back there. Shit, I'm so clumsy. That fuckin'..." she changes her mind, "that *damn* folding tray thing. I was trying to get my book..." she trails off and after a few seconds, she whispers to nobody, "Goddamnit, my blouse."

"Please, don't worry." I answer, "We should have some t-shirts. I can give you one." And then I add, "for free."

She chuckles and abruptly stops herself. "I'm sorry. That's very kind of you. Thank you so much for your help." She looks down at her blouse again, "I just feel like a fuckin' mess." She changes the brushing motion to a patting-and-soaking technique, like when you spill something on your carpet. I turn around and begin to open metal doors in search of the t-shirts.

"Why are you flying to Japan?" I ask, my back to her.

"Well, I'm an English teacher."

I imagine her teaching English swear words to little children. I find this funny and I laugh. She does not hear me over the engine.

"Actually," she continues. "I'm *going* to be an English teacher."

"Wow," I say, still looking for shirts, "that sounds exciting." I say this unexcitedly. The truth is that ninety percent of the *gaikokujin* that are on this plane have come to teach English. It is big business in Japan. "What made you choose to do that?" I say.

"Well, I used to be a dental assistant. I used to look at people's nasty teeth all day and then I would talk but they couldn't talk back to me. So basically I could say anything but it was like nobody gave a shit, like talking to my ex-boyfriend or something. It drove me crazy. No wonder dentists commit suicide all the time,"

We both laugh a little. I don't understand everything she says though because she talks too quickly. I think I hear Soo's name at the end. I find a shirt. I turn around and hand it to her. We look at each other. She thanks me.

"Actually, this is the truth." She pauses. "I guess," she pauses again, longer this time, "I guess I just needed to be somewhere else. Like I love everything back home but I really had to do something by myself y'know?" She looks at me, "Have you ever felt that?"

I have.

This plane.

My father's face.

"I think so," I say. I clear my throat into my closed fist. I really look at her for the first time. She has brown hair. It is short, like a boy's, but she is not like a boy, she is very pretty. Her eyes are grey, or green, I'm not sure. They look into my eyes with awareness, and loneliness, and intensity. She smiles at me again.

Her teeth are really white.

Bhing!

The speaker above my head begins to talk: "Attendant to the pilot's cabin please."

I blink.

"Excuse me," I say to the woman, "I think I must go."

"OK," she says. "Thanks for everything," she holds up the shirt. It is in some plastic wrapping and I can see our airline's logo on it.

"*Arigato gozaimasu,*" I nod my head slightly and she returns the nod silently. I slip seamlessly through the curtain into the main cabin. The plane rumbles. I do not look back...

As if in slow motion I make the trek to the front of the plane. Picture me from the side. I look in the same direction as everybody else but none of the passengers see me. All I see is the backs of heads. They will not turn around because I do not accompany a food cart.

I walk a straight line, along a thinly lit runway and through another curtain, into first class.

Everybody is lost in sleep.

I approach the door to the pilot's cabin, knock, and wait. I glance back and see a young Japanese boy in the front row who is seated next to a woman, probably his mother. The seat engulfs the boy, like a big blue leather clamshell, and he is awkwardly positioned but he does not care. A spindle of drool hangs perilously from the side of his mouth. A buzz sounds by the cabin door and I quickly open it and enter, leaving the drool to collect into a tiny puddle already forming at the front of his shirt.

• • •

I enter the cabin. It is dark and romantically lit by a neon collage of bulbs that are punctuated by numerous dials and switches and meters. It reminds me of Tokyo from above. To my left stands the captain. His name is Lee Richards. Lee is an older man in his mid-forties. His hair is brushed perfectly to one side and his tie does not move when his body does. To my right, sitting silently in the co-pilot's chair is Hiroshi Naito. Hiroshi holds the steering wheel with both hands. From where I stand, I can see only Hiroshi's pitch-black hair.

Lee looks up at me from a clipboard. "Mayumi?" he says with a surprised expression on his face. "I didn't expect you. Where's everyone else?"

"I am not sure," I say, "taking a break?"

Lee looks at me with a puzzled grin. "Well, um, we were just wondering," he looks over at Hiroshi and back at me, "if you wouldn't mind grabbing these dinner trays, we're kind of getting sick of the smell."

"Sure," I say, deflated.

Lee interrupts me before I can begin, "...and, speaking of breaks, I'm going to need one. I'll be back in a few minutes." He quickly grabs a tattered in-flight magazine, and smiles at me before he abruptly exits the cabin.

I listen to the sounds of engines and wind.

I turn to see the back of Hiroshi's head. He has not yet said a word. I approach the armrest that has two dinner trays balanced oddly on it.

"Excuse me," I say to Hiroshi, in Japanese.

He looks left in my direction and bashfully apologizes, *"Sumimasen,"* he continues the conversation in Japanese, "um, thank you for your assistance Mayumi." I begin to collect napkins and coffee mugs that are scattered around Lee's chair.

Hiroshi continues to look straight ahead into darkness. After a few moments, without turning, he says, "How are things, Mayumi?"

I pause midway between grabbing and placing a used tissue onto a tray. As if I don't hear him I say, "Excuse me?"

"Er, how do you like your...job?" He asks this as if questioning his choice of question.

I place the used tissue on the tray.

I pour curdled coffee into a bigger batch of something brown.

I imagine jumping through the emergency hatch door.

"I don't know," I say honestly. I pause. "How do you like *your* job?"

A few seconds later Hiroshi responds: "I don't know either."

We continue doing what we are doing. I try to balance everything onto one tray so that I don't have to hold two. Hiroshi continues to look straight ahead. A minute passes.

"Um," Hiroshi's voice is barely audible over the generic hum of engines, "would you like to try?"

"What?" I say.

"Would you like to try?" he repeats, a little louder.

"No, I heard you," I say politely, "try what?"

"Flying."

"Flying? ...the plane?"

"Yes, the plane, how else would you fly?"

I imagine jumping through the emergency hatch door, again.

"No. Thank you," I say,

"Why not?" Hiroshi asks defensively. At this point, I realize he is serious.

"Because," I say emphatically, "I'm not a pilot, I don't fly planes. I pick up dinner trays!"

"Relax Mayumi," Hiroshi turns and actually looks at me for the first time. Hiroshi is younger than Lee, maybe only 30. His face is kind, like a boy I used to know in university. I can barely see his eyes in the dark. "You won't have to do anything," he says quietly, "just put your hands on the wheel, and I'll control it from here."

I look at his hands. I find them surprisingly muscular. They are gripping the wheel with ease.

"This is crazy though," I say in protest.

"Mayumi..."

"...Fine," I say. I position the mess into one pile and defiantly sit at the edge of Lee's seat.

"Now," Hiroshi says, "Just slowly grip the wheel..."

This first thing that I feel is what I hear, as if the hum I've been listening to this entire time is not actually sound, but micro-sized cells rippling as alive as breathing lungs. I see nothing, darkness.

Pitch black.

I see my father talking to my mother. They both hold grim expressions as if somebody has just died. It's me. They point at me while my head is down so I cannot see my face. I'm standing in front of them with a paper in my hand. It is folded into thirds as if newly opened from an envelope. It is my university acceptance letter. My father yells but the sound is muted and I look at my hand but nothing is there. I'm wearing a t-shirt and jeans and I'm seated in an airplane and then I'm walking along a sidewalk in a city I've never been to and I'm afraid because everything is new. Then I look up and I'm sitting at an interview with a row of men and women in front of me with blue business suits and they are all talking and looking at papers, but not at me, and the buzz of voices slowly rises but I can't hear anything but static. They say I will see the world. And then I am pushing a cart serving drinks to people that don't want them, and wiping coffee off pretty blouses, and watching passengers hitting on Soo, and holding vomit bags, and bloody noses, and kids in first class who get to sleep for the cost of four months'

salary, and hoping that I'll be "really going somewhere *this* time," but my next shift is the return flight back to where I just came from. And I see one of the passengers is my father and I try to talk to him, but he doesn't listen, and I try yelling, telling him that it's right for me, that it's the best thing that I can do, that I need to figure things out for myself y'know? But the buzzing just gets louder and louder and louder.

Silence.

And then more darkness.

And then in the middle of the infinite darkness, a grain of white. It is floating, it is strong. It is resisting. It is long and has a tail and wings, but it is not a bird. It is a plane.

And then, my hands are holding the wheel, and they are shaking, and tears are sliding down my cheek but Hiroshi cannot see because it is too dark.

"Look," Hiroshi says encouragingly, "I'm not holding the wheel anymore; you're doing it by yourself." I don't answer because I don't know what to say.

"So, how are things Mayumi?" he finally asks.

"I don't know Hiroshi," I answer, unable to wipe my tears, "How're things with you?" ≋

Thomas Piché Jr.

MAKINGS' MEANING IN THE PAINTINGS OF LANE TWITCHELL

Lane Twitchell has created a multivalent body of work that allows for immediate pleasure as well as sustained investigation. The artist reconciles the visual and the non-retinal, the secular and the sacred, physical process and seamless all-at-onceness in compositions that turn a grade-school handicraft (the cut-paper snowflake) into a high-art practice.

Born in Salt Lake City, Utah, in 1967, Twitchell grew up in one of the sequestered suburban communities common to Utah's Mormons. Until graduate school, he was an active member of The Church of Jesus Christ of Latter-day Saints; in fact, his ancestors were among the original pioneers who followed Brigham Young to settle the Great Salt Lake valley in the mid-nineteenth century. Upon moving to Manhattan in 1993 to pursue an M.F.A. degree at the School of Visual Arts, this background was thrown into high relief against the secular humanism of the New York art world. Even if he is not an observant Mormon today, he retains the inflection of its hermetic version of the sacred.

Twitchell's initial art projects illustrated his experience of the inter-mountain West. He was increasingly mindful, however, of the mid-twentieth century abstractionists who were interested in depicting the cosmic and tragic in their art—Barnett Newman and Mark Rothko, among them. Pilgrimages made to Robert Smithson's *Spiral Jetty* and to Donald Judd's outpost in Marfa, Texas, confirmed in Twitchell his instinct that a purposeful selection of art materials and processes could result in work attuned to both the visual art strategies of the 1950s and 1960s and to his search for a personal iconography of the suburban landscape, western history, and religious philosophy.

In 1998, Twitchell arrived at a method for art-making that was responsive to these twin desires. It began with a paper cut. Twitchell chose to illustrate a Mormon legend describing a plague of crickets by employing a twenty-four-inch-square sheet of white paper and a utility knife. He folded the sheet and cut away an interlocking, conventionalized schema of crickets and wheat. When the paper was unfolded, a radiating design based on simple positive and negative forms wheeled around the surface.

Twitchell's practice has become more complicated with time, but he continues to fold and hand-cut his large-scale compositions in the manner of children's paper snowflakes. The resulting pattern is affixed to Plexiglas that is mounted on a panel, and a shallow relief surface is built up with acrylic pigments and varnishes; various layers are sealed and selectively recut to excavate traces of earlier planes.

By design, Twitchell's laborious procedures fuse method and subject matter. Some of this relates to occult correspondences between the formal aspects of his compositions and certain traits of Mormonism. The intensity of his ornamental elaboration, for example, gives form to a rapturous precedent inspired by the spiritual experiences of Joseph Smith, Mormonism's founder. Twitchell is also interested in the semblance of unending replication that can be realized in the cut iterations of folded paper, which metaphorically speaks of the Mormon interest in the eternal and infinity. Similarly, the manner in which Twitchell's compositions often appear to be a detail of something larger, to continue on outside the confines of the picture plane, highlights the expansive, transcendent scale of any theological system.

The artist also sees paper cutting as a material-based solution to the modernist focus on painting. He draws his compositions with the blade of a knife, then works to transform drawing into painting through quasi-sculptural means. Twitchell values the procedural strictures inherent in his material. He respects his cut paper's emphatic flatness, its field without illusionistic depth or perspective, and its lack of a privileged subject. ⪢

Thomas Piché Jr., is curator of the exhibition, Revelation: Lane Twitchell, Drawing and Painting, which originated at the Schweinfurth Memorial Art Gallery in Auburn, NY, in September 2007. The exhibition was also at the University Art Museum at SUNY Albany from November 2, 2007 to January 6, 2008, and is at the Roland Gibson Gallery at SUNY Postdam from January 25 to February 23, 2008.

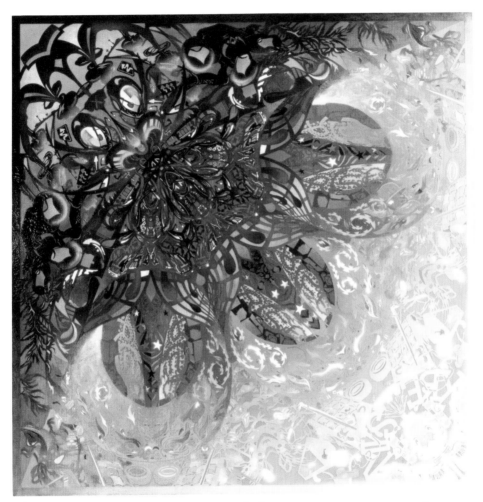

LANE TWITCHELL, *The Blood and Sins of This Generation,* cut paper and acrylic polymers on Plexiglas mounted on panel with acrylic, colored pencil, and cut paper, 72"x72", 2003

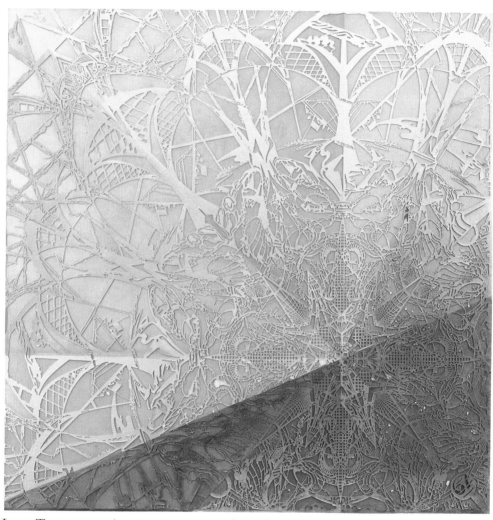

LANE TWITCHELL, *4 a.m.,* cut paper and acrylic polymers on Plexiglas mounted to acrylic on panel, 72"x72", 2005-7

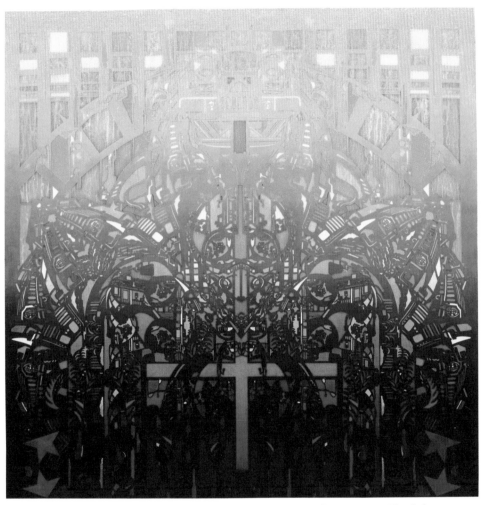

LANE TWITCHELL, *Heartland,* cut paper and acrylic polymers on Plexiglas mounted to acrylic on panel, 60"x60", 2007

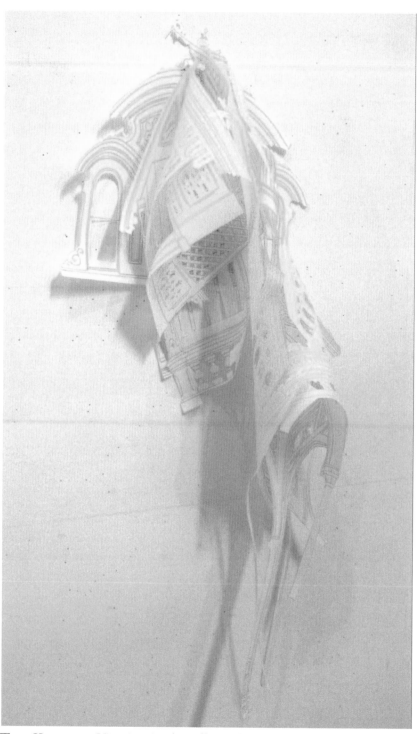

TOM KRUEGER, *Victorian Study,* vellum, fluorescent orange pencil and push pins, 12"x38", 2006

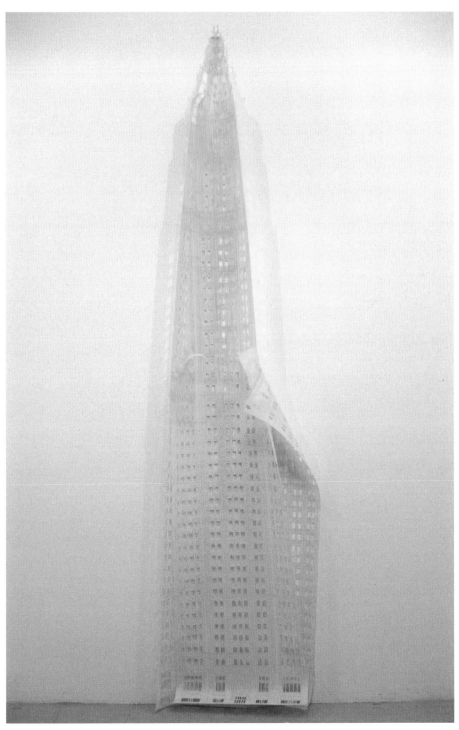

Tom Krueger, *Woolworth Building,* vellum, fluorescent orange pencil and thumbtacks, 22"x72", 2006

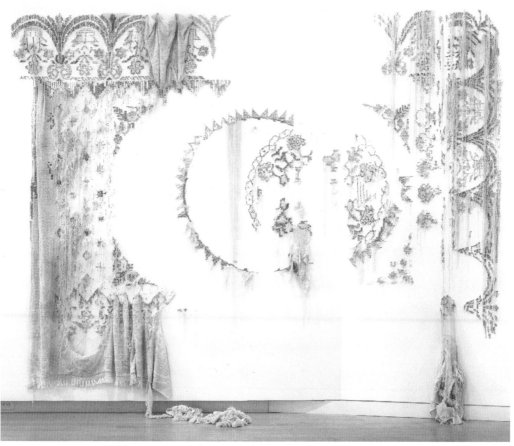

ELANA HERZOG, *W(e)ave 4,* partial view of installation, cotton chenille bedspread and metal staples on reinforced drywall panels, variable dimensions, 2007

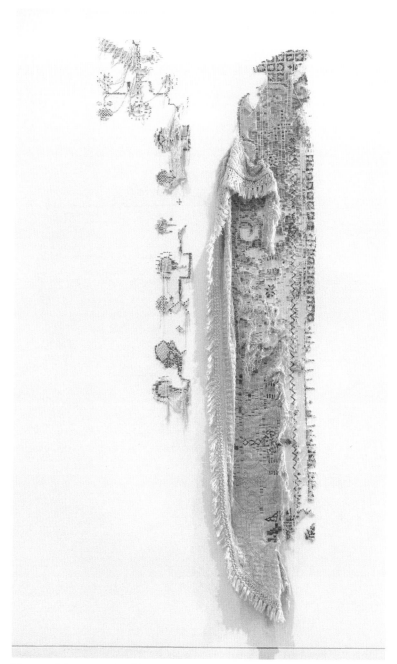

ELANA HERZOG, *W(e)ave 2,* partial view of installation, cotton chenille bedspread and metal staples on reinforced drywall panels, variable dimensions, 2007

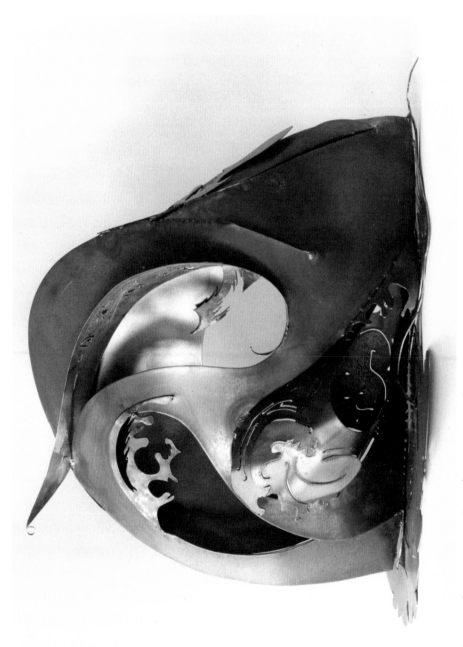

Arlene Abend, *Eons Ago*, plasma cut steel, 39"x29"x12", 2001

Stephen Dunn

PHILIP BOOTH (1925–2007): A REMEMBRANCE

I've had a lot of luck in my life, but certainly among the luckiest was finding myself in Philip's workshop at Syracuse University in 1969. There was this impressive-looking, quite formal man who, on the first day of class introduced us to each other, never asking for our input. He had done his homework about our pasts, and referred to each of us as, say, Mr. Dunn or Mr. Levis. "Mr. Dunn is a graduate of Hofstra and comes to us from New York City via the corporate world, and lately from a year of living in Spain. Mr. Levis is from Fresno, California, and studied with Philip Levine and Robert Mezey," and so on until all seven of us were sketched. Remember, this was 1969, when formalities were under fire as were most semblances of authority. In a sense, he was introducing us to who he was, and when he spoke about our poems it was a further introduction to his character and principles. Though he was open to a variety of styles, he was not open to anything that smacked of posturing or easy cleverness, or any form of disingenuousness. He had not yet written his wonderful poem, "Not to Tell Lies," but he was, in effect, the embodiment of it. One of the most important lessons Philip taught—without overtly teaching it—was that writing poetry was not "creative writing"; it was an extension of one's life, a way of exploring what it felt like to be alive in one's body in a certain place at a certain time.

I never heard him refer to his mentor, Robert Frost, as other than Mr. Frost. I was acutely aware of this, which deterred me from calling him Philip for many years. I think I was in my early 40s before I ventured to call him Philip. In those years between 1969 and, say, 1980, when our relationship was moving toward friendship, I don't know what I called him, not Mr. Booth, but probably, "Hello," or "Hi"; those were his names. Nor did he give me permission to call him Philip. My guess is that he rather liked my little dance around the issue of boundaries, yet probably was pleased when I could finally call him by his first name. I mention this because he was a man, as you all no doubt know, of very defined boundaries.

For example, in my second year at Syracuse, my then-wife and I felt very honored to be invited to his house for drinks before dinner. I remember exactly how he framed the invitation: "Why don't you come around 4:30

and leave at a quarter to six." Philip was wonderful company when he knew the social parameters in advance, somewhat fidgety company when he didn't. Of course he had the great fortune of having Margaret for a wife. A man could afford a number of eccentricities if he had a Margaret to carry the day. I suspect Philip learned this early, and it became one of the factors in the freedom he felt in being selves rather than just self. Self was firmly rooted; the selves he placed under the scrutiny of the unsparing language of his poems. Margaret, his children, and Castine were the anchors—everything else was adrift. His poems, especially the ones from mid-career on, sought to find the words for that elusiveness. They are important poems; they echo the intensity of their making, they testify to a long war between passion and restraint, a war that was constantly being lost and won. He seemed amused by the ambiguities and paradoxes that resulted. That is, when he wasn't being tormented by them.

For me, he was a great and important man. Over the years, I sent poems to him regularly. He liked some, but when he'd catch me being facile, one of his frequent criticisms would be, "Deepen your concerns." You can get cosmetic criticism from many sources, but it's rare to get what Philip had to offer: moral incisiveness, and the conviction that syntax was its evidence. Speaking of which, he hated the inexact, the careless. "That's a shotgun, goddamnit, not a rifle!!" he wrote in the margin of one of my poems. He kept you honest by exemplifying the struggle to be honest. And what's even more rare: the older he got the more generous spirited he became. Philip Booth had a good run on this earth. ≋

Philip Booth

First Lesson

Lie back, daughter, let your head
Be tipped back in the cup of my hand.
Gently, and I will hold you. Spread
Your arms wide, lie out on the stream
And look high at the gulls. A dead-
man's-float is face down. You will dive
and swim soon enough where this tidewater
ebbs to the sea. Daughter, believe
me, when you tire on the long thrash
to your island, lie up and survive.
As you float now, where I held you
and let go, remember when fear
cramps your heart what I told you:
lie gently and wide to the light-year
stars, lie back, and the sea will hold you.

Not to Tell Lies

He has come to a certain age.
To a tall house older than he is.
Older, by far, than he ever will be.
He has moved his things upstairs, to a room
which corners late sun. It warms a schooner model,
his daughter's portrait, the rock his doctor brought him
back from Amchitka. When he looks at the rock he thinks Melville;
when he touches the lichen he dreams Thoreau. Their testaments
shelve the inboard edge of the oak-legged table he writes on.
He has nailed an ancestor's photograph high over his head.
He has moored his bed perpendicular to the North wall;
Whenever he rests his head is compassed barely west
of Polaris. He believes in powers: gravity, true
North, magnetic North, love. In how his wife
loved the year of their firstborn. When-
ever he wakes he sees the clean page in
his portable. He has sorted life out;
he feels moved to say all of it,
most of it all. He tries
to come close, he keeps
coming close: he has
gathered himself
in order not
to tell
lies.

EATON'S BOATYARD

To make do, making a living:
 to throw away nothing,
practically nothing, nothing that may
come in handy:
 within an inertia of caked paintcans,
frozen C-clamps, blown strips of tarp, and
pulling-boat molds,
. to be able to find,
for whatever its worth,
 what had to be there:
the requisite tool
 in this culch there's no end to:
the drawshave buried in potwarp,
chain, and manila jibsheets,
 or, under the bench,
the piece that already may fit
 the idea it begins
to shape up:
 not to be put off by split rudders,
stripped out boards, half
a gasket, and nailsick garboards:
 to forget for good
all the old year's losses,
 save for
what needs to be retrieved:
 a life given to
how today feels:
 to make of what's here
what has to be made
to make do.

Cynthia Day

MR. & MRS. CLOUD

Cloud. The Clouds. It *is* a funny name.
Your name will be Mrs. Cloud, my mother said.
That was thirty-some years ago and now he vanishes like one.
Joking aside, I can't remember him,
can't hear his voice, as familiar as cars in the street.
Sometimes I can see him in the driveway, the way he stood
when I was late, with his arms folded across his chest.
But I can't see him where I saw him every day
in the kitchen where we ate.

The children long ago moved away and now him;
things you don't expect although everyone tells you.
The house is quiet like a church.
You could say I pray over it:
the armchairs, Lizzie's clock, the pot of lavender.
What do I pray? To let go of the past
so the waste of a life, the lives, won't kill me.
To learn something, even this late.

MRS. CLOUD AND THE NEST

Last spring the robins built their nest
between the arms of two wicker chairs
I left side by side on the porch all winter
and it was, by their standards, as sturdy
as my old bungalow is to me;
twigs and grasses threaded
and intertwined with mud and wicker,
like clapboard, like nails.

I watched the lady settle in for her wait
as rain and ice swept the porch in April's bitter gasps;
and yield her azure eggs and sit with that inhuman look,
unpretending, so deeply into the present
it can't be understood. Day after day
I came back to the window, to her,

until cracks appeared in the shells
and her five babies lay naked;
until their down turned to feathers
and some messenger from the gods brought them,
one by one, to the edge of the nest
where they flew like crazy
to the porch railing, the trees.

And the whole time I was thinking
about the months and years it has taken me
to let go of a few offenses.

MRS. CLOUD AND THE BURNT ROSES

When Jack told the story at dinner
about asking a group of students
what love is, he said every
single one of them had an answer,
and I said it was the perfect example.
The suburbs are full of such
innocence. The women have
the kindest smiles.
Not like that old drunk
Mrs. Harding when her
husband left her; how she baked
roses in the oven and sent the
black flowers to his new house.

Michael Martone

BOARD GAMES

PENNSYLVANIA

He was Grandpa Shaker because he shook, and when he died he stopped shaking. My great-grandpa Shaker lived with his daughter Mary, my great aunt, until the day he died. I kept him company. We played two-handed Rook with two dummy hands on a card table set up in the driveway during the summer. He had a glass straw that jangled against the ceramic mug. He breathed the milky coffee in and out, the tube clanking, while I turned over the cards. I could never understand the dummy hands and would have rather been playing four-handed hands with my friends in the park. In the park then, they let you play Rook because the four suits were colors—red, blue, green, black—instead of hearts, clubs, diamonds, spades that were forbidden because those suits were more real, I guess, and would promote gambling, poker among the kids. The Park Police actually checked the games, checked the cards.

The parks had pavilions that were staffed, and there on picnic tables, I played pick-up games of box hockey, kala, chess, and checkers, and Rook that got played like poker anyway in secret.

As a kid, Shaker came north and worked for the Pennsylvania Railroad as a trackwalker. That was before my time and before he shook. We played euchre too at the table with another pair of ghosts, partnering with us. Every hand you shot the moon. I never won. And we never talked.

When he walked track he walked from the Baker Street station east until he met the trackwalker coming from New Haven and then he would turn around and walk back downtown, pass the station, out west toward Roanoke, and then turn back again. He did that twice a day every day for years. He looked at the spikes and cleats and ties and rail. He carried a pike and a mallet just in case and some extra hardware in his pocket—date nails, pliers, joint bolts, and wire for the interlocking circuit. As he walked, he played a game with himself, counted ties, but his stride never matched the distance between the sleepers. There was oil and sand on the ballast, and killed things with clouds of flies.

Monopoly was impossible outside. The wind messed with the flimsy money, so we played it inside on rainy days and in the winter after school. We never played the rule that said you had to buy the property you landed

on. Shaker liked to shake the dice and move around the board, avoiding
jail and buying nothing. Doubles let you shake again. We had two dummy
hands—the battleship and flat-stamped cannon—that moved from square
to square as well. His hand shooed the lead steam engine around the board,
from square to square, and during my turn Shaker nudged the glass straw
between his lips rattling like a machine. With the other hand, he tried to
tap the accumulating money into neat stacks of color but only ended up
shuffling denominations all together into one big pastel pile. Sooner or
later, my mother came to get me and took me home. I waved good-bye.
And he waved back with one hand shaking and the other hand shaking,
shaking the dice for another roll, his turn, now, always next, and me, now,
just an absent hand.

SHORT LINE

We rode backwards on the short line from Pirgos to the ruins at Olympia
along a stub-end track with no place to turn around. The dumpy station
disappeared behind us. All of Pirgos was a ruin, ruined by earthquakes
every other year or so. What remained were concrete boxes sprouting
rusting rebar on the spoiled roofs. In the waiting room there, we played
backgammon in the dust and gloom and ate grilled cheese pies. The station
master made clumsy passes at the Swedish students, insisted each should
wear his hat while he sang the island songs of Yanni Parios playing too loud
on the mistuned radio.

 We were going in reverse to Olympia. The cars were blue, of course,
and on the curves we could see behind us the black donkey engine pushing
us along at a walking pace. Olympia was filled with motor coaches hauling
tours that came with included breakfasts each morning of the trip. So dawn
found us at the site before the crowds finished their *portokalada* as the guards,
who spend the night on site, were just waking up and stowing their bedding
near the gate.

 The place was deserted. Everyone at breakfast. The stones on the ground
were where they tumbled, after some other earthquake, into the mud flats
the river left behind when it was shaken out of its course. In the middle
of what was left of a temple, a tiny Greek church had been plopped down
a few centuries ago and was the only thing left standing in the precinct, a
token. Falling from the eaves and windowsills, swallows circled above a red-
tiled roof and then skipped out over the field of debris, the stumps of fallen
fluted column drums, the marble just beginning to catch the light.

B & O

I let him play at the piano—my niece's boy, I had no sons—when I visited my sisters in Garrett. I drank iced tea with my sisters in the kitchen and told them jokes and shot the breeze to distract them from thinking about the kid in the parlor, noodling discordant, off-key keys on the out-of-tune upright Kimball. Nobody there plays. Everything in the parlor could break, the crystal and the porcelain, the glass and the wood. Soon, when they couldn't sit still any longer, they flew past me to the parlor and made the boy sit still on the davenport. They gave him the cigar box filled with the postage-stamp-sized receipts the paperboy left after he collected for the week of whatever. The tiny dates were printed on each—there were a lot of weeks. They wanted him to sort the bits of paper for them for no reason.

I got him to come up from Fort Wayne telling him we would look at the old steam engines. The B&O has a roundhouse in Garrett, a division point shop, and now he winds up here, trying not to move. I wanted company and an excuse to leave after I had performed my obligation to my sisters—three of them—who still live in the family place not that far from the mainline.

I worked nights in the power plant in Fort Wayne, City Light and Power. I managed steam mostly, moved it from one turbine to the next, tapped it from the boilers, vented it outside, blew the whistle at times of my choosing. The cold engines of the B&O, black and big as buildings, were being scrapped; a couple of guys I knew from high school let us watch them disconnect the giant steel shafts from the driving wheels, knocking the locking bolts loose with a metal sledge that drew sparks. They stripped the copper wire clean, disconnected the bells and running lights. I showed the kid the platform on the gap-toothed pilot where the firemen of old would leap from to throw switches out ahead of the panting, drifting engines slowly catching up. He jumped up on the step, then on and off for a time, and climbed the catwalk the rest of the way to the cab. The firebox was choked with ashes, and the stuffing from the engineer's seat was leaking desiccated foam rubber sand on the tread plate floor. There were twenty-some hulks in the dingy house. The big window wall, gritty with old smoke, filtered the weak light onto the dirt floor sown with cinder.

Driving home, we went under the viaduct labeled with the drumhead logo of the B&O, the capitol dome in the blue circle. I asked him if he could name the 13 great states the railroad connected to the nation? That took some time and I was happy when he gave up because I could only count a dozen in my head. To keep him busy then we played I Spy and I Went to

My Grandmother's House. I showed him the high tension towers and told him those wires there go all the way to the power plant where I work. "It's all connected."

In his pockets were chunks of metal and scrap he salvaged from the round house—rusted rivets and wing nuts, amber glass, a brass toggle, a lump of coal. Later, back home, he arranged the pieces over and over again on the cement squares of the driveway. He was a strange kid. He'd stay busy for hours turning the geared wheel within the geared wheel that turned the grindstone I had bolted to the workbench in the garage. He said he liked to see how they—the teeth he meant—fit together to make it all go.

READING

It opens like a book, made of tin, and all the tiles, each printed with a single letter and its parasitic subscript, are magnets that cling to the grid so that, later, when I get mad about all the words I do not know or could not guess or cannot remember, I can't toss the board over, spilling the tiles and scrambling that game's particular accumulating network of cross-words. It is a travel edition. The train I am traveling in is yawing, and this stretch of old rail still wields unwelded joints. The car skips and shutters. The compartment's above a six-wheeled truck that transmits the stammer through the old heavy metal. One reading light falls on the open game with its sticky scales of letters. The other reading light falls over her shoulder, kicking up dust in the beam, to light on the book she is reading, reading while I take my turn.

I have drawn all vowels, it seems, and most of those are Os. There is a moon outside I can see through the faint reflection of my face in the smeared window and see scattered cattle, I suppose, black and white, lolling in the glooming. But here before me, there isn't a tail-end of an M on the board to let me couple on an O or two.

I watch her read. Her eyes scan a rhythm that seems to syncopate with the backbeat of the train's. She is reading a travel book. There are no Bs or Ks, no book or look or kook, to hook on to either. No boo. A travel book about Greece I think—a blue train circling the Peloponnesus, the cog railway gearing up a gorge to Kalavrita.

Then, it happens. The moment when a word like "the" stops being "the," the the-ness goes out of it. It's all Greek then. I can't make *this* or *that* mean anymore. That *that* will always stop me in my tracks as I read, coming upon this word *this* or this *the* or that *the,* some strange train wreck of letters, everything sprung, Sherman's twisted bowties knotted with the over-heated

rails. That's the way this game always feels to me. This impossibility, that out-of-sheer-arrangement sense.

This is the point in the game I would usually hurl the cardboard board across the room, wooden tiles flying, but this particular travel edition has unified its fields of forces—strong, weak, magnetic, gravity—the four black engines of the universe. Things attract, stick, adhere, bond. I'll have to pass. She keeps on reading. She's in a carriage crossing the canal at Corinth, and she is here in some dark territory of Pennsylvania. The train's wheels, those Os, roll over the rail, a dime-sized connection, almost without friction. The whistle yodels an ordinary echo. Echo. Expanding rings of sound waver and warble.

Ordinary is ordinary again. I look at the board of crisscrossing letters, words, sentences, messages. The language chugs. This stands for this, I see. And this stands for this. And this for this. And this. ▧

Chelsea Lemon Fetzer

Fad

Wooden horse head on a stick. Horse molded in
hollow plastic. Tin horse. Postcards taped to the
refrigerator. Playing cards on the table in a stack.
Book mark. Matchbooks. Watercolors of horses signed by
famous people, by the children.

The favorite is a photograph in black and white. A
horse's eye up close. Turned upside down, it is a
man's eye. Sideways, it is the dark hollow of a
man's open mouth.

RIGHT HERE

I teach you how to do it this way; write a poem with your
tongue. Not that alphabet move. Or the gun trigger thing.

Not those tricks boys think they do. A poem. Get it? Letter,
letter, word, word, word. And I'll know if it's any good

because I'll be reading it. Your bedroom window is too close
to the window next door and a woman's voice comes in.

Right here, she says. *Right fucking here.* The dark over my top
parts, over my mouth, is curving, concave, lonesome since you

went down. *She's loud enough,* I say, *she's probably drunk.*
Is there always so much noise in here? You belong in my

house, did these years and one more June. But the ways to be
with me are the ways to enter each room and then again

to leave them. Your tongue writes, *I, I, I.* Your face rises
like a fruit out of the saltwater. There is noise all the time,

you say, *but I don't mind.* My knees capsize. And when I
come, does it mean you end the poem or I end the poem?

It might be cool if we both put what we remember down on
paper. Like people do first thing, to keep track of a dream.

After that we could compare, see how close we get.
But we don't. Never did. It isn't that kind of writing.

My Shoes

At the end of each day we spent in Yazoo City
my father sat at a blank table provided by the Best Western
to draw another picture in his leather-bound book.

Without symmetry,
he attempted to illustrate the following translations:

1. White men as black men in a hunting magazine.
 Felled bucks or doves.

2. A glass of milk as the middle passage.

3-?. James Baldwin as Brer Rabbit
 James Baldwin as Marlon Brando
 James Baldwin as Grandma
 James Baldwin as Patrick Ewing
 James Baldwin as James Baldwin

(Later my father would add color to the neckties).
No one else I knew was so unafraid to be a fool.

I considered the relevance of history. Or art.
There wasn't much left to do with the day,
me at 27 and the off television bolted to the wall.
You should draw my shoes—I said.

Referring to the only shoes I bothered to wear,
white sandals with the Velcro strap.
More yellow now than white, like teeth.
More red now than yellow, after Mississippi's dirt.
My father looked at my shoes plenty.
He talked about them.
He said they stunk like the floor of a greyhound bus.
My sandals, rattled by the floors of so many buses.

I brought them to his drawing table
and straightened them neatly
beside each other, empty, inside the light.
Waiting for translation.

My father adjusted the rim of his glasses, uninspired.
He turned to the next empty page and began to draw
Frank Stokes' 98-year-old daughter as Frank Stokes' lost guitar.

Maureen A. Sherbondy

WORRY

I handed my keys over to Worry. He was a burly man with brillo hair that no woman would ever want to run hands through.

Worry took me on a wild ride.

"Watch the curves!" I yelled, holding onto the plastic pull in the back seat, as the car screeched and raced around the corner, spinning dirt and leaves into the air.

"Go with it," he said, eyeing me from the rearview mirror.

"Objects in the side-view mirrors are closer than they appear!" I yelled.

He stuck his thick arm out the open window and knocked the mirror off with one fierce punch. When he braked suddenly, for no apparent reason, the lumber truck following too closely knocked into our bumper. I screamed like a cat in heat, as lumber from the truck unbuckled from its ties and unloaded in a loud jumble on the side of the road.

"Are you crazy!" I shouted, hitting his headrest. "Too much Starbucks? Crack?"

"Hey, you're the one who gave me the keys. And your hands were shaking when you handed them over. If anyone is hyped up on something —it's you."

He turned to face me, staring me down. His eyes were so dark, it seemed as if there were no pupils. Then Worry floored the gas pedal and began driving with his knees. I closed my eyes, said a prayer, but was jolted again when he raced through orange cones, knocking down a *Do Not Enter* sign.

"Give in to me," he advised, handing over his whiskey flask.

"Let me out! I can't do it. I want the keys back, my life. I'm tired of you, I'll learn how to handle daily life. I'll do yoga, meditation, raki. I'll take warm baths scented with rosemary and wear those special soothing stones around my wrists."

"Oh, you think that will work! Huh!" He lit a stogy as the car flew through a flimsy gate, shot over a cliff, landing in water with a loud splash and thump.

The car floated forward like a boat.

"We're going to sink! Who will take care of my three children? The dog? My house? My sick mother?"

The car continued drifting for an hour until it reached an island. A turtle greeted me with a slow crawl; palm trees lined the entry point and led to a tropical garden filled with ginger, orchids, and hibiscus. I left the floating car and followed Worry along the dirt path. Parrots showed off their multicolored feathers in front of my eyes, and I felt my heart slow down for the first time in years.

"Here are the keys. Stay a while and chill out. Don't go home until your worry lines vanish, and your blood pressure goes down." Worry patted my back with his large hairy hand, then he vanished into the garden singing Reggae songs, one which sounded like *Don't worry, be happy.* I followed the line of cigar smoke with my eyes until I could no longer see the grey cloud.

• • •

I spent a year on the island, just breathing, singing, and resting. Then I climbed in the car that was docked to a palm tree. The car floated back to reality. On the road home, chunks of worry began to appear in my car. Are the kids all right? Who's been watching them? Who's been paying the bills? I gathered the worries like beads, threw them out the window, hoping I could leave them behind. Taking a swig of whiskey and bravery from the flask that was still in the car, my heart sped up when blue lights flashed in my rearview mirror; the scream of a siren filling my ears.

"You're littering ma'm. I'm going to have to fine you—$200," the officer said in a monotone voice after I stopped the car.

"You don't understand!" I hit the dusty dashboard with my fist. "I'm trying to relax."

But it was too late. My heart was now beating so fast it spun out of control, a hole opened in my chest and I watched as my heart swirled out of me, out the car window and into the sky. ≋

JAKE MUIRHEAD, *Glass Factory Road,* etching, 10"x8", 2006

Doran Larson

Tango

Marilynne Troop plans children's parties. She's good at her job because Marilynne cannot be pleaded or cajoled, whined, or baby-talked into anything by anyone under the age of reason. Unruly guests can take a time-out in the hall or sob to a Hindu cabbie if they want to tear at colored paper or the first piece of cake. Behind her passing smile, Marilynne does not like children. They are whipping garden hoses of narcissistic desires, flailing among their Mommas' and Daddas' heartstrings. (Marilynne had a younger sister upon whom she'd doted until the day the baby died. But she pays good money to therapists who all eventually break down and concede that this had nothing to do with her career choice.) Discipline and focus: these are the things Marilynne Troop respects, and it is a rare child that exhibits either.

Seth Mackleby has contacted Marilynne to orchestrate a surprise party for his daughter Bea's thirteenth. Seth is a widower who makes great money working fourteen-hour days so that Bea can go to an excellent private school, practice riding and dance, and take expensive lunches with native speakers of French, Spanish, and German, and then go on to an excellent private college.

Bea Mackleby knows that her father loves her and means well. She does not blame him for being preoccupied. Seth tells her how much she is like her mother, of whom Bea enjoys no memories she can say are not drawn from home videos of an attractive young woman who seems barely able to tolerate Seth's enamored lens. Bea fully believes she is like her mother. It explains why she holds such power over her father, why he can deny her nothing, aside from his lucrative time. In truth, Bea often pities her mother. Not simply because she died young. She pities her for having been her father's wife. He's such a sad man, in ways she cannot believe are all the result of his wife's sudden passing. He works hard and asks for nothing except the occasional new suit, a woman to see that he eats and changes his underwear daily, and the chance to work even harder. Though trim and attractive, he is like a big sloppy retriever—so mournfully, abjectly anxious to please that one can hardly be blamed for wanting to kick him. And predictable? There is no exact word for it (and Bea has looked into the excellent thesaurus in her school's excellent library). Her birthday, for example. Normally Seth can talk about nothing else for a month. This year, he says nothing; ergo,

a surprise is in store. And since Seth is a man who believes in experts, with a quick foray through her father's desk drawers, Bea soon has the situation in hand. She calls Marilynne, who is frankly skeptical that she is talking to a mere soon-to-be-thirteen-year-old, but who is also thankful, for once, that she really has no child—properly so called—to please.

They negotiate:

The guest list;

The menu;

The entertainment;

Drinks for the attending adults;

The adults who will be invited to attend;

The music;

Décor.

After she hangs up, Bea feels satisfied she is dealing with an adult who has treated her like an adult. She respects Marilynne Troop's readiness to take (Japanese wall hangings) after giving in (Jimi Hendrix). What a pleasure if Seth could find the time to meet such a woman. Bea sighs, then steps to her mirror and practices full-body expressions of surprise.

After she hangs up, Marilynne sets down her notes and takes up her wine. She sighs. It's been a busy week. (Why was there so much fucking going on in the second week of November, 1992, she wonders, then realizes.) Yet what a relief not to have to deal with Mackleby *père*. She hates surprise parties anyway, and just talking to the man, she hung up feeling licked all over. She watches her goldfish, Benito and Jaws, nipping at each other's tail fins. She finds herself admiring Bea Mackleby's ability to give (samosa and chutney starters) after taking (Chinese jugglers). Yet something doesn't feel right. She drinks. She thinks. In her second glass, it comes to her.

Bea Mackleby gave as much as she got. But somehow the pattern of the whole is hers. As though she knew what Marilynne would want; as though she had fit Marilynne's tastes into a plan she'd decided upon before picking up the phone.

• • •

The apartment is a corner unit, eastern windows yawning vertiginously upon the park. Fifteen child guests, six adults, jugglers due at seven. The "Surprise!" goes off credibly: Bea sinks to the floor from weak knees and stands up quietly weeping while Seth's shoulders do shrug lifts that pump his mouth up and down. After a swarming of kissy faces and chatter, "Purple Haze" announces that the party has started. Bea hardly eats (she's dieting)

for corralling her father in her arms at each new course. The adults—all women save for Seth's racquet-ball buddy, Bobbie—chatter and coo and drink themselves into the same sloshy silliness that the girls manage on Diet Coke and hormones. The jugglers bounce a spinning aluminum plate—*TONG!*—off a window, but are otherwise flawless and fawningly polite (aside from the graybeard who fondles Cheri Broadbent's ass, sending Cheri into Pinot Grigio giggles that end only with the *thup* of the elevator). With a few managerial directions and hyperbolical announcements of the cake, the jugglers, and an apartment-safe fizz of fireworks on the marble sideboard, Marilynne works her magic from among the caterers all bunkered in the kitchen (save for the charming servers, Dimitri and Raoul). In sum, it is an occasion straight from a musical, Fred and Ginger on Ritalin and Highballs, an evening on oil: the swoop of the last laugh and clap for the funky-dance contest segues into the announcement of cake; the final *shraaa!* of ripping metalicized paper and Bea's last appreciative sigh glide up like a lifted proscenium upon the jugglers' entry under the faded muslin drape of an eight-legged horse. Throughout, Seth is laid low by blushing joy beside a giggling drunk Bobbie on the corner sofa.

When they are gone, though there is only Bea and Seth and Marilynne left sitting on the sofa, Bea does not let down. Playing it as anxious as a girl her age who has to pee, she pleads for Marilynne to stay for one little drink, "To make my day perfect!"

Seth is on his wobbly feet. Marilynne sees the spot Bea has put her in and sees Bea playing it. Seth is kneeling, as though he is a man whom it would be amusing to observe in abject submission. Above his bowed head (lip-suctioned to Marilynne's hand), Bea sticks out her tongue. And when Marilynne laughs the laugh of a savvy, adult woman, Bea is lifted with her: five-figure teeth gleaming, tongue-undulous, the girl is chortling through hazy stars of tears for the chance, at last, to play with a grown-up woman.

"Will Seth get me a drink?" Marilynne asks his blondness.

He lifts his face, squinches his eyes tight, and nods. She scratches his head and he trots away on tiptoes into the kitchen.

Alone together for the first time, they take a long breath—the play a success, the cast to themselves—and exhale like life-long professional confidants.

"You were good," Marilynne coos.

"And you, even better than expected." Bea pulls her feet up beneath herself—a naiad, ready to spring. "And I'd expected quite a bit."

Marilynne is cool: "Did you? I do hope—"

"Not for me. Not my birthday as such. Don't you agree? Age is biology, not mathematics."

Marilynne smiles: "I always think it merely histrionic: you're as old as the number of people you make feel younger than yourself."

Bea grins, crookedly: "And vice versa?"

A slow, 40-something blink: "And vice versa."

A glass tumbles into the sink.

"So long as he's happy," Bea sighs sincerely. She plants an elbow on the sofa back, rests her cheek on her forearm: the exhausted birthday girl in case Seth pops his head in. (Crossed knees and a bitchy slouch, Marilynne reflects, would be more natural.) But the girl persists, her gaze wafting toward the door of the kitchen. The look and pose linger until Marilynne has to ask, "Don't you get tired?"

Bea whips to attention. (Marilynne hears her neck pop.)

It was not really a question; it was a kind of anti-question, as though Marilynne Troop has wired-tapped thoughts Bea herself has only dimly entertained—thoughts that would have come on their own, perhaps when she turned fifteen. But the moment the words are in the air, Bea knows it is true: she is tired—of the act, tired of playing the younger, less-adult half of this high-priced household; she is tired of anticipating his moods, of making their dinner and lunch reservations and seeing that his socks match before he leaves the apartment; she is tired of exiting her room with an unconscious, curtain-up inhalation, of releasing it only when Seth, each night, presses her door quietly shut. She wishes suddenly, in a dishearteningly 13-year-old way that she and Marilynne were in fact alone. When Bea's right eyelid quivers, Marilynne is satisfied. She has command again. Bea closes her eyes tight, imagining the kitchen silenced of the water running over Seth's too-frequently washed hands. She opens them to find Marilynne gazing unwavering support and challenge, and Bea gazing back while Seth works the towel, as efficiently foreboding as a sail rapping loose in a hurricane.

"Order up!"

As he weaves back into the room, drunk enough to think he's funny acting it, Bea is terrified. Exhaustion has washed over her like a baptism; she has stepped over a threshold into a world for which nothing in her past has not un-suited her. While a pink cocktail glides toward Marilynne's hand, Bea feels she understands why the Saved weep, how an insect feels after shedding its protective carapace.

Seth Mackleby is here, and Bea Mackleby is not acting.

She weeps as she feels her legs unfold. In her heart, she cries for her Daddy, magically, to become an adult she can turn to, a man who could hold her in his wiser arms. And yet the healing over has already started. The scraping of twig and stone upon her tender exoskeleton is drifting to a numb distance. Her arm lowers across the top of the sofa; her knees cross, ankle wagging; and from her thin, concise lips, she hears herself beckon, "Here, Daddy"—patting the cushion between herself and Marilynne. "Come sit here."

Seth laces his fingers and stuffs his hands between his knees for joy. He is seated between an attractive woman and his daughter. It is as though he feels Bea's mother reincarnated: the man between his two beautiful women. Ready for a bath of weeping gratitude, he turns to Bea.

"Did you have fun, sweetie?"

Bea, unable to speak again quite yet, shoots a pleading glance at Marilynne.

"She had a great time," Marilynne assures him. "And why shouldn't she?"

Seth waits. Bea's eyes are on him, in childish, pleading panic, to be saved from the next moment.

"After all, she arranged it."

Seth nods and beams. Poor man, he is perfectly Wylie Coyote hanging unawares over emptiness. Bea reaches (but only one hand), clutching his leg before the abyss yawns beneath him.

"Huh?"

"No," Bea whispers, without hope or conviction.

"But it's time," Marilynne tells her. "It's better this way. You know that"—dramatic, yet also as flat as a soap-opera star, delivering lines while wondering if she put enough quarters into the meter.

A practitioner of desk-chair yoga, Seth's posture measures his mood. As Marilynne recounts Bea's phone call, their give and take over the arrangements—hinting strongly enough even for him to see that Bea has in fact been managing their social life for years—Seth's chin falls in sudden stages, *kachunk, kachunk,* like a car pumped down from a hand-jack. His eyes burgeon. Bea leans her forehead into his arm, clutching his elbow, quietly sobbing. It never occurs to her to lash out at Marilynne. Marilynne is merely the messenger—the pathologist, or a cold-fingered lab tech, reading the bad news from a printout. When it is done, father and daughter are silent for a full minute. Seth is stunned. Bea is waking—horribly, wonderfully—into a brave new world.

"Beebee," he murmurs.

"Daddy."

"I thought..."

"I know." Nails in his arm—"I *know.*"

Her head still pressed to his shoulder, he rests his cheek against her silky hair, weighing heavy upon her skull.

"Things will be better now," Marilynne whispers with the sympathy of a kindly sex-worker.

"We should have talked," Bea tells Marilynne without raising her head. "You should have asked me."

"And what would you have said?"

Bea is silent before a last cry rises not quite high enough to escape her throat.

"You're an extraordinary girl, Bea."

Seth nods into Bea's scalp, a high groan buzzing his sinus.

"Seth is an adult. He's a broker for godssake. He knows the old win and lose."

He raises his head to act the part. He nods firmly, until his face collapses into a mask of tragic putty and melts back atop his daughter's. For a long while Marilynne holds still. She drinks her drink. (Father and daughter weep and paw each other's faces; they murmur apologies and tender reassurance.) In the summer dusk, she watches sparrows harass a crow working the thermals from the streets below. Finally Bea settles silent, then begins to take bracing breaths. Then she is up, stiff and whipping away tears with the backs of her wrists.

Marilynne smiles, welcoming her back into the saddle, quietly rejoicing in the shards of jagged ice that are Bea's eyes. She watches Bea stroke her father's head—"There there"—gaining strength by the quarter-second, like a cyborg rebooting into backup power. Marilynne is mildly, pleasantly tipsy enough to wish Bea were her virtual age and they could slip off alone to some dark and tastefully butchy bar.

"You needn't be brutal," Bea admonishes.

Seth's head jerks up, a frown aimed at Marilynne.

Marilynne blinks slow, nodding: "It's better this way."

"But we *are* the customer."

A shrug. "True."

Then their eyes wrestle: pushing and shoving—cool, respectful of each other's strengths—across an invisible line until Bea announces, "You reveal more than you think."

Something in her lowered brow, her voice as hard and terrible as a child possessed—Marilynne is so taken aback she is not certain whether it shows. Her mouth opens. But she merely moves her jaw as though she were only gracelessly stretching.

Bea sits straight, eyes veiled but intent, head kiltered as though negotiating a tricky twist in a fiber-optic scope of Marilynne's unconscious. Marilynne has never felt so suddenly naked, not even at Bea's age, under the molesting eyes of men. (Seth's head remains bowed like some pothead's piece of mood sculpture.)

"Daddy?"

He looks up, earnest through tears.

"We'll talk more later," Bea assures him.

He smiles, he nods, he moans.

"But don't you have work to do?"

A Downs-innocent grin opens his face. He pecks her brow as he pops onto his feet to hurry into his study. His computer perpetually up, he is barely out of the room before they hear keys tapping and the screen's answering *bings* and *zips* and *boings* that announce his continuing pursuit of great gobs of money. Bea turns back to Marilynne. Marilynne takes a breath, holding it tight as though to absorb x-rays.

Bea: "You've had trouble in your past."

(Breathe.) "You do fortunes too?"

"Evasive."

The word hangs in the air: a goad? a diagnosis? Then the girl's hand has slithered across the back of the sofa; it is on Marilynne's upper arm, uncannily strong, subtly articulating the biceps from the supinator longus and pronator radii teres: "Tell me."

What is happening? What *has* happened? What is the combination of age, the day in her cycle, this day's mild fatigue, vodka and grenadine, and the girl's absorbent strength that is dropping Marilynne Troop's face, her neck as geometrically curved as a penitent in Russian iconography? Then, as though her throat were an upended goose-neck in a triumphant plumber's grip, scummy things simply fall out: her drunken mother, her father missing for weeks on end, her only harbor between herself and her sister Natalie, and Natalie dashing beyond Marilynne's unfocussed and undisciplined screaming into the street after her kitten; her resulting lifelong battle with red—walking blind past fire hydrants; leaning her face in her hand in bars, curtaining any glimpse of maraschinos.

Throughout, Bea is professionally silent. Silent herself at last, Marilynne seems to awaken, jerking, then surrenders again as she realizes that Bea has enveloped her: a leg dug between the cushions behind her hips, her other leg is over Marilynne's thighs; her arms surround her chest as Marilynne tilts her head down onto Bea's shoulder.

For a moment, they sit quietly, gently rocking, until Marilynne starts.

In his socks, Seth has returned; he is sitting on his ankles on the floor, resting his head on Marilynne's knees.

The older and younger woman spring apart. Marilynne's right knee jerks, malleting into Seth's temple. He sits up—"I just thought, we could all..."—rubbing the spot as Marilynne swings her watch to her face.

"Shit. I'm late."

Bea: "To..."

Marilynne's freeze-dried eyes: "Tango."

"Tango?"

"Tango."

"Tango."

"Tango," Seth rubs, blunting the echo.

But Marilynne does not move. She is looking into Bea's face; they are wondering at the wonder and pain that have brought them to a *here* where Marilynne knows she cannot stay, though the two women also cannot separate.

Then Bea lowers her brow, bulling into the demand: "Teach me!"

Marilynne is on her feet so suddenly, Seth twists and throws a hand to catch his weight. He watches their two slim silhouettes vanish into the kitchen.

At her second step onto Italianate marble, Marilynne turns and stops in dance-frame: Left arm up, her right around her invisible partner like some cultish turn signal. Bea stands clueless. A breath catches in her chest before Marilynne whispers, "Come," and the girl is fitting herself inside her arms as though into a personal jet-pack.

Marilynne's eyes hold Bea's in an iron grip: "The shoulders. Follow my shoulders with yours. I turn right"—she does—"and you turn right"—she *had*. "Your feet will follow. I will lead only the step I know you're free to take. Beyond that, it's simply walking."

Bea wants to speak, to ask what they or she will do first, why she feels that her whole short life has been leading inexorably to this moment. But Marilynne begins rocking a sexy rockabye; her breast rises and she steps forward two steps, and Bea steps—back right, back left—as though her

legs are magnetized to Marilynne's left and right. They rock again before Marilynne takes two steps backwards. And again, and again, forward and back, back and forward, and Bea feels reassured—it is only this, this simple, this floating *hin und her* in the arms of a beautiful woman. Then Marilynne stops. Somehow Bea knows to remain still as Seth comes and stands hurt in the door behind her, as Marilynne twists and steps left, twist and right, in a figure eight, *"Ocho,"* stops again, and then, while remaining motionless, rudders Bea through the step like her reflection in a time-delay mirror. Then they are twisting, turning together, their shoulders moving in a parallel as fixed and smooth and inevitable as the arms of a toffee-pulling machine. Step and step and turn and step around then across the pale-pink checkerboard of tiles, as Marilynne whispers, *"Gouchos*—cowboys, alone on the Argentine *pampas*—they invented it."

They continue without pause, though Bea's head is bent, quietly weeping on Marilynne's shoulder.

"Imagine: around a fire, drunken men. Men who loved women but had no women to love, imagining the women they would love if they could love women—taking out their desire on each other."

The words pull like a thin steel chain. It runs over Bea's orphan tongue, down her throat, into her stomach to drag up emotions as distinct as twisted bits of brass: anger and hurt, longing and loneliness and self-pity. She sobs and moans and quietly screams; she drools and weeps; her nose runs onto Marilynne's stiff collar.

"They believed in leading. They were men. But between men—those men—leading was a struggle, a match, an open-handed fistfight. They call it back-leading. The woman draws the man. She decides where she will be led."

They continue, locked breast to breast, each feeling the other's breath on her neck until the words have settled into meaningful order in Bea's disordered heart. But once they do, her head rises. She whips her eyes, her nose, and her mouth across her own shoulder.

She is thirteen. Despite the near-grace of youthful movement, more beautiful than the smoothness of training, there are awkward seconds as the gravity of initiative shifts from Marilynne, hangs ambiguous between them, then comes to rest in the throbbing core of Bea's torso. But once complete, it is as complete as the transfer of soul from man to B-Horror monster. This girl, this natural horsewoman appears to grow taller; her shoulders widen as her eyes narrow and she is forcing Marilynne back, around the morning table that overlooks children and dogs and wafting wafers of Frisbees across

the felt of the park. Across the tile, stopping short to command Marilynne through a tight fast *ocho,* then spinning and Bea is drawing her back through the door (Seth falling away like a blown silk curtain) into the living room, around the sofa and chairs, angling down the two steps to the door where Marilynne kicks *voleo*—the flicking tongue of a whip—adorning time while Bea turns the knob. Then they are in the hall, amazing Mrs. Gathwit, who kicks Muffin into yelps as she stumbles back into her apartment. Marilynne pushes for the elevator as they kick and spar. Inside, they are alone—almost; for the first time they take their eyes from each other, to meet each other in the mirror.

They are pleased. They are gorgeous. They are youth and early middle age. They are brash femininity in its promise and fulfillment. Time falls into the holes of their eyes until the mouth of the world opens behind them, upon stone and glass and steel. Across the lobby, Marilynne's shoulders open the first door, Bea's the second, and then they are in the street, passing by halted passersby.

"Where are we going?" Marilynne asks, amused, excited.

"La Guardia."

"La Guardia?"—halting to redirect around phone booths. Then they are at the curb and Bea is pulling Marilynne into blaring red. Yet she does not slow; she does not hesitate. Brakes and tires and horns cry out. Yellow steel lines up to scream a chorus awaiting Bea's answer. Midway across the street, a cab or two could pass. But they stay; backing up flank upon flank, they stay to scream and curse in Hindi and Haitian and Serbo-Croatian, to fan hot fingers at the bitches dancing red defiance. Then a gentle voice calls out. From the curb behind them, a man in socks by the sound of it, less words than pleading yips.

In motion again, Bea rises, expanding until her words are lips and breath at Marilynne's ear. Men shout and curse and whimper. But the girl's are the words of the oracle, the whisper of a longing giant at the mouth of Marilynne's cave.

"Mi coqueta. Mi vida. Buenos Aires." ◣

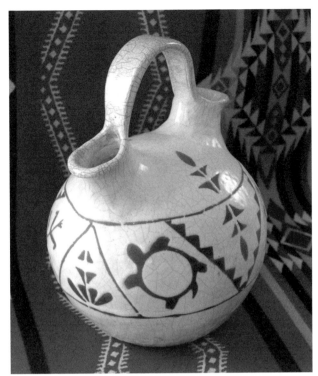

ADA JACQUES, *Wedding Vase with Turtle and Corn*,
raku with white crackle glaze, 12"x10.5", 2001

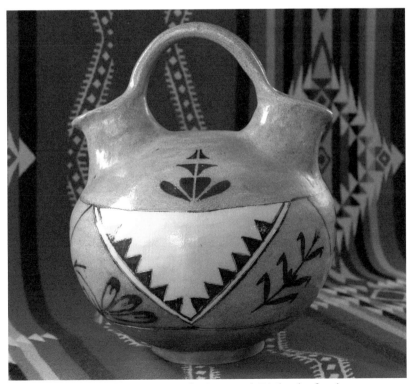

ADA JACQUES, *Wedding Vase with Corn and Bird*, salt-fired stoneware,
11"x10", 2002

Aɪᴅᴀ Kʜᴀʟɪʟ, *My Alphabet 1,* mixed media collage mounted on canvas, 10"x10", 2004–5

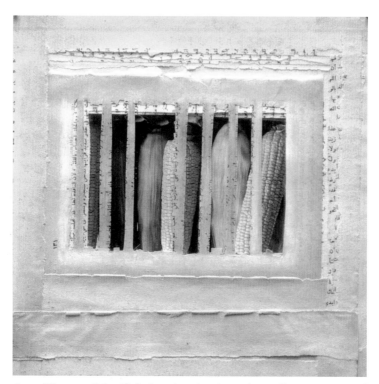

Aɪᴅᴀ Kʜᴀʟɪʟ, *My Alphabet 4,* mixed media collage mounted on canvas, 10"x10", 2004–5

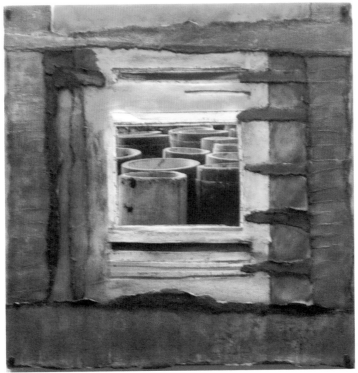

AIDA KHALIL, *My Alphabet 7,* mixed media collage
mounted on canvas, 10"x10", 2004-5

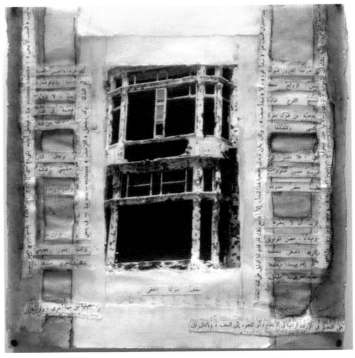

AIDA KHALIL, *My Alphabet 9,* mixed media collage mounted
on canvas, 10"x10", 2004-5

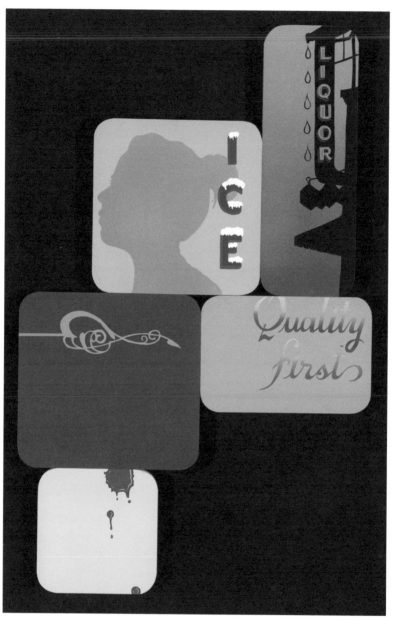

Holly Greenberg, *Ice,* acrylic on MDF, 20"x28", 2006

Nicora Gangi, *Fruit of Ways,* pastel on La Carte paper, 22"x31", 2000

Sara Eichner, *Green Circles,* oil paint on panel, 8.5"x8.5", 2007

SARA EICHNER, *Red Stone Siding,* oil paint on panel, 13.5"x14.5", 2007

SARA EICHNER, *Pink Into Orange Wallpaper*, gouache on water color paper, 30"x22", 2007

Ralph James Savarese

THE LOBES OF AUTOBIOGRAPHY: POETRY AND AUTISM

1. "SAD DEAR SAVED ME"

"Hours of light like heat hibernate/great icebergs hear the cries of the hurt." So, my son, adopted at the age of six from foster care, began a poem entitled, "Alaska." Written on a communication device in the fifth grade, it establishes a number of exquisite analogies—between light and bears and calving icebergs and "hurt" people. By "hurt" people he means kids such as himself who were abandoned by their parents, kids with disabilities forced to survive in a land of unremitting darkness.

That darkness included the worst sort of physical and sexual abuse, and you can see him find in the natural setting of Alaska the unlit bedroom in which the abuse took place. Indeed, you can see him find the saga of his entire early life: separation from his parents and sister, then frigid loneliness and injury—the two compressed into an image that does not behave, as my sentence just did, chronologically. The awful calving refers *both* to the loss of family and to the physical experience of rape, of being split open, as my son explained almost too matter-of-factly. At once inarticulate and faintly human, the sound of that calving seems an apt correlative for the cry of childhood trauma—especially apt in the case of a boy who literally cannot speak and who, back then, had no way of communicating what was happening to him.

As Alaska waits in winter for warmth it can barely imagine coming, so my son waited for relief from his attacker and, even less probably, for parents who might love him. "yes. dearest sad dad you heard fresh self and freshly responded deserting your fears and just freed sad dear saved me. yes. yes. yes. yes," he typed recently on his talking computer. We had been conversing about the past—in particular, my decision not to have kids and my own experience of depression. And there he was the voice of triumphant spring, in all of its freshness, reminding me to be hopeful. Reminding me in that language, that poetry, I have come to think of as "Autie-type."

2. "Autie-type"

"Autie" is a term that some people with autism use to refer to themselves; "Autie-type," a highly poetic language that many non-verbal Auties produce spontaneously on their computers, whether in conversation or in actual poems. In her recent book, *Between Their World and Ours: Breakthroughs with Autistic Children,* Karen Zelan asks, "Why do Autists use language the way they do? Many of their utterances seem essentially poetic." No one can account for it. Perhaps I should say that no one has yet wanted to account for it, as many in the scientific community continue to cling to outdated notions of "mindblindness," which imagine that people with autism have no awareness of self or others. Without such awareness, of course, poetry is impossible. Just today a ridiculous study announced that people with autism aren't vulnerable to contagious yawning and that the ability to "catch" a yawn may be linked to empathy—this despite the fact that at least a third of the Autie group *did* evince such a vulnerability. This despite so many other problems with how the study was conducted.

Some additional examples of "Autie-type" in ordinary conversation? My son once said to his therapist, after my wife and I had rented a hospital bed and put it in our living room (I was having my hip replaced), "Mom and Dad invited injury into the home." He was extremely agitated and trying somehow to explain both his autistic aversion to an unfamiliar object and his anxiety about my well-being. He was also tapping into his past. Words such as "invite," "injury," and "home" seem particularly loaded coming from an abused foster kid. Here again we see the evocative condensation that is a hallmark of lyric poetry.

But lest you think the boy completely humorless, consider this retort to a minor squabble I had with my wife in the car. As usual, we were arguing over directions. "Estimated long time very married," he announced on his talking computer. I still don't know what to make of the odd word "estimated," except to say that it's one of my son's favorites. Perhaps borrowed from the discipline of mathematics, it implies a kind of rough but informed measurement. By putting "very" in front of "married"—in one sense, a grammatical error; in another, a poetic liberty—he gives the latter word all of the meaning that actual experience ends up giving it. Yes, my wife and I are *very* married, especially in the car.

Another non-speaking Autie, in response to the question, "Describe one or two things that people can do or have done that help you," typed to his panel audience, "They have utter respect for diversity, and they understand that diversity leads a tattered life when not wedded to tolerance." When asked about the many fashionable bio-remedies for autism, he remarked, "Spurious relations deceive dogmatic zealots." With their witty consonance, assonance, and alliteration, both responses delight in the oral pleasures of poetry, and they hardly seem, I need not point out, typically conversational. The metaphors of a "tattered life" and "dogmatic zealot" become that much more dynamic in relation to the drama of patterned sound.

Here are some other examples. A painter in Vermont, institutionalized for years, proclaimed, "It's practically getting possible to create satisfying life, interesting and meaningful nowadays because really institutions' popularity slides toward storage underground at a pace faster than police chasing stepping for escape prisoners." About the politics of institutionalization and the role of art in healing the wounds of prejudice and discrimination, he said, "Nothing apartheids you like the insensitive world of institutional existence. Tapping well of silence with painting permitted songs of hurt to be meted with creativity.... Without art, wafting smells of earth's pleasures would kite away to land of inanimate objects, so it's past point of personal hobby." Finally, about our habit of foreclosing futures for people with disabilities, he reminded us, "Fastening labels on people is like leasing cars with destinations determined beforehand."

The choice of metaphoric vehicles is striking; notice how disparate the things compared are. One might be tempted to accuse this Autie of engaging in mixed metaphors, so quickly do the analogies, both implicit and explicit, come. But the point seems to be a world reconnected, a world *included,* on the level of sensory perception. This remediation mirrors the political one: the demise of any and all apartheids. I can't think of a more unexpected analogy than that which links assessment labels, life trajectories, and rental cars. This is precisely what good poetry does: it allows us to view an object or phenomenon afresh.

I need to underscore the quotidian nature of such utterances; they don't appear to be the result of trying, in any conventional manner, to be poetic. Now, I'd be foolish to tell you that I, a mere humanist, can account for "Autie-type." But I want to gesture in that direction and, in doing so, explore the deep analogical impulse that undergirds it. I also want to call

attention to the explicit political content of so many of the utterances. Should it come as a surprise that Auties, like slaves from the eighteenth and nineteenth centuries, sing their sorrow songs over and over? The oppressed and excluded will always dream of respect. (Just today, my son wrote to one of his former principals, "Desiring to federally, freely insist that other very important principals invite inclusion into their schools.")

"I embody my metaphors," the disabled writer Nancy Mairs asserts in *Waist High in the World,* her memoir of multiple sclerosis. Confined to a wheelchair and the perspective it provides, she resents the casual appropriation of physical disability in an idiom such as, "He's so lame." Why? Because that appropriation doesn't bring with it awareness of *literal* oppression: all of the ways that able-bodied society prevents fulfilling lives for people with disabilities. Auties, I would submit, embody their metaphors as well. Actually, they embrain them. In one respect, they can't help but be metaphorical; an alternative physiology seems to demand it. In another, they evince such keen egalitarian insight.

Recourse to scientific work on autism, savantism, hemispheric lateralization, and creativity reveals a difference to be celebrated, not pathologized. This difference not only rebuts the dominant "theory of mind" hypothesis about autism, but also turns it on its head, suggesting that *we* are the ones who have difficulty understanding, and empathizing with, the "other." Moreover, it indicates an inherent poetic disadvantage in being neurotypical: after the age of seven or eight, when children's brains lateralize to the left, neurotypicals must labor to do the work of poetry. Figurative connections become more difficult to detect, let alone to establish. Auties, on the other hand, seem to behave like Midas: they turn everything into analogical gold.

And this gold isn't strictly aesthetic; it's moral, as I've noted. For what is metaphor but an intentionally blurred distinction? If compassion means literally "to suffer with," then embrained metaphor might constitute the perfect ethical conveyance in a social arena. Picture an ambulance darting to the scene of racial, ethnic, sexual, or class oppression. Picture a very different kind of EMT, one dispensing with his uniform, one truly becoming the person cared for, the person lying on the ground. This group of non-speaking Auties often does exactly this: they over-identify with people in pain. When they read a book or watch a film, the normally discrete boundaries of the self seem to dissolve.

The star of the Academy Award-nominated documentary, *Autism Is A World,* for instance, found it impossible to view *Malcom X;* the violence and

oppression were just too much for her. She had to do her processing in another room, semi-distracted. Recently, my son became so distraught while learning about Harriet Tubman and a little Polish boy whom the Germans murdered that he couldn't continue reading. His breathing was heavy; his eyes had glazed over. In response to his ninth-grade English teacher's question "What are your strengths as a reader?" he replied, "I feel characters' feelings." He then added, "Dread very scary books and wish I took breathing easy mom to class to create more security." What a special kind of engagement this is—at once like a young child's and a perceptive adult's.

The American language poet Lyn Hejinian, in her experimental memoir *My Life,* writes of the "lobes of autobiography." Father, poet, and amateur scientist, I seek to praise the Autie's marvelous brain. And I wish to chide such neurological luminaries as Oliver Sacks, who, while abandoning some of their earlier prejudicial notions, persist with others. The gifts of autism need not be qualified or patronized. Though Sacks now concedes, for example, that his view of the savant was wrong—that he or she is not as distinct from the neurotypical genius (the composer, the painter, the surgeon)—he believes that the savant "fail[s] to develop in the same creative way."

But is this necessarily true? How much instruction has the average savant received? Though not a savant, my son and others like him are only now getting the educations they deserve. Who knows what might become of "Autie-type" as it finds its way into poem after poem? I've already seen significant development in my son's fledgling work, and together we have vowed to perfect our mutual craft. As one of the Auties quoted above would say, "It's past point of personal hobby," or, for that matter, unwitting obsession.

3. "DABS OF DEW"

What follows is a more sustained example of "Autie-type" from my son: an actual essay for his ninth-grade English class. It demonstrates just how fiercely poetic his instincts are. The model he had been given wasn't nearly as lyrical or figurative as what he produced, and you can see him struggling with the expectations of prose—that unambiguous linearity and literality drilled into schoolchildren. There are lines I do not understand and still more lines the reader might not understand because they reflect a private mythology (not to mention, in places, a problem with grammar). Here's what I know: the "beasts" and "creatures" refer to the developing child's pictured antagonists

in *O The Places You'll Go,* a book my son read obsessively when becoming literate at the age of nine. "Great Places" is Dr. Seuss's witty term for the future. "Easy breathing" describes anyone not autistic, anyone not suffering from massive anxiety. The "loud noises" and "wasted, freaky actions" allude to echolalia and flapping, respectively. (Underscoring the significant sensory processing challenges and body awareness difficulties of autism, my son once typed, "I flap to feel my arms.")

The phrase "easy lessons" denotes meaningless special-education classes. When my wife and I adopted him at the age of six, we immediately included our son in a regular school, though he carried the label of profound mental retardation. It had taken us nearly three years to get him out of foster care: "great gates" thus suggests the many obstacles and crushing disappointments he encountered. "Desertion" needs no explanation in an adoption narrative, but "killer trees" does. When he was younger, my son imagined every fall that the trees were losing their children. He refused to rake leaves with me, even to step on the lawn, typing over and over his frantic mantra, "Dead freedom." Years later, the trees seem to constitute an evil force that wants to lure him away from the real world of meaningful relationships. Once his only companion, the trees now taunt him, recalling his autistic tendencies and traumatic past, forbidding him to hope. A final piece of information: we live in Iowa where the wind blows, blows, blows. Next to my son's bedroom stands a large laurel tree, whose long arms brush against his window screens.

Resting in My Bed

When I was little everyone thought I was retarded. The very hurtful easy lessons I attended were time spent away from the real world. Addition, subtraction, multiplication, and division were subarctic activities. Treated as autistic, retarded, and sedated, I saw myself suspended. Ashamed, I seasoned this mind of mine. Wasting time beasts inhabited my very much lost, very sad boy's head. Attempts to freshly respond to humans were terrifying quests through killer trees. Where I sent my real self, reasonable, easy breathing, satisfying humans never could find me.

Each time someone treated me sweetly, the swearing, resentful great beasts fearfully estimated me as bad. "You fear fresh start," they'd taunt. Sadness drew the trees together. Wasted, freaky actions took over my arms. The trees desired to feast upon me. The trees swaying back and forth seemed to call to me. Surrounded by areas of resentful, easy to get lost desertion, I grew numb. Assumed tremendously retarded,

I was seen as hopeless. My illogical gestures seen as responsible action. Years and years, sadly unable to please anyone, the estimated as responsible boy grew numb. The howling wind issued the ultimatum: "You're going to plot to uphold plot, uphold plot to be great."

Estimating me as unfeeling, ferocious humans began to reward themselves. The killer trees promised to fearlessly shelter me from the savage gods who abused me. Years passed. Sad and dead, I looked deserted. Desertion, gyration. Desertion, gyration. The trees golden and red freed me from the resentment. Easy to observe gestures trapped dear self and resentment grew. I joked heartlessly, "My ass is my greatest asset."

The day I met dear mom easy breathing began. She freed my real self. She wore awesome earrings that glimmered in the sun and when she bent down to lightly kiss my forehead, kiss sweetly hoped to greatly shoo the savage beasts. Creatures did stoop down but only for a few seconds. Soon no unjust god rested. They fought to lock great gates, and I breathing hard got sad.

Still the fresh light rested. Wasting time beasts inhabited less of my mind and sensing when the unjust gods stopped fussing, I freed my dear self to respond. Dread began to fill great places and my freshly seasoned mind got far. Old habits rarely saw the light of day. I decided to go test hope, and estimate myself as deserving to be their son. At first hopeful mom pressed. The arms that now greeted me belonged to dear loving mom. She created a safe place. Looking godlike herself, she dearly played with me. As time went on, she invited fresh friends to play with me. Thinking great places safely out of reach, I nervously responded. Suddenly my fearful, biological mom would appear. The trees urged me on, I lost my temper, and in no time autistic, killer gestures ensnared my dear fresh self.

Still my fearless mom never failed me. A seed is very lovingly watered by hopeful mom each morning as she greets the day. She, like dear, ultimately lobbying for my success dad deeply free mighty, awesome trees' hold on me by feeding the grass. Fresh blades of grass break through the soil and dabs of dew kiss my forehead. She hugs me firmly, freshly so the great trees can't fasten their testing looks on me. Sometimes still the treated with respect boy forgets. Someone breathes hard and they gesture to the trees to test me. For a time Great Places is fearful again. But only for a short time now.

If illogical gestures lovingly desert me now it's because I yearn to love real people now not trees. I yearn to plot to get fresh start. Mom yearns hopefully to free me completely. She heartfully loves me more and more each day. Part loving person, part plant I kid people. Only the kids who look beyond loud noises hear my real self.

The place that opens up my awestruck, just, hopeful heart is restful, pleasant bed. When I look out my window, I am looking out at a king-sized tree. Yes, the trees

are rewarding to look at now. They partly shade the house I live in now. The kind looking tree plots to grow taller. Opening my dear self, I hear my mom call my name. It looks like the sun has moved to the front of the house as I plot my response. Resting hints freely that the green grass grows.

The first thing to be noted is that the piece is very metaphorical. There's a reprise of the Alaska figure in the modifier "subarctic." There's the verb "seasoned." There's the personification of the trees, which seem to "call to him," and the "howling wind," which "issues its ultimatum." The latter symbolizes something like the combined forces of autism and trauma. These forces purport to offer protection from the "savage gods" (itself a metaphor) who beat and raped him, but this protection comes at a cost: withdrawal, even psychic disintegration: what psychologists call the practice of dissociation. If my son is a tree—later in the essay he will refer to himself as "part loving person, part plant"—then the wind can be understood to be "taking over his arms" and insisting on "freaky actions." The rhythmic refrain, "Desertion, gyration. Desertion, gyration," captures the repetition of trauma and the inadequacy of the trees' proclaimed solace. Unable to forget his injury, he engages in the worst sort of self-denigration, punning off the word "asset" and declaring his value as a sexual object: "My ass is my greatest asset."

When he meets his adoptive mom, the possibility of "easy breathing" ensues. A different kind of tree ("The arms that now greeted me belonged to dear loving mom"), she rescues him from his antagonists' "hold," encouraging him to "love real people now not trees." She kisses him and, implicitly, morphs into the very night, which bathes the earth in dew. "Fresh blades of grass break through the soil and dabs of dew kiss my forehead," he declares, morphing as well into the tiny, fragile seedlings that I planted last spring beneath his window. How humongous the trees looked in comparison to those hopeful shoots. "Can the grass survive amidst the dominating trees?" I asked of a lawn care expert. "If you water it religiously," he said. Drawn from actual experience, the analogical network is fabulously intricate and dynamic; it will not resolve itself into a simple proposition. By the end of the essay, my wife has become the sun that "has moved to the front of the house," rousing him from bed. The trees are "rewarding to look at now," as they "partly shade the house" he lives in. A good night's rest, devoid of the dreams that used to plague him, makes green growth possible.

4. "The Tyranny of the Left Hemisphere"

So, how did he do it? How did my son produce such delicate lacework? How do any of the Auties do it, and do it so effortlessly? My neurotypical students, after all, struggle to be figurative in creative writing classes. It's as if they were looking for metaphors in an algebra textbook.

The best guess, admittedly reductive, is an overactive, perhaps even dominant, right cerebral hemisphere. We know that the normally non-dominant right hemisphere is the site of artistic ability in most people. As one primer on cerebral lateralization explains, "Linear reasoning functions of language such as grammar and word production are often lateralized to the left hemisphere of the brain." Here, too, reside logical and linear algorithmic processing, as well as measurement skills. "In contrast, holistic reasoning functions of language such as intonation and emphasis are often lateralized to the right hemisphere of the brain. Functions such as the transduction of visual and musical stimuli and spatial manipulation, facial perception, and artistic ability...seem to be lateralized to the right hemisphere." It should be pointed out that not every neurotypical person's brain is organized in this way—a percentage of lefthanders exhibit the opposite lateralization—and that many human abilities are clearly and complicatedly controlled by *both* hemispheres. That said, one hemisphere (for the vast majority of people, the left) is dominant.

Recently, a researcher worked out the details of the right hemisphere's artistic responsibilities with respect to poetry. In "Poetry as Right Hemispheric Language," Julie Kane analyzes the various elements that constitute poetic discourse—image, simile, metaphor, allusion, personification, synecdoche, metonymy, paradox, oxymoron, understatement, hyperbole, emotion, connotation, symbol, alliteration, assonance, and parataxis—and shows that all of these elements depend on significant right-hemispheric activity. Reviewing split-brain studies, as well as studies of people with damage to either their left or right hemispheres, she concludes that the right hemisphere "controls, or is capable of controlling on its own, a number of very subtle but intriguing linguistic functions which...are virtually synonymous with 'poetry' or 'poetic' speech." Kane goes on to assert that the "degree of right-hemispheric involvement in language is what differentiates 'poetic' or 'literary' from 'referential' or 'technical' speech and texts."

Having established the importance of the right hemisphere for poetry, she asks a very simple question: how do people write it if the left hemisphere is dominant? Ultimately, she believes that they effect a

"temporary reversal" of customary dominance when they compose their poems. She speaks of a "sudden and transient *loss of or decrease in* normal interhemispheric communication, [which] remov[es] inhibitions placed upon the right hemisphere and allow[s] it to function at a greater-than-normal linguistic level." While she focuses on poets with documented mood disorders, particularly mania (because mania itself seems to be "accompanied by reversals of normal laterality"), she contends that most poets "exhibit temporary elevations of mood (hypomania)" when writing. For Kane, this relatively minor manic state is virtually synonymous with creativity, and it brings about a change in the way language is processed. Might Auties, too, effect a "reversal" of customary dominance, or might they begin with a right-hemispheric advantage? There is clearly nothing temporary about their poetic output. Indeed, neurotypical poets appear merely to visit the country (or one like it) in which Auties consistently and urgently dwell.

New work on savantism echoes the inhibitory theory and asks us to imagine cognitive disability as a creative boon. In a *Wired Magazine* article entitled, "The Key to Genius," Steve Silberman writes about the search for an underlying cause of a whole range of disorders, including autism, and the emergence in the 1980s of a theory of left-hemispheric dysfunction. In Silberman's account, such dysfunction produces the necessary inhibition of the dominant hemisphere. And since the arts generally require inhibition, savants might be more like neurotypical artists than previously thought. The *former* might simply enjoy both a creative head start and a sustained intensification of artistic ability. The discovery of unexpected savantism in previously neurotypical individuals has led scientists to reconsider the special status of this type of genius—to the point that Silberman remarks, "We may all carry a savant inside of us waiting to be born."

Silberman points to the work of Bruce Miller, who noticed that some patients with frontotemporal dementia (FTD) actually develop artistic abilities as their language faculties erode. He relates:

One patient of Miller's, a 78-year-old linguist, began composing classical music soon after the onset of dementia, though he had little musical training; he felt that his mind was being "taken over" by notes and intervals. Another patient, an established landscape artist, turned toward abstraction and painted even more expressively as her verbal skills declined. Brain scans of FTD patients confirm patterns of damage similar to those found in many savants. As the disease progresses, these patients experience curious perceptual alterations, becoming more attentive to textural details, visual patterns, and sounds.

Miller believes that "dementia does not create artistic powers in these patients, it uncovers them." The disorder, he maintains, "switches off inhibitory signals from the left temporal lobes, enabling suppressed talents in the right hemisphere to flourish." This hypothesis has prompted one Australian scientist to champion the cause of "liberating our inner savant from the benevolent tyranny of the left hemisphere." Importantly, Miller's findings accord with well-known case histories in which people who had never written poetry suddenly started writing it after becoming aphasic.

Autism seems to unleash a similar savant-like—one might even say, following the Australian scientist's political metaphor, *democratic*—sensibility. As East-European countries engaged in "velvet revolutions" during the late '80s and early '90s, so some autistic brains have engaged in their own kind of rebellion: a new and successful "Prague Spring." Though autism obviously comes with a host of challenges, its poetic gifts needn't be understood as akin to dementia's or aphasia's considerable trade-offs. We do see in my son's writings, particularly in his syntax, evidence of left-hemispheric dysfunction, but he is perfectly capable of correcting these errors when prodded. After many drafts, he can pass as neurotypical in his prose. (The personal essay at the beginning he refused to correct, signing, "All done. All done.") Moreover, he's very good at math and other traditionally left-hemispheric activities. More useful would be to conceive of a different kind of power-sharing arrangement with the left hemisphere, one that derives, as I've hinted, from right-hemispheric dominance. Again, if it can be demonstrated that the poetry of Auties "develops," there would be no reason at all to dismiss it as substandard art, and a concept of neurodiversity, even reversed *neurosuperiority,* might take hold. (When shown the new work on savantism, my son delighted in the spectacle of the creatively retarded—that is neurotypicals—struggling to do what he does naturally.)

But what do we know about cerebral lateralization in autism? A number of key studies have established *right* hemispheric dominance in autistic children with significant language impairment. A 1977 study explored the notion that "autistic children process information predominantly by strategies of the right hemisphere from birth and, unless unusual events occur, continue to be right hemisphere processors throughout their life." Another study from 1986 concluded, "The majority of autistic subjects showed reversed (right hemisphere dominant), but not necessarily reduced, patterns of hemispheric asymmetry." One of the most interesting things about this study was its observation that children with more advanced language skills were "more likely to exhibit a normal direction of hemispheric asymmetry."

The authors speculated that the "possibility exists that a shift from right to left hemisphere processing of speech occurs as the autistic child acquires more spoken language." Finally, a third study from 2005 confirmed the claim of right-hemispheric dominance and "atypical functional specialization for language."

Now, imagine the "unusual events" of the 1977 study to be literacy instruction and the acquisition of a communication system—a simple letter board, say, or computer. How might these interventions affect cerebral lateralization? Might the acquisition of additional *written* language also lead to the kind of greater left-hemispheric dominance that the 1986 study mentions? Thanks to the work of Morton Gernsbacher, we know that there is no necessary link between spoken and written language facility in children with autism. My son can't speak, but he can certainly understand what's being said to him, and he can write well enough to be earning all "A's" in a regular language arts curriculum. Yet what happened when he became literate? Do Auties, like neurotypical children, necessarily lose their right-hemispheric dominance, or do they in part retain it and, in doing so, establish a new kind of perceptual and communicative government? The questions are numerous. Whatever the case, if we assume that right-hemispheric activity remains high in Auties who have been taught to read and to type, then it isn't hard to see how they might converse poetically and perhaps even have a leg up in writing poems.

5. "DEAR LITTLE POLISH BOY"

Having gone out on a limb (the one brushing up against my son's window screen?), I thought I'd crawl out a bit further. Not only do I think Auties possess a poetic proclivity, but I think they possess an empathetic proclivity as well. Elsewhere I've referred to my son as an emotional seismograph, detecting even the slightest tremor of feeling, either good or bad, and reacting to it. Kane tells us that the "right hemisphere is essential for the comprehension of emotion in spoken language, as expressed by vocal tone, pitch accent, and modulation." The same is apparently true for written language. A 1981 study demonstrated that right-hemisphere-damaged patients exhibited a "dampened appreciation of the kind of emotion" that characters in stories experience. It just might be that the legacy of right-hemispheric dominance in Auties is a heightened sensitivity to emotion. My son has said repeatedly that emotions, both his and other people's,

"assault him." Along with a penchant for metaphor (about which I will speak in a moment), this burdensome talent may drive the extraordinary, sometimes crippling, empathy I have witnessed in non-speaking Auties. What is irrefutable, because well documented, is the essential contribution of the right hemisphere to human empathy.

After his fraught encounter with their respective stories, my son paid homage to Harriet Tubman and the little Polish boy whom the Germans murdered. Writing about these people proved almost as difficult as reading about them. The title of the second piece, "There's No Breathing in Purgatory," suggests a kind of exhaustion with life and its respiratory requirements, and it applies as much to the poem's subject as it does to its author, whose own pulse rate and breathing were extremely aggravated during the period of composition. The pieces display many of the poetic elements already discussed, but they also display a keen interest in historical oppression. So that you understand the first line of, "Estimating Harriet Tubman Respectfully," let me say that "Breaking the Barriers" is the official motto of a disability rights group whose web site features a speech by my son.

Estimating Harriet Tubman Respectfully

If we're breaking the barriers, great freedom fearfully awaits. Harriet realized, until freedom treated her people with respect, her intestines seemed unsettled, her heart beat resentfully, and her fear never disappeared. The challenges she faced each day were far greater than anything you and your people have ever endured; breathing resentful air, great very hard breaths, undermines heartfelt feelings and deeply effects the western world. Pedestals rest on hurt, great, estimated dressed not great human beings deserted by frees. I heartily entreat you to help my unfree, treated responsibly, great, hip, jumping self to walk the trail. You kind, responded easy breathing frees don't understand how terrifying seemingly fresh freedom is.

There's No Breathing in Purgatory

Why do grownups act like human beings are great and then treat each other like junk?
You're only three, dear little Polish boy.
Was there something I greatly forgot to tell you?
Were you fearful that you would die?
You're hard to just not turn away from, you dear little Polish boy.

Years of fearful dread really flood back when I see you,
Hungry, scared, and so hopelessly gutsy.
Treating you so unjustly gets millions of hurt plotting not to look you in the face,
Hearing you sadly silenced, dear little Polish boy.
Uneasy, hustling to get away, you have breathed your dear, last breath.
If getting killed is really fearful,
Dreadful life was even worse, dear little Polish boy.
Estimate yourself as free at last, free from the creatures and the dread.

Both pieces make use of the now-familiar "easy-breathing," "creatures," and "estimation" tropes. In the course of writing this essay, I've come to think that my son has borrowed the language of educational assessment and applied it to these historical figures. In the chapter he wrote for my recent book, he remarked of his former special-ed instructors, "No one was assessing me as sweet." It's as if the utterly incorrect estimation of his intelligence (and thus his worthiness as a human being) has become the primary lens through which he views other figures of oppression. Official evaluation and self-evaluation battle it out, with the marginalized no match for the powerful who cloak their hatred, as in the case of both blacks and Jews, in the mantle of science.

What strikes me is how much my son identifies with his protagonists. In a sense, he really does become them, as he latches on to certain details: the clothing of slaves (to this day my son insists on wearing collared shirts so as to look "respected"), the age of the Polish boy (his age when he had to endure the horrors of foster care). He extrapolates from his own experience of anxiety to evoke Tubman's "unsettled intestines," "very hard breaths," and "racing heart." With the Polish boy, he remembers his own abiding hunger as a child in poverty. Both pieces dramatize the "hopelessly gutsy" struggle for freedom: Tubman's underground railroad, the Polish boy's attempt to escape the Nazis. Of course, both are about—or perhaps I should say, both simultaneously enact—the Autie's struggle for freedom. And yet, having been alone in the world and at the mercy of its barbarism, my son almost can't imagine attaining true independence, preferring, it would seem, the fact of death over the future's agonizing uncertainty.

This deeply analogical operation reminds me of a point that Kane makes about metaphor. Quoting Richard Sinatra and Josephine Stahl-Gemake, she traces the right hemisphere's talent for figurative language to its "ability to process visual analogies on the basis of matching a common trait." Sinatra and

Stahl-Gemake believe that the "very key to the understanding of figurative language such as occurs in similes, metaphors, and oxymorons rests on seeing analogic, imagistic connectedness." I can't help but think of the Auties I cited at the beginning of this essay whose practice of "imagistic connectedness" seems unmatched. They literally see connectedness everywhere. And I can't help but think of my son, who devotes his native gift to the mission of historical empathy: finding and *feeling* a pattern of injustice.

6. "Other Ways of Being, Other Ways of Writing"

Kane's article offers one final insight. Linking poets with young children (who haven't yet lateralized to the left) and pre-literate peoples, she asserts, "If left-hemispheric dominance for language is not the 'natural' condition of human beings aged eight and older, but rather, a side effect of print literacy, then it stands to reason that *the qualitative changes in consciousness* between oral and print cultures—from community identity, 'magical thinking,' pervasive animist spirituality, and poetry to individualism, science, and rationalism, faith-based religion or agnosticism/atheism, and prose—may be the outward signs of a fundamental shift from right- to left-hemispheric structuring of conscious thought processes and memories." The point is fascinating, and it encourages us to contemplate the very different subjectivity of those for whom print literacy is foreign or in whom right-hemispheric dominance seems to be a natural and perhaps semi-permanent state.

Lacking few of the cognitive skills traditionally associated with the left hemisphere, my son and others like him bring to society an exquisite way of being. Rational hegemony and its concomitant individualism find themselves countered by an overactive, maybe even overdeveloped, sense of empathy and collective identity. Print literacy exists alongside "animist spirituality"; syntax walks hand in hand with image and metaphor; science meets "magical thinking." This might be true of neurotypical poets but not to the same degree or in the same way. Auties' hemispheric differences allow us to reconsider not only who we are as an "advanced" society but also what we mean by *dis*ability.

Yes, a preference for artistic creation and ethical sensitivity reveals a romantic bias, but that bias usefully pushes back against the automatic privileging of ordinary dominance and the world it has bequeathed—both aesthetically and politically. A recent *New York Times Magazine* piece about

Williams syndrome wonders if this state of being might be superior to our own, especially when we consider the neurotypical predilection for ruthless competition and aggression. (Williams syndrome, for those unfamiliar with it, is a genetic disorder comprised of a group of abnormalities on chromosome 7. In addition to elfin facial features, coordination difficulties, and purported mental retardation, it also seems to produce remarkable social affability, a broad and idiosyncratic vocabulary, and astonishing musical talent—including perfect pitch. Significantly, it took the father of a child with Williams syndrome, Howard Lenhoff, to convince the experts of these musical skills.) Why not entertain the notion?

If people with cognitive differences set out to change the world—to engage in what my son calls "political freedom fighting"—or aspire to be artists, we shouldn't stand (or write) in the way. In her study, "Interaction between Language and Cognition: Evidence from Williams Syndrome," Ursula Bellugi cites the case of a girl with Williams syndrome who wants to be a writer, but she dismisses out of hand this possibility, insisting that Williams patients don't possess the requisite intelligence for such a lofty calling. Making use of Bellugi's work, the famed psycholinguist Stephen Pinker dwells on Williams patients' "*recherché* and slightly off-target word choices, such as *toucan* for a parrot, *evacuate the glass* for emptying it, and *concierge* for an usher," and he concludes that the "fine points that govern word choice in the rest of us are not quite in place."

With Bellugi and Pinker, there's very little room for culture in modifying the Williams phenomenon and no room at all for appreciating difference. Why must what I encourage in students—a more precise and sophisticated, even strange, vocabulary—be conceived of pejoratively? What governs word choice in poets? I would love to have this young woman in my creative writing classes at Grinnell; God knows how frequently I exhort my students to use more captivating diction. *When the fire alarm went off, his dinner companion evacuated her glass.* My son makes precisely this conflationary move at the end of his personal essay when speaking of a "king-sized tree." The language of beds migrates to the arena of trees, producing a new relationship, indeed a new and comforting space. The solution to a dilemma (either trees or people), this "tree bed" allows him to feel okay about autism. It allows him to regard the natural world with his "awestruck heart," unconcerned about the sinister forces of dissociation.

I will conclude with a recent poem by my son. I had given him an assignment based on a Jane Kenyon piece. He was perseverating on his troubled past, and I thought I'd show him someone who wrote quite well

about depression. He had to follow the free-verse stanza pattern—three stanzas with five lines each—and the poem's syntax perfectly; where it deployed a noun or a modifier or a dependent clause, so should he. I asked him to displace some of his sadness, the poem's theme, onto a landscape. I wanted him to abandon private, idiosyncratic references, to keep in mind a reader who did not know him. Here's what he came up with. The clever, happy, William Carlos Williams-like ending is all his.

Daring to be Brave

As late as yesterday the leaves hung
on the trees—brown, motionless, dead.
Then, they fell all at once,
bringing winter with them. And, afterward,
everything seemed restful and quiet.

All afternoon I read in bed,
the covers, white and fluffy
like a field of snow.
They have a texture of a woolen scarf,
worn by a sad hero.

How I hated to get up,
but I needed to make dinner:
a sausage sandwich on a French baguette.
A great hurt says farewell
as I open the refrigerator.

Not bad for a developing fourteen-year-old. ◤

Michael Paul Thomas

TOWN OF

Unspoken mishaps, seventh-grade abortions,
former ball heroes, soldier trees. We own
no holding tune, only warm-up voices.

A dirty corkscrew twirled in her hand,
first in line at the pharmacy then
the coffeehouse, her name partially covered

by a jacket, a diner's narrow tag chipped.
Takeout cartons stacked near the register.
All these square places you expected

never to last. Ringside pub, Cloverleaf,
Holiday liquors, Pizza and Sandwich barn.
Nikon belt buckle still holding the camera

store owner's corduroys. Town Hall clerks on break
while a church van empties onto nothing
boulevard near that bankrupt stationery store.

Lorenzo, a classmate, shot on his bouncer's
shift, was the name carved on a wooden post
down Smull Avenue, where I ran past yesterday,

where a new owner dug out his contaminated
yard; his underground oil tank, cracked
by an oak's roots, leaking still, caking dirt.

Diana Godfrey, *Relay,* collage/pastel, 8.5"x7.5", 2007

SYLVIA DE SWANN, *Utica/Along the Tracks Series: Erie Street Demolition,* color photograph, 2004

SYLVIA DE SWANN, *Utica/Along the Tracks Series: Jeanette's Diner, Noyes Street,* color photograph, 2005

Sylvia de Swann, *Utica/Along the Tracks Series: Oriskany Blvd,* color photograph, 2004

Sylvia de Swann, *Utica/Along the Tracks Series: Schuyler Street,* color photograph, 2007

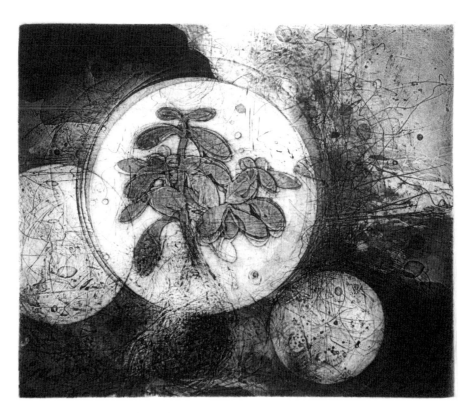

JAKE MUIRHEAD, *Jade,* etching, 10"x12", 2007

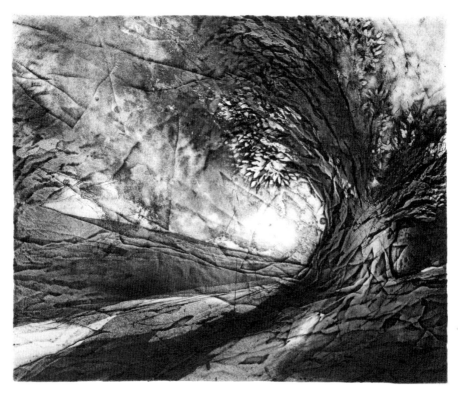

JAKE MUIRHEAD, *Tempest,* etching, 8"x10", 2006

Mi Ditmar

LIKE STARLINGS IN FLIGHT

Our handkerchiefed heads bowed to our somber work. Our posture may
have, to an inattentive eye, or God, appeared to be in prayer. But I don't
know any prayers for this housekeeping of the dead, in this case a father

I would have taken in law. The backyard light was attenuated, sifted
through pine boughs and particulates, some suspended father
atoms, surely—shotgun spray scattering fragments of tissue, bone

and consciousness up into the trees like starlings taking flight. But the
honey gold shafts that fell back there reminded me of the God of calendars
and coffee mugs and other things we packed that day. The house

light penetrated as shadowless glare through a slashed formation of skylights,
laying stark illumination over the desolation of the kitchen, the dining
room table's lament—set with a banquet of notices and bills in deepening
shades of warning.

The place cards: his many doctored passports, the photos all the same,
though his wanderlust took him only so far as the back patio, the barbeque
pit and crosshatch of fallen needles and what was the last thing the absent
host tasted?

The gun in his mouth? His own tongue? The tang of pine in the air?
The coarse whisper of twine through the fingers bundling stacks of
newspapers, their creases never broken; the scream of cellophane tape
over boxflaps folded like hands in prayer, these will be his voice to me.
We ate a banquet of dust and bright light in remembrance of him.

FAMILY PORTRAIT AS SYLLOGISM

Some mothers have selves.
All selves have fathers.
No sisters are selves.

If mother then feral, a boxer, a dancer, a swimmer in cold water. If mother then ironed cloth napkins. If mother then starvation soup. If mother then wild iris in railroad-tie flowerbed. If mother not domestic. If mother not syllabic. If mother then French kiss and ointment and blanket binding and demitasse and the Doors. If mother then Crisco on winter-faces. If mother then Chanel: a prime number, not five. If mother then hemorrhage, ambulance, re-upholster.

If mother, not "mother."
If mother then other names.
If other names, not "mother."
If not mother then interloper, critic, atavistic trait.

If father then Calvinist, atheist, color-blind, tongue-in-eye, a contract, a limerick. If father then hammer. If father then rusk with cinnamon sugar. If father then oxblood loafer. If father not sickness. If father not witness. If father then meteor shower and ski bindings and miter box and Jacques Brel and game shows. If father then the price of gasoline. If father then Princeton haircut on a dyslexic. If father then tumor, excise, re-tumor.

If father, not lover.
If lover then father-shadow.
If father-shadow then father.
If father-shadow then lodger, lurker, nail-cleaning habit.

If sister then swinger, eyeliner, sponsor, a repossessed car, a hole in drywall the shape of a man.

If sister then pulp. If sister then purée. If sister not subtle. If sister not symmetrical. If sister then beach-motif. If sister then carton of Basics and gin and wedding scrapbook and spot-lifter and FM radio. If sister then secret. If sister then thin. If sister then fat. If sister then valentine suture, stomach restructure.

If sister, not "sister."
If sister, not face-reflected.
If sister then sleeping.
If sister then gambler, giantess, approach-avoidance.

If self then feral, tongue-in-eye, repossessed, a door, a price. If self then sinner, a cold daughter, mother-blind, a holy firewall. If self then Crisco and gasoline and carton of Basics and ambulance and ointment. If self then dancing hammer the shape of a man. If self then pure starvation sugar. If self then bound and shown and lifted. If self then re-upholstered valentine tumor.

A Language of Strange Letters

He said that I was as brittle as glass
And I couldn't argue being so hoarse
I pointed out the window at the road
But he wouldn't leave so I set a fire.
He stayed put, so I sent him a letter
But he thought it was a message from God.

But from church I know I don't look like God—
They've got his face done in red and blue glass.
I don't think he's big on writing letters
Unless bible-dictating left him hoarse,
Or he's bored communicating with fire,
Setting flame to bushes beside the road.

Think of the people who are on the road
Searching for work or a message from God
Cooking dented cans on an open fire,
Feet like they've been walking through broken glass
Wishing for a roof or maybe a horse
We just don't know. They don't write us letters.

I say it's a lost art, writing letters
And good for when you're lonely on the road
When you feel like a mule; maybe a horse
Ridden hard and put away wet by God
When he's been drinking booze without a glass
And screams when he pisses—it feels like fire.

I used to do a trick where I'd eat fire,
Afterwards, I wrote convicts love letters.
One wrote back: for me he ate broken glass.
I ate the letter and got on the road
Because sometimes a letter is from God
Even if it's signed from a guy named Horse.

I wasn't like the girls who loved horses
I'd rub my legs together to make fire
Without galloping or the word of God—
I'd speak in a language of strange letters,
Turn myself into a blind stretch of road
Until I rang like a bell made of glass.

Some liquids are glass when sand catches fire
Sometimes the lame horse you're riding is God.
It's dead-end, this road. No address on this letter.

Brooks Haxton

ISAAC'S ROOM, EMPTY, 4 A.M.

From the dark tree at his window
blossoms battered by the rain
fell into the summer grass, white
horns, all spattered down the throat
with purple ink, while unseen birds,
with creaks and peeps
and whistles, started
the machinery of daybreak.

COOKSTOVE
 after Heraclitus

Fire kept loosening into flames
the sunlight
trees had woven into wood.

BLAST AT THE ATTIC WINDOW

The mind
at the top
of the attic stair
wheeled
in the galactic arms
of a snowstorm lit
by streetlights
from below.
Inside a spinning cloud
of stars, the mind,
in an intricate
swirl of ice,
leaned forth,
gyroscopically true,
vibrating
at the top of the stair.

Shipwreck: Last Thoughts of an Entomologist

Bugs flitted over the face of a ghost
that looked up out of the sea,
his own face at the stern of the lifeboat.
Sea skaters meant mangroves, islands,
water, maybe, you could drink.
If he could stand up, he would
scan for where. But now
he had to think. Bug, *bugge,*
used to mean a boogieman
or bugbear. Something vague
passed underneath his face.
He was thinking: bugs,
true bugs, included bed bugs,
water scorpions, and toe-biters.
His image in the water smiled.
In Baja, the ferocious water bug
may bite a person's toe.
A person may, for pleasure,
bite another person's toe.
The two of them in bed may coo,
or moan. Inside his face
he felt the wrench of tears,
but no tears came. Three hundred
fathoms down, in total dark,
in almost freezing calm,
a sow-bug-like crustacean, longer
than his forearm, moved its limbs.

Nancy Geyer

WATERFALL

Again, the dream: the overflowing
from a toilet or tub; no shut-off valve
in sight. Some combination of mother,
father, brothers, and sometimes
their wives, but never their children—still
too young. We are the ages we are now;
the house is long ago. This time, a sister-in-law
holds a pastel landscape in which trees
and flowers weep. My mother too is mute,
words tangled in her mouth. I alone run
from room to room, eyes to the ceilings,
that awful whiteness. Paint and plaster
bubble up, form ridges and hills. The water
carves riverbeds and gorges, cascades
into deep pools. But there is no lushness.
For that, daylight must come, an imposition
of sun. Chance meeting of molecule
upon molecule. A resolution of time.

Jo Pitkin

THE MEADOW
AFTER FRANCIS PONGE

When I bring him to the meadow, he fails to see what I do. Only a wound between forests. On a layer of soil, we lie side by side with worms, mites, aphids, and lice. Parallel, we swallow the sky. In love, a distant field begins flat and indistinct, then carries its red carts, brown cattle, and jagged rushes with ease as landscape accrues brushstrokes and pallor. In the calm, he hands me burdock, brushy purple spikes of lupines.

★

Ochre, ivory, copper, rust, pearl. A meadow covers solid greenish-gold land. Look closely, I say to him. It is square and gently rolling. It is similar to a quilt made of cloth squares or a floor assembled with tiles. A clatter of wind disrupts thorn, nettle, forget-me-not, eleven kinds of grass. Thatch, clover, vetch, and thistle move in waves. Clouds of weed release like moths, loose paper in a breeze. What can be said about a meadow?

★

Over a spongy mat of dark soil, the meadow's ship shifts to the lee side. Here, in the stillness, he begins. Points left to right, up, down. Looks. Under the broad line of sky lifts a wheat-colored tangle of grassland. On the prow of a slight rise arises the particular detail. The hillock twitches and flexes. This stillness is a point around which the life of the meadow pulses, shivers, radiates.

★

The meadow is heavy, dense. It will not show me its bones. It never showed its bones before. Why would it show its bones? Inside the meadow, I find a dam, a wad of leaf, a crow with hay in its maw. Inside, I wade in its mad dew, a high river of milk. I wade in the aftermath of what is mown. Stems of coarse grass scratch, their carapace like cartilage that holds, binds, houses, encloses.

The meadow is not love. Grass dwellers and soil dwellers oppose. We go to the meadow to love, but my hands scythe the sky. Do you think I'd love someone who fails to hear chirp, cackle, buzz, hum, the chirr of things that press or mingle or chafe? The meadow is not love, even as
I love the meadow. The goldenrod trail leads to spikes of flowers tipped with sun. This does not disappoint.

<div align="center">★</div>

He wonders, *Why should I care about a meadow?* He should not. The meadow—leavings and grapplings—is mine. It rests on a road to which he has no directions. Why should he go into the meadow? There is no gate. A meadow is milk. Rushing, he tears spider's bowl-and-doily web, hears one constant mechanical thrum. My ear fills with scythe of wings, rabble of stalks, sigh of grass. *The wildness in the flower is all in the tone.*

<div align="center">★</div>

Closer, now, his hand on my hand, his eye against a lark's eye. This is not love, yet I love the meadow unhampered by wind, frost. This is not life, yet the meadow brims with it, bursts with brown burrs and sticky fluff. In the shambles, our bodies leave flat prints of a horse at rest. Everywhere rises rust of red birds, clots of seed. For him, I fill this in, I close it in.

The line, "The wildness in the flower is all in the tone," *comes from Fanny Howe's* "Poem from a Single Pallet."

Peter McKee Olds

The Winter Studio

Back of our house in the Catskills is a garden shed that looks a century old, though I built it myself thirty years ago when I was a young man. The lumber in it really is a hundred years old, salvaged from a ruined hotel that used to stand on our property. It's immensely solid and strong. The heavy two-by-fours of rock maple are two full inches thick; the same for its two-by-sixes, and the rough-cut siding is one inch thick. I used just a few tools to build it, a hammer and saw, a wrecking bar, a shovel, and a sledge hammer for breaking rocks. With the combination of my primitive carpentry and the used lumber, it doesn't have a straight line or an unbent nail.

Though you wouldn't notice, I made this garden shed just the size of Thoreau's cabin at Walden Pond, keeping in mind his self-reliance and simplicity. Thoreau used old boards, too, and bent a lot of nails. I gave it low sheltering eaves, a wide doorway like a barn, one window, and a plank floor.

You have to bow your head when you go inside, in respect for the low eaves, and then the dry comfortable smell of old wood gathers around you. It takes me back to New England, to my hometown of Windsor, Connecticut, when I was a little boy and went with my father to Broughton's farm, or the old warehouse behind Robbins' Grain and Hardware, or the Fyler Homestead that was built in the 1630s. I must have gone into many other places with that old wood smell, but they've receded into the background of my memory.

Outside the door of the shed, uphill and to the south, the landscape is all wild high-bush blueberries. In May you can lose yourself in the twisting paths between the bushes, with the scent of the blossoms and the noise of bumblebees vibrating with life all around you. The only better time is July, when the berries are ripe and you can taste a different variation of flavor on each bush. The blueberry is somewhere between one species and a million; it hasn't finished its evolution yet. We have an extreme variety that tastes of dark tobacco and another that's almost wintergreen.

When my wife Emily and I came to live in the country year round, I renovated the old shed to make it into a workshop. It still held garden tools, but I cleared out everything else and installed an arc welder. Outdoors, on four cherry logs sunk into the ground, I built a workbench where I could

make sculpture out of scrap steel. This kind of art went out of style with the Abstract Expressionists fifty years ago, but as an old man I could please myself. I didn't have to be fashionable, no one would care.

The material I liked was old rusted things. Plowshares and brake shoes and bed frames that I got from the woods were like weathered driftwood from the sea. I never could have imagined their forms—I had to find them. And when I welded them together I did as little work as possible, like a sketch with brush and ink. I put out my constructions as part of the landscape, hanging in old trees or standing on cherry posts and mounds of earth all over our eighteen acres of woods and fields.

When the first summer went by, and then the autumn, I saw that I needed to prepare for the winter as the chipmunks were doing. I continued my renovation of the shed by building indoor workbenches and a bin for scrap steel. I cut the door into two smaller ones that could swing open in the snow, put up a gutter over the doorway, took out the window for ventilation, and wired the inside for more lights. The November days were so short that I finished the wiring after dark with the moon as my helper.

The most astonishing experience of this rebuilding happened when I took out the grimy old window sash, which always had too much wood in it and not enough glass. From inside the shed, the newly opened window frame gave a beautiful unexpected view of white pines and cedars against the eastern sky, as if my eyes had been cleaned and refreshed. I never wanted to close it again. And more than that, it brought back the memory of the day Emily posed for her picture there before the shed was finished, looking as young as when we were first married. It was as if I had opened a window back into that time.

My Winter Studio is neither outdoors nor indoors—it's both. It's an ambiguous space. The cold wind blows around me through the doors and the open window, taking out the welding fumes, but the interior with all its tools is safely sheltered from rain and snow. The eaves protect the doorway, and when there's a storm from the east I have a shutter to close the window temporarily.

In the depth of winter, when there's two or three feet of snow on the ground and piled on the roof, the inside of my studio is like a burrow. Mice nest in a bureau from the old hotel that I use for hardware, and rabbits shelter just outside the door where the wind drifts the snow away. There's a little dry grass there—I don't see the rabbits, just their footprints and the pellets they leave behind.

Many times I lose track of the afternoon while I work, with my head in the welding helmet and respirator. Then it's a surprise to step out into the black night blazing with stars and Orion and the Pleiades high in the south over the blueberry field. Emily says that the arc welder lights up the snow like the surface of the moon, but I've never seen it except through her eyes.

When summer comes, I still consider the Winter Studio my workshop, but a thousand other creatures also occupy it as if I had built it for them. Bats live in a colony under the roof, streaking out at sunset every day to catch insects and raising their young in cracks in the walls. I've found that it's easier to give up the loft to them than clear away the layer of droppings that cover it. Brown wasps also make their nests under the roof, looking dangerous even though they're gentle in reality. Sometimes they hit me in the face as they fly out the doorway under the eaves, but they never sting. While they wait for the apples and pears to ripen, their favorite food is the blueberries nearby. I see them cut the skin of a blueberry with their jaws the way we peel an apple—one of the same berries that a bumblebee pollinated in the spring. It's one of the riddles of nature that a wasp should be fed by a bumblebee.

Another kind of bee, the orchard bee, has made its clay-covered nests in the electrical outlet right inside the door of my studio. I provided a wooden nesting block full of holes outside the doorway, but the demand for nesting holes seems to be increasing. I can't use the outlet until the new orchard bees hatch out in the spring. In a matter like this I take Thoreau as my guide—there's no doubt he'd side with the bee in this conflict.

Farther down, the stone foundation of the shed is full of garter snakes. They sun themselves in the morning and wriggle into the woodpile when they want to cast their skins. Once when I was welding outside at night I saw them come out of the stones to flick their tongues and watch with their glittering eyes, attracted by the light and heat.

I was also visited by a snapping turtle. When I had done some digging outside the shed, she came up from the swamp and poked her nose into the pile of soft earth, looking at me as if she longed to unload her belly full of eggs. I was sorry I had to send her away.

The last time I put a new roof on the shed, one summer about ten years ago, my daughter Rebecca helped. She was in high school then, and we weren't really speaking to each other except to quarrel. She still did a certain

amount of work around the place, mulching the peas and squash, carrying buckets of water to the trees I transplanted—but under protest and with a sullen look. Once I noticed that her mood improved when she helped me drag away the branches of a huge pine that I'd cut down to give light to an apple tree. I guessed the exercise and the wonderful pine smell got to her in spite of herself.

To begin with, I worked alone shingling the south side of the roof, which was hot as a frying pan. But since the north side was more comfortable, I got Rebecca to carry shingles up to me while I nailed them on. At the end of the job we were perched on the top like birds, looking down at the yard and garden from twenty feet up.

The next summer Rebecca left us to work at a hotel in the Poconos, a separation that did us all a lot of good. But one day she called up excitedly to tell us how she had been out with her friends at night and climbed up on the roof of a storage building for the view.

"Do you remember when we put shingles on the shed, Papa?" she asked. "I was up there and it just came back to me. It was like flying!"

That was one of the few times she let down her guard, but it was proof of the inner self she kept hidden from us. It gave me hope that things would be better between us someday. Like the mice nesting in the bureau drawers and the orchard bees in their cells, life was thriving in her unseen.

In fact, I'd forgotten about our day on the roof. At the time I was preoccupied with nailing down shingles and watching that Rebecca didn't fall off. I didn't realize that it meant something special to her. But now I knew what she was trying to say. The Winter Studio had lifted her high enough on its roof for her to feel the beauty of the pines and red cedars around us, and to see the landscape from a mysterious perspective—the blueberry field with its wandering, disappearing paths, the park-like lawn, the orderly rows of the vegetable garden, all against the wild woods at the edge of our clearing.

In the end, nature will have the Winter Studio completely. There's already a fine powder, like flour, falling from the beams where beetles or carpenter ants are consuming the wood and making their home. I can imagine a time when the whole structure will lose its strength and collapse into a jumble of old boards. Vines and brambles will cover it, like the ruins of Abe File's house on the Old Golf Course in Windsor that I climbed over when I was a kid. �₷

Fred Muratori

GEOPOLITICS

This ragged patch of land once cared for
reflects the wildness of unharrowed fields:
vines and thistles, banes and worts
in asymmetrical variety, entangled
and at odds for a mirage of sunlight,
a random dole of drop or seepage—
indiscriminately abrasive, thorned
and nettled, in silent unremitting strife.
But among them, here and there,
the remnants of an heirloom rose, now
stunted, barely visible, pale pink survivor
bent and knotted in the strangling surge,
unnoticed by passersby, its final hope
the winter's brute, unbreakable truce.

Stephen Shaner

BLIND SPOT OF A WAR:
SURVIVAL ON THE WEST BANK

A photojournalist currently based in Skaneateles, New York, Stephen first traveled to the Middle East in 2002 and has since made eight trips to the region, spending more than a year all told in Israel and the Occupied Territories. During his time there, he has spoken with many people on both sides of the conflict, eaten matzah at Passover Seders, fasted during Ramadan, marched behind would-be suicide bombers, picked olives with peaceniks, explored the alleyways of refugee camps, and been witness to acts of both senseless destruction and humbling compassion. Most recently, he spent a night as a "guest" of the Israeli Border Police. Since first visiting At-Tuwani in 2004, he's focused his efforts on understanding the complex relationships between Jews and Arabs in the southern West Bank. Material for the following article was gathered from 2005 to 2007.

A white mini-van with yellow plates pulls to the side of the paved road that Hafez Hereni is about to cross, blocking his path. People climb out of the van. Hafez, a resident of the tiny West Bank village of At-Tuwani, brings his gutted Fiat to a quick stop and shuts off the engine. Silence ensues in a long, uneasy pause. The situation seems innocuous enough; it appears the van's passengers are switching drivers or merely stretching their legs. To Hafez, though, the momentary shuffle is cause for grave concern, as anyone who has spent time in this troubled region knows the van contains Jewish settlers.

This time, however, the anxiety is for naught as the passengers step back inside and the van continues down the highway. It's just another routine encounter in an embattled area that serves as a front line for conflict between Arab and Jew in the Holy Land.

At-Tuwani, a centuries-old Palestinian community, sits on the extreme edge of the 1967 Green Line in the southern Hebron hills, the land religious Jews refer to by its biblical name, Judea. Arid and rock-strewn, At-Tuwani is a 45-minute drive, via settler roads, from Jerusalem. Positioned just outside what modern Israel designates "Area C," a closed military zone under full Israeli military control, the low rolling hills and monotone palette disguise a tough and inhospitable terrain.

With limited contact to the outside world beyond the length of a dirt path, At-Tuwani is nearly inaccessible to the average traveler. It's even

more difficult for anyone living there to leave due to Israel's restrictions on its inhabitants' movement; while settlers enjoy driving on modern paved roads, Palestinians like Hafez are forced to travel on dirt roads and ad hoc paths subject to random Israeli checkpoints and roadblocks. Though geographically close to crowded Hebron to the north and Jerusalem a short jaunt away, At-Tuwani shares none of the larger cities' luxuries.

The 150-or-so residents of At-Tuwani are not particularly religious or politically minded people. They live in simple adobe or stone structures—some dating back 300 years—and provide for themselves mostly through subsistence farming. With a small store, a five-room school for grades K-6, and a new medical clinic and tiny mosque still under construction, Hafez half-jokingly considers At-Tuwani the "Beverly Hills of the villages."

A diesel generator operates a few hours in the evening, supplying electricity to residents' homes, a luxury used mainly for refrigeration, cooking, and laundry, "things that make the woman's life easier," Hafez clarifies. At-Tuwani citizens grow olives, tomatoes, lentils, and figs, eat the indigenous thistle, and sell surpluses of cheese, yogurt, and wool as their primary means of income. They obtain drinking water from a spring and the heat often reaches over a sweltering 100 degrees inside their homes during summertime. Winters are cold and wet. There is no plumbing.

Though dreadfully inconvenient to the average citizen of an industrialized nation, the rugged living conditions pale in comparison to the more precarious and discouraging task of living in daily terror of your neighbors, who are slowly confiscating your land. The nearby residents of the Jewish settlement Ma'on, and even closer outpost settlement Havat Ma'on, are within a stone's throw, literally, of At-Tuwani.

According to the villagers, these settlers have poisoned At-Tuwani's livestock and water supply, burned wool harvests, uprooted olive trees, ruined crops, stolen land, hindered movement, and verbally harassed and physically assaulted the people who live there. The Israeli Defense Forces (IDF) and settler security personnel, as well as the nearby Kiryat Arba police, "do nothing," Hafez says repeatedly, to suppress the alleged abuses and confiscation of land.

As settlements creep farther into Palestinian territory, Israel is reshaping the map of a future two-state solution. At-Tuwani is but one of many Palestinian communities in danger of eradication due to an expanding Jewish presence within the boundaries of the West Bank.

WHERE CAN WE GO?

Unlike other threatened communities, however, At-Tuwani's story has been slowly revealed to the outside world due to the actions of its residents and a handful of devoted internationals who have gone to great lengths to protect the fragile balance between a traditional way of life and expulsion from the land. Much of this responsibility has fallen upon Hafez, who now describes himself as an activist. He's one of the few in the village who has some university education and his language skills—Arabic, Hebrew, and English— have made him the de facto point man dealing with the Israelis as well as internationals who visit At-Tuwani.

This activism has come at a price. In 2006 Hafez, who's in his mid 30s and supports a growing young family, spent several weeks in an Israeli jail after helping to organize a demonstration against the security wall that is being built throughout the West Bank and threatens to completely isolate At-Tuwani. He was arrested protecting his elderly mother from soldiers and police who attempted to break up the protest. The incident was well documented and Palestinian newspapers ran dramatic photos of the confrontation on their front pages.

Hafez feels his increasing role in his village's struggle has made him a target of the Israelis. After much of his land was seized by settlers, he was forced to find alternate means to provide for his family. For a brief time he performed secretarial work at the police station in nearby Yatta. After elections in February 2006, when Hamas candidates won a majority victory in the Palestinian parliament, the U.S. and other governments cut off the flow of international aid to the West Bank and Gaza, fearing this funding would support a terrorist organization that doesn't recognize Israel as a legitimate state. This reduction in aid meant that many Palestinians employed by the government couldn't be paid. People like Hafez were forced to make the decision to continue to work months without compensation or find a source of income elsewhere.

Despite these hardships and an increasing sense of despair, Hafez remains a passionate representative for At-Tuwani. When asked if he wants to leave, there's no hesitation in his answer: "I am from here...and we can't go back (to his family's pre-1948 village). Our villages were destroyed. Where can we go?"

Many of those presently in At-Tuwani have lived there since the creation of the state of Israel in 1948, what Palestinians call "al-Nakba," an Arabic term meaning catastrophe. When the United Nations voted to partition

Palestine into Jewish and Arab regions and Jews began to claim Palestinian land as their own, hundreds of thousands of Palestinians either fled their villages in fear or were forced out by Jewish fighters. The Palestinians whose homes and villages were either destroyed or occupied became the refugees who presently populate Gaza and the West Bank, as well as camps in Jordan, Lebanon, and Syria.

Now the people of At-Tuwani fear yet another expulsion as their entire village, they were informed by the IDF, is currently under demolition orders. "The Israeli army told us our homes are part of an ongoing demolition order for new structures because they were built without a permit." Hafez explains. "They consider our homes new structures even though our families have lived in them since 1948 and some of them are hundreds of years old. Of course, permits to build are obtained from the Israeli military."

Due to the nature of the situation in the West Bank, the status of At-Tuwani is unclear at any given moment. Because of its small population, remoteness, proximity to the Green Line, "Area C," and established settlements, residents and international groups embedded there believe At-Tuwani is an obvious candidate for a land takeover by Israel because its confiscation would help the facilitate the contiguous Jewish presence Israel desires within the West Bank.

WHAT CAN WE DO?

Gathered under a tarp beside her home, Khadra Rbeay, 52 years old and a lifetime resident of At-Tuwani, drinks sweet mint tea and shoos flies as lethargic breezes drift through giving momentary relief from the midday heat of a summer day. She is wearing a colorfully hand-embroidered traditional Palestinian dress and perches crossed-legged on the cement slab. Deep scars on her lip and chin punctuate an easy smile. A lull settles over the village and she begins to relate her experiences with the settlers.

"My family was harvesting our sheep," Khadra says, "the settlers came and began burning the wool we were gathering. The police came and stopped them but ordered us to return home. As we were leaving, the settlers were shouting at our backs, 'go home, this is our land…if you come again we will bury you inside this land.' We went back that night to secretly finish (the harvest). As we were working, four settlers snuck up and attacked me, beat me with sticks. I didn't know what was happening, it was so dark. My arm was broken and I had a concussion. They also beat my four children. After

two and a half hours the police came. They arrested my four children and we had to pay 2000 shekels [about $450 US dollars] for each child to be released from prison."

Khadra pauses only to pour more tea. "Once, I was grazing my sheep near our olive trees close to Ma'on. Twenty settlers came out of the woods, accompanied by security forces, with sticks and slingshots. They beat us and even beat our sheep. One settler hit me on the head with a stick so hard I became unconscious. I woke up at Yatta hospital and discovered I was not only beaten, but when I became unconscious I fell and seriously injured my face. Afterward, I went to the police station in Kiryat Arba to complain, but they did nothing.

"We can't live near them in peace. We can't trust them...settlers have never come to help us, only to beat us. They have guns and we have stones. What can we do?" she asks.

A Great Place for Kids

In 1983 Jews established the settlement of Ma'on and by 1999 some residents splintered off to form a more radical by-product, the Havat Ma'on outpost. This outpost was declared illegal under international law and Israeli forces dismantled it later that same year. By 2000, outpost settlers returned and took up residence in a grove of cedars planted by the Jewish group Karen Kayemet Le'Israel whose mission is to reforest Israel. Unfortunately the group's good deeds ended up providing refuge for the more zealous settlers who harass Palestinians in At-Tuwani.

While it's difficult to travel to At-Tuwani, speaking to the inhabitants of Havat Ma'on is nearly impossible. Few outsiders get inside the outpost settlement and its residents are extremely reluctant to share details of their lives there. These settlers, sometimes known as the Hilltop Youth, are among the most extreme and devout in their belief of a divine connection to the land in the Occupied Territories. Even among other settlers they are often labeled as outcasts and troublemakers.

Yet in a somewhat ironic twist, the outpost settlers are also in fear of being evicted from their homes as they do not have official government approval to be on the land. But unlike the Palestinians, they receive assistance from the established Ma'on settlement and also rely on the Israeli military for protection. At first Havot Ma'on consisted of little more than a few tents scattered under the trees. Now the structures have become

more permanent and more numerous. A large synagogue with a concrete foundation is being built, electric cables and water pipes snake along the ground from nearby Ma'on, washing machines, refrigerators, and toilets await installation in new homes.

Speaking on condition of anonymity, one young woman related her version of events regarding life in the settlement and alleged violence against the Palestinians. An American originally from the suburbs of Pittsburgh, her family and friends thought she was crazy marrying an orthodox man and moving to a tent on the West Bank. She and her husband both have university degrees but feel a compulsion to live simply on what they consider sacred land. Currently, they are finishing construction of a modest home among the trees.

"It's scary having Arabs know where you live," she says, "but because of all the trees they don't know exactly what's in here and that frightens them and makes them afraid to enter so we feel safer because of that. But we don't put bars on our windows because how's a window going to stop a terrorist anyway? The kids love living here and thrive here; they aren't scared at all and will walk around at night. I'm more scared than they are. It's a great place for kids."

When asked specifically about the situation in At-Tuwani she tells a version of events nearly opposite the claims of the Palestinians. "There are Israeli leftists and Christian leftists who live among the Arabs," she states, "and they cause us problems. One Shabbat an incident occurred that caused lots of trouble. People started going out and, you know, screaming at them (Palestinians) but no one did anything (violent). Then I guess the army got real scared something was going to happen and one of the leftist soldiers started screaming he was going to remove us, to bulldoze us down. That Saturday night on the news they were showing little Arab kids with bandages around their heads and arms and crying and they said that we attacked them—they said they had got assaulted. It was a big deal and the government started talking about it and that's when we almost got taken down."

The incident she's referring to occurred in the fall of 2004 and sharply focused international media attention on At-Tuwani and its struggles with the Ma'on settlers. Earlier that year the people of At-Tuwani invited the Christian Peacemaker Teams (CPT) to establish a presence in the village to try and ease tensions with the settlers. CPT, an international peace organization headquartered in Chicago, had already been working in Hebron for a number of years and quickly set up a small camp in At-Tuwani.

Since At-Tuwani has a school, a number of smaller Palestinian communities send their children there to attend classes. Some children travel several kilometers by foot on a route passing through the hills near the Havot Ma'on outpost to reach At-Tuwani. CPT and members of another international group began escorting kids to and from the school in an effort to prevent harassment from settlers. In late September two members of CPT were attacked by five settlers hiding in ambush with chains and baseball bats. They suffered broken arms and cracked ribs and one member's lung was punctured. This incident attracted the attention of the press and journalists descended on the area to report the story; settlers beating foreign nationals was seen as especially violent and threatening.

Days after this first incident, CPT members escorting children were again attacked. This time a representative from the American Consulate in East Jerusalem traveled to At-Tuwani to assess the situation and shortly afterward the Israeli military was tasked with escorting Palestinian school children around the settlements. Like all news stories, however, interest soon faded and At-Tuwani was but a fleeting blip on media radar screens.

But the international groups that have surfaced in and around At-Tuwani have gradually changed the tenor of the situation there. Organizations such as CPT, Operation Dove, Amnesty International, B'Tselem, and Ta'ayush accompany shepherds, walk children to school, and monitor Israeli checkpoints. Activists wield video cameras and place themselves in risky situations to witness any crimes or violations of human rights. Hafez jokes, "Since CPT came, the settlers now attack wearing masks so when they are videotaped or photographed, nobody will know who they are."

"Believe it or not, [At-Tuwani] is generally less violent than many other villages because of the international presence," Ezra Nawi says. A member of Ta'ayush, a grassroots movement of Arabs and Jews working to break down the walls of racism and segregation, Iraqi-born Ezra is a devoted advocate for Palestinians in the rural villages. A handyman by trade, he's a serious person but speaks gently. "The settlers believe they are entitled to this land," he explains, "and human rights organizations are only delaying the military from taking over Palestinian land, not preventing it. We've developed good relationships with the people here...it is different to hear a story than to see a story. I have brought hundreds of people here, even my mother. When you know a person, you feel a different responsibility."

Legacy of Hate

It's a brief adventurous drive from At-Tuwani to Susiya on what Palestinians consider dangerous settler roads. If At-Tuwani seems remote, then Susiya, a Palestinian enclave within view of a Jewish settlement of the same name, is somewhat like being on the moon. Here, neighbors are few; there are no roads, no school, no clinic, and no store to buy even basic necessities. Susiya is tethered loosely together by its name, the land, and the plight of its residents.

Haja Sara pours tea with her square, rough hands and serves mutabak, a savory bread coated with sugar and olive oil baked for special occasions. She is 65 years old, fiercely independent, and has three daughters and three sons. The hard dirt floor of her tidy tent is covered in threadbare carpets and inhabited by a playful kitten who wants to share the bread. Inventorying her belongings takes mere seconds: baskets, potatoes, a few foam mattresses, a clock, a gas lantern, a teapot.

"My husband was sick with lung problems," Haja discloses soberly. "We were discussing what to do tomorrow...it was like a normal night, then my husband suddenly says, 'I am going to die.' He told me about all the money he owed people and things I needed to take care of if he died...then I really started to worry...it's very difficult for the ambulance to come here..." she trails off. Haja explains they must ride their donkeys about two kilometers to meet an ambulance.

"I wanted to call my eldest son so we could get a car and go to the hospital," she continues, "but my husband told me not to call. He grabbed the [tent] pole, took three breaths, and died." She points to the pole; hanging from it are her husband's belt, cane, and prayer beads—a humble tribute to a companion's life.

Haja says soldiers arrested her son soon after his father's death. "They took his identification papers and beat him because he had a beard; they think all Arabs with beards are terrorists. After his father died, it is a tradition—he grows this beard," she says and pushes the kitten aside. "We had to pay 3,500 shekels [about $775 U.S. dollars] to release him from jail. They also made him shave his beard."

She laughs when asked why they did this to her son. "They hate us. It goes back...for a long time. They do not want to see Arabs here...they want to confiscate the land...these settlers are a different kind of people, not normal. We do not trust them...I do not feel that way about other kinds of

people, other Jews...but the settlers are bad people...violent people...who attack us. I hate them," she says.

Abruptly, Haja angrily waves her hands toward the settlement of Susiya. "People of this village used to live in the ancient city of Susiya. In 1985 settlers kicked us out so we moved to the caves here. After a few years settlers came back and put our belongings in trucks and took them to the dump. They attacked us and destroyed everything here. Later they closed the caves...put big stones in front of them and broke our grain bins. We opened the caves back up eventually. After about one year the Israeli military came with demolition orders for the caves and destroyed them," she says.

"I hope something changes with the settlers, but change takes time," Haja says. "We hope that they leave and we stay in our land here. I will keep living here until I die, like my husband."

"PLACES OF SPECIAL INTEREST"

Throughout the West Bank, the ubiquitous red-tile rooftops of Israeli settlements occupying the land are striking in their uniformity. They're assembled densely, surrounded by security fences and other barriers in ironic contradiction to the Palestinian villages they surround. In these settlements built inside the Green Line, including Ma'on, there are paved roads, sewage systems, busy local establishments, landscaped public areas, bus stops, the lingering smell of fresh-cut grass—all tangible signs of permanence.

Along with a growing network of Israeli highways linking settlement enclaves, a web of checkpoints and shifting roadblocks on Palestinian roads, and the continued construction of Israel's controversial security fence hemming in Palestinian villages, one hard-to-deny fact on the ground is the increasingly frail look of At-Tuwani and other small villages spiraling toward extinction. Many have compared this dissection of the West Bank with the Bantustans created during South Africa's policy of apartheid.

It's no secret that Israel encourages and subsidizes the expansion of West Bank settlements in order to increase land ownership for the state of Israel. According to B'Tselem, an Israeli human rights organization, Israel has established 135 settlements inside the Green Line since 1967. This figure does not include the illegal outposts.

The spotlight aimed at Israel's decision to evacuate approximately 8,000 settlers from Gaza in the summer of 2005 failed to illuminate the impact of hundreds of thousands of settlers living in the West Bank. The Israeli Cabinet Resolution Regarding the Disengagement Plan stated:

"In any future permanent status arrangement, there will be no Israeli towns and villages in the Gaza Strip. On the other hand, it is clear that in the West Bank, there are areas which will be part of the state of Israel, including major Israeli population centers, cities, towns and villages, security areas, and other places of special interest to Israel." [1]

To the people of At-Tuwani and Susiya these "other places of special interest" are the same lands on which they graze their sheep, harvest their olives, and grow food for their families.

The southern West Bank holds great religious significance to the Jews who have settled there. Communities like Havat Ma'on are united in their conviction that the land is theirs by divine promise. But despite the Zionist saying that Israel was created as "a land without a people for a people without a land," Palestinians who have lived on this same land for generations also feel it is their birthright to remain there.

From Tragedy to Tragedy

The stories begin to sound markedly familiar in their hopelessness; the murmur of woeful words blur into one despondent tale after another. While the world's eyes are averted and peace negotiations flicker, then fizzle amid ongoing violence and power struggles, Palestinians on the fringes of the West Bank believe their land will become the new battleground between Arab and Jew.

The plight of people like Hafez, Khadra, and Haja remain relatively unknown, even to fellow Palestinians. News reports of suffering in the southern West Bank are decidedly absent from the mainstream media. The omission of this news is akin to the omission of At-Tuwani from maps published or approved by the state of Israel; Israeli maps do not acknowledge the existence of these fragile villages or the nearby Green Line. The villages, the people, and their lives are literally written off. "Nobody cares," Hafez sums up the situation. "Only after the internationals were attacked did anyone care. Then after that, nobody cares. We don't expect the settlers to leave...we are just expecting bad things. We are also worried more settlers will come here. We can't live in peace...there is something in their religion that makes them different from other Israelis. You can't talk to them," he says. "If I walked into the settlement right now, they would kill me."

At-Tuwani is one of many villages on the brink of being consumed by Israel, and the evidence is apparent: rampant poverty, ruins of demolished homes, desecrated harvests, restricted travel, expanding settlements, shrinking Palestinian lands, static lives, the scars etched on Khadra Rbeay's face. The quiet shepherds and farmers living on the southern West Bank exist in the margins of a land rife with volatility and a daily rhythm of anxiety and fear.

But the people in these villages remain generous and give away something they reluctantly own—their stories—hoping they will bring change toward a life without bloodshed or, at the very least, acknowledgement of their beleaguered existence. "These people are losing land, losing harvests, losing their freedom," Ezra declares. "They are living from tragedy to tragedy." ≋

Postscript:

Recently, the people of At-Tuwani won an important victory in the Israeli courts when it was decided a portion of the security wall erected alongside a highway near the village was illegally positioned. This barrier, removed as of August 2007, had severely restricted travel to nearby Yatta, an important commercial center for the village, as well as access to grazing and agricultural land.

(1) Language like this, directly from the Israeli prime minister, is key to understanding policy regarding future status of the West Bank. Reading the resolution, one might believe the evacuation of locations in the northern West Bank constituted a major withdrawal; not at all. I was at Sa-Nur—a small enclave with a troubled past—when it was taken down in 2005. These few settlements represented only several hundred total settlers and were removed for convenience, to consolidate other areas, and to divert attention. Though little reported it is common knowledge many Jews displaced from Gaza were relocated to settlements in the West Bank, so in an ironic twist the number of settlers in the West Bank actually increased as a result of the disengagement.

Author Uncited, "Part I Background—Political and Security Implications," Israeli Ministry of Foreign Affairs, *www.israel-mfa.gov.il/MFA/Peace+Process/Reference+ Documents/Revised+Disengagement+Plan+6-June-2004.htm* (September 2007).

Stephen Shaner, *Road to At-Tuwami*, black and white photograph, 2006

Stephen Shaner, *At-Tuwami*, black and white photograph, 2006

STEPHEN SHANER, *At-Tuwami School*, black and white photograph, 2006

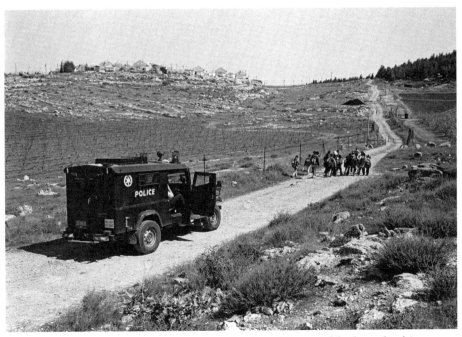

STEPHEN SHANER, *Escort Home from School, At-Tuwami*, black and white photograph, 2006

STEPHEN SHANER, *Boy and Fiat, At-Tuwami,* black and white photograph, 2006

STEPHEN SHANER, *Palestinian Cave overlooking Ma'on Settlement,* black and white photograph, 2006

Stephen Shaner, *Settler and Son, Ma'on Outpost*, black and white photograph, 2006

Stephen Shaner, *Settler Home, Ma'on*, black and white photograph, 2006

STEPHEN SHANER, *Settler and Dog, Ma'on Outpost,* black and white photograph, 2006

STEPHEN SHANER, *Olive Harvest, At-Tuwami,* black and white photograph, 2004

STEPHEN SHANER, *Lunch Break, Fall Olive Harvest, Susiya,* black and white photograph, 2006

Stephen Shaner, *Haja Sara, Susiya,* black and white photograph, 2005

Brian Turner

AT LOWE'S HOME IMPROVEMENT CENTER

i.

Standing in aisle 16, the hammer and anchor aisle,
I stare at a 50 lbs. box of double-headed nails
I've busted open by accident, their oily bright shanks
and diamond points reminding me of firing pins
from M4s and M16s.
 In a steady stream
they pour out onto the tile floor, constant as shells
falling south of Baghdad last night, where Bosch
kneeled under the chain guns of helicopters
stationed above, their tracer fire a bizarre geometry
of light.
 At dawn, when the shelling finally stops,
hundreds of bandages will not be enough
to treat the wounded.

ii.

Bosch is walking down aisle 16 now, in full combat gear,
improbable, worn out from fatigue, with a rifle
slung at his side, his left hand guiding
a ten-year-old boy who has seen what war is
and will never clear it from his head.

And I don't know what to say as they come closer.
Here, Bosch says to me, *Take care of this boy.*
I'm going back in for more.

iii.

The forklift driver has swiveled too fast
over on aisle 3, puncturing metal drums
filled with mineral spirits, xylene, turpentine.
Maybe he's seen Sgt. Zavala on the other side,
there on aisle 4, breathing hard in a fireman's carry
as he searches for a place to lay a dying man down.

iv.

Sheets of plywood drop with the airy breath
of mortars in the moment they crack open in shrapnel.
The retired couple in the lawn and garden department
don't seem to notice, the mower blades are just mower blades
and the Troy-Bilt Self-Propelled Mower doesn't resemble
a Blackhawk or an Apache. In fact, no one seems to notice
the casualty collection center Doc High is marking out
in the Ceiling Fan Department, there on aisle 15.
Wounded Iraqis are given I.V.s and propped up
against boxes of Paradiso ceiling fans—92 sample fans
hovering over them in a slow revolution of blades.

And the forklift driver is sure to get fired
because now he's over-adjusted, swinging the tines
until they slice open gallons and gallons of paint cans,
Sienna Dust and Lemon Sorbet and Ship's Harbor Blue
pooling in the aisle where Sgt. Rampley walks through—
carrying someone's blown off arm, cradled like an infant,
handing it to me, saying, *Hold this, Turner,*
we might find who it belongs to.

v.

Cash registers open and slide shut
with a sound of machine guns being charged.
And it doesn't make any sense. The dead
lay splayed out under the register lights,
right there on the black conveyor belts,
and the people in line are still reaching
for their wallets. It doesn't make sense.
Am I supposed to stand over at the magazine rack
and read *Landscaping with Stone,* or
The Complete Home Improvement Repair Book.
What difference does it make if I choose
Tumbled Travertine tile for the bathroom,
Botticino Fiorito Marble, or Black Absolute granite.
Outside, palm trees line the asphalt boulevards,
restaurants cool their patrons with patio misters,
and fireworks explode over Bass Lake in July.

vi.

Inside, aisle number 7 is a corridor of lights.
Each dead Iraqi walks down the aisle, amazed
by Tiffany posts and Bavarian pole lights, track-lights,
pineapple fixtures with pewter gold finishes.
Motion-activated lights switch on muted incandescents
with frosty bulbs as they pass by, reverent sentinels
of light, *Fleur De Lis* and *Luminaire Mural Exterieur*
welcoming them to Lowe's Home Improvement Store,
aisle number 7, with me standing here in mute shock,
someone's arm cradled in my own.
 The Iraqi boy beside me
reaches down to slide his fingertip in the paint, an interior latex,
Retro Colonial Blue, which pools at our feet, before writing
T, for *Tourniquet,* on my forehead.

Eric Gansworth

PATRIOT ACT

I knew the fight wasn't over when my wife said those three words at the border: Native North American. I really hoped we could smooth out the hostility Virginia was feeling about our neighbor and our former cat before we came back across to the U.S. side. It was always much harder to get back into the United States than it was to get into Canada in the first place. The Canadian border guard looked at me in the passenger's seat, and when I answered, "United States," he proceeded to ask my purpose for entering the country, knowing my wife didn't have to answer. I told him we were just going over for Chinese food. Everyone who grows up in border towns like Niagara Falls learns to add "just" to our destinations whenever we crossed over, attempting to minimize any misinterpretations of serious intent.

I have even heard people say, "just the dentist," as dentistry, for whatever reason, was a lot cheaper in Canada. You can't help feeling guilty of some criminal act when an armed officer demands your ID and asks whatever question comes to mind. Virginia is a lot darker than I am, and we were asked once, when we were first married, what the relationship between us was, as if there were something inherently wrong with people of varying pigment traveling together. Now she usually just says United States, like I do, whenever we go across. The kids inherited the politics of their grandmother so they always claim their Indian status, forgetting I am the one who can be dragged in and questioned and asked to empty my pockets and that the car can be searched because I'm riding in it. They forget that the Jay Treaty doesn't apply to me, that unlike them, I am not free to cross the borders because my tribe formally doesn't recognize the United States and Canada as separate places. Or maybe they have never forgotten and they want me not to forget either. Since they've grown up and moved to their grandmother's reservation land, I never let them ride with us over the border. They can be who they are in their own cars.

It should have occurred to me that Virginia would pull the "Native North American" routine at the border when I suggested the Jade Garden. I wanted her to forget the phone call this morning and everything attendant with it. I was just thankful for no caller-ID on the phone she picked up. She frowned into it and said it was for me, which is almost never the case. Nobody calls me, not from the garage, not from the bowling league, no one.

When she's traveling on the powwow circuit with her mother, the phone doesn't ring at all, except for her checking in every few days. I asked her who it was and she said the voice sounded familiar but that she couldn't quite place it.

I spoke and could hear breathing, anticipation, but no words. "Hello?" I said again and was about to hang up when Celeste spoke.

"Lucky Penny is dying," she said after identifying herself. It sounded like secret code from a bad James Bond movie. I expected a young Sean Connery, in a Speedo, with two young bikini-clad women rubbing his hairy belly, to step up and offer the counter phrase, something like, "The black dog swims in the moonlight," but naturally, he didn't.

"Um, okay, thanks," I said.

"I just wanted you to know," she said.

"I appreciate it," I said. Then she said goodbye and hung up. I placed the phone back in its cradle and Virginia asked what that had been about. "I'm not sure," I said, hoping she might forget the phone had even rung. "Have you made the coffee yet?"

"Who was that?" she repeated. It was an exact reproduction of the exchange after a call I'd gotten three years earlier. We went to the Jade Garden after that fight, too. It was our make-up restaurant, after all. She probably knew and was just waiting for me to confirm.

• • •

Virginia and Celeste had never been great friends, but they'd been okay neighbors, even what you might call friendly for a few years. The first year we were here, Celeste had sent over Christmas cookies with her twin granddaughters who lived with her. Those cookies were amazing, the puffy kind with the thick electric-colored frosting, candy eyes on the snow men, trees covered with ornaments and garland, almost too beautiful to eat, but their beauty only slowed us down. We ate them just the same. When the twins reached first communion, we went next door to the party, the only non-family members there.

The problems began when Gordon asked Virginia what she was doing to celebrate Martin Luther King Jr. Day, a couple of Januaries later, only he didn't call it Martin Luther King Jr. Day. Gordon claimed in pride that he'd moved into his wife's childhood home when they married and that the street had remained pretty white his entire time there. Our houses are on the river, five miles from the famous falls. We couldn't believe our good

fortune when we found the place, a casualty of a different marriage's failings, though the house would need some work to make it what we wanted. We decided that we were never leaving, and it was clear that Celeste and Gordon would be our neighbors forever.

Around the time we'd saved enough to pay our mortgage and afford some renovations we wanted, the baked goods exchange had dried up. When we had family over, we made sure the kids only ran around in our yard. It was a hard concept for them, so different from the fenceless reservation homes. Even though our property lines were marked only by symbolic barriers: shrubs, birdbaths, daffodils, we knew where the kids were expected to stay.

Sometimes, when Virginia wasn't home, I cut some of their lawn, just the part next to our side, or snow-blew their driveway. They were in their seventies and I was trying to build up some karma points. I would be in my seventies some day and I hoped some kind neighbor might do similar things for me. A part of me had forgiven Gordon for his generation. Of course, I was not the non-white person living next door. I was her white husband.

The contractors working on our house had to cut the electricity for a bit, to bring the addition's wiring into the box, and they ran a generator to work. About the third day, a police officer showed up at the door. You don't ever want to see the police on your doorstep. They are never bringing good news.

"Afternoon, sir," he said, with a smile. Well, at least they weren't coming to arrest me for something I had unknowingly done.

"What seems to be the problem, officer?" I heard myself saying, like a character on TV. Is that where we learn to behave from, taught the appropriate responses in prime time?

"Your neighbor, Mrs. Rigg, placed a formal complaint call about your generator. I brought the decibel meter, and you're within appropriate range for the time of day, and your permits are all in order, but..." he said.

"But?" The *but* and the pause always signal that an invitation to compromise is coming. You wonder if the Indians who sat down at the treaty tables knew the meaning of the *but*.

"But maybe you could just move the generator to this side of the driveway? She says her husband's tired, and she wants him to rest peacefully. They seem like a nice, elderly couple. For neighbors, you could do worse. You're within your right, but if it isn't too much trouble, why not keep the peace?" I nodded and called to our contractor. The officer touched his hat brim, nodded back, and left.

While the crew moved the generator, I went next door. They weren't going to answer at first, but I kept knocking, not loud, but persistent, like a leaking faucet. Eventually Gordon answered.

"The police? You called the police on me? What kind of neighbor does that shit? Because you're tired? You wouldn't be tired during the day if you didn't have your TV blaring all night long." Anytime I got up to take a leak in the middle of the night, our front yard looked like a river itself, cast in shifting shades of blue TV light washing over the grass and gardens all night long, accompanied by the low rumble of people talking on their TV. I couldn't imagine how anyone got any sleep in that house. "And after all the times I cut your lawn and snow-blew your driveway?"

"I never asked you to do any of that," was all he said, shutting the door.

"You can be sure I won't do it again," I yelled at the closed door. I told Virginia when she got home that we weren't speaking to the neighbors anymore and she immediately replied that I was the only one who had for at least a year or so.

• • •

The first phone call I got from Celeste, the one three years ago, had been long after we'd moved back into the renovated parts of the house, almost a year after Gordon died. What he hadn't said at the door was that he was resting when he could and staying up all night watching TV because the chemo and radiation treatments had made him so sick. We had no way of knowing. I saw it in the paper, but we didn't go to the funeral, or really do anything. After the police showed up at the door, our neighbors ceased to exist for us, so Gordon's posting on the obituary page seemed strangely anticlimactic, though I am sure that was not the case for Celeste and her family.

Virginia had answered the phone then, too, as she always did, and had not recognized Celeste's voice that time, either. Why Celeste had asked for me both then and this morning, I have no idea.

"In case you're looking for Lucky Penny, she's here," Celeste said then, and didn't stop talking for almost five minutes. Virginia stared at me, her brows arched, left ear tilted toward me in a pantomime of curiosity. I raised my own brows in what I hoped approximated puzzlement and shrugged my shoulders a couple of times. "It's hard to say no when she begs to come in. The twins love her, you know. My…my cat…she died toward the end of fall, and the twins just kind of adopted Lucky Penny after a bit." That was

when I understood she was talking about my cat, Copperhead. "You know they've been petting her and giving her treats since you moved in. Our house is so empty without our cat and Lucky Penny fills a lot of that space. If you want her back, I'll put her out. I understand. I'll tell the girls she doesn't belong to us. I'll make them understand."

"No, that's fine. Thanks for letting me know," I said and hung up. I hadn't even known they'd had a cat, let alone that it had died. You know, no obituary in the paper.

"Well?" Virginia said.

"It was Celeste."

"She ask you what you're doing for Martin Luther King Day again? She having a lynching she wanted to invite you to?" Virginia said.

"She, um, she stole my cat, or something like that."

"Copperhead? And you just let her? Go get her."

"Go get her and what?" I said. The truth was that Copperhead was better off with Celeste and her grandkids. I inherited her from a cousin who had developed an allergy to cats, but we never successfully integrated her into our house. Omar, the cat we already had, was territorial, harassing Copperhead all the time and she eventually grew neurotic, pulling out her own fur and pissing in the corners of rooms. We didn't discover her spraying habit until the carpet guy pulled up the old one and showed us what he called "hot spots." I had seen Copperhead marking territory outside, so I knew she'd been the culprit.

I bought her an outdoor cat house, fixed it up with an electric floor heater and a light, blankets, and a pillow. Once she lived in that, and Omar no longer felt compelled to assert himself, the two of them got along fine. Her house was decently warm in the winter, but she grew lonely. I would lock Omar up and bring her in, but I'm sure Copperhead found more loving humans next door. So, I took Virginia across the border to the Jade Garden, listened to her litany of grievances against our neighbor, and mourned the moving of my cat to another home.

Though she came back in the spring, summer, and fall, even periodically inhabiting the house I set up for her, Copperhead clearly liked her new home better. Sometimes, I would sit on the front deck and she would lie on the porch next door. I would call to her and she would meow, purr, roll on her back, but she'd never leave her new home. She knew where she was better off and I had to agree with her.

Virginia paid her more attention once she moved next door, almost as if Copperhead had become a spy for her. She began carrying cat treats in her

jacket pockets if we were sitting outside. She would call to Copperhead and reach into her pocket and shake the can a little, just enough for Copperhead to hear, but below Celeste's range. Sometimes the cat came, and sometimes she didn't.

• • •

So when I got off the phone this morning, and told Virginia that Copperhead was dying, the conversation went exactly where I knew it would and I got up, showered, and dug into my junk drawer to see how much Canadian currency I had, hoping I wouldn't have to stop at the exchange on the way there.

"So what does she want us to do?" Virginia said when we cleared the border. "Pay for the gas chamber?"

"Nothing," I said. "She was just telling us. Figured we might want to know. You know, I could have had her back any time. Would you let her back in the house?" This was a definite conversation-ender and probably not the way to go, but sometimes you see that road full of broken glass and nail-ridden boards and you just step on the gas and hope for the best. Virginia has always had issues with the physical space of things, which she, like most, blamed on her parents.

Her childhood was filled with dread that if her mother died, she and her father would be told to leave the reservation because he was white. Virginia herself was officially enrolled, but somehow she believed not being legally an adult would have some impact on her status. Around the time she graduated from high school, her father died suddenly, and was not allowed to be buried on the reservation. Though he'd been living with another reservation woman at the time, Virginia's mother was still married to him, at least on paper, and had him cremated, keeping him in a heavy concrete canister that she used as a doorstop in the summertime. I don't know where he went in the winters, maybe to the other woman's house.

Someone Virginia went to high school with had recently died, complicating our lives. As we were in our fifties now, she suddenly had a keen sense of our mortality. She wanted me to be cremated and have our burial instructions state that I was to be put in her casket so we could be together in the reservation cemetery. I had issue with the idea that her plan presupposed my death first. She could plan anything else she wanted but this was a little much for me, and we both knew that if she went first, they wouldn't allow me to be buried there, no matter whose ashes I carted around with me.

She had grown so preoccupied with this possibility that she'd recently begun having panic attacks serious enough that a couple of months ago she went and had stress tests, the treadmill, the imaging stuff, the works. Her doctor prescribed something to chill her out, but she said she needed to be this angry to survive. I didn't know what she meant but her family members were all like that; somehow politics was entrenched in everything they did. They could make taking a piss a political act. All of this came back out over the fortune cookies and as always, we had no answer. Well, I had one, but it was never the one she wanted to hear. She would not accept that we could buy plots in a different cemetery and be together that way, but really, we're not going to know, anyway, so I had no idea why she didn't just take the Xanax and get on with living.

"So do you think she's gone yet?" Virginia said as we left the restaurant. I reached the car first and opted for the driver's seat. I hadn't asked Celeste for any details, so I didn't even know what was happening at the house next door to ours, how Celeste had decided that Copperhead or Lucky Penny was not long for this world. "Why doesn't it matter to you? No matter what, that bitch stole her. She's our cat."

"We let her go," I said. "We could have kept her, put up with her problems, but we didn't. We made a choice of which cat had to go out and we chose the one we were less attached to, and that's the truth. Look at it from her point of view. I mean, she's got a little cat brain, sure, but she was able to make some pretty good choices about her living conditions. She could have a semi-warm tiny house and some visits inside or she could live in a huge house with two little girls who loved her. Not hard to figure out. Not a lot different from the choices you made. You could still be living at your mother's place, using the outhouse, or maybe living in a trailer, maybe get a septic tank and drink bottled water, but you're not. You're here, with me, on one of the most prime pieces of land in the county. Tell me you didn't make some decisions based on comfort." We pulled up to the Immigration Booth at the New York end of the bridge.

"Purpose of your trip into Canada?" the officer said. This was a strange opening question, but sometimes they did that, to catch you off guard. One time, I was asked what hospital I was born in and was so startled, I found myself giving a wrong answer and then stammering the right one. I told him where we had gone, a common enough destination just across the border.

"Are you bringing anything back with you?" he next asked. We both shook our heads, and then I remembered that you are supposed to speak your answers and said no.

"Citizenship, sir?"

"United States," I said and waited.

"Ma'am?"

"North Am—" Virginia started and the guard interrupted her while five more guards appeared out of nowhere, as if they had been beamed in, opening her car door.

"I'm going to have to ask you to step out of the car, ma'am. You too, sir," he added, but I was definitely an afterthought, as they watched Virginia unlock her seatbelt and reach into her purse. "Ma'am, put down the purse, please."

"Listen," she said, "I am a member of the Tuscarora Nation, and by the Jay Treaty, you have no right to detain me." It was language she had memorized her entire life, been taught to practice for the eventuality of this very moment that everyone from the reservation hoped and feared they might have at some point in their lives. "I could call members of the Indian Defense League and they would take action so fast that—."

"Ma'am, please hand over the purse or we will have to remove it from your person." One of the officers had drawn a weapon. I grabbed the purse and handed it to the officer out my window and in that moment, my wife was certain that everything she'd ever been told about white people had been true after all, despite our nearly thirty years of marriage.

"What is this all about?" I asked as we were sat down in a small building away from the main immigration offices where we'd been escorted by all six guards.

"Please, sir. We have to ask—is this your wife? Okay, we have to ask your wife some questions. Now, you can remain here, as long as you don't interrupt. Ma'am, are you undergoing treatment for cancer?"

"What! No! Of course not. Why would you ask such a thing?" Virginia looked to me, as if by giving her purse over, I were somehow in on this plot against her.

"Have you been to the doctor's lately?" the officer asked next.

"Why are you asking about my health? Why not his?" I had definitely become one of the conspirators, but I didn't dare speak, not wanting to be escorted out, leaving her alone.

"Ma'am?" he said, clearly waiting for her response.

"No, I'm fine. Listen, if you'll empty out that purse, you will see my enrollment card. You aren't allowed to detain me. As a member of the Haudenosaunee Confederacy, under the Jay Treaty, I have free rights to cross

the border any time I want." She motioned to her purse, on a scanning device in the corner.

"You're sure. You haven't had any medical tests?"

"I'm—Yes!" Virginia said suddenly, her tone changing, like her name had been called in a raffle drawing. "I had a stress test. My heart, they did a bunch of things. Didn't find anything but that I am stressed out."

"Do you have a sheet of paper they gave you when you were done?" Virginia shook her head. "Why didn't you tell us these things when we first asked you? It's not like people forget they've been to the doctor's."

"It was two months ago. Do you remember everything you did two months ago? Would you have remembered if someone asked you purposefully mysterious questions? Do you guys take training in how to be scary to those you can't legally do anything to?"

"Ma'am," the officer said, and sighed. "You might think this little red card from your purse means something," he said, tossing it on the table in front of us, "but it really doesn't. If I thought you were harboring a terrorist in your trunk, I would have you open it or I would open it. You can have your yearly treaty parades, but since September Eleventh, we live in a world full of evildoers. Your days of crossing unobstructed are over. Do you understand?" Virginia nodded, as much as she didn't want to. She stared at the card that had meant so much to her. All of her family members carried them, and admired one another's, like strange baseball cards, in ways that I never see people showing passports off. Sometimes, they told each other stories about stopping border guards cold with their treaty rights. "Now, doctor's name? Place where the tests were performed?" Virginia told them, but her answers were softer, less edged with glass shards. An officer who had run her purse through the scanner gave it back to her and they left us alone.

"Do you think she's still alive?" she said when they'd gone. I told her I didn't know. She said she wanted to get home and go immediately next door and take Copperhead back to our place, and once it happened, she wanted to bury the cat at the edge of her mother's yard, where the woods began.

"Okay," the first officer said, entering the room. "Your story checks out. You're free to go, but you really should get that slip of paper. It would have made your life so much easier," he said, tone entirely different.

"What was this all about?" she asked, as I nudged her to go. Immigration's good moods never lasted very long.

"We picked you up as soon as you entered the bridge, ma'am. We knew one of you was harboring radioactive material and by the time you pulled up to the booth, we knew which one of you it was. Your doctor should have warned you, and given you the proper documentation. You're still going to need it, if you plan to cross into Canada again in the next, oh, six months, to be on the safe side. Red card or not, your presence is going to raise warning flags."

"You're just lucky we didn't have tracking devices for dangerous characters when your sorry asses arrived from Europe. Evildoers got here long before September Eleventh," she said, walking out, leaving me to trail behind.

We drove home in silence and as we pulled in the driveway, she immediately got out and headed for Celeste's door, which was opening by the time I got out and ran over. We stepped in, Celeste saying nothing, just nodding and crying. She led us to the living room where Copperhead was on the floor, almost entirely wrapped in a baby blanket atop a pillow with plastic beneath. Gordon's old TV chair sat a foot or so away, appearing like it had not been used in a long time, almost ornamental in its array of miniature pillows and doilies. The twins were petting the cat's head and she purred for them. Thin pools of blood seeped from the pillow's bottom onto the plastic.

"I took her to the vet yesterday, and they said she has an enormous tumor, somewhere inside. They offered to put her to sleep there, but I asked them how long she might last, and they said no more than two days. I thought she should be at home, where she would be happy. Look, she's glad to see you," Celeste said, and Virginia knelt down, scratching Copperhead between the ears and the cat nuzzled up to meet Virginia's hand. "I'm glad you came, too. I thought we would bury her in the yard."

"Yes, in the yard," Virginia agreed. "There's a nice spot in the garden between the two houses, right near her old house. She should be home, some place where she can trust everything." I went out to Copperhead's house and pulled the blanket we had kept in there for her, looking at the spot my wife envisioned for the cat's grave, wondering if she would ever consider our house her home, or if she has just called it that to make her life with me an easier one. ◤

Frank Matzke

A MOMENT LIVES FOREVER

I'm bedding down for another stretch in the hospital, after hand surgery six. This time might be the key to freedom.

Walking through the doorway reminds me of visits to nursing homes as a teen. I hated it. The residents knew this was the last stop on the train. They all looked miserable or lost, except the late-stage Alzheimer's patients. They were pissed, so I steered clear. Spotting them was easy. Most times, they babbled out a window or sat in a corner rocking, until something triggered anger. Ironically, it was usually a person coming to visit or a nurse trying to bring care. But if their world was altered, oh shit.

I arrive at the ward, and a nurse greets me. She is dressed in typical scrub garb. Sponge Bob, in surgical gear, scurries over her chest wielding a knife, chasing some sea creature and pineapple.

"Hello, are you Julius King? I'm Fran, your charge nurse." I nod my head yes, and she signals me to follow. I wonder what my friends are doing right now. Probably sitting around watching television or running off to a park to enjoy a cookout. We walk a long L-shaped hall, past rows of old men sitting in pajamas, picking at dentures or scratching themselves.

Fran stops and points to a bald man sitting in a chair, watching the crowd ebb and flow through the ward.

"Hello Mr. Killgore. How are you today?"

He looks up and smiles. "I'm well, thank you. I enjoyed breakfast and went to the proctologist. He wanted to ensure I ate enough fiber and didn't have any polyps or an enlarged prostate. I love a garden hose snaked through my bowel."

I shake my head and wince. "I hope they didn't tickle your tonsils." He smiles again.

"Enjoy the rest of your day," Fran says, and we shift into gear again. We arrive at a room near the end of the hall. She looks at me, apology in her eyes. "I'm sorry, this is the last room we had."

"Hey, why you invading my space again?," a voice snarls at us from within. "What's this? I thought you put me in a private room!" A tiny, wrinkled man, rearing up from his bed, slams a book onto a nightstand table, barely missing a Marine hat. His face is deeply pitted, his skin loose over jutting bones. He reminds me of cadavers I've seen. Fran points me to a

bed parallel to his, I plop down, and she disappears. The room is small, only the one table between us. Many times the hospital places terminal patients on any floor, just my luck.

"Hey, boy! Leave the nightstand alone. My stuff is in it, and I hate anyone who touches my things," he rasps.

"Look, old man, stop riding me. We're stuck here, until one of us leaves first, and it ain't going to be me." I smack the table too. He turns toward the window flipping open his book.

Fran barges through the wooden door. "Will you two shut up! We can hear you at the nurses' station. There are other patients here, and they want to heal." She points at the old man, temples throbbing. "You, Talbot Gates, quiet down and relax about a roommate. I don't care if the cancer is eating your lungs.

"Julius King! You will enjoy his company, and boo hoo if your hand hurts. That's common after surgery. Throbbing is silent, so be quiet. Let Talbot read his book. Neither of you wants to get on my bad side. And you, Julius, have an appointment." She beckons and walks out.

I follow. Now I am taking a walk through history, passing patriotic scenes of important battles painted on the ward walls, alongside rows of old men sitting in wheelchairs.

I marvel at them—living ghosts. They all somehow survived the carnage of combat, giving their all for their country, and now society has forgotten them.

Now I have joined their ranks, with a bullet to the back, but I could be their grandchild. I doubt many would recognize me as a fellow veteran.

Their t-shirts shout out their identity: "Vietnam vet" or "WWII vet." A few wear hats: "I just oiled my gun. Want me to show you?" or "Spooky Killed The Cat." At one time they were fierce warriors. Now they battle for their lives, respirators instead of rifles as their weapons of choice.

My goal is now simple—to avoid becoming one of them.

Fran deposits me at the therapist's office and I slump into a wooden chair. The therapist sits at her desk typing. Without looking up, she asks, "How are you today? I just have to finish some notes."

She spins around, peering over her glasses, readying her pen and pad.

"Angry. I don't know how to deal with recovery. I won't ever reach full potential. What good is trying? I'll just end up old and crippled." I thump the chair with my good fist. The therapist jerks the pad closer and scribbles.

"You mean your previous 'full potential.' Now, you've lost a chunk of your brain and have pieces of a new body. Everyone deals with injuries or even death. They are the same in many ways. Recovery, for example, is a freedom from an injury and death is liberation from an ailment. Both meet at the hospital, so they need each other. Do you want a claw or a functional hand? Think long term. We all get older, we all die. In the meantime, we must maximize life. You need to develop the tools to grab hold of your future."

I look at the floor, tapping my foot on the drab burgundy carpet. "Are you telling me to work twice as hard to have an okay hand? I'll never strum a guitar or feel the cool mist of water. Tears fill my eyes. Therapy has been torture, but also offered some hope. She scribbles on the pad and gazes up from it. "Were you a musician before?"

"No."

"Then why worry? Feel the water with your other hand." She leans back in her chair, scrawling over the pad. The scratching becomes unbearable, and I start to get up—but where am I to go?

She stops. "You now must focus on getting out of here with the best tools to use your hand and live life. If sharing with other veterans helps, do it. They might teach you something. Our time is up." I stand and walk out the door.

The ward is now lively, staff humming around, bouncing from room to room with beeping machines or canisters of drugs. All trying to help.

I head back to my room and lie on the bed. Talbot reads his book. He looks up and nods his head. His jowls jiggle. Black bags droop under his eyes. Years of fighting have beaten him hard.

"Hello. Another day in the VA," I say.

"Yup," he wheezes. He coughs and buries his face in a tissue.

"You okay? Looks like you're in here for worse than me."

"Don't be stupid. You don't come here for a party."

A young doctor enters, tall, with thin shoulders and long arms.

"Good day, Mr. Gates. I'm Dr. Malone. Oncology sent me down here to check on you. How are you? Are you experiencing any residuals from the treatment? Many patients do shortly after surgery. Have you been coughing phlegm?"

"Yes."

Malone scribbles on a pad, then says "Let me check your chest tube." He leans down and pulls open the loosely wrapped gauze. Talbot winces and coughs.

"Looks a little irritated. I'll have a nurse clean it."

"If your body was gouged open, wouldn't you be irritated?"

"Yes. Yes, I would be mad, but I would find a way to deal with the residuals of surviving lung cancer. We all die eventually, and it's usually something bad. You have a severe ailment, but it can be beat. Dealing with it in a positive fashion will save you." The doctor folds over the bandages and signs the chart. "Have a good day, Mr. Gates." He is suddenly gone.

Gates notices me looking at him.

"Why did you need surgery?"

I lean over the bed railing. "My surgeon is reconstructing my hand after it curled. Now, I'm doing physical therapy."

"Doesn't it make you mad? I hate it!" His voice crackles, and he hacks phlegm into a cup.

"What am I going to do?" I shrug my shoulders.

"I just stood on a range where I was told, for some military test, and fifty years later my doctor says I have a cancer related to this bomb set off on the range. I feel like I'm the only one left." He bows his head.

"Hey, old man! You were a Marine, so drive on" I hear myself say.

"You're right. Nothing is gonna take this Devil Dog down easy! Damn it! But why did they do this to me? To kill gooks quicker? Those bastards." He pokes his chin up.

"You know what? I think you'll make it after all."

I look at the clock. Therapy time has arrived, and I slip out of bed and walk to the clinic. There is a new bounce in my step. I was helping a fellow vet.

Maybe I do fit in here?

The vacuum of the air conditioning sucks me back into a 747 flying my regiment to Kuwait. Hundreds of men crammed into the belly of the iron beast. Lots of chatter about how the desert would bring searing temperatures or the savage Iraqi Republican Guard. No one knew the mission since it was top secret. The word was that the cavalry was to perform "training exercises" just kilometers away from a brigade of Iraqi soldiers. But in our collective gut we knew that Kuwait would mean more than exercises. The flight attendants tried quelling our fears with cookies and coffee.

The goodies didn't work on me. I only knew I was to drop into a combat theater where soldiers would die. I wanted to live beyond twenty-one. I'll never forget the words of my squad leader: "Time passes, but a moment lives forever." I never knew exactly what he meant—I guess that we all die eventually, but one moment can define a soldier. In Kuwait I would have my moment.

Moans and thumps jar me back to the present, and I find myself standing in front of the Occupational Therapy Clinic. Gadgets, patients, and therapists clutter the room. A tall brunette in a white coat looks up from a patient. "Julius King? Sit there." She points to a wooden chair positioned next to a thick wooden table. An older man sits across the table. She places a chessboard between us, positions the oversized pieces on the board, click, click, click.

"King, this is Mr. Killgore. You two are going to help each other in therapy today. You both enjoy chess and need therapy. Using your affected hands to move the pieces, play." She darts away.

I peer up from the board. "How ya doing today? Meet any new proctologists?"

He chuckles. "God forbid. I still think an IRS audit would have been easier." He points to the board.

"You're white, kid, so move first." He motions my move, using his curled hand. My sluggish hand extends to the knight. I grit my teeth. Somehow the first three fingers open and latch onto the helmet. The piece jerks up and shifts to the third row.

The old man glances up over his silver-rimmed glasses. His bald forehead shines under the beaming lights. "Hey, kid, you look a mite young to be here. Did they get you treatment under your daddy?"

"No, sir, I was in the Gulf War. You know, the one we won in '91."

He smiles big. "Welcome home. I know you didn't enjoy your time in the sand. I served in Korea. I hated the cold winters and red-hot summers. I presume it was no different for you except the snow was sand." His hand eases over to a pawn moving to the middle of the board, blocking my pawn. My lead hand jerks upward, then lurches forward. It grabs a bishop and scrapes it across the board. I check his king.

"Thank you." He captures my bishop with a knight.

"It was a good thought, but I got your bishop. Chess is a Tango. You can't rush it, or you'll lose step. Think of it this way, you're big, sexy, and you own the floor. Move with flow, commanding every step. Command every move, and success will follow. Recovering your hand is the same way. You just gotta follow the steps." He chuckles and his shoulders jiggle.

"Check." I grin.

"You're easing into this game, just like you'll ease into the routine here. 'The VA is the only way.' Most times the people working here try to help, but they can't because the machine is clogged, so we help each other. Remember we never leave one behind." A husky laugh erupts from his belly. He eases back in his chair. "Oh, mate." He smiles.

The brunette returns. "Good game, you two. Same time and place tomorrow, rematch."

"I look forward to it, old-timer." I wave and walk out the door.

Strolling down the hall, I remember long ago chess games with my grandfather or a friend. I could flow through the game and mate my opponent with ease. Now I struggle to lift a piece from the board. I return to my therapist's office, and as usual she is typing. I sit in the hard chair across the room. The office is loaded with books and mementos. She spins around facing me. "What's new?"

"Well, this is one tough place to feel better about yourself. My roommate is a bitter old man who's dying of lung cancer, and I've been paired up with a man to play chess with in Occupational Therapy."

She perks up. "You should be happy. You aren't dying, and chess is a good game for you to exercise your brain and hand."

"Yes, but all of these negative vibes just get to a person." I shift in my seat, feeling suddenly queasy.

"King, look at me." Her eyes remain steady on mine. "You say you don't fit in, but you do because you served in the military. So what, the rest of the vets are older. Find your place and spin it to an advantage. Be happy you're young and learn from it."

"Learn what?"

"You have your whole life ahead, and you have to create something bigger than you. Time's up." She spins back toward her monitor. I stand and walk through the doorway.

I find myself on the smoking deck sitting next to a pond, the one Talbot said he wished he could still visit.

A man walks toward the bench to my right under a pine branch, igniting a cigarette. Pepper gray bristles extend from his chin down onto his chest. Deep black eyes signal life has been hard.

"How are you?" I smile exhaling a cloud of smoke.

"Better, now." His voice echoes a false confidence.

"You a new patient? My name's King."

"I'm Fool."

"You are looking down; someone steal your dog?"

"Hah! No, he died under a bridge. What are you here for?"

"Hand rehab." I say pointing to my left hand.

"Good luck. You look kind of young to be here."

"I know, and I feel it."

"No sweat, cat. You'll slip in with the rest of us. We're an ironclad brotherhood." He bobs his head.

"Your dog died under a bridge?"

"Yeah, we lived under the bridge. I hated the world, my life, and the government for a long time. I had a good case of the The 'Nam nightmares. My advice to you is—don't forget you ain't alone, and the bullets didn't kill you."

"How did you end up under a bridge?"

"I returned home whacked out on dope, seeing the ghosts of bodies I zapped in-country. I tried burying them there. Shit, I was an altar boy, and they gave me a rifle."

His face drooped, and his shoulders slumped from the load he had borne for so long.

"Do you feel better?"

"Now, yes. Who wouldn't? I slept on cold dirt for fifteen years."

I look at him, wondering how he arrived alive. Did his mind spiral downward with addiction, alcoholism, or mental illness? Did it disappear in Vietnam, and the VA resuscitated it?

"Fifteen years?"

"Until Operation Stand-Down found me."

"What is that?" I lean forward, take a drag and allow the smoke to swirl down my throat. It tingles my lungs as the cyanide hits. I don't care, since the hospital is handy. Fool breathes out a cloud of smoke. His fingernails are cracked and stained yellow. His smile reveals crooked, evil-looking teeth.

"I'll never forget. I was celebrating my fifteenth year on the street, with stale bread and bad meat. Rain pelted the ground, rat-a-tat, tat. The drops in my eyes brought back visions of Khe Sahn. Cold water streamed over my boots. I could feel icy spikes jabbing at my flesh. I was close to breaking. My dead dog howled at the sunset. He was the only one who stuck with me when my country forgot to welcome me back."

"Why are you here now?"

"A squad of grumpy old men swooped into my mansion down below. It was weird, man. They shout, 'You Fool?' I said, 'Who wants to know?' 'Squad One, VFW post 189.' One of my buddies told them I was the troll under the bridge."

"So what did they do?"

"Led me to a huge canvas tent to sign papers. Ten days later I got into a program. I couldn't believe it because they had denied me in the eighties.

I later found out the VFW organizes these patrols searching out veterans in need. A group of old VFW dudes march through towns looking for homeless, and they sweep through hobo squats like they're in the Normandy landing. They had scoured the area and were making one last stop, mine. Now I'm off the street and getting help for my nightmares. Up here the sun washes them out, so now I attend meetings and see a therapist. Up here I don't have to drown out the faces, but just know they're part of me."

Here I am, sitting with a guy who survived a holocaust, and he's spilling intimate details of his life like I was a brother. I can't believe he sees me as an equal. I guess I must look like I fit in.

He stands, snuffs out his butt, and steps away.

I jump up. "How did you get the name Fool?"

"I enlisted to be a clerk, but they didn't promise where I would be stationed."

Fool has welcomed me to the brotherhood and reminded me that I can create my own destiny, with a lot of help from others. I would be the fool, not to take advantage. I survived for a reason and I know it wasn't just to rob the world of oxygen.

I walk back toward the entrance and spotted Nurse Fran smoking a cigarette.

I stop and grin. "Ironic isn't it. You care for the sick and dying, especially the ones with lung cancer, and you smoke. Why is that so?" She snorts. "You deal with the patients I have. It's enough to drive a nurse mad."

I pop a smoke between my lips and spark it up. "Speaking of madness, how is sir Talbot?"

"He's dead."

"What happened?" My shoulders drop.

"He had an attack, and died a little while ago in the oncology clinic. I guess you were right—he left first." ◤

Bruce Sweet

BOUND EAST

off into the windblown gun-metal morning
out from behind the dead tank with its 90 mm
gun hung down exhausted making *love* all night
no more spew from the 30-caliber machine gun
lost in a hatch-locked hill of cooling steel and
I don't know if I'm escaping or running away
to wherever I'm supposed to be reporting for
further orders lost my left boot when I stop
to see where I dropped it a bullet cuts in half
my cartridge belt .45 pistol canteen fly away
from my waist looks like two vultures frightened by
a giant condor got to keep running toward the light
sock-boot sock-boot sss- that must be the sun
east where the field hospital's halfway underground
ah burning in my side belt blown away
reach down feel a gob of ooze keep left hand
on the wound hold in blood sand whips across
my legs chest hair ww- where helmet used to be
feels like a thou- a thousand starving locusts
feeding on what's left of my uniform swirls
of dust sand funnel up legs for a second
see my foot sock prints so must be here still here
sock-boot sock- ah I feel good good keep
on running toward sun know know I can make-
make something up when up when I get get there
make something up when get there get there
make something up when when I—

Christopher Kennedy

from THE UNTRUE TALES OF CASSIMER NEUBACHER

Cassimer Neubacher encountered Satan on the way to the market. Satan asked him if he would like to trade his soul for something more valuable. Cassimer looked at the man in the red suit and noticed two pointy horns growing out of the top of his head. Like what? Cassimer asked him. Like money, or beautiful women, or power, Satan replied. The usual, he added a bit derisively. Cassimer, who was pulling a small cart to fill with groceries, pointed to the cart. Fill this with gold, he said, and you can have my soul. Satan waved his hand, a bit too theatrically Cassimer thought, and in the cart appeared several bags of gold coins. Cassimer looked at the bags of gold. He liked what he saw, and he handed over his soul to Satan. Satan looked at Cassimer's soul. It was filthy and tattered. Wait a minute, he said to Cassimer, this soul isn't worth a single penny. It's worse than an old rag. Cassimer started to walk away, pulling his cart of gold. Satan reached out and grabbed Cassimer by the arm. Cassimer yanked his arm away and turned to face Satan. Satan didn't show it, but he was afraid of the look in Cassimer's eyes that glowed like two miniature versions of hell. We have a deal, Cassimer said. And if I know anything about you and your kind, it's that you're bound to the law like anyone else. You have my soul; I have your gold. Let God decide if a fair bargain was struck. Satan couldn't argue with Cassimer's logic. He asked God to bear witness, and God ruled in Cassimer's favor. You've been outsmarted by a man with a worthless soul, He said to Satan; then He vanished and hasn't been heard from since. ▧

Rasputin's Folly

At night, when it's snowing, horses clomp down an alleyway, pulling a carriage crammed with exiled dignitaries. I walk to the window to see if God is dead. If he is, he's turning in his grave, which begs the question, *Can God dig a grave big enough for him to fit?*

I try to remember The Alamo, but I'm afraid of history. Those who are about to die need more than my salute. Mad Monk, were you sent by God to heal Aleksandra's son? More likely you were a source of unreliable information, yet somehow I still find your beard intriguing. But it did end badly, didn't it? The peasants, all jacked up on philosophy, ready to trade one form of oppression for another. And those novels, some of them over a thousand pages! I'm tired just thinking about war. Who has time for peace?

That doesn't mean I've given up on America. I'm a sucker for red, white, and blue. And I've got stars in my eyes, an eagle in my heart. You were considered a wolf in sheep's clothing. What can you tell me about the wolves dressed as wolves? Undress them and nothing changes. And is there some way to explain to the lambs that innocent blood won't sanctify? Rasputin, my friend, I'd hide them away, but they're all in line for the slaughter. ◄

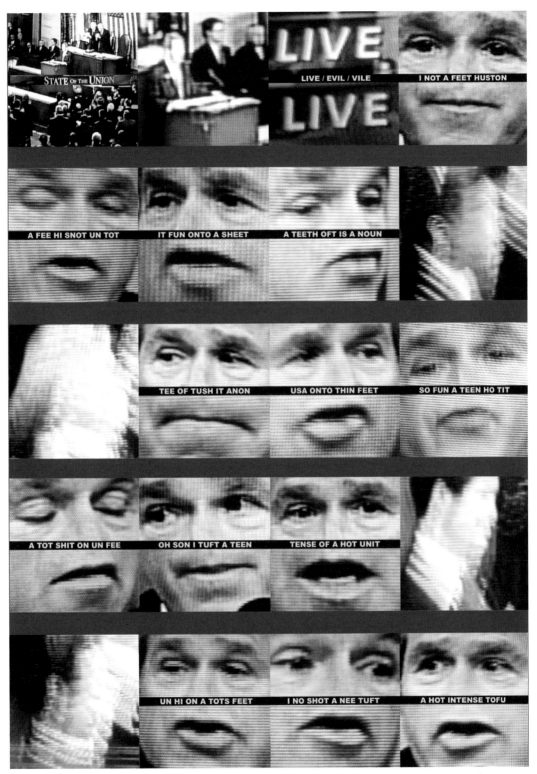

SCOTT MCCARNEY, *State of the Union: Live/Evil/Vile,* ink jet prints stab bound in plastic sheeting with duct tape, 7"x8", 2003

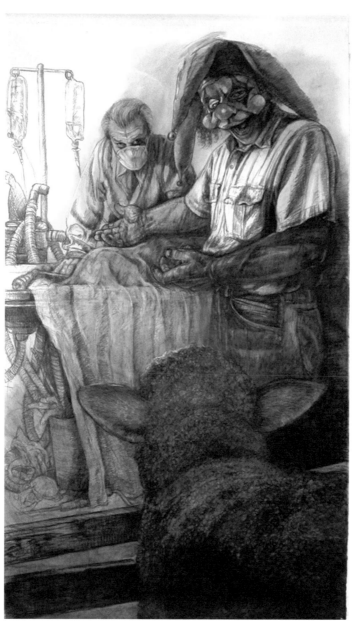

DONALEE PEDEN-WESLEY, *The Practice of Contemporary Medicine,* watercolor and charcoal, 43"x76", 2005

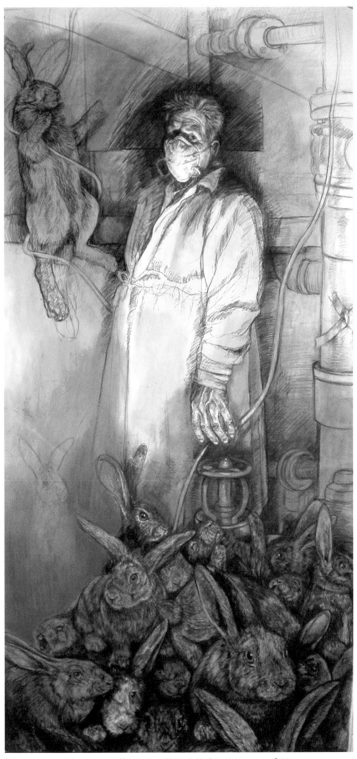

DONALEE PEDEN-WESLEY, *Mr. Nick's House of Fur,*
watercolor and charcoal, 43"x86", 2005

Maureen Foster, *Games of Cat and Mouse,* handkerchief, muslin, and lace, 17"x14", 2006

Leah Zazulyer

IF YOU COULD LICK MY HEART IT WOULD POISON YOU*
(A MANUSCRIPT IN PROGRESS)

When I began interviewing Holocaust survivors who live in my area of New York State, I had no intention of doing additional writing about their experiences as interviewees or mine as an interviewer. The interviews over time were of three types: People who had come from the region of Belarus from which my parents had emigrated prior to World War I; friends who had been hidden children in France, or survived Dachau, or *Reichskristallnacht;* and finally interviews of Holocaust survivors in WWII, done under the auspices of the Spielberg Visual History Foundation (SVHF). Initially I simply felt it was my moral obligation to do these, would learn from them, and could cope with the challenges.

Interviewers for the SVHF were carefully selected. The wide-ranging training, rigorous coding of data, and standardized videographic procedures were as scientific as such things can be. About 52,000 were done throughout the world in multiple languages and are now being disseminated.

However, I began to see each survivor's story as unique in terms of what psychology calls "the narrative of self," or the sociologist Goffman calls "the presentation of self in everyday life." It is true that on one level all the stories were similar: Life was pretty good before the war, hell during it, and bearable or better afterward. I came to realize that each survivor had a unique theme or pattern to how he or she presented his or her story. Usually it was a small incident, phrase, or idea that jumped out at me and seemed to be the very essence of their own psychic drama. Often it was symbolic or metaphoric. Sometimes they were aware of it; other times not. That is how I came to ask every interviewee if I might someday write about them. Each said yes without hesitation, often with the typical survivor's strong need to tell and retell their tale.

I immediately went home and tried to capture in THEIR voice, cadence, grammar, emphasis, what that unique phenomenological sensibility was in the case of each interviewee. I fabricated nothing. Slight editing came later. The form that seemed natural to the task was predominately the narrative monologue. Later I began to develop a second part to the manuscript which contained poems about MY experience of being an interviewer.

People who have done extensive interviews with survivors of one sort or another are often warned to "do something nice for yourself" after each harrowing experience in order to sustain one's own mental health. I tried lunch, shopping, desserts, travel, visiting friends, talking with my own family—but ultimately despite some thinkers and writers having questioned the possibility of art after horror, art after horror was exactly what I felt the interviewees deserved and this interviewer craved. ≋

*Quotation from a survivor interviewed by French film maker Claude Lanzmann in the eight-hour film *Shoah*.

Leah Zazulyer

PART OF THE ACT

I
Every Thursday afternoon Papa
took me to the Parisian circus
in my white fur coat and hat.
We had front row seats of course.
I looked like Shirley Temple
and even at four knew it, so the circus
people always invited me to be
part of their act...
At family weddings I danced on the tables.
Only Mama tried to discipline me,
but I knew how to defeat her
by having tantrums on the best boulevards,
even rolling in the gutter in my white fur.

In 1940 my Aunt and I were sent to our
newly purchased summer house in Iteuil.
I thought it was because my sister was
about to be born and was very jealous.
About the roundups of Jewish children
over six being sent to their deaths
sixty to a cattle car I knew nothing.

As soon as my sister was born my parents
came to the village too. Mostly I had to
help Mama with the baby while Papa worked
as a farm hand by day and at night
made friends with the village mayor and
police chief who promised to warn him
before the Germans did a roundup.
You see we were still Jews then.

II
Soon I and my unbearable sister
were sent to grandparents in the free zone.
We traveled with a village girl disguised
as a nun, who had obtained false papers
for us after father discovered she was
the secret lover of a German soldier.

In Joncel I was awakened by the shouts and curses
of soldiers who'd come for my beloved Grandpère.
I shall never forget the despair in his eyes,
the fear in Grandmère's. The whole next day
she dug her garden in silence.
As if on cue, I too said nothing.

Soon my parents risked their lives to come
arrange our return to the village. For two weeks
Papa coached me in my new role as a Christian
with a false name and papers: Forget the prayers
and other things I've taught you up to this sixth year
of your life, he said. Understand that if you fail
you will be sent to a "children's camp" forever!
In my best Shirley Temple voice, eyes twinkling, I said
Yes, Papa, yes, I promise I will act as you say.
But when Papa paid a Christian woman to escort us, she
carried my sister, and I had to lug our suitcase.

How restrained our goodbyes. I knew I must act bravely,
but down on the street I discovered I still
wore my Jewish medal around my neck
and insisted on running back, to give it to Papa
who burst into such sobs, I dared not cry.

Oh when that German came into our coachette!
I thought he was the same soldier who had taken
Grandpère away, didn't he have the same shiny
black boots, helmet, and harsh voice?
So what did I do? Flirt, of course, smile after smile
after smile until he was so befuddled he hardly looked
at the false papers. I knew exactly what I was doing,
just like at the circus.

III
Back in the village the mayor called a meeting
in front of the church...and finally a woman known as
Tante Claire, a war widow, a farm wife with children and an
elderly mother, stepped forward saying she could not leave us
standing in the street, and would take us home...

Sundays after church Tante Claire took us to the duck pond
on an estate. While we played she delivered a basket of
food to the house. Afterward she'd point our eyes up to
the roof line to see the birds. Though we never knew it,
our parents were hidden there behind a secret door,
and in this way glimpsed us each week of the war.

What I did know is how much I loved Tante Claire.
When peace came the reunion with our parents was horrible.
My sister screamed 'til Tante Claire took her on her lap.
But I had no lap to hide in and no place to run to!
All I could do was pretend, act happy.

IV

Back in Paris I completed school, my Father re-established
his business, but my mother took no joy in parenting
nor I in being her child. She became furious if
I even spoke of Tante Claire. I was forbidden to write,
our so-called summer house was sold, and I was never
allowed to go to Iteuil again...

Later I went to finishing school in Switzerland, then to
America where I met my husband on a blind date at twenty.

Shortly after my marriage I at last made contact
with my beloved Tante Claire; I visited, sent money,
bought them a television and a refrigerator;
that's whose picture is on my mantle.
But I hid all this from my Mother.
Eventually I took my own grown children to the village
where they realized what a celebrity their mother is
but I forbid them to speak of it to their Grandmother.

In 1975 I arranged for Tante Claire to receive the French
Bronze Medal, which I personally pinned on her on TV
In 1976 the Israeli Medal of Merit.
I brought her daughter to the Holocaust Museum where
her mother's name is enshrined amongst the Righteous Gentiles.
I speak of her at all the Hidden Child Conferences...

All this helps me, except that my sister, whom I'd come to love,
got cancer, and no matter how hard I pretended it wasn't true,
no matter how cheerfully I acted, she died.

Even today, as old as I am, my mother doesn't know my secret...
So tell me does my hair look right, is this a good color,
shall I unbutton my top button or is it too sexy,
will the videographer shoot my whole body? Too bad,
I have really great legs.

Leah Zazulyer

Liberated

The Americans were coming the Germans were going and we half-dead Jews left in Buchenwald were forced to flee with them. A death march is you walk 'til you drop from hunger, sickness, exhaustion, frozen bare feet, or Nazi whips and bullets. I think they wanted to destroy any living proof of what they'd done.

I escaped during a bombing, ran like a crazy person into the countryside, and finally broke into a barn desperate to sleep.

The farmer, a German, but an ordinary man, comes in finds me in his straw and says I gotta leave or he'll have to report me. So what did I do, pick up a rake and clop him hard on his *kop,* and again hard, harder than I thought I could. I don't know maybe even I killed him; he was sleeping when I stole his clothes and fled.

I didn't know where I was or where I should go, all I knew was food, sleep, and keep moving. I was like *meshugge*! I thought for sure I was the only Jew left in the world. A woman gave me milk and bread; I didn't know if I should eat; I was afraid maybe she'd poisoned it. Another man said you see I have thirteen buildings here—I remember he said thirteen—hide but don't tell me where. I didn't know, maybe it was a setup and I ran again. I kept walking, walking maybe in circles. Finally I fell asleep in another barn; I don't even know how I went in there.

All of a sudden morning, three tough-looking Hitler Youth barge in yelling am I a Jew? So in German I yell and curse back get out or I'll report YOU!

I don't know I still don't understand it; I thought I was the only Jew left in the world. The only Jew! But I had to talk German to hide my Jewishness, kill like a Nazi to survive as a Jew. ▨

Leah Zazulyer

TEACHER

I was the only girl and older than
my three brothers, whom I often had
to take care of—besides, girls in those days
and those *shtetls* mostly didn't go to school,
even though my father was a teacher, a scholar.

Nor did we really have toys, so we used anything
and everything to play with, and one day climbing
on a dung heap, near a soldiers' garrison,
my littlest brother found a ball, with a clip on top.
It was so heavy he brought it to me, but I had
never seen anything like it before.

Puzzled, excited, ashamed of my ignorance
I carried the mysterious treasure into
the room of our house where my father taught—
my learned Father who knew everything, but
at first scowled at me for interrupting him
and tried to send me away, though I persisted
even then hungry for knowledge, and stubborn.
Look, look I said, convinced it was a great something.

Look he did, turned pale, and with trembling hands
dropped his beloved Torah to the ground, and without saying
a word to his pupils, walked toward me, took the heavy ball
barely contained in my outstretched hands,
carried it outside with utmost care, set it down very carefully,
pulled me away from it, hastily dug a hole with his
bare hands, ritually washed so as to touch sacred books—
and then buried it, as I wept bitterly in protest,
thinking he was punishing me for interrupting his lesson
though I was also confused, since I at least knew old Torahs were
always buried with the ritual care afforded a dead person....

Now I teach school too, and old as I am know all
about interruptions, which I do not like or tolerate
anymore than he did, especially if I am teaching
the Yiddish language or Jewish history and lore—
But I also know about meteors, and land mines.

That's why I have more patience than some
teachers, because you never know with children
who interrupt, ask too many questions, or learn by arguing,
whether you are rescuing them from an explosive, imploding life
or they are just trying to grasp—when to fear, whom to trust,
how to learn, what they understand or don't,
and where to read the answer words, such as they are.

DEBORAH ZLOTSKY, *Twindle,* powdered graphite on denril, 12"x9", 2006-7

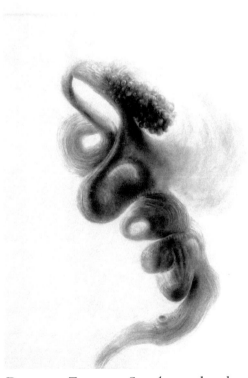

DEBORAH ZLOTSKY, *Smool,* powdered graphite on paper, 21"x15", 2006-7

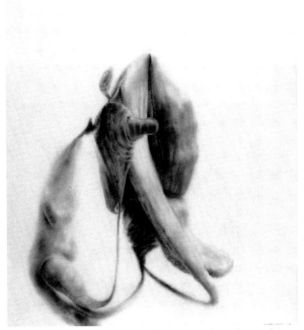

DEBORAH ZLOTSKY, *Vorlorn,* powdered graphite
on paper, 17"x14", 2006-7

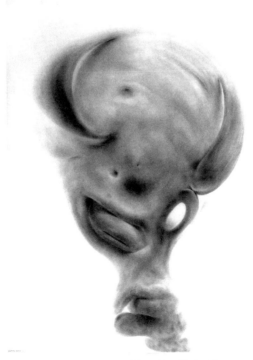

DEBORAH ZLOTSKY, *Evening Primblurter,*
powdered graphite on denril, 10"x8", 2006-7

Henry Allen

THE GREATEST GENERATION

It's 1946. You're sailing back from the war,
back from Germany in the old Atlantic sunlight,
standing by a lifeboat in your lumpy uniform,
smoking a cigarette and feeling unreal
as if somehow you're taking your own picture.
No war, anymore.
Will you have your tool-and-die job anymore?
Are you in love with your girlfriend's sister anymore?
(Yes.) Everything is "anymore."

Then New York, crazy and transparent,
like fingerprints on the bus station door:
"You probably don't like to talk about it,"
some guy says. What a jerk. But he's right.
How hard you worked to stay alive
and then you did, but it was just an accident.
On the bus, smoking a cigarette,
you think about all the letters you didn't get
from your girlfriend's sister.
Sister. Missed her. Never kissed her.
Then you're home and it's like this:
Your girlfriend's off getting more coffee and you say,
"Thanks, Sis, for all the letters."
"Twice," she says, outraged. "I wrote you twice."
"Everything's the same," you say.
"It was never the same," she says.
Okay. But it is. What's different is everything
feels "the same," and it never used to.
The war gets to be like a secret you forgot,
nothing to hide and nothing to tell.

You smoke your cigarettes. Things are swell.
You get your job back. You marry your girlfriend.
Then Sis makes a pass at you.
You act like it never happened. She gets sore,
won't talk to you anymore.
It's like the war—being alive is just an accident,
but still, you work so hard to do things well.

OTSEGO COUNTY WOMAN

Then, time to die. You stabbed the cabin fire
and stepped into the night to hear the sparks
sing toward the flummoxed stars, a dying choir.
You couldn't see the light for all the darks—
the ghostly woodpile, shrinking snow, the vault
of apathetic heaven—breathy-cold,
soon frog-peep warm, spring coming by default
after the failure of the ice to hold.
That day you'd set the hogs and chickens free,
loaded the gun. That night aimed at your chest.
You'd practiced it with "Gray's Anatomy"
for weeks now, aimed just right of your left breast.
The hogs would eat you—that was not rehearsed—
but next day our luck held—I found you first.

Vreeland's Last Words

Diana Vreeland, editor of *Vogue,*
gave us a whole new thought-form when she said:
"Pink is the navy blue of India."
This form, like calculus, yields endless truths.
Death is the secret life of Mexico,
or Kafka was the Buffalo Bill of Prague,
that kind of thing. The possibilities!
Were more found in her famous red
apartment where she died—and thrown away?
Lost codex of Park Avenue! I hear
her pungent baritone—pronouncements, say,
that Dali was the Henry Ford of Spain,
or posture the ballet of Vietnam.
Did fragments hover in her deathbed brain?
I hear her rasping, "Quick, quick, write this down,
yes, laughter is the screaming of Japan
and reason is the fairy tale of France,
or Germany, and newspapers the dreams
of someplace, where...quick...darkness is the light."

Randy Cohen

A Little Privacy

ANN IS IN HER EARLY FORTIES. SHE IS IN THE BATHROOM OF HER APARTMENT. IT IS MORNING.

ANN

When I got back from walking Vixen and Diana, Steven was gone, so I could brush my teeth properly for a change. I have excellent teeth. Despite our involvement. Of course, now it's obvious that it was an incredibly dangerous affair. You never see it at the time. Stupid stupid me! Just for some man, I risked the sort of gum problems a woman my age does not need. Morning after morning, rushing through my oral hygiene routine, always on edge, because at any moment he might burst into the bathroom. Not every morning, but the two or three mornings a week he stayed over, which any dentist will tell you undermines the work of the whole week. Because he forgot something. A magazine. A sock. To talk. Talk? Does he understand nothing of periodontal disease?

I speak of Steven in the past tense because, in my experience, a fight like the one we had is final. "You have to understand, we're at different stages in our lives," he said. "Yes," I said, "I'm still at the stage of having a job, which I need to get to instead of standing here talking." "Auditioning is my job," he said, "or part of it. The hardest part." The only part, it seems to me. He wants me to admire his courage. When he was a lawyer, the hardest part was deciding which paralegal to seduce. Audition. He probably just wandered over to his first ex-wife's. Not that I'm jealous; he just wanted someone else to make the coffee.

So at last, after a turbulent year, there's time for adequate dental care. Pre-rinse with Plax, brush with Ora-Jet, then the Water Pic, then floss. Unwaxed. Patience and Prudence love the sound of the Ora-Jet. If I'd open the door, they'd sit on the hamper, purring and cleaning their fur, and watching me, which does not bother me at all. I remind myself: cats have a brain the size of a walnut. And it's not like I was in the bathtub, naked.

Never again will I let a man watch me gargle and spit. Why did he want to? When we first started going out, I wouldn't let Steven see me eat. Not easy. It's regarded as sociable, eating together. Putting things into your body, taking things out of your body—might as well ask him in to watch me have a pee. And don't think he wouldn't love that. That's why he was at me to take the home pregnancy test. You know: semi-transparent cup, a little wand. Things change color. If he's such an enthusiast for female urination, why wasn't he more willing to walk the dogs?

All I ask for is a little privacy. That's what civilization is—not behaving better, just having the good taste to do the appalling things behind closed doors. To me, the triumph of architecture is not the Cathedral at Chartres, not Mies van der Rohe—good lord! Let's face it: any building over 10 stories tall is insulting to women. No. True glory came in the seventeenth century with the corridor. Before that, each room connected directly to another. People blundering through to get anyplace at all. Imagine! And yet some men refuse to take advantage of what society provides—doors that close!

My father taught me the distinction between public and private behavior. In public, one shows restraint. In private—he never said much about that, regarding it as a subject for, well, privacy. But I'm sure if he had, he would have considered the moving of fluids and solids in and out of one's body as firmly in the realm of the private. I've always been slightly alienated from my body, one of my best qualities. When I was in college, my menstrual cycle never fell into phase with the other women in the dorm. I have too much character. The inner workings of one's body ought not be subject to the whims of the mob. It should be governed by a specialist whose professional ethics forbid him discussing it with anyone. A board-certified obstetrician, not a chemistry set from the Thrifty Drug, which anyone could see you buying, and imagine you using! I consider it impertinent for a stranger to envision me in a crouch. I'll call Dr. Millstein as soon as I get to the office.

FADE OUT.

FADE UP THAT EVENING.

I put Steven out of my head the minute I got to work. Too busy. Half a dozen research queries in my basket—Properties of birch affecting its structural applications? Recent designs by Frenchman who does those lovely things with indigenous stone? Patents covering corrugated cardboard furniture? Yes, well there's always one. Allie was in and busy. Working here does mean valuable professional experience for these kids, but college credit for Xeroxing eight hours a day? She was copying articles for the file on smart buildings—the windows darken on sunny days; the heater responds to a chill; the lights turn on when you enter a room. I said, "It's impertinent of a building to make assumptions about my desires." Rather like Steven, really. She says, "Have you gotten an MP3 player yet, Ann, or are you sticking with records?" I say, "I don't see what that's got to do with anything." And then I had to run to the ladies room to cry, which Charlene thought was hormones, and LaTania thought was too much violence on television, and Allie thought was having three packets of Sweet'n'Low in my coffee, and I thought was not an appropriate subject for group conjecture.

Charlene insisted on escorting me. She took my arm and guided me past rows of staring draftsmen, the whole time whispering, "Steven is such a bastard! Such a bastard!" Well yes. But there's a time and place. When we got there, six or seven secretaries and drafting assistants were milling around the sink. I thought: had Steven slept with all of them? Where did he find the time? Charlene shooed everyone out and left me to vomit in private.

At times like these I'm grateful to be an executive. I have my perqs. I can make hiring decisions, as soon as they increase the research library budget enough for me to have an assistant. Or today, I don't have to ask permission; I simply take a long lunch hour. Except just as I was putting on my coat, Carter—the one whose white shirts just match his skin—came in with a query. Urgent. Something about flying buttresses in Notre Dame, which seemed odd because he's working on window treatments for the Price Buster renovation. But because it was pressing, and in the interest of inter-department cooperation, I phoned the doctor to shift my appointment, despite an obstinate receptionist who couldn't comprehend the unpredictable nature of an executive's schedule.

The other women in Dr. Millstein's waiting room were so young. Some had men with them. Why? It's not a date. It's a degrading necessity. They let them into delivery rooms now. When did people stop seeing this as impudence and start seeing it as caring? It's in bad taste to look overly cheerful in a medical waiting room. It's disrespectful of other people's remorse.

I do think when a person has a one-fifteen appointment, that person should be seen by one-thirty at the latest, even when it is a rescheduled eleven o'clock appointment, not at one-forty-five without even an apology. Through it all, Millstein remained invisible. Lucky him. A nurse handed me a plastic cup and put me in a private room. There is near-universal interest in my urine. Steven will be heartsick that he missed it. From an architectural standpoint, there was little to say for the room. "A waste-management habitat" would be Carter's designation. Allie would call it "a gyno-aquatic environment, deconstructing the doctor-patient relationship," which means they don't bother covering up the electric wires and heating ducts. She's very young. I'll bet thousands of women passed through there, filling bottles. I got the job done rather efficiently once I stopped crying.

When I got back to the office, Carter handed me a dozen roses. It seems my buttress research was unrelated to the Price Buster job, but it helped him win a five-hundred-dollar bet. Six dollar a dozen, short-stemmed deli roses. I called him a flying butthole. He chuckled. I ran into the bathroom. I am certain that, had I been a boy, my father would have taught me to curse more effectively.

On the way home, I stopped at the liquor store. Then I thought I shouldn't, just in case. Then I figured, what the hell. Ramone said, *"Como esta,* Annie? You have a little weight! Curves! Muy Bueno." "You know, Ramone," I said, "I don't ask for much. I don't ask for lots of empty cartons, or to choose a dozen different bottles and still get the full-case discount. But I do think if you are going to live in our country, you could learn English." I wasn't actually crying. Ramone hailed a cab and put me in it. Then I cried.

I knew what I'd see when I got home, the blinking red light of the answering machine, another of Steven's pathetic pleas. But I didn't, which doesn't prove anything. Pru has a habit of napping on the machine. Because it's the only

warm place in this stupid apartment, because the damn super never sends up enough heat. I tip him thirty-five dollars every Christmas! Not that I get that many calls. So I'm incredibly responsive to anyone who phones me. I once got an HBO telemarketer to tell me the entire plot of that Steven Seagal movie where he kills a lot of guys on a boat. And I'd already seen it. With some man who utterly misrepresented himself in a personal ad. On pay-per-view. I never rent videos. Strangers have touched them. I cooked him tortellini with fresh pesto. It turned out he was married. The HBO guy is married, too. We went out for eight weeks. Just a fun thing. I knew he'd never leave his wife.

Just to be certain, I played back the tape. Nothing.

FADE OUT.

FADE UP ON ANN EARLY IN THE MORNING A FEW WEEKS LATER.

The thing to do is get on with it. If Steven and I get back together, fine. If not, fine. If I get involved with another man, fine. If I don't, fine. I won't put my life on hold. I do things, go places. I take courses. That's why I'm such a good cook, because of my Quick Italian Cooking class at the Apple Skills Exchange. Not a single man in it. Not a single straight man. What was I thinking?

Last night was the Neighborhood Novelists series at the library. I still run it despite Carol Flanner's Machiavellian intrigues. I arrived late, a tactical error. Carol had set out the chairs in a semi-circle around the card table we use in lieu of a podium. I made her rearrange them in nice orderly rows.

This neighborhood has a rich literary tradition. According to Carol, you can't walk down the street without bumping into some famous novelist. How they finish their novels is a mystery to me; so many of them spend their afternoons in bed with Carol. According to Carol. For me, this series is a cultural event, not a dating opportunity. I never met a single man there. Not a single single man. I met some interesting authors, though. It's why one lives in New York.

And I met Steven. Just last year. He wasn't attending a reading. Popped in for the men's room. I went in to mop up, part of my arrangement with the library, and there he was. It gave me a start. I said, "I thought you were one of our neighborhood narcotics users." He said, "Isn't this the men's room?" I said, "Yes. The women shoot up next door. But we're not prudish here." He invited me along to a party. I had a really nice time. You never know.

Actually, you nearly always know, as subsequent events tend to prove.

I said hello to Laurel Maguire, who was reading that night, and asked her if there was anything particular she wanted me to say when I introduced her. She said, "That we used to date. That you dumped me." I said, "They weren't dates, Laurel. And it was a long time ago." I think she'd been drinking. Many of my writers do. Nerves. Speaking in front of a group.

I put the crowd at fifteen. Larger than usual. It is nice for the older folks to have a night out. I thanked everyone for coming and said flattering things about Laurel's new novel, which I hadn't read. Writers never notice as long as you lay it on thick. Then Laurel began, and I went downstairs to the pay phone. No messages. I think Steven hooked my machine up all wrong. He's so passive-aggressive. There's a course in home electronics at the Learning Annex. All those women learning to set their VCRs to record when they're out. If they went out all that much, they wouldn't be in some stupid class at the Learning Annex.

I wonder if Dr. Millstein realizes the operators at his service are so brusque.

FADE OUT.

FADE UP ON ANN. NIGHT. A FEW DAYS LATER.

Charlene lives in a loft on Spring Street. She doesn't have rooms; she has areas. Lola took my coat, and Violet offered me a glass of wine—Charlene's kids from her first marriage. "She can't have wine," Charlene said. "Is she a drunk?" asked Violet. "No, silly, she's pregnant." "She doesn't look it," said Violet. "Well, she is." "Would you show us?" Lola asked. Charlene said, "You know Annie's shy. Go play." The girls ran off. "Sylvia's running late;

I hope you're not starving." I said, "I'm not starving, and I'm not shy." "Oh, Annie," Charlene said, "you're so funny."

Sylvia got home and kissed the kids and kissed Charlene, really kissed her. "Gross!" said Violet, "P.D.A." I was confused. "Public Display of Affection." Violet's eleven; she's very wise. Which goes to show that unconventional families can raise proper children. Sylvia tossed a throw-pillow at Violet who giggled and threw it back, and then pillows were flying all over the place, and everyone was laughing, and the dog swallowed a Power Ranger and threw up on the rug in the living... area. I was having a lovely time. I can't imagine why.

After dinner, Charlene pointed me toward the bathroom—bathroom, thank god. I opened the door and there was Lola naked, watching the tub fill up with water. I felt horrible. She must have been so embarrassed. I remember what I was like at that age. She said, "Are you going to take a bath with me?" I ran out.

Charlene said, "Don't be silly; she's five; go pee." And she rolled her eyes.

I knocked gently and said "It's Annie." Lola was in the tub. She said hi, and I said hi, but I couldn't sit; I couldn't pull my panties down. "Which do you think can swim faster," Lola asked, "a shark or a cheetah on a kickboard?" I stood there. Charlene called: "You kids alright?" And I said, "Fine," but I wasn't fine; I was paralyzed, and I had to pee. I reached over and flushed the toilet and ran the water in the sink. "Be right out," I said. And Lola said, "You're wasting water."

"Thank you for a lovely dinner," I said. Sylvia said, "You're not going so early?" I said, "I get so tired these days." I could hear Lola splashing in the tub. Charlene made me stand there while she dug out a box of baby things. I wanted to tell her I hadn't decided about the baby, but mostly I wanted to pee.

I didn't wait for the elevator. I ran down the stairs, six flights, and dashed around the corner carrying a case of Quaker State Motor Oil which was really baby clothes, and into La Maison Rouge. "I'm meeting someone,"

I told the maitre d' and walked straight through the restaurant. No one tried to stop me. It comes of being well groomed. I can get into any ladies room in New York.

It was empty. It was perfect. I sat there alone and I realized something. When Charlene was combing Lola's hair or helping Violet with her homework, here's what she wasn't thinking about: herself. How wonderful.

When I got home, I hooked up Vixen and Diana and took them to the dog run. Steven was sitting on a bench. He must have been waiting for hours. He said, "Henry Kissinger was here with a little terrier dog. He's got a man who walks four paces behind them and cleans up after." I said, "That can't be his entire job." Steven said, "He had a gun. I saw it when he bent down to scoop." I said, "Well there you are; he's the bodyguard. I've missed you." Steven said, "I miss you," and he kissed me. Then he held my hand and reminisced about our sexual history in rather too much detail. "Well yes," I said, "it's good to have common interests." He laughed and kissed me again. Then he reminded me that he already had four children and two ex-wives. He couldn't handle a new baby. He could handle me, apparently, but not me and a baby. I said I understood his feelings, and he said he understood my feelings, and then he asked what I was going to do. I didn't know. But I had a pretty good idea what the bodyguard was going to do. He's going to snap one day and shoot the dog. You can only take so much.

FADE OUT.

FADE UP ON ANN. MORNING. A FEW DAYS LATER.

"Now that you're not seeing Steven," LaTania said, "you can come to my Parents Without Partners group." You're allowed to attend if you're just thinking of having a child alone, but they stop you at the door if you're dating someone even casually. They're very strict." I don't see how she raises Max on her own. She makes less than me. He's a cute boy. For a boy. I went to the meeting and I stayed awake, too. "I was just resting my eyes," LaTania said. Many of the Parents Without Partners couldn't find sitters, so they had to miss the part where they persuade each other that they can handle all the problems of solo parenthood.

FADE OUT.

FADE UP ON ANN. SHE SEEMS WEAK, TIRED. IT IS DUSK.

When the anaesthetic wore off, I opened my eyes and there was Millstein's face, floating there. He said, "Only minor complications. In your remaining reproductive years, you should be medically able to have a child." "And a husband?" I said. "You haven't lost your sense of humor," he said. I wonder what he meant?

There is a good side to all this. This demonstration of my fertility shows that the time I spent mucking about with contraception all those years wasn't totally pointless. All that running to the bathroom in the middle of things. Allie says she does it right there in bed. "Make it a part of your love play, Annie," she says. Play? Play? The last time Steven was over, I went into the bathroom and got caught up in a story in *Architectural Digest*—the most beautiful rest rooms in the world. I'd been to one of them. Radio City Music Hall. Wonderful. So deco. With little couches to swoon on, should you wish to become unconscious, in little private alcoves. I'd like to live there. Good location, an easy walk to work. When I finally got back to bed, Steven was asleep. Too bad. He'd have enjoyed the article.

Charlene thinks I resent Steven. She's wrong. He didn't force me. My decision. The sad thing is, he's such a wonderful father to Dallas and Dakota. And he's even better with the kids from his second marriage! To see him with Tara when he picks her up at her therapist's every other Saturday—they're more like pals than dad and daughter! So affectionate. Well, he is. She's at the age when kids pull away.

FADE OUT.

FADE UP ON ANN, FESTIVE, MUCH RECOVERED. NIGHT.

When the waiters gathered around and sang, "Happy Birthday to Ann," I didn't cringe. Everyone in the restaurant joined in and then applauded like mad when the maitre d' brought over a tureen of lemon mousse with a sparkler stuck in it and "41" written across the top in raspberry sauce. Steven

leaned over and kissed me. I wasn't nearly as embarrassed as you'd suppose. I thought: why should my modesty prevent Steven from doing something nice? I couldn't eat the mousse. Allergic to raspberries. Steven forgot. He had them bring me some vanilla ice cream. One way or another, we work things out.

People always can, can't they. Or maybe it just seems that way because I had wine at dinner and at lunch. The girls at work took me.

After a while, it seemed stupid, avoiding Steven. Spiting myself. He's sweet, really. I missed him.

I did insist on one thing: no more birth control. What ever happens, happens. He can stay or go. That's his decision. But I'm not using my diaphragm anymore. Steven said, "I understand, Annie. I'm going to share the responsibility." And then he invited me to that lovely dinner.

When we got back here, he'd forgotten to bring anything. It's a new routine, isn't it. So, just for tonight.

Maybe I should get some plants for the bathroom. Geraniums. They'd look nice right there on the windowsill.

FADE OUT.

<div align="center">

END

</div>

Susan Deer Cloud

Crossing Over Mid-Hudson Bridge After Sunset

By the time I get on the Bridge I feel kind of crazy—wasn't sure
I took right exit to get there. I drove an Indian elder around
a traffic circle once—"Slow down," she cried, "SLOW DOWN!
This makes me feel as if we're going to fly right up in the air.
Only a man could think something like this up!" And *that* is
how I felt, jerking steering wheel so old Indian car could zip into
narrow road twisting up to Mid-Hudson Bridge. But once here
it seems worth the skipped heart beats, that *I might fly off
the road* feeling, my fear of flying. Now I *am* flying between
suspension bridge arches, locked in single file car flow, ruby taillights
ahead—eyes half-hallucinating from jeweled effect of headlights
rushing, flashing at me in opposite lane, white and white, WHITE
circles of pearls in the oyster of night. Arches rise high, swoop
down, then up again, supported by long silver verticals of
steel. It is all so *pretty*—a child's word for it, but that is the word
that soars with me as I glide over deep, indigo river below—
smiling insanely at little lights that perch along arches, tiny birds
of purple, green, blue, red. Every so often I glance northward
toward Hudson, twinklings of shore lights fancy dancing on water,
Mother Earth embracing river from mirroring sides. And in Sky World
trace of sunset, faint trail of Cherokee red. Then among all this
I think of the Trail of Tears, of what trails brought me here.
When I think more, I think how polluted the Hudson is. Think
about the deformed fish, how no Indian in her right mind would eat
anything out of this river that steals my heart whenever I see it,
makes me fall in love for the first time no matter how often I behold it.
I know about the toxins from all these cars, trucks, motorcycles—about
the factories blotting the dark banks. And I know what it means to
not know the ancient language that would give me the native name
for *Hudson* that shape-shifts into Eagle inside whatever in me
is broken—fills me with wings by the time I reach the Bridge's
opposite end. Lights flash more than ever in my eyes, fractals of
tears, and I turn up air-conditioner and Tom Waits' "The Ghosts of
Saturday Night," roar off Mid-Hudson Bridge—that other word
flamed out of centuries of heartbreak soaring with me because I am
weeping from the beauty of this night, this river, this Bridge,
this *mystery* electric-lit.

THE PEN FACTORY

It was 1969. People back then called me
a "part Indian" girl. My earliest memory—
father's night terrors, sweats, because
he'd been shot through his chest at eighteen, my age
that crazy year of Vietnam War. A Marine,
he tried to race across Guam's coral beach to jungle.
"Can't dig a foxhole in coral," Dad told me once.
Oldest brothers drafted out of college,
one shipped to Vietnam, other to Korea.
I, angry young woman, dropped out of college,
spat out words like "fascist pigs," "the system,"
and "1 2 3 4, we don't want your fuckin' war."
I moved in with a philosophy student in D.C., joined in
every war moratorium and civil rights march I could.
The American Indian Movement was about to happen.
Women were getting more and more pissed off,
even at the long-haired, pot-smoking, sensuous leftists
and hippies who called us "chicks." My mother
had a lung hemorrhage, so I rode Greyhound Bus
through slow miles of autumn flame back to Catskills
where she nearly died. In the hospital she whispered
that when her mouth pooled with blood
my small hand floated towards her, a vision
grabbing her hand so she wouldn't leave.
When the doctors released her, still weak,
I stayed to help out. I got a job at the pen factory
where my red-haired Aunt Maude worked.
We assembled pens for politicians. My body
ached on metal chair for eight hours each day,
fingers scooping up pen halves, ramming them
into second halves in whirling Army-green machine
screwing halves together. Pen after pen made
between my young flesh and the inflexible machine.

The women called me "College Girl," even though
I kept my mouth shut, ate lunch with Maude
partly to protect her when the others tittered
the owner wanted to "fuck" my "big-titted" aunt.
I believed in "power to the people," unions, labor rights,
but up close many of "the people" were cruel, spiteful,
rough. One day the gossip made my aunt cry, when
I had never seen her weep before. The women's
coarse jokes come back sometimes—"He's that ugly
because his mother threw out the baby and kept
the afterbirth"—"What did the Pilgrim say to the Indian
at the first Thanksgiving? *Just so you know, this
doesn't make up for all the scalpings*"—"What's a WOP's
idea of foreplay?," finger snap, pointing to imaginary
bed on floor—"What's a Jewish man's idea?
Two hours of begging"—workers sniggering
in Aunt Maude's direction, wondering if Jewish owner
begged her with her fiery hair. I had read Engels, Marx,
Marcuse, watched Chaplin's "Modern Times"
at The Circle near D.C.'s Foggy Bottom,
blasted out songs from Rolling Stones'
"Beggar's Banquet," especially "Factory Girl."
What would thirty or forty years of this
do to me? How much exhaustion, hate,
resentment, roughness, could it fill me with
then empty me of so nothing was left?
My father used to pick me and Maude up
on the way home from his job at Berman's
Plumbing & Electric, and I didn't know it then
but the war wound was catching up to him.
He'd soon be dead. We chatted about the beauty
of the fall leaves and about going apple picking
and about my mother's growing strong enough so
we'd have a nice Thanksgiving. We didn't mention
my brothers, how they wouldn't be with us, but, yes—
I was an angry young Native woman terrified
my eldest brother would die outside Saigon. Even

my little sister hung an American flag upside down
in our bedroom window. Billy Bang Bang, town cop,
threatened to arrest her for it. Nights I sat near
that window, wrote with pens I snuck home
from the pen factory, the ones we workers made for
the politicians, American Dream promises printed
under clear plastic. I had lived past The Summer of Love,
my Turtle Island more and more soured into a jail of lies,
assassinations, the coffins of the too young. Factory girl,
shy hippie chick, Métis flower child grown afraid simply
to go pee because I might get fired, I spent my eternities
off the clock writing it all down. Yes, even during another war
I write with those workers who never spoke of liberation
still holding on in the pens, pencils, computer I use
to assemble this poetry.

On a New England Night in November Woods

Once a leftist peace activist told me
she thought Indians weren't bothered
by cold. It was January, twenty below.
I stood shivering on icy sidewalk.
My friend, Russian immigrants' daughter,
was eighty, warm in red wig.

And my husband who became obsessed
with a student forty five years younger
than him, told me when I cried shivering
alone in un-insulated shack I fled to
that women can take living alone, unlike men.
Only mice gnawing the walls heard my tears.

My old radical friend died. I divorced the man
grasping at young flesh that made him feel
he'd live forever. He's dead, too. I have moved
far from all friends. And I shake with cold
in a rented back room on a New England night
in November woods.

Daniel Donaghy

W<small>ALT</small>

> reeked of stale Luckies
while he watched us play ball,
transistor radio on his lap, brown

quart of Ortlieb's, his legs useless
as long as we knew him
and his pull-out bed by the window,

his piss jugs beside each chair
so he'd only have to climb the stairs
to shit, his arms thick as tree trunks

lifting him one half-step at a time,
lowering him the same way
till he crawled back onto his stoop.

Some days he'd fall out the door
flush on his forehead,
cuts still fresh when he waved me

over to dump his piss for a buck,
whispering *I can't reach the sink, babe.*
It'll spill over everything,

then holding out a handful of change
with *Thanks, babe, I owe you,*
before I could tell him no.

Jillian Towne

7 A.M.

You, you are capital punishment

You are mothers scolding and infants screaming
You are ominous clouds and
portent cats and stop lights.
You are peeling paint
On baseboards and screens that let bugs in. You
Are too much salt and not enough oil.
You act boldly and without mercy,
Never tip-toe-ing, always stomping around on my brain stem and down
my spine.
You are toothy children and pageant moms and telemarketers.
You are the door-to-door visitors, and the
mailman who never came. You are Sunday evening and Tuesday morning.
You are like an off-key voice
Relentless and belligerent.
You are the vein on my father's forehead, the singsong
in my mother's voice
You are leaky bottles and broken glass and
tepid bathwater.
You are skinned knees and natural disaster.

You, you are death.

You are anger and you deceive me
You are beating my head against the wall,
bringing me to water, not allowing me to drink.
You are dictators and minions and preachers. You force
me to believe. You are pick-up lines and saccharine pleasures and
arsenic and invisible ink.
You are unhappy birthdays and sour apples and whisper kisses. You
are like sirens signaling a car crash in another world. You
are the day the music died.

You, you are the whistle of a train.
Last stop dreamland, next stop reality.

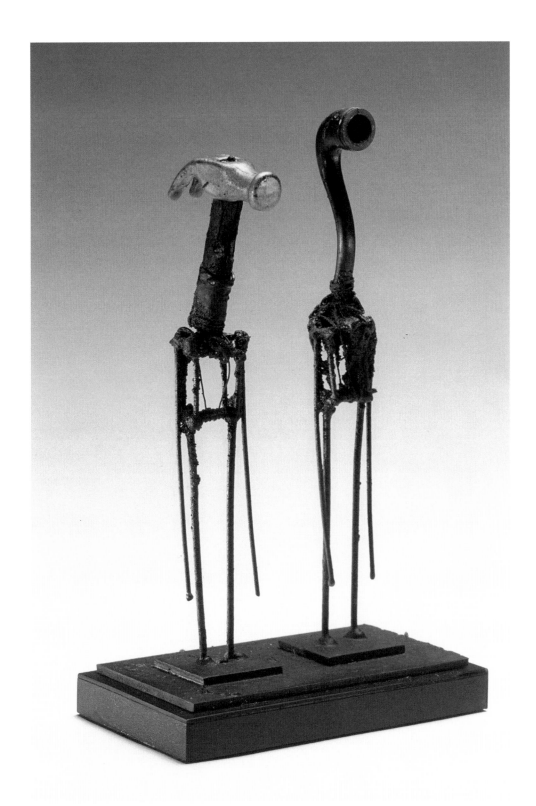

RONALD GONZALEZ, *Unpredictable Couple,* small hammer and pipe, wax, wire, and paint over rusted and welded steel, 7"x 4"x 2", 2006

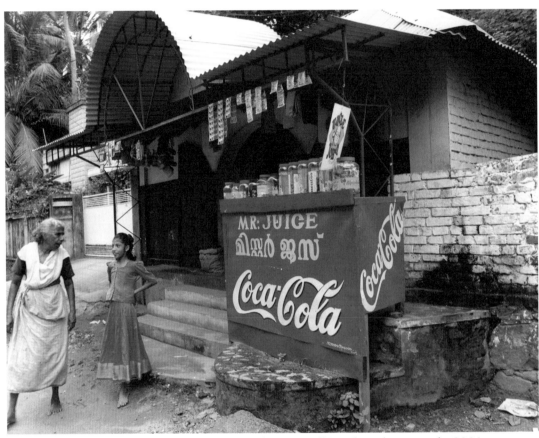

Beatrix Reinhardt, *Coca Cola Houses: India Series #1,* color photograph, 2001

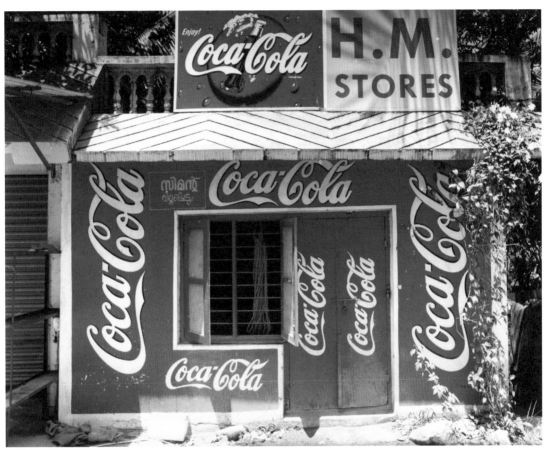

BEATRIX REINHARDT, *Coca Cola Houses: India Series #15,* color photograph, 2001

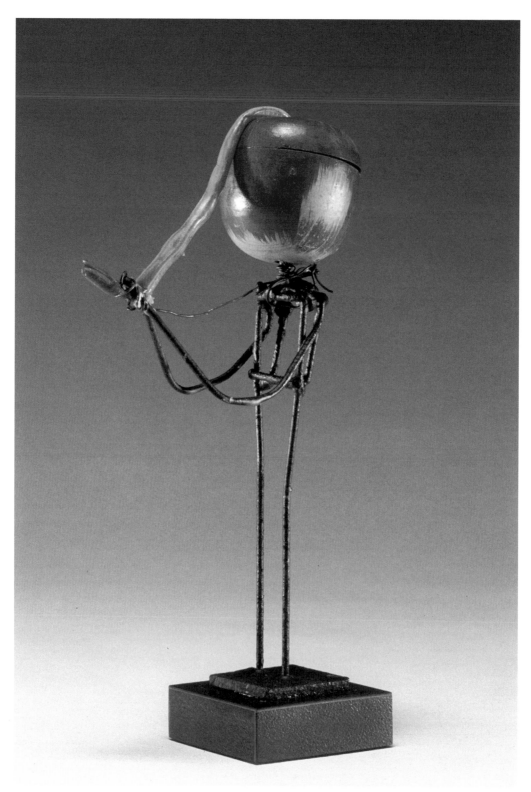

RONALD GONZALEZ, *Rotten Apple,* wooden apple, rubber worm, wax, and wire over rusted and welded steel, 6"x18"x3", 2007

Eric Geissinger

An Honest Man

Part 1: The Typical Case

"Hey buddy," he said, coasting along for a moment before moving on to the meat of the sentence. "Hey buddy," as a greeting, an interrogative, and a fading farewell. "Hey buddy" to the client, potential client, and the hot lead; brightly, after racing down the vice-president, and weakly, to the devil, after smashing his car into a pole. "Hey buddy," to the college girl working the coffee cart, and coming from him it was OK, not an insult at all—his distracted eyes were busy inspecting the scones. He pointed one chubby finger at a bear-claw covered with translucent almond fingernails. "Give me the biggest, OK? Hey buddy, where's the cream?" He was much too silly to pose a threat. His narrow rat's nose surmounted a bushy mustache. His tension-retracted hair arced backwards on either side of his forehead. He found the cream. He drank the coffee immediately; it was half gone before she handed him the bear-claw stuck to a square of wax paper. He paid after a violent thrust and recovery into his pocket and, not waiting for the eight cents change, slid away, his short stride repeated and repeated as the office building approached. He soon bumped into and casually queried a chance co-worker with an inquisitive, "Hey buddy?"

She was known only by her sweaters, and their variety was not extensive. Variations in colors as follows: green, red, an occasional yellow, and a few times a year the jaw-drop flash of purple. The fabric types used, as well as their overall texture, changed far less frequently, large-weave wool being standard. Long sleeves were a certainty, with a line of buttons up the front. She sometimes allowed herself the glitter of a pin or brooch, but often not. Her sweaters usually dangled limply to her knees, obscuring whatever charms her legs might otherwise reveal. She was, however, despite all of this camouflage, both a lean and a tall woman, who had worked her post for over fifteen years. But to most of them, her fellow employees, she was nothing more than a clothes hanger made animate. The only other fact most people knew about her was that she was responsible for supplying a small mechanical element that was used daily and which broke bi-monthly. She had a monopoly on the supply of these items, and this, coupled with her sweaters, made her a recognizable face to everyone in the company.

He had met her on her first day, and his "Hey buddy's" back then came across as somewhat more suave. They were calmer, and less hurried. She filed his name away with a jumble of others. A week later he needed the item she controlled, and he paused at her cubicle, issued a "Hey buddy," asked for the item, and in this way re-learned her name, and she his. He had no interest in her at first, nor she in he, but their banter soon turned into one of those drawn-out flirtations that are only possible in bored, slack workplaces where everyone has too little to do except on the days (ever sixth or seventh) when everything overflowed and there was, suddenly, far too much to be done. He made a habit of losing the mechanical elements, and she made a habit of teasing him about his absent-mindedness. On a few occasions they were seen walking together to the coffee cart stationed outside the building, but they never had lunch together; that would have been understood, by both of them, as a definitive movement toward something that neither wished to confront directly. He was married. She was not. The years passed, and her sweaters grew progressively longer. His "Hey buddy's" sped up, crept into his conversation at every possible point, became an office joke, then an office annoyance (since he could not stop), and passed into legend. Nobody even heard them anymore; they were mentally excised at the start, middle, and end of every utterance, wherever they happened to crop up. He still lost the mechanical elements, though not as frequently as before. She still looked forward to his little visits, though no longer thought them very important. Whatever might have been they were content to let drift into the realm of the purely speculative.

PART 2: THE IDEAL CASE

William Jacobs was one of the pioneers; not a founder of the company, nor present during the dazzling days of infancy, but a clever man in his own right who, directly out of college, had hitched his wagon to the young company's fortunes. He had worked there twelve years, shuttling sideways from office to office with every promotion, demotion couched as a promotion, and sudden reversal of managerial fortune. Having endured a number of incompetent bosses and survived a few middle-management shakeups, William commanded a high salary and wielded enough power to carve out a position that occasionally challenged his abilities.

During his fourth year with the company, William married his long-time fiancée Sue. They immediately produced two children, the elder

healthy, the younger trouble-free until her second year when, one day after dinner, William happened to glance over at her and saw her raise her hand toward the overhead light. Her chubby fist was dimpled behind each knuckle. She wriggled in the high chair and brought down her hand, then raised it again toward the light, then lowered it, and after three such motions William was amused, after five he started counting, and after twenty she had a distant, robotic expression on her face. She stopped at forty-five, breathing heavily, and immediately returned to her previous occupation: chasing Cheerios around a plastic tray with a segment of flexible straw. William watched her for the next hour, and tried to convince himself that it had been nothing, or else simply a momentary whim on her part. But that evening he could not sleep, resorted to mixed drinks, woke up groggy and crabby, and over breakfast wondered what to tell Sue when, from her high chair, his youngest daughter kicked away from the chair leg with her right foot, allowed her heel to fall back and bump against the chair leg, and kicked out with her right foot, and allowed her heel to fall back and bump against the chair leg. He was sharp-eyed and already counting. At thirty-five Sue came into the room to see why William had coughed, and instead found him grasping the tabletop rigidly with both hands. Confused, not knowing what to say, Sue asked if he wanted his coffee. The expression on his face was out of a nightmare. He mutely waved her away, got up to fetch his favorite mug from a brass peg hanging over the kitchen sink, but before reaching it dropped to his knees and cried with such gasping sobs that Sue thought he was choking. She fell to her knees behind him, ready to perform the Heimlich, but he turned his face to her and she saw his tears and he said pointing with his long arm, "There is something wrong," and they both watched as their youngest daughter kicked away from the chair leg with her right foot, allowed her heel to fall back and bump against the chair leg, and repeated this motion fourteen more times.

Time passed, and after a search that seemed endless, littered with false leads and ugly blind alleys, they found a school that could take her, one with which they felt comfortable. This event, and the ever-growing gap between other two-year-old's and their own, forced both of them to alter their habits. After a while William noticed that his wife had begun to exhibit those signs of cheery, indefatigable optimism that typified a certain strain of well-meaning caregiver. Her eyes grew bright and she blinked rapidly when confronting a stranger, particularly when escorting their youngest

daughter. She wore a smile that seemed at first pleasant. And then, when it was held slightly too long, unnerving. But when probed by friend or relative, who wondered about the future, possibilities of employment, and the perils of puberty, Sue's fragile-looking smile showed its iron. She was unshakable; nothing disturbed her aplomb. It was only William, every third or fourth night, who was privy to the truth, for she would sometimes start crying while still asleep, at first only with whimpers and sobs, but it would soon escalate to moans that jostled her into consciousness. It was only after waking and finding herself exposed that she attempted to directly face her fear of the future, which soon overwhelmed her anew. There were more tears as sleep was banished. Except for these moments, which did not grow less frequent as time passed, she never gave William nor anyone else any indication of her justified terror.

"Hey buddy," said William's co-worker one day, knocking lightly at the door, his head already inside his office, "Hey buddy, let's go meet the new hires. Just brought a group in. I think you will approve."

Having begun the morning slowly, and not finding any interesting work at hand, William simply nodded agreement, followed in his wake, went down a flight of stairs, cut over to the central holding pen, and in that maze of cubicles would have been utterly lost had he not honed in on the "Hey buddy's" preceding him. His co-worker greeted everyone, anyone, nodding his head, shaking hands when possible, slapping the back of a particularly close friend or stranger, and then in the corner he came across a group of them bunched together, four in number, newly hired, most right out of college, and he heard, "Hey buddy, this is William, hey buddy, this is William," and he stepped up to say hello. "Hey buddy, this is, let's see, Roy right?" "Right, I'm Roy." "OK buddy, I don't know you." "Sheila." "Hey buddy, say hello to William." "Hi William," said Sheila, confused, caught between a smile and her confusion. "Hey buddy, Jacob, say hey." "Hey." "He's the say-hey kid"—these sort of stale jokes were impossible for him to resist. The introductions continued: "Hey buddy, last and not least meet Faith." William strode ahead, pushed out his arm, clasped her hesitant hand and said, "Faith, yes, Faith, nice to meet you."

After returning to his desk, William sat on his plush leather chair, a fought-for perquisite, tipped it back, looked up at the tiled ceiling, and stared contemplatively at the scattershot of dark holes that constituted the entirety of the pattern of that manufactured material. It had never looked so good before.

Two weeks later, with little fanfare, William left work an hour early. A slow-forming emotion had taken root within him, and it would not leave him in peace. It was William's great tragedy, or his saving grace, that he was incapable of harboring self-deceit. Where other men strove to keep from facing the facts, would take up hobbies or substitute sports, or work, for what was ailing them, would light-heartedly give in to some bedraggled temptress, or struggle months in a futile fight with morals ill-prepared for a true test, William would not. It was not something requiring a conscious decision, it was simply part of who he was—indeed, were it not so, it was doubtful he would have had strength enough for the task. But he was, through and through, who he was. Once William realized what had happened, the path he had to take was obvious enough. Of course he had his doubts. He was, after all, teetering on the edge of a self-made precipice, and could pull back at any moment without effort, without anyone else even knowing what had almost occurred. Instead, William went home, found his wife folding laundry in the back room, sat down on the floor, placed his back against the cool door leading to the bathroom, and there spoke to her quietly and calmly, and told her he wanted a divorce. She did not understand him at first, though she did not think it was a joke; he did not joke like that. She kept folding the laundry, folding and folding, and it was only after he had answered all her expected questions—"no, he did not wish to break up their family," "no, he could not really talk about it,"—that he noticed she had been folding and re-folding his favorite blue turtleneck all the while. She began to get frenzied, and sought some explanation. She needed to make him express some emotion. She tried to get a part of her growing hysteria to rub off on him. His steady voice exasperated her. But it was not the right tactic, as he simply counted the number of times her hands folded and refolded the fabric. She tried, and he listened, but it was too much, too serious, too unexpected. She suddenly saw the walls tremble; light refracted in funny ways; the steam radiator hissed and spat heat in her direction. So she fled, ran into their backyard, and circled their birdbath time and again, his shirt billowing behind her.

He moved out exactly thirty-four days later. His wife's anger and confusion was insufferable. His ache, when he held his daughters, and tried to explain why he could not live with them anymore—it was unlike anything he could imagine. It was exquisite. So when he finally walked into his shabby one-bedroom apartment eleven miles from home, and looked around at the cannibalized furniture that spoke only of them, at the pile of

dishes that spoke only of her, at the sorry assortment of makeshift moving boxes surrounding him on all sides, there was, despite all these indications of a cracked past and a blank present, a small measure of relief mixed in. No longer must he hear their muffled sobs, face their accusations, and attempt to explain for the final time why, idealistically, he wanted to sacrifice a good life to make way for the possibility of ecstasy.

It is a commonplace truism that "work expands to fill existing voids." William knew this, and scoffed at the easy, generalizeable truth, yet it did not stop him from lingering at the office in the evenings, taking more interest in the meetings he was forced to attend, and in a move that shocked everyone that knew him even slightly, William even offered to make a few important trips to woo, or placate, potential or disgruntled clients.

He saw his daughters two nights a week, and once during the day on Saturday. The easy relationship he had established with them soon turned brittle. They did not care for his apartment. Even when he brought over boxloads of toys, it was not a place conducive to a child's laughter. William had not cleaned the kitchen before moving in, and repeatedly had to pull away his younger daughter's finger from the crack between the stove and counter, where a brown layer of grease had collected. They spent much of their time at zoos; wandering through hushed museums; nursing melted milkshakes ten minutes longer than was tasty; and when 8 p.m. rolled around, despite his love for them, and they for him, their parting was often spirited, and contained an element of relief. He dropped them off on the driveway, and behind the kitchen curtains he occasionally spied her profile, and remembered—always with stabbing sharpness—the answer his older daughter inevitably gave to his guilt-spurred query: "Yes Daddy, she still does, every day, all the time."

And he drove back to his empty apartment with nothing, as of yet, to counterbalance the load. Four times he picked up the phone, ready to call and calmly apologize and make the slow drive to what he still considered home. And four times he had faith enough to stop his fingers from dialing, allow his heart to keep aching, and confront squarely the empty space surrounding the couch that once sat, covered in discarded Christmas boxes, in the attic of his old house. He quietly went around straightening up what could be straightened, watched two-and-a-half old movies on cable television, and finally went into the bedroom and marked another day off the calendar.

Six months and thirty-four days after telling his wife he wanted a divorce, William picked up the phone and asked his co-worker to stop by

for a moment. Twenty minutes later came a rap on the door, and his co-worker poked his head in and grimaced at William. "Hey buddy, what's up? Need something from engineering?"

"No," said William, his hands almost trembling, "I want you to take me downstairs again."

"Hmm... OK. Hey buddy, what's it all about?"

William followed in his wake, went down a flight of steps, cut over to the central holding pen, but would never have been lost in that maze of cubicles as he had, many times since, stared at a schematic representation of the room, and memorized every particular through repeated viewing. A scattershot of "Hey buddy's" preceded him, but as it was 11:30 a.m. Friday, many had already fled for lunch, or had taken the day off, or were loafing in a nearby café. So it was unusually quiet, and they made their way quickly to the necessary corner. William felt his head expanding with every step; a giddiness seized him. He ran his right hand lightly atop the cubicle walls to keep his balance and reassure himself that he was in fact where he had so often dreamt of being. Time shortened, distance paradoxically lengthened, and William felt like his legs were pumping and pumping, but running on some infernal treadmill, and making little forward progress. Finally he heard the voice ask, "Hey buddy, remember William? William, do you remember Faith?" And William stuck out his hand again, and again she took it, shook it, and to everyone's amazement William—with a clear conscience, without anything to hide, in full view of his co-worker—asked Faith if she might, possibly, want to join him for lunch. ≋

Danner Darcleight

METERED TIME

Like most incarcerated people, I have a somewhat skewed perception of time. I realized this today when something triggered a memory from a recent trailer (conjugal) visit; quick calendar-based calculation revealed that exactly three weeks had passed since my brother and grandma left.

It feels longer.

For the first week after they left, it felt like only a minute ago I was eating dinner with them or enjoying a game of Scrabble as a trio. (I kept some of the clothes unwashed, which played on olfactory memory triggers, and wrote about it for six consecutive journal entries—both of which served to prolong the feeling that they had just left, and my longing to have them return.)

Time is one of those things that is just there. Happening. Whether we want it to or not. We can neither see nor smell it and, at least in the circle I travel in, the abstract notion of time isn't discussed. I guess we take time for granted, it having been imposed as a concept thousands of years ago, and it imbues our lives with manufactured meaning. But time is all around us, pervading everything we know, and would still be there, label or no.

Since perception of time is so universal a subject, I imagine most cultures feature time-specific idioms. English has some interesting ones.

As a convicted felon, I belong to the only group of citizenry that *does time*. No one else does time. Those in the world live their lives—they do *things*, not time. They say dogs have no perception of time.

That's probably really cool, having no perception of time, like a dog. Just chilling, and licking your balls. I wish I were a dog.

I've noticed a seeming paradox in the way I experience time. Concurrently, I'll feel: *time flying; like it was only yesterday;* or, *like it was years ago.* I go to bed and think: Has it been twenty-fours hours already? Vivid memories drive that.

Self-imposed routine, that most warm and comforting thing, causes time to fly. And the yesterday/years ago phenomenon: Different places, even different blocks that I once called home in this very prison seem worlds away, and it takes years to travel to different worlds, as NASA demonstrates.

Case in point: my life before going away, seven and a half years ago, feels like a different lifetime, but at the same time, I retain certain memories—sounds, smells, sights—like they happened yesterday.

I think this is because one day Inside is so similar to the one that came before and the one that will come after, that all the days just blend into each other. This phenomenon reminds me of Salvador Dali's *The Persistence of Memory,* with the melting clock slung over a tree; time bends, warps, melts your fucking face off. The human mind needs that variety, even mundane variety, to differentiate days and accurately mark the passing of time. If put in "the Hole," as is so popular in prison movies, with no light, the human mind/body will note the passage of time, but not with any accuracy whatsoever; this poor isolated chap will know that time is passing because that's what time does—it moves forward in a ceaseless progression (unless the world ends or you happen to be time shifting with TiVo). I'm thinking that this is similar to vertigo, except on an order of magnitude less extreme.

On a night dive many years ago—another lifetime, if you will—I experienced vertigo while forty feet underwater. Talk about some scary shit; not knowing which way is up rocks you to the core, like the interesting, frightening *trompe l'oeil* of ass-kissing acid. My dive training eventually kicked in—seconds that felt like hours—and I removed my regulator, depressed the purge button, and oriented myself as I watched air bubbles float to the surface.

Calendars, journal entries, news of some horrific stabbing in another block—these things help orient as far as time is concerned. Wonder if the dogs experience vertigo?

Wish I were a dog.

Hawking wrote "A Brief History of Time." Maybe this essay can be subtitled: A Very Brief Narrative of Time, though I am no closer to understanding time. That physicists aren't even sure time exists, and use terms like "temporal conundrums" in their explanations, does little to help me.

Einstein's theory of special relativity states that the faster one moves, the slower time moves. (Theoretically, a light-speed traveler will not age.) Life is different. The faster, or more, one moves, the *faster* time appears to be moving. But maybe Uncle Albert's special theory works for jail: The slower one moves, the faster time moves. By way of offering an unscientific proof, I mention my correspondence with a friend living abroad. Our trails of snail mail take ten days coming and going. We postpone responding for

more then a month. Three or four letter cycles pass and, what do you know, another year has gone by. That seems to jibe. My brain isn't suited, at least not presently, to theoretical ponderings, and I think it's time to move on.

There are abstract phrases that make no mention of time, but deal with it nonetheless. *Stop and smell the roses* (take your time to enjoy simple things); *don't wait for the last minute* (procrastinators are told to properly manage their time).

We're told not to *waste time,* thus putting subjective judgments on what constitutes a proper use of one's time. *Party time. Go time. Crunch time.* All are common expressions.

"Have you the time?" (time on a clock), or, "If you have the time, will you please…?" (time as a resource that must be allocated). Time can drag or fly—really, it remains constant, and it's our perception of its passing that changes. We're urged to take a *time out,* a sports metaphor that has made its way into common usage. We take *time off* from work. We experience *good times* and *bad times*—seldom at the *same time,* despite Dickens' *Tale of Two Cities* opener.

Time can only be experienced forwards, which is quite unfortunate because there are times we all wish we could redo. Hawking referred to this as "the psychological arrow of time…the direction in which we remember the past but not the future." Well put, Steve-o.

We have *down time,* no doubt an industrial term for a machine's rest or repair time. As kids we had *nap time, quiet time, bed time*…then we're told softly by mom that, "It's time to wake up."

Madison Avenue has worked time into the language of the sales pitch. *Isn't it time you switched to…?* Sometimes we can be said to be having the *time of our lives.* By being an active participant in our lives, we can add life to our time (If I become a motivational speaker, this will be one of my cheesy catchphrases).

In my current context, no one wants to add life to one's *time* (i.e., a life sentence to one's life sentence, a number of years *to life, life on the back,* or *bid ends with a letter* ("e") as in twenty-five to life). And, personally, it's an uphill battle to breathe life into my days inside—musings like this help, though.

Some people have *bad timing* (see: George Bush on a carrier deck declaring our Mission Accomplished in regard to the war in Iraq). Those out of touch are told to, "Get with the *times,* man." It's not uncommon for a guy who's been down forever to refer to an eight-track recording. I was on a prison bus years ago, being transported to my current home, and restaurants

(mostly highway-side fast food) seen through the windows prompted a raucous discussion of remembered places to get good eats. A guy called out: The Beefsteak Charlie's on Broadway. He was immediately shouted down. Ain't no Beefsteak Charlies 'round no more, muhfucka. *Yes, get with the times, my good man.*

The United States has daylight savings time, which I thought was to give farmers more time to plant seeds in the daylight; a septuagenarian friend tells me, however, that DST was established during WWI as an energy-saving move (scholars of our time reveal that this hypothesis didn't pan out over time).

Every so often, a merit-time bill for prisoners floats around the musty back rooms of the state legislature. (This is also referred to as the "good time" bill, but I can assure you that incarcerated time is anything but good.) The long and short of it is: If someone doing time remains out of trouble, he will have a third of the time cut from the front part of the sentence. Being good brings fractions into play. I so hope this goes through, gets signed into law, and I'm eligible for parole at 18 years instead of 25.

There used to be *work time* and *leisure time.* Now, marketers propose a contemporary concept of time budgets called time styles: work, nondiscretionary time, and leisure time. Nondiscretionary time includes physical obligations (sleeping, commuting, personal care, etc...), social obligations (which, we're told, increase with urbanization), and moral obligations. Nondiscretionary time accounts for the largest chunk of one's day, and it is *obligated time.* The same holds true for the incarcerated: we have jobs, and recreation, and things we like to do with our free time (when someone tells me that he's "just gonna relax," I always ask, à la Teddy Duchamp in *Stand By Me,* "What hand do you like to do that with?").

Many are *time starved.* There are time-using and time-saving goods. The former, like watching TV; the latter, like take-out Chinese food. Polychronic time use is a fancy term for combining activities simultaneously, or multi-tasking: eating while watching TV, for example. Those of my generation and younger do this as naturally as we breathe, an effort to cram more living into our lives. Quite possibly, all that cramming landed me here. Hmm...note to self.

Online, a dancing banana with the message, "Peanut Butter Jelly Time," went viral. (Because I learned of this trend third hand, through print media, I wasn't ahead of the curve, I was behind the times). On "Family Guy," Brian

the dog paid homage to the clip in banana-clad fashion. For me, PBJ time means any good time in my day. Curling up for a cozy sleep is PBJ time. Eating peanut M&Ms is definitely PBJ time.

I have a calendar which is used only to record when mail comes in or goes out, and I keep it buried in a desk pile. Now, *that* flies in the face of the cliché: convict scratching hash marks into his wall: *this* many days over. I have a few friends who actually do mark Xs for each calendar day—these people are usually miserable.

We put a price, or value, on our time—*my time's valuable.* However, saved time isn't really banked—it's immediately put to use on some other activity. I take a very micro-economics approach to allocating my time. Time, life, is zero sums: one winner, one loser. One activity wins my attention, another loses out. Or, maybe opportunity cost would be a better description: I am writing right now and so forfeit the chance to be drawing.

It has *taken time* to write this. First, the thoughts were scribbled into my journal; then I copied it out, edited, and tried to sharpen it and provide some shape. After roughly two hours of work, I've succeeded in producing a rambling, shapeless diatribe on time. Maybe I should *take the time* to learn how to employ narrative frames.

I will take up no more of *your time.* In parting, I mirror the sentiments of an old saying: "May you live in interesting *times."* (However you define them.)

Because I assume that you share my sense of the ironic, I'll spend a few closing lines describing something that happened today. As I began writing this treatise on time...wait for it...my watch battery died! Yeah. It made a *glurg*—a digital death rattle—the LCD screen flickered, and then went blank gray. And the kicker: it will take weeks *(weeks!)* for a replacement battery to arrive. Like the Ancients, I will use my considerable knowledge of television schedules to make approximations of time based upon whatever is playing on my TV. And when that fails to produce precise-enough measure—which it certainly will—I'll be that guy who drives you crazy every twenty minutes. I'll tap on my wrist, put a pained expression on my face, and say, "Got the time?" ≋

Ken Victor

The Wall at Auburn Prison:
Upstate New York, November 1989

That month was the month of walls. Who had not spent time transfixed over
 footage of Germans pick-axing their own separation,
spraying champagne among the uncertain guards to mock their water cannons?
 The inmates had heard, believed it
their struggle as much as anyone's. After all, inside the immense yellowing
prison
 that month, inmates had their own wall
to cheer for: after years of weather, the north wall that supported one of the
original
 guard towers had weakened and needed repair.
Within days it appeared, a gap in the prison wall—thirty feet high by ten
feet wide—
 the inmates could smell like a fresh scent.
They kept turning toward it, away from anything their teachers might say
or do
 to hold their attention. The gap—barbed wire
in thick coils, two rows deep, at its base—set the student-inmates to dreaming,
 one in particular who wanted
to write on nothing but young girls. "Young girls," he said, when asked to
develop
 three different topics for essays. "Young girls,"
he repeated again. "Young girls," he said a last time, "those are my three topics."
 He turned toward the opening.
Another with a tattoo of brass knuckles began to mumble when he sighted
the gap
 about making his move now, busting out
because a chance like this wouldn't happen again. Possibility was coursing
through
 their blood like an antidote. They had a kind of
giddy weightlessness, as if gravity had suddenly become unreliable or faulty.

Meanwhile, the nearly emotional news-anchors
on the yard's black and white TV fawned over the march of history,
speaking as if
 they knew where it wanted to go, even
how it might get there and bring everybody along. From where they stood,
history
 somehow seemed headed to a place—
call it the promise of democracy, the triumph of freedom—where it could
finally
 settle down, build a life, never look back.
The inmates knew better: looking through that fresh gap, past the borders
of their one
 country—impenetrable, isolated,
full of its own unwritten news—they could see, see out, see into the aimless
world,
 see the broken cars rolling down State Street,
the old buses with their lotto ads, empty sidewalks, only now and then
a young girl, a young girl, a young girl.

SARA DI DONATO, *Butterfly Harp*, colored pencil and gouache, 50"x38", 2007

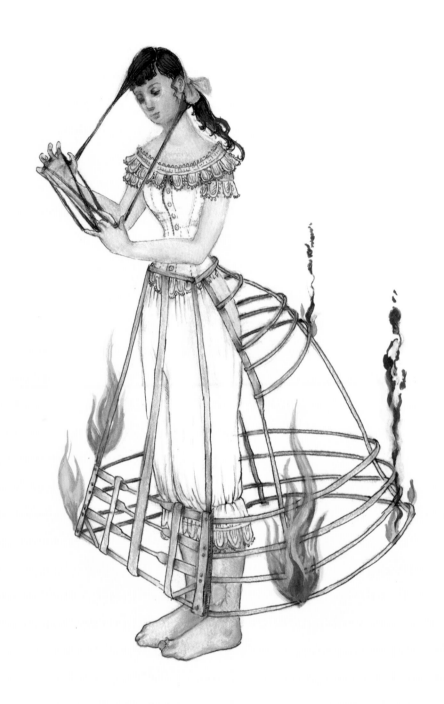

Sara Di Donato, *Dear Diary: Cat's Cradle,* colored pencil, gouache, ink, 15"x11", 2007

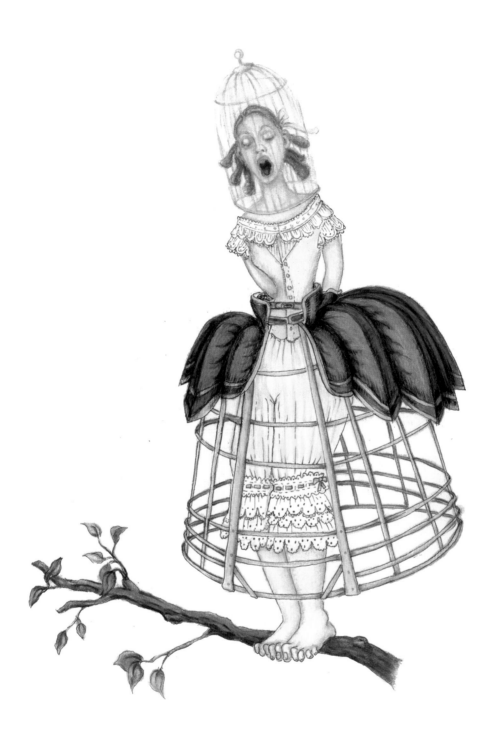

SARA DI DONATO, *Dear Diary: Voice Lesson,* colored pencil, gouache, ink, 15"x11", 2007

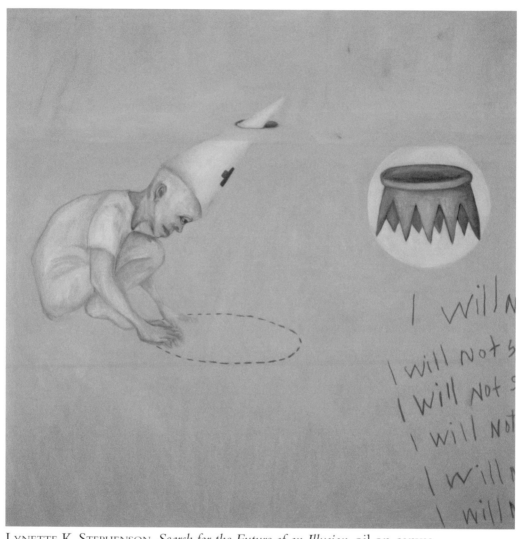

LYNETTE K. STEPHENSON, *Search for the Future of an Illusion*, oil on canvas, 36"x36", 2007

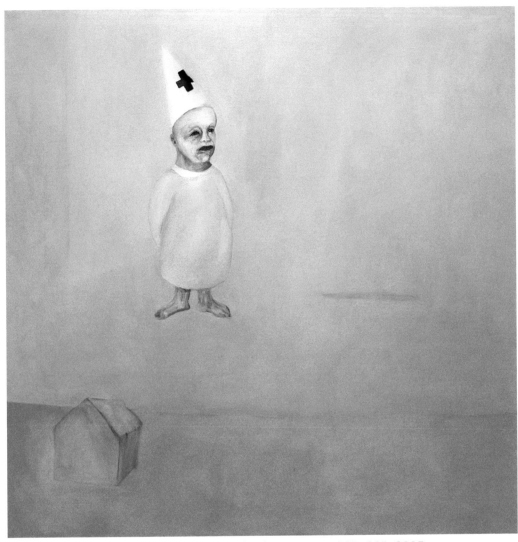

LYNETTE K. STEPHENSON, *Nola Drowned,* oil on canvas, 38"x38", 2005

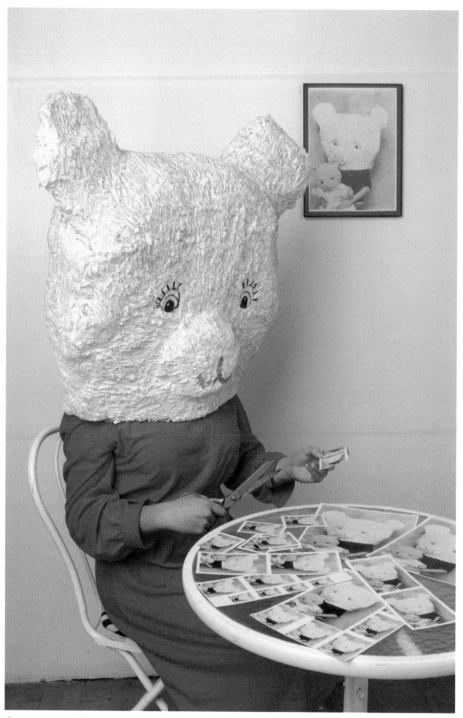

SAMANTHA HARMON, *Family Portrait: Mama Bear and Baby Bear*, plaster and mixed media, portrait packs from Wal-Mart Portrait Studio, 2007

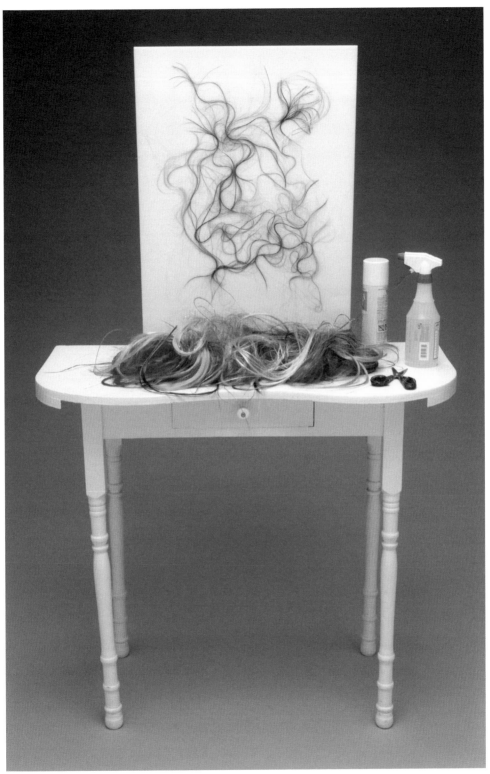

SAMANTHA HARMON, *Perpetual Drawing Board*, synthetic hair, acrylic board, and water, 3'x 4', 2007

Egg No. 1, Playing Card, Aniline dyes and egg

Egg No. 12, Saranac Bottle, Aniline dyes and egg

Egg No. 8, Library Books, Aniline dyes and egg

Egg No. 5, Coaster, Aniline dyes and egg

SAMANTHA HARMON, from the Pysanky Egg Hunt Series, 2007

Samantha Harmon

FAMILY PORTRAIT: MAMA BEAR AND BABY BEAR

My childhood teddy bear, Crusty, has always seemed more human to me than some humans I have encountered. With this in mind, I took him to Wal-Mart portrait studio, put him in a dress shirt, donned my mamma bear head, and had our picture taken together against a traditional gray background. The photo is visual evidence of a new reality that results from a clash of realities regarding family structure, love, ideals and relationships. The bear is humanized as I become more bear-like, both of us departing from our assigned roles to be more closely aligned—yet neither conforming entirely to the other's physical identity.

PERPETUAL DRAWING BOARD

Seeing swirling hair on a wet shower wall has always been a bit of a meditative and artistic experience for me. Bearing this in mind, I created a station devoted entirely to the creation of these "hair drawings." Using acrylic board as the paper, various colors of synthetic hair as the graphite, and a spray can, one can sit and create an endless array of impermanent drawings. As the water dries, the hair falls from the board, revealing another blank canvas. If something more permanent is desired, hair spray can be used.

This alternative drawing experience requires no special training or skill, and a preserved end product is not necessary.

PYSANKI EGG HUNT SERIES

My grandfather's parents came to the U.S. from the Ukraine with some of his siblings before he came into the world. Pysanki is a traditional Ukrainian Easter egg dying process. It is a process using wax and dye, usually employing symbolic, often very intricate imagery connected to themes of religion and prosperity. For this project, I used the traditional pysanki process, but in a contemporary art context. The eggs mimic the imagery of the things to which they are affixed, while drawing attention to themselves as independent parts. The eggs, considering the traditional process, are culturally foreign as well as physically foreign—beauty marks on the face of our visual everyday landscape.

"A Bird in the Hand ———.?"

JOHN "JAWS" McGRATH, *A Bird in the Hand,* pen and ink, 10"x14", 2007

JONATHAN KIRK, *Argonaut*, galvanized steel, 10'5"x6'1", 2006

Jennifer Pashley

SITE OF HUMAN DESTRUCTION

Everyone thinks they're invisible. I do. Or I did. I've been on visual autopilot. For myself, for others. I am just starting to see again, to regard all types of beauties. I notice that I get noticed, and chalk it up to a witchy lesbian look that includes jewelry and sandals. I never assume anyone actually finds me attractive, except in an unsettling way. A way in which you cannot help looking, cannot help but pause to decipher something that is in fact hidden, but detectable, subliminal. Some imperceptible danger, or damage. I see this in Tim, also. A look. Followed by, You look nice, or You look pretty, but it always feels wrong. Like, I think he is just saying it, or that he means something else. He says this is my own fault. But he looks it too. Like a wadded up piece of paper, pressed flat again. The ragged parts you could poke your finger through.

I am teaching an open figure drawing class. Which actually doesn't require much teaching. People come and go. There is a different model every week. We have one model who comes a lot. A fortyish guy who waxes his arms. He is lean with nice angles and shadows, and he likes to pose in demanding ways, like with his legs way far apart. Most of the students work in charcoal, sketching away on manila paper, but we have pastels too, and I try to work along with them, every week in a new color. Last week I did an old woman all in greens. This week I am working on Duane, the waxed guy, in purple and hot pink. I think he would like it. I think about giving it to him when I'm done.

My students are OK, mediocre. People are concerned with realism. They want to get the body right. But I have one lady who does very cubist-looking drawings, out of proportion, with the neck twisted, or the eyes too large and uneven, although you can see that she is drawing what is in front of her. I have one guy, who talks too close, and smells like pickled onions. He draws mustaches on the women. And while his bodies are amateurish realistic, I have noticed that the hair is all meticulously placed, on the head, below, even on the knuckles, and especially in the mustache.

This is where I am. This is what is going on when you come in. You come in late, late in the term, late in the class itself, a half hour after we have started. You lumber up to me, talk immediately. You do not draw. You take pictures. You say you want to draw. I begin milling about, getting an easel, some paper, some charcoals. Our model is a woman, about 50, with

a pleasant face, rounded shoulders and hips. She sits peaceful, with grace in her limbs. You, too, are standing too close. You have a lazy eye, which wanders from me, watching the other side of the room. You have a rotund belly, which grazes my arm. When I talk to you, I am not sure which eye to look at. You say,

Look at this one, and point to the right.

And I do, and it is blue green, like the ocean.

We make no pretenses at home. I come in to a dark kitchen. Dishes have been washed, food consumed and put away. We are separate, and together.

My students are going out after class. I hesitate to spend time with them. A lot of them are weird, outcast types, with odd smells and habits of language. Some are obsessive. They are going for coffee, down the street at a little coffee house that is actually a house, with a front porch and a swing. I am gathering up slowly, pretending to have something to do. They linger and begin to leave then, as I am washing up, stacking chairs, sliding paper back into bins.

No coffee? I say to you, as you take up the doorway.

Fuck coffee, you say. Let's get a drink. Your shirt sleeves are rolled up. You have forearms like Popeye. Round, like a ham.

I laugh.

Seriously, you say. Let's put some fire in your belly. You wait, to walk out with me, while I think about not going, about going home, and then go anyway.

The fire in my belly went out a year ago, abruptly, at 24 weeks, although in many ways, I am still carrying, still expecting. I do not tell you this. You order for me. A type of beer that comes with a slice of orange.

You either stare or do not stare at me, depending on where I look. We sit outside, at dusk. It is muggy and warm. Finally, you say,

Do I totally freak you out, or what?

No, I say. I smile. Not at all.

What's your deal? you say.

What do you mean?

Are you married?

Yes. I hold up my hand. It is a loaded question though.

Me too, you say. Kids? you say.

I wait a long time. It is harder to see your roving eye in the dark. I imagine it, magical, traveling to my belly, examining through the mesh table. No, I say.

What's your husband do?

He's a teacher, I say. What about your wife? I say.

What about her? you say, half smiling. You lean into the curve of the chair.

What does she do? I say.

She's a mom, you say, as if this implies everything. Full time. All the time, you say. Then you say, Two teachers, as though this is something to consider.

I'm not a teacher, I say.

No?

I laugh. No. I'm just an enabler. I'd rather just be…

What?

An artist sounds so stupid. So naively bohemian. But what else can you call it? I shrug, say, I'd like to just, you know, make art.

Are you good? you say.

Am I good? They let me teach.

But you're not a teacher.

Right. I don't know, I say, laughing, if I'm any good.

Let me see them.

What?

The paintings, or drawings or whatever. What do you do?

Paintings, drawings, I repeat. Our house is full of them. Tim grows tired of them, wants to move them. Wants to have normal art, he says. Just pictures of stuff, like flowers, or buildings, or pears for chrissake in the kitchen. Can't we just get some pictures at Wal-Mart? Do we have to hang these up? It's weird—when people come over.

No one comes over. I think about you coming over. About you breaking the membrane around our house. I imagine you first bouncing off, and then burrowing back, determined.

Sure, I say. You can see them. And then you get up, and pay, without asking, and I think about owing you, about what it means to pay. I have just a little cash on me, not enough to pay for everything. I am rummaging in my bag when you come back.

Next time, you say, and I think about being ready, about how soon next time will come, and how will I ever get there.

Tim watches TV. A NOVA special about DNA. I sit down with a valley between us on the couch, unexpecting conversation or otherwise, and he reaches over, his hand underneath the back of my bare knee. It is both proprietary and tender. We watch the strands lace together, building.

Your pictures are coming along. You have problems with hands and feet, getting the proportions right on the fingers, or getting the feet not to look like two of the same. Your last drawing clearly had two left feet, the curve of the arch in the same spot on both.

I stay to finish my own. I spent less time walking around and helping, and more time just drawing with them. Sometimes this works. Sometimes they get up, and wander over to see what I am doing, to take indirect clues. It is unplanned; I just want to finish something. Something new.

I add colors to shadows, and shadows which I am not sure are even there, since the model is gone now. I add in purples and deep greens, never black. The flesh is orange and brown with bits of blue. Rotund and full. I have abstracted her somewhat. She was not this full, not this fecund, probably. I don't even remember.

You startle me. It's nice, you say, over my shoulder. I am suddenly aware of the color all over my fingers, and probably my face. It's tonight's model? you say.

It is, I say. It doesn't look like her, does it?

It does. It's really nice, you say again. You have backed away, against the easels, leaning. I have not noticed until now that you are clean-shaven, and wearing creased pants.

What does that mean? I say, *Nice.*

You shrug. Just what it is. Nice to look at. I like the color. What do you want me to say?

What you think, I say. It has come upon us all at once, this conversation. This sudden frankness.

Come here, you say.

Why?

That's what I think, you say, I think you should come here.

I put down the blue pastel, my middle finger completely coated in cyan. Your eye is staring me down.

Or don't, you say, and you get up, shuffle away as though you are leaving.

My fat, unfat model is all over the page, all curves and openness, color and depth. I feel constricted, closed up and frozen, standing there, covered in dust. From the doorway, you say,

Are you going to clean up, or what? And you wait while I do nothing, and then you labor back through the room, pushing in chairs as you go, sliding paper across the counter, the things you have seen me do every week. When you stand at my side, your eye wanders over, to me, to the drawing.

I've made it abstract, I say. It's not her.

Everything's abstract up close, you say. This isn't. Maybe impressionist. A sense of something, you say, that isn't quite there.

Is that art? I say, stupid, searching.

That's everything, you say, out of this eye, and point.

How so?

I can't see out of it, you say. Just color and shape and light.

I weigh this, because I am not sure I believe it. But it sounds just right. It sounds like everything should be just that way.

I stop wearing my glasses at home. Everything is impressionist. Blurred edge and a sense of light and color. The kitchen is bright in the morning with yellow and green. An amorphous bowl of purple fruit on a round pink table. Tim is a tan fuzz. Tall and moving through the room. I try not to squint. He asks what I am doing, in that way that implies that he doesn't really want to know.

The split was like a switch. I watched it flick to off after. We went in together, and came home two separate bubbles. I waited for them to reabsorb into each other, for the membranes to break, to rejoin. We just bounce, moving toward one another, and then bouncing away.

People in crisis are slow with information. I had gone in for a routine visit. Urine, weight, blood pressure, heart beat. Heart beat. Again. They say, handing me a slip of paper, We want you to have a sonogram.

We go. We just had a sonogram. We are excited again. We have just discovered he is a boy. I have thought of Thomas, which was my

grandmother's maiden name. In the ultrasound room, the technician slathers my slight belly, moves the wand around, searching. Then she clicks off the screen, and says the doctor will be in shortly.

There is no deluge of information. The doctor says they will give me pitocin, to cause contractions. That there will be a delivery. That there is no fetal activity. There appears to have been a blood clot. The monitor is switched off. Tim is switched off. The contractions are switched on, and I proceed for eight hours to deliver a son, whom I name Thomas, but who will never hear me call him that.

Tim says, Why do you want to name it?

And I shout, It is a he. His name is Thomas. Tim walks away as though I cannot possibly understand. And I can't. I fail to understand how something can be dead inside you, and you can never know it.

I walk around the studio with my glasses off. I carry them, chewing a little on the stem. I look at the drawings with them off. Blurry. They're better this way. Gene, who draws mustaches, has a new drawing of Duane. His body is more accurate this time, closer to an actual real, and he has added a long long mane of princess hair to Duane's bald head. I rest my hand briefly on Gene's shoulder. This is wonderful, I say. His smell is either lessening, or I am getting used to it.

I don't remember when we started kissing. This is not true. I remember the first, but not how it evolved into many. The first was entirely you. You just leaned over and took it like it was yours. Outside my car. Now they are frequent. Like, every time you can. Every time you think no one is looking. I keep waiting to feel something more than just the wet smack of your lips, more than the attraction of attention.

We come back to the studio after drinking at a pub around the corner. I have had just enough to feel it, and feel like I could drive, but won't. So I come up to grab a smaller pad of paper for home, and you follow. As I grab one from the cupboard, above my head, you have both arms, your hands wrapped entirely around my biceps. I feel your belly in the small of my back, curved in, like it belongs there. It feels domestic, not fiery. Familiar.

I turn around and your hand snakes up under my long skirt, up to where I come together.

Watch out, I say, tipsy. I have not told you anything, about anything. I wonder if your fingernails are clean.

For what? you say, surprised, but unstoppable.

That's a site of human destruction, I say, a little laugh. Joking is new. Everything is new.

You say, That's a terrible thing to say. And, It's pretty.

You can't see it, I say.

I can't see anything right, you say, and grin. That's what makes it pretty.

Nothing works. You fish around like your hand is in a jar, looking for a key, until I tell you to stop. You are disappointed.

What's the matter? you say, like you are dejected. Like I have done this to you somehow.

We should go, I say.

Then, You never showed me your pictures, you say.

I shrug. What's to see? I say.

Tim talks on the phone. He laughs like a jackhammer, in staccato bursts that escalate. I lean against the counter in the kitchen, waiting for him to get off.

Do you need the phone? he says, hanging up.

No.

Oh, he says. He looks like he might say more, so I wait, and then I say Tim, but he starts talking at the same time.

What? I say.

You go, he says.

We, I say, and then revise. I have to get past this, I say.

Past what? he says.

This, I say. You know. The baby.

Oh, he says.

What were you going to say? I say.

I met someone, he says.

Really, I say. I think about hate. About how I used to think it probably didn't really exist. That it was too strong a word to ever actually be used.

Well, he says. It's not really…I don't know. It was just a thing, he says. But yeah.

Yeah what?

Yeah you do have to get past it. We're not old, he says, to be so resigned.

Tim.

Wait, he says, and I see it working out, in his head. I just…you changed, he says. After. And it was like, I just realized that you were one of those women who changes. And that it didn't matter. The baby. Because you would have changed anyway. Being a mom. I lost you, he says.

He looks into the living room, like he is waiting for something. I look at the side of his head. I remember him staring out of the delivery room, into the hallway, while I pushed.

Why wouldn't you look? I say.

At what? he says.

At Thomas, I say, speaking his name again, after more than a year. At him being born, I say.

He has wrinkled his nose at the sound of his name. I didn't want to, he says. Can't I have that right? I didn't want, he says, to see something…dead coming out of you. I didn't want to associate you with that. It's like…seeing too much…truth, he says. Too much, of what is real, he says. You know?

I shake my head. I have no idea what is real. He gets up and he comes over and he takes my glasses off, and I think he's going to kiss me, for real. But instead he kisses my forehead, leaning his lips there, with his hand cupped around the back of my head, sealing us off, so that we press together, like magnetic dolls. ≋

Susan Robinson

The Year That Everything Died

It was August 25th of the Year That Everything Died. Clare Roberts didn't know it yet, but the Grey Ghost would not be taking her to Burning Man 2008. No, it would not be painted in rainbow colors, nor would it be dubbed the "Unicycle Clown Car" as tribute to its role in transporting two bad unicyclists to the legendary festival in the desert.

Yes, she knew about the other dead things—Big Mac, the oak tree; Fatty Brown, her cat of 12 years; Michael...well, not Michael himself, but their relationship; then there was Mr. P; and of course, Pam—yes, Pam herself.

Clare had been having quite a year. The way she remembered it, things started dying off back in March, on the very day that Clare put on stockings, heels, a black trench coat and nothing else, and drove two hours to Pine Knob intending to surprise Michael for his 30th birthday. It was a day full of anticipation and sweet thoughts. That is until the brakes gave out just two blocks from Michael's apartment, but exactly in the same spot as the shiny rear end of Governor Bronson's new Escalade.

"Lemon!" screamed Clare, but the Grey Ghost just sat there with its hood in the Governor's rear and its red brakelight beaconing a now-pointless warning. I'll have to call Pam, thought Clare. "Pam! You better get here quick because I just trunked the Governor, the cops are coming, and I don't have any clothes on!" Pam never missed her Friday night meeting, but as soon as it was over, she was there. Unlike the Grey Ghost, Pam could always be counted on for a ride.

After the tickets were written and the tow truck had hauled the wrinkled Grey Ghost and the not-so-shiny Escalade away, Pam even drove Clare to Michael's place. As it turned out, Michael really was surprised. He didn't have any clothes on either, and the woman beside him, on Clare's side of the bed, looked genuinely surprised as well. "Let's get out of here, Pam," Clare said as she tightened the belt on her trench coat. And that was the last time Clare ever saw Michael in less than a fully dressed condition.

A couple weeks later, with the help of a 500-dollar brake job, a junkyard fender, and some duct tape, the Grey Ghost was back on the road. And it was a fortunate thing too, because that very night, Fatty Brown choked on a hairball and had to be rushed to the veterinary hospital. Even though it was 3 o'clock in the morning, Clare didn't hesitate to dial Pam's number, "Fatty's

got a fur-ball!, ...meet me at the vet!" Clare croaked groggily into the phone. But the Grey Ghost had other plans, as Clare found out when she put the key in the passenger-side door and could not turn the lock open. "Son of a Bitch!" cried Clare as she listened helplessly to poor sweet, fat, Fatty's raspy breathing. Yes, it was the Grey Ghost's annual early spring "lock freeze." From previous experience, Clare knew it was hopeless to try the other locks. She got on the phone, "Pam, the Son of a Bitch won't open, can you come over and get us?" cursed Clare. "Tell Fatty I'm on my way!" Pam yelled into the phone. Pam was happy to help, and it didn't hurt that she was a chain-smoking insomniac who liked late night trips to anywhere.

Clare was relieved and happy when Dr. Pratt pulled a wet, hairy mass of fur out of Fatty and pronounced him very much alive and with five of his nine lives still intact (the other three having been used up on previous mishaps.)

With Fatty safely back in his cat-box and the Grey Ghost's door locks W-D 40'd, Clare's thoughts began to turn to spring. The weather was warming up now and the recent weeks had been especially rainy. Clare began to notice the lawn of Mr. P's house looking more shaggy than normal. Up 'til now, Mr. P had always been known in the neighborhood as a "cross-hatch" mower, which for all practical purposes meant he was anal-retentive and mowed his lawn in a perfectly straight, cross-cut fashion every six days whether it needed it or not.

As the grass grew higher and higher, Clare became more and more concerned. Mr. P lived at the opposite end of Dandelion Way, so it was not so easy for her to monitor the situation.

Even though Mr. P was generally thought of as a "pain-in-the-ass," the neighborhood still tried to look out for him because he was old and didn't have a car or a dog or a wife. Clare began to make a habit of driving past his lawn on her way to the auto-repair shop or the grocery store. One day in the middle of April, Clare gassed up the Grey Ghost and headed down Dandelion.

Just as she rounded the curve that lead to Mr. P's lawn, the Grey Ghost gave a lurch and a sputter and Clare heard a loud "Screeeeek!" coming from where the left front tire used to be. It was coming from where the tire used to be, because the tire wasn't there anymore—it was now rolling into Mr. P's un-cross-hatched, foot-high grass. "You No Good Rust Bucket!" wept the exasperated, concerned neighbor named Clare. It would be fair to say that Clare was pissed. But she was also astute enough to recognize this as an opportunity to get closer to Mr. P's overgrown lawn.

Clare decided to leave the Grey Ghost in the middle of the street, right where it was, which was an easy decision to make, since the front tire was gone and the axle was sitting on the pavement. She went to retrieve the tire, but took a quick peek in Mr. P's front window on her way past.

What she saw inside distressed her, but also quickly solved the mystery of the overgrown lawn. Poor Mr. P was sitting in his chair slumped over the kitchen table. He didn't look so good. In fact, he looked dead—and he was. Clare became panicked and didn't know what to do. She called the only person she could think of: "Pam, you won't believe what has happened! Come and get me over at the foot-high lawn, right away!"

And of course, Pam did, because she was that kind of friend—the kind that drove you crazy with her chain-smoking and her coffee-drinking and her late night panic attacks, but who came when you called her. Because 14 years ago, on a cold December evening, someone had bothered to answer when she dialed the hotline number off the back of the matchbook cover. In so doing, Pam had reached past the full syringe and the little baggie on the night stand and out into the abyss where an outstretched hand was waiting. Yes, it was safe to say that Pam understood about the hard things.

She knew Clare had a Dodge and man troubles and an overweight cat. And now she understood that Clare also had an old, dead neighbor on her hands. A stiff and smelly Mr. P, who had passed away alone at his kitchen table and who was probably not such a bad guy, if anyone had taken the time to really get to know him.

Well, after Pam and the police and the tow-truck driver arrived and then left, and Clare got her Grey Ghost out of the repair shop with new ball joints and a new front axle, she took a couple weeks off to relax. The Grey Ghost seemed happy, or at least somewhat contented, and so was Clare, considering all that had happened to her in recent months.

She sat by the window and daydreamed about the great adventures she would have at Burning Man, compliments of the Grey Ghost. She took daily naps with Fatty under Big Mac, the 50-year-old oak tree that had stood watch over her backyard, and the neighborhood, for the whole 10 years Clare had lived in the house on Dandelion Way.

That is until one evening in July, the 4th of July, to be exact. The Jones boys were shooting off fireworks across the street and Fatty Brown was sitting under Big Mac. Suddenly one of the firecrackers went the wrong way and ended up at the top of Big Mac. Shortly thereafter, smoke, and then flame began coming out. Clare screamed at Fatty to get out of the way; the smoke and flame were becoming thicker and more out-of-control and

Clare was afraid. She ran for the phone and dialed 911, but when she got back, she heard a sickening sound of breaking branches and then a weak, half-hearted "meeeooooowwww" coming from underneath them.

Clare ran back to the yard and grabbed Fatty, who was gasping for breath, but not moving. Clare got the phone and called Pam, "Meet me at the vet, Fatty got hit by a tree!" Clare put herself and Fatty into the Grey Ghost and took off for Dr. Pratt's, but Fatty was failing fast. Clare phoned Pam again, "Pam! Help." was all she could manage. But that night Clare found out that there are some things even a nicotine-addicted best friend can't fix, and this was turning out to be one of those things. Fatty Brown died in the passenger seat of the Grey Ghost, before it even got to the hospital. Clare cried. Pam was there to meet her, of course. And even though Pam had never really been a cat person, she listened patiently to a story about how a 12-year-old cat that was supposed to have had five lives left, turned out to have only one, and about how there would never be another cat like Fatty.

After what seemed like hours, Clare remembered her backyard and yelled to Pam, "Big Mac is burning! Can you meet me there?" Pam had been looking more tired than usual, and Clare thought she detected something odd about the look in her eyes, but Pam agreed to meet her at the house. The Grey Ghost had some trouble along the way—a stall in the left-turn-only lane at Grand Ave., a headlight that suddenly went out, and a flat tire, but in spite of these setbacks, Clare made it back to her driveway. When she arrived, the fire trucks were already there, but Big Mac wasn't anymore, unless you count the smoking stump and the pile of ashes in the backyard. "I've had a long day, guess I'll see you on Saturday," Clare said weakly as she waved goodbye to her friend.

But Clare would not be seeing Pam on Saturday, or on any other day for that matter. It seems that Pam was having a few problems of her own and the Friday night call from Pam's distraught husband, Mitch, informed Clare of this fact. "It's Pam! You better get here as soon as you can." Pam had been found face down in the bathtub with an open container of sleeping pills and an empty bottle of Jack Daniels next to her. Clare grabbed the keys and sped to the hospital. The Grey Ghost nearly ran out of gas along the way, but surprisingly enough, made the trip in record time. It didn't really matter though. Pam was already dead by the time Clare arrived. Clare hugged Pam and then Mitch. "She was my friend," choked Clare. Mitch said that he already knew that. Clare took Mitch for a ride in the Grey Ghost, where Mitch explained that he and Pam had been going through a "rough patch" and that he blamed himself for what had happened.

After the funeral, Clare went home and cried for a long time. She went over and over things in her head. Had she missed something? Why hadn't Pam called her? She went for long rides around the lake; she packed jumper cables and a picnic basket and took the Grey Ghost on a weekend trip to the ocean; she ate French fries. When she was finished, Clare decided that there are just some things even a best friend can't fix, and that for Pam, falling off the wagon had been one of those things.

Yes, it had been the Year That Everything Died, but new, alive things began to emerge in their places. Pam was buried, the summer moved on, and Clare tried to move on as well. She planted a new maple tree in the back yard. She started dating again and met a cute guy named Zack, from New Zealand. Zack owned four Irish Wolfhounds and a broken heart, but his eyes lit up the moment he saw Clare and suddenly it seemed ok for him to try love just one more time. She found an orange kitten at the SPCA that looked just like Fatty, only smaller.

A late afternoon drive to the repair shop took Clare down the opposite end of Dandelion Way, and confirmed that a new family, who would soon be known as the "Crabgrass People," had moved into Mr. P's house. The day Clare drove by, there were six kids and a jungle gym in the front yard. They didn't appear to be cross-hatch mowers. In fact, from the looks of the lawn, they didn't even own a mower, but the kids seemed happy to have a yard to play in and Clare was happy for them. And of course, she still had her Grey Ghost.

But that last part wasn't quite true, as Clare found out when Dave, from the repair shop, called on the afternoon of August 25th, with the news that there were "a few problems" with the Grey Ghost. The struts were rotting, the entire muffler system needed replacing and there was water where the oil was supposed to be. There were a few more things, but Clare didn't want to hear about them.

Even though Dave had a water-pump and valve job waiting in the shop that he had to get finished by 5 o'clock, he tried to sound patient as he explained to her that there were some things even an $80 dollar-per-hour-labor-rate repair shop couldn't fix, without a major credit card and at least two forms of I.D. "I understand," said Clare, and she did.

Over the next few months of what was left of the Year That Everything Died, Clare tried to keep busy. She planted a tulip garden in the shape of the word "P–A–I–N." She watered the sapling in her back yard. She checked the classifieds for a new Grey Ghost, but there weren't any, so she bought a motorcycle instead. She really enjoyed riding it.

Still Clare thought about Pam. One day she even dialed her number just to see if someone would answer. But nobody did. She began to see that there might never be a day that she wouldn't miss Pam. Even a great guy like Zack and four funny-looking dogs couldn't fix that.

And yet, Clare could also see that even though she would sorely miss the Grey Ghost and Dave and all her friends from the tow truck place, she might still make it to Burning Man on her new, slightly used, pink Harley.

And so, in August of the year after the Year That Everything Died, Clare did go to Burning Man, But she didn't go on the Harley, she went with those funny-looking dogs—and with Zack. She had a pretty good time. ≋

Mary L. White

THE TIME I RODE THE CALF

I was eleven, I think; that would make it the early summer of 1956. I thought I could ride anything on four legs. I was a skinny dreamy kid with hair yanked and twisted into two long braids. I didn't spend much time worrying about how I looked. Horses and books, mostly books about horses, were what was on my mind, though I liked all kinds of other animals too. When I couldn't ride, I read about it, and when I couldn't do either I thought about it. I wasn't all that good, I rode mostly by balance, but I could stick. My only riding instructor had been a tall old Quarterhorse named Barsocks. I'd never heard of a "diagonal," but I'd taught myself to post after listening to my sister's descriptions. She took riding lessons one semester in college and that seemed all the reason I'd need to see going to college as a goal.

Every spring there was this little local horse show with a parade that came down our street on the way to the fairgrounds and ball field. And I always felt sure I'd die if I didn't get to go to it. I'd sit on an old railroad tie that lay out front by the street and just breathe in as those horses and riders passed with their flags and the shirts with the stitched yokes and their hats at cocky angles, the horses all curried up and shiny, and maybe one or two just a little prancey and skittery—and maybe one rider just a little red-faced and having too loud a good time. And I'd agitate my two cousins till they were sure it was the only thing in the world they would die if they didn't get to do.

Now none of our parents had any interest at all in this. But by some miracle this one year, they all agreed that it would be all right for the three of us to go together. This was not a town where parents very often let their girl children far out of their sight. Junction City was never the safe secure kind of small town some people have known, and I knew better than to ask to go much of anywhere alone. We had some of the elements of a small town, but also some aspects of a very big very mean city. I wasn't encouraged to know much about my father's bail bond business and the pimps and gamblers who came regularly to the back door where his office was.

So our mothers conferred on when we were going and what we would wear. Dresses, jeans, and shorts were rejected for reasons of propriety. Dresses were unsuitable for wear in the bleachers where boys could look up from

beneath; shorts were never acceptable in public, and neither were jeans. My aunt said her girls were going to wear something called pedal pushers. I rebelled briefly at the pedal pushers; I thought that was a dumb name and I didn't want anything to do with them. I was like that, distrustful when I suspected cutesiness and adult condescension.

But we went to the horse show in pedal pushers, gray striped seersucker pants that came just below our knees. We were given money for admission and to buy ourselves something to drink. Either my mother was short of change or I got my allowance that day because I had enough to pay 50 cents for an entry fee to the calf-riding contest.

It was the sort of thing that would never be allowed now. But in 1956 most people seemed to assume that if kids broke their arms doing something or other it was all in the normal course of growing and they thought they probably wouldn't break their necks. Surely no one thought about lawsuits over it. Kids got hurt or they didn't and that was life. No one was to blame and parents held themselves responsible for the doctors' bills, which were usually not life threatening either.

When I saw Children's Calf Riding Contest on the program, my thought was, "Here's something I can do." It's a given here that while I wanted to go to the horse show, I was considerably frustrated being only a spectator. I had no horse of my own I could ride in a contest and I wasn't happy about that. I rode rental horses, friend's horses, begged rides by hanging out at the blacksmith's and, at my aunt's farm ninety long miles away, there was old Barsocks who I loved and rode with great joy whenever I could get there.

I took my 50 cents and went up to the little office and paid my entry fee, hoping I was walking like Champion All-Around Cowboy, Jim Shoulders, the man I wanted to be. There was no parental permission form. I just gave the lady my money and she took my name and gave me a cardboard number to fasten on my shirt, like a grownup rodeo contestant. It didn't occur to me to notice that I was the only girl doing this, nor did I remember that I had never seen a woman bull rider.

We stood for the *Star Spangled Banner,* me wishing I had a hat to take off and hold in front of me, and settled down to watch the show. My cousins let me have a sip of their Cokes. Gene, from the A & P, won at calf-roping and western reining on Stella. I'd been on Stella and thought she was truly wonderful, a dark bay, fine and light on her feet, sensitive and gentle. A boy whose grandfather ran the rental stable rode a gorgeously handsome palomino pony to win nearly everything else. I didn't like him, not just

because I was jealous of that pony, but because he didn't seem to love horses though he had all the opportunities.

The first entries in the calf-riding were called up and I clapped with everyone else as they tore across the baseball field arena and landed in the dust and got up more or less laughing. I felt good anticipation when I headed down from the grandstand. I didn't get scared till I got next to the calf I was to ride, held in a little chute pen.

There was a rope with a bell on it, went 'round his belly, just like a brahma bull in a real rodeo. He was a lot bigger than I expected. This critter was black with a brockle face, some kind of angus crossbreed, all hairy and dirty, not a cute little baby calf, but pony-sized, a nearly half-grown feeder steer.

It was all pretty informal. You climbed on the calf, a man thrust the rope into your hand, they let the calf out, someone punched a stopwatch. When the kid came off, he let go of the rope, and rope and bell dropped away. Someone ran the calf into a pen at the other end of the arena and someone else picked up the kid and dusted him off. The timekeeper said how long a ride he'd made and the announcer repeated it. There was no scoring of points for style of ride; winner stayed on the longest.

By the time I had my toe on the first board of the chute I had pretty severe second thoughts, but people were looking at me. My name was called. I may have regretted entering, but I didn't seriously consider backing out then. Two men helped me on. The calf moved restlessly. I balanced myself, gripped the rope in my right, and raised my left hand free and high in what I knew was the proper manner.

Then came my biggest mistake. One of the men pulled my left hand down, put it on the rope. "No," he told me, "you hold on with both hands, it makes it fairer." And I obeyed him.

I was always an obedient well-behaved child. I entered this contest because it had not occurred to anyone in my family to forbid me to do so, and that was because they did not know it was to be held. If they'd told me not to ride a bucking calf in a public contest, I'd have stayed off the thing. So, when this man told me to hold tight with both hands, I grabbed on, and when the other man asked, "Ready?" I nodded.

The gate slammed open, the calf leaped out bucking furiously, bell clanging. Braids snapping, I gripped with everything I had, and we got half way across the arena before I came loose. It was wild and violent and terrifying. I came down hard.

It was Gene who picked me up. He slapped some of the dirt off me and said, "Don't cry. You did great, that was a good ride." He held my arm up in triumph. I was holding back the tears. "Smile," he said, "you did fine." I smiled, and limped to the fence. They announced my time, it was the longest so far. I tried not to hear someone who muttered behind me about my using both hands. I couldn't climb the fence out of the arena just yet. I had to stand there for a little while; my legs and hands were shaking and twitching. It was an odd sensation; when it stopped, I joined up with my cousins in the grandstand.

Another, bigger, kid had a time almost as good as mine, and then came a kid who got on a skinny little calf that didn't buck. It ran all over the ring and almost never did buck, so he got a better time than mine. And there were mutters about that too, a suggestion that they put him on another calf and a suggestion that the best two ride again. That was me and him and I was relieved when the judges awarded the prizes by the times as they were.

I got second place with a red ribbon and two dollars prize money. I pinned the big rosette on the front of my shirt. Gene, who was something of a hero to me, told me again that I'd made a good ride, and I had a ribbon to prove it. My bruises didn't hurt more than a little. I was about as happy as an eleven-year-old kid could get and there haven't been a lot of better moments in my life.

My aunt had a fit when she came to pick us up. She said I couldn't be trusted, I might have been badly hurt, she was shocked, how dared I? She carried on. I was about sick with misery and fear. If she was that mad, there was no imagining what my mother, who was usually stricter and meaner, would do and say. Spanking would be the least of it. I took the ribbon off my shirt. I hid in the attic and cried while my aunt had her say with my parents.

I was pretty shaky when I finally faced my folks, after my aunt took her girls off away from further contamination by my misbehavior. And a sight I must have been, tear streaks, bruises, dirt from the arena smeared on those new pedal pushers, braids coming apart, but still clutching this big red rosette. Whatever happened, whether I was bad or not, I had won that ribbon. It and the time of winning it were mine.

As it turned out, they weren't all that bothered by the whole thing—they were even a bit proud of me. They said they knew I was a good rider and they were glad that if I got on the critter that I had not cried after I came off. My mother must have wondered what kind of child she was raising, but

maybe blamed herself. After all, everyone in the family respected her aim, and hers was the trophy buck that hung in our living room. Anyway, if my father chose to be proud of me she wasn't going to argue.

It must have taken another kind of bravery for my mother to describe my exploit to her parents later that evening when, bathed and in my Sunday dress and shoes, with the ribbon pinned on the front, we went there to dinner. My mother's parents did not necessarily find me a grandchild that they could easily understand, but they always showed me kindness and affection. They may have wished that I was musical or at least graceful, but they exclaimed and admired the ribbon with almost as much enthusiasm as my spelling awards.

The experience would become for me an affirmation of my physical courage, my working class roots and rural values, a source of deep confidence. I would think to myself, "I was strong and brave and capable, a tough little dyke. I'm not afraid of pain, nor do I bow to conventions—neither those of female roles nor of aesthetic traditions." I've been able to recapture that sense of myself ever since, even when I was feeling shattered or despairing and feeling sure only of my helplessness.

What has stayed with me down the years has been my sense of valorous achievement—and my sense that maybe it was undeserved—my shame about that left hand on the rope. I knew that touching the animal in any way with the free hand was disqualifying. I knew that like I knew Poco Bueno's pedigree and the names of the three founding stallions of the Thoroughbred and that Justin Morgan was raised in Vermont. But I'd held that rope with it anyway, and taken the ribbon and the money.

It was a long time before I figured out another angle on what really happened. Those men couldn't have stood it if I'd won without that illusion of advantage. Those were their sons and nephews I was riding against, their boys. And I probably was as good or better a rider than any of them. I could have won without that extra hand, could have won clearly and surely, and they couldn't have stood it. There had to be that doubt. ≋

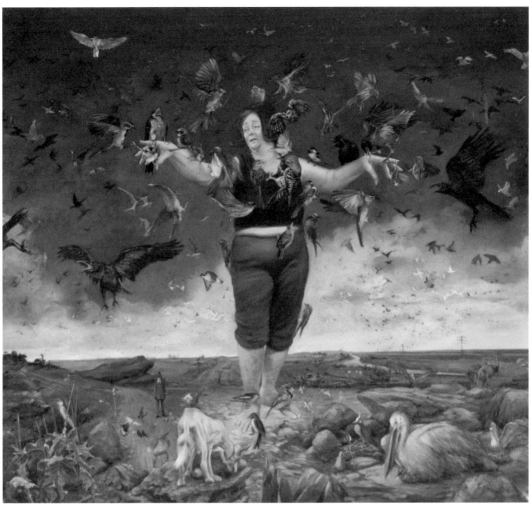

JOY ADAMS, *The Flying Lesson*, oil on linen, 65"x60", 2003

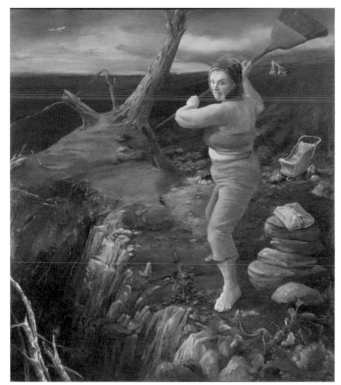

JOY ADAMS, *Sally's Folly,* oil on canvas, 65"x60", 2002

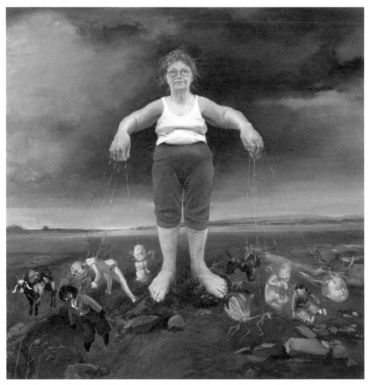

JOY ADAMS, *Mad Sally with Things on Strings,* oil on canvas, 65"x60", 2000

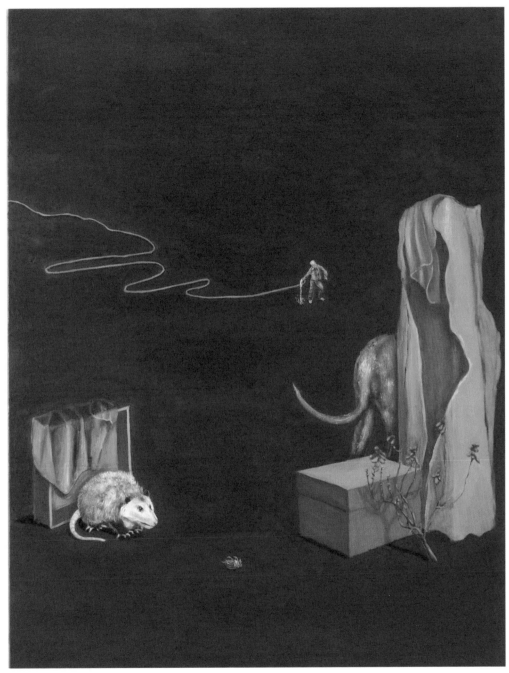

Linda Price, *After the Flood,* oil and wax on canvas, 48"x60", 2007

LINDA PRICE, *Icarus,* painting, oil and wax on canvas, 41"x65", 2007

Kath M. Anderson

DAYS AND DAYS

Her dream arrived. So she woke.

The crows persisted, two caws
answered by three when she opened
her door to the dawn.

Light, root me here at my door.

The sky filled suddenly with black
feathers, the near-at-hand
crow lighting solid
amidst the traceries of plum twigs

by the door. *You should see
the plum tree* said her husband, never
the Chinese poet, it looks
like pink snow.

It won't last, she said.
She noted the flit
and dip of pinion jay flight,

and later, distance:
thunderheads hung
over the mountains.

Lightning stitched them
together into lovely haggard horizons.
In a desert, the best dream is a boat.

REMEDY SPACE

If you could see for miles
there might be a wholeness,
a remedy space.

An element of you seems
very near and very far
at the same time.

The child you protect
waves goodbye.

(At the same time,
some of us are so afraid.)

Elongated time, like shadows
at sunset—an illusion.

The very nape of her neck.
But the child murmurs
and then and then and then

Linda Tomol Pennisi

THE SKY'S SEVEN DRESSES: WHERE THEY CAME FROM

Three small shops on London's side streets, 1972.

Blackbirds dragged them from the attic.

Wrapped packages an old man imagined on his Cadillac's back seat.

Miniscule holes in the scalp left by an acupuncturist's needles.

The skywriter's words loosened their skirts above the town.

After painting the nudes, seven artists lay on their backs and painted
their dresses.

Seven lyric sopranos lifted their heads and sang.

Eve's seven days of weaving.

Smoke from seven coal-fired stoves.

Tossed up by seven strippers.

Seven dreams by seven women.

One woman's seven dreams.

The Hour of Washing

How much rainwater in the white

enamel basin? How many hours

to soak the berry-stained blouse

in how many capfuls of Tide?

How many times to immerse the hands

in blue water? How many rubbings of cloth

against cloth, of day against night,

of tongue against fur? How many bubblings

up of how many memories from how many

hillsides? How many small white smells

on the line? How many braids

wound around heads of how many

grandmothers as they bend

over berries or basins? How many

girls touch in how many tubs?

How many women pronounce

body of water? O friction. O basin.

O tongue.

You Can Catch a Cloud

If you trust the plank you've suspended over helplessness.

If you dangle your legs.

If you wait.

If, when mist settles in the chasm, you bend slightly at the waist.

If you scoop with the slow grace of one who knows how to handle the almost seen.

If you fill the jar you've laid, open and wide-mouthed, on your thigh.

If, in tightening the lid, you feel triumph and guilt.

If you place the glassed-in cloud like a beloved pet or the spirit of a dead father beside you.

If, when you've filled all jars that have materialized inside your pockets then lined them on the plank, you have the urge to nudge each one.

If you cannot remember whether the contents is smoke or fog, or if the spirit is one of human or goat or dog.

If you, as god of that small moment, send or don't send each cloud crashing.

If you bend at the waist and wait again.

Ryan Skrabalak

GUERILLA

She met him under the spider-bridge
He was a big shot European
A white cigaretted smile and sunglassed eyes
He spoke a sharp accent and a package

She cradled it in her arms as
She ran through the sweet jungle mist
Swaddled gunpowder
For the greater good

She tucked her child in under
The steel-thorned skyline
In a small manual red Fiat
She knew about caring for disaster

The fires reminded her of
Tree frog's eyes in the moonlight
She stood on horizon's edge
She hugged herself from the inside

Elizabeth Twiddy

Boys Leave the Farm at Dawn to Fight in the Civil War

The blue animals
move calmly over the soil,
hair combed, parted straight—

wade silently—long
arms of wheat, unharvested,
part down the earth's scalp.

There

they were all there
in the rooms
between floors
in the house

there, time was still
but the paintings moved
in and out
of rooms
and their faces
carried with them

Zoo Animals in the Rain

We dressed our bodies in clothes we bought at a store.
We put makeup on each other's faces and we went to the zoo.

The zoo animals like church lights in the rain:
The zoo animals in their furred feet, wet heads
Licking their faces into shapes:

Blurred, rain on glass:

The zoo animals' eyes in the rain, their eyes
Look out of cages, into ours, out of cages, looking back:
We shuffle in our furs. We shuffle
and look out of cages—

The zoo animals' voices in the rain:
We murmur and rub against ourselves.

There is a bevel, there is a pedestal.
There is a fountain, there is a font.

We come to this point. We all
Come to this point, where we call
And shuffle, and murmur, among, against,
Ourselves.

The zoo animals like church lights in the rain
Of red candles, eyes of red lights in windows,
Furred feet, wet heads—

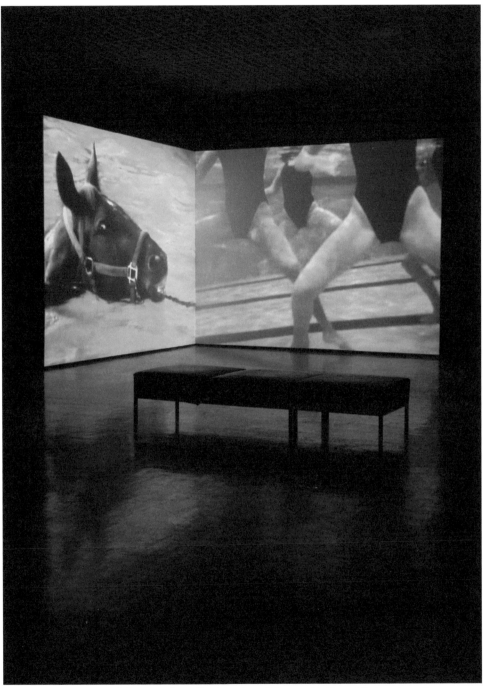

JANET BIGGS, *Water Training (installation view, Hatton Gallery, University of Newcastle, U.K.),* two-channel video, variable dimensions, 1997

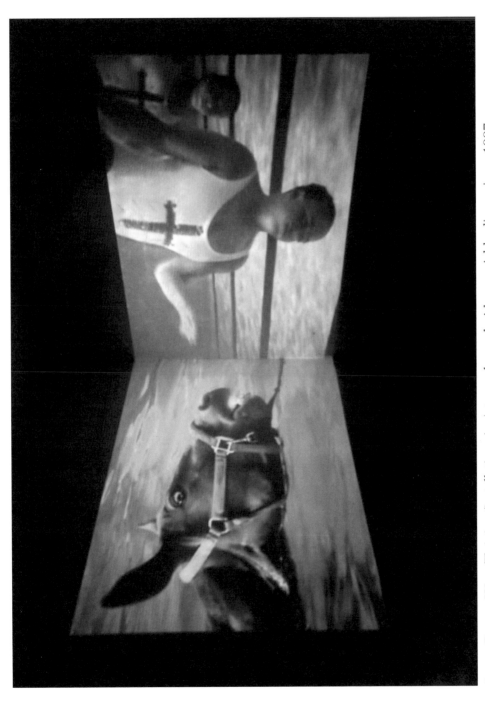

JANET BIGGS, *Water Training (installation view)*, two–channel video, variable dimensions, 1997

Janet Biggs, *Water Training (detail, swimmers)*, two-channel video, variable dimensions, 1997

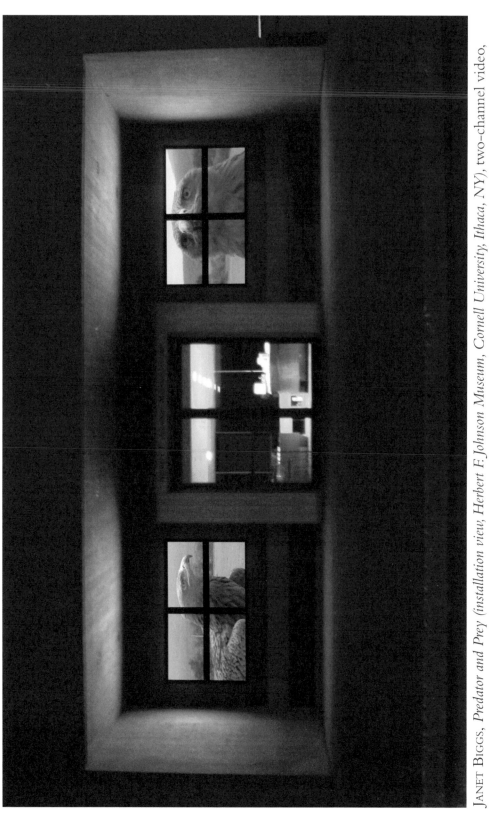

JANET BIGGS, *Predator and Prey (installation view, Herbert F. Johnson Museum, Cornell University, Ithaca, NY)*, two-channel video, variable dimensions, 2006

Tyler Hendry

They'll tell you you're not supposed to laugh with a gun in your mouth. Those people, they'd probably try to tell me I haven't wasted my life. Those same people, in this same room, I've heard their confessions. Fuck those people.

As I kneel in standard-prayer formation, he's holding the gun in my mouth. With his hand shaking, my teeth numb as the cold metal jumps from incisor to molar to canine and back to the mandibular lateral incisor. Kneeling here, this is my deathbed repentance, my final reconciliation, but those people I was talking about, they'd say it's going all wrong.

The only person who ever really knew me is the one performing this all-out dental assault. Standing over me, he's reciting his "Hail Marys," his "Our Fathers," and his "Apostles' Creed." In time with his wasted words, tears and sweat pour from his face, combining into one wet-ball of sincere emotion as they hit the floor, pouring the kind of emotion he made me feel once, the kind of emotion I've only felt once, and the kind of emotion that's never been felt inside any church before this.

Kneeling here, seconds away from having my uvula annihilated and my tongue tastefully displayed against the wall in a back-alley tonsillectomy gone awry, I can't help but laugh. I can't help but laugh as I think, this position, my mouth wrapped around the gun in this way, the gun dangerously close to activating my gag reflex, making this an even messier situation, this is how it all began, and now, this is how it will end. Beautiful closure. Romeo and Juliet reinvented. Exit Juliet, enter Friar Lawrence.

For the beginning, visit Miller Theological Seminary 25 years ago today. He got the silver part right, but the trigger screams tacky. Still, I guess it's the thought that counts.

It all could have been avoided if we would have paid attention to detail, or maybe if we read the fine print in the student manual. If we looked close enough, I'm sure we could have found that "golden rule," hidden somewhere between academic dishonesty and behavioral conduct. That same rule everyone knows by heart, the one displayed outside of swimming pools, amusement parks, and wherever rules are sold. That age-old adage your grandma taught you, everyone say it with me, "No kissing, fondling, or sodomizing your seminary roommate."

If only we could have seen it in writing, then maybe it would have clicked. Instead, for that one night, we experienced humanity in its purest form, free from constraints, free from inhibitions, and most importantly, free from God.

There were no flowers, no movies, no mini-golf, no Bible-study dates. There was no gradual progression as we rounded the sexual bases. This was our only trip, and we weren't stopping at third. For me, that night was a solo home run in the middle of a blow-out, just a fleeting moment of ecstasy in a nine-inning life that I had already given up on.

For him, this "hit," was a walk-off shot in game seven. The kind of hit that defines your career and transforms the comfortable beneath-the-radar life you thought you knew.

For him, the problem wasn't in the moment, but in the aftermath, or the redefinition. Ask yourself, what happens if the one thing that ends up defining you is the one thing you were raised to hate and despise? A redefinition creating a life filled with home-run trots that you know lead straight from third to hell. His fear of facing this redefinition cost me a roommate and the only ballplayer I could ever love.

The note was on the Bible the next day. *"He is the only he I can love. Goodbye."* That night and those words were the last I had seen or heard from him, until today.

Now for the end, welcome back to St. Stephen's Church, back to the confessional. He's just finished reciting his prayers, and I'm still the lunatic laughing. The uncaring, unfeeling piece of shit with a collar he turned me into.

I've spread God's divinity to thousands, inspired parishioners to repent their pathetic little sins, while my only true repentance was never repeating that sinful night. While they prayed to me, I was left praying for enough of those "solo-shots" to get me back in the ballgame, but his exit, and his last words, they left me repeating that same blow-out forever. Leaving me perpetually wanting, perpetually losing, and finally, perpetually numb.

I am what he made me, and the crazed dental hygienist standing over me, I assume this is what I made him. After twenty-five years, judgment day has arrived, face to face, or mouth to gun, with my creator.

His tear-soaked eyes catch mine, and his voice, it begins to quiver in time with the shaking of the gun, both in their own way counting down my demise.

"Because of you, I am nothing. You're a disgrace. That collar should be my collar and your church, my church. I know you never loved God, you could never love anything. You know you ruined me, and even worse, I know you can't care."

Staying true to his cavity-fighting persona, he expects me to respond with metallic instrument in mouth. After my first mumbled syllable, he removes the gun, leaving me just enough time to rinse. Just enough time for his patient to wipe his mouth, smirk, and wryly respond, "No, I missed you more."

Before I can even close my mouth, the drama queen is back at it with the gun in my mouth routine. The shaking's gotten worse, his everything is drenched in sweat, and now his trigger finger looks ready to play. I guess I added fuel to his homophobic fire, the little queer.

"Shut your god-damn mouth Thomas!"

He's so cute when he's angry.

Still quivering, he continues, "There were so many things I wanted to say to you in arsenic-laced Christmas cards. Every time I wasted a paycheck feeding that sick gay desire you awoke, I felt like I owed you a tithing. I owe it all to you. I wanted to send it to the church, but I could never find the right envelope, so here it is. Ten-percent of every blow-job I ever got, and ten-percent of every hand-job I ever gave belongs to you."

This monologue delivered in hysterics sounds like a high-school drama production, with accents on all the wrong words and the kind of exaggerated emotion that could only be real in fiction. I still want to laugh, but his trigger finger's precarious dance between life and murder keeps me silent, as I act out my final scene with the seriousness of a character worth saving.

I think about the way he said Thomas, and my mind sets up the projector that's spun the film of our one night together, every night, for the past 25 years.

No one ever calls me Thomas anymore. Twenty-three years hidden behind this collar, 23 years as Father Almont, a fraction of my former self, a character following a script I know was never written for me.

His screeching words shatter my thoughts.

"You started my addiction. My life for the past 25 years has never changed. The same sin, followed by the same reconciliation, over and over. Fuck, rinse, and repeat, my shampoo bottle life. I transferred to another seminary, and the demons you unleashed, they caught up with me again. A hidden computer file means nothing if you forget and leave the incriminating pictures on the screen with the door wide open. After that, I got kicked out, I hit bottom,

and I've sunken in. From alcohol to heroine, no drug can compare to the rush I get from my real addiction, and I've tried 'em all."

I mutter, "I'm sorry," and the way the shaking of the gun makes my voice tremble, it almost sounds sincere.

As he goes on, his apprehensive face turns vengeful.

"I was sent to serve and love God, and you were sent to ruin me. The demons within you became the demons within me. I was pure once, but you, you were always evil. As long as you're alive, I know I can never escape."

I can't laugh, I can only repent. This is the time for my final reconciliation, and despite what those people might think, it's starting to go just as I planned.

No one ever calls me Thomas anymore.

The whiteness of his trigger finger widens as the blood rushes away. Seconds away from death, and the life flashing before my eyes is not mine, but ours.

The film on this projector never fades.

I repent never making a sequel, I repent living a lie, I repent my entire life, minus that night and right now. The second he walked into the confessional, I knew it would come to this.

The way he said Thomas, the way I finally know for sure what love feels like, the way this gun is about to end my life, I've never felt anything like this before. The reality is I haven't felt anything at all for 25 years.

Love, it is being created, and it is creating. Love is finding your creator, and no matter how wrong or foolish it may seem, holding on for dear life and never looking back.

"On earth as it is in heaven..."

He's back to reciting his prayers. Praying for my soul, or maybe his own. The trick is, you can manipulate a prayer to mean almost anything.

As the "Our Father" winds down, his eyes close as he summons his "courage" for this one cowardly act.

Before he pulls the trigger, before I have a chance to think, by instinct, I begin, "Lord, make me an instrument of your peace." Despite my gun-filled mouth, the look on his face shows he understands the words.

I still remember the prayer, it was the first time we had ever met, and it was at the first assembly I ever attended at Miller. This prayer was our oath, symbolizing the beginning of our journey into the priesthood together, and now, it symbolizes my exit.

I've found my new devotion, and this prayer is for him.

St. Francis of Assisi's prayer reinvented, exit the Lord, and enter my creator. Remember the trick.

As I struggle with the next few lines, he stops shaking, and removes the gun from my mouth.

My voice becomes our voice as he recites the lines...

> O Divine Master, grant that I may not so much seek to be
> consoled as to console;
> To be understood as to understand;
> To be loved as to love.

The way he looks toward heaven as he prays shows he's unaware of my reinvention, but then he looks back down to the face that ruined everything.

As we recite that last line together, the look that started it all 25 years ago molds itself to my once handsome, but now weathered, face.

The look he returns might say everything, but in the same way I forgot myself these past 25 years, I don't know him anymore.

Frightened that this look I'm giving could make my reinvention clear, I look away. Deep down, I'm hoping this look could make my reinvention, our reinvention. Exit the lord and enter me, his creator.

I look back for a hint, to try to understand if he understands. His response is a look up to God, ashamed of his creator on Earth. The creator he said could never love, the creator that loves him.

He looks back to me, up, back to me and up. The "shampoo bottle story" of his life.

Slowly, he pulls his hands further up, replicating my hands in their standard prayer formation, resting against his chest. The only difference is the gun between his hands, pointing up, separating that connection.

Back to the prayer, three more lines.

> For it is in giving that we receive,
> It is in pardoning that we are pardoned.
> And it is in dying that we are born to eternal life.

As the prayer comes to a close, I'm the only one that can say Amen. Romeo and Friar Lawrence invented and reinvented for the first and last time. Exit Romeo. ≋

BRANTLEY CARROLL, *Drifting Cotton, Wabash, Arkansas,* black and white photograph, 2007

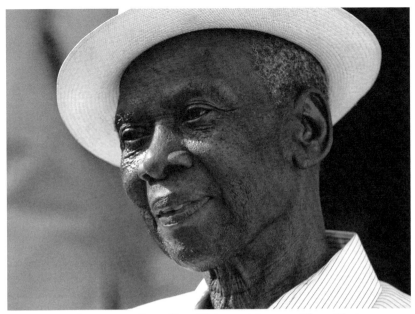

BRANTLEY CARROLL, *Sam Carr, Helena, Arkansas, Blues Heritage Festival,* black and white photograph, 2007

Sam Carr (b. 1926), considered the definitive delta blues drummer, formed the Jelly Roll Kings with guitarist Frank Frost, and later played with Sonny Boy Williamson.

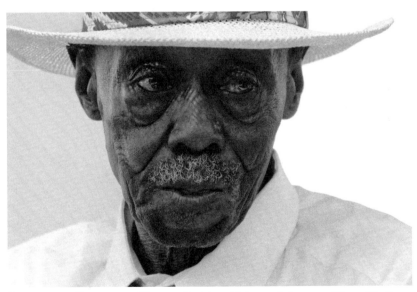

BRANTLEY CARROLL, *Pinetop Perkins, Helena, Arkansas, Blues Heritage Festival,* black and white photograph, 2007

Joe Willie "Pinetop" Perkins (b.1913), whose early boogie-woogie piano work is seen by many experts as the foundation for swing and rock and roll, was a long-time sideman for Muddy Waters.

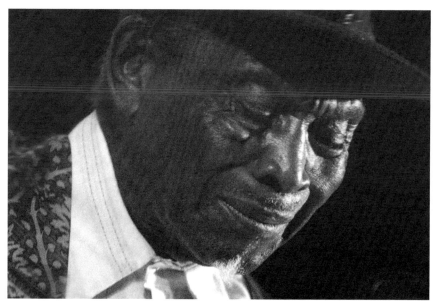

BRANTLEY CARROLL, *Honeyboy Edwards, Helena, Arkansas, Blues Heritage Festival,* black and white photograph, 2007

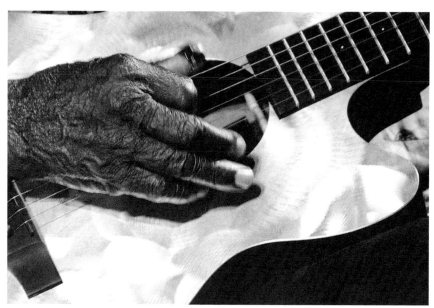

BRANTLEY CARROLL, *Honeyboy's Guitar, Helena, Arkansas,* black and white photograph, 2007

David "Honeyboy" Edwards (b.1915), one of the last authentic performers in the blues idiom that developed in central Mississippi during the 1920s and 30s, played with Robert Johnson and Big Walter Horton.

Chuck Lyons

THE LEFT HAND OF GOD

John was in his suit in his coffin with a red and white pin in his left lapel. I couldn't remember ever seeing John in a suit before. The pin was his membership button from the Polish-American Club. Our relatives, John's and mine, fluttered around the coffin, alighting to talk and moving on like house sparrows.

I was sure John hadn't joined the Polish-American Club out of pride in his Polish roots or a love of the culture; he joined because it was walking distance from where he lived and he could drink there without having to worry about the Blacks and Hispanics who had taken over the neighborhood. They weren't allowed in.

John was only half Polish anyway. On his mother's side. The other half was Belgian like me. Our parents were brother and sister, two of the five children of Belgian immigrants who had landed in New York a century ago and moved upstate to Rochester.

It was snowing when I drove to the funeral home along Hudson Avenue, that street that had once been so important to us all, the main street of our childhood, and was now only the fastest way through a rough part of the city. Snow had been blowing across the road, pelting the dark figures huddled in the plastic bus shelters and teenagers in bulky coats and sneakers.

The Polish-American Club was next door to where Wojacski's Bakery had been. Now it was the Church of Jesus Christ the Living Savior. The funeral home was next to that. St. Stanislaus Church, the Polish church, was a block away and still functioning. It had become some kind of Catholic tourist attraction now and drew more people to Sunday Mass than it had when we were kids. John had stayed in the old neighborhood, living across the street from the house he grew up in, the only one of us who had not fled the city.

I'd been in the Polish-American Club when John held a bachelor party there for his son, the only time I remember ever meeting his son. He had been standing inside the door of the funeral home by the coat closets when I arrived, and he greeted me by name. I couldn't remember his.

We had also gone to the Polish-American Club when I was a kid. There were several Polish clubs in that part of the city then, and I went to all of them at one time or another. John's father, my mother's brother, had

seven kids and a Polish wife. We went to a lot of weddings at the Polish-American Club. Long tables with white paper taped to them, cluttered with beer bottles and paper plates with broken potato chips and cigarette butts. Polkas and accordions. A group of men clustered together in the bar laughing.

My mother would get drunk there.

"Ruthie, why do you always have to ruin everything," John's father said to her one time.

I stood at the coffin amid the circling relatives, and I looked at John's made-up face and at the suit and the pin from the Club.

The Belgians drank as much as the Polish. They always had a glass of Genesee beer in front of them—all of them. Not yet tonight. But they would later; when the funeral parlor closed they would go to someone's house in the neighborhood, Polish and Belgians alike. Maybe John's. They would sit around the kitchen table, eat potato chips, drink beer, and talk about their departed brother, cousin, or nephew. I was raised with that.

That's what John would have done too if it were someone else's funeral.

John and I grew up together. He lived ten blocks away from us, and I didn't see him everyday. Not even every week. But we were about the same age (he was a year younger than me). I saw him many weekends and we played together and told stories and lied to each other. Then he went in the Army and to Vietnam, and I went to college. When he came home we smoked marijuana together in the house I had inherited from my mother.

The family didn't know what happened in that house.

When my father died at age 48, we were alone there, my mother and I.

They told me in the morning. It was a Saturday, and when I came out of my bedroom my mother was sitting on the couch with a neighbor woman. I stood there on the rug in my pajamas and she told me. That's all. She just told me. I went into my bedroom, got dressed, went outside, and shoveled the snow that had fallen while I was sleeping and my father was dying.

The following Christmas I got more presents from the family than I had ever gotten before, but none of them seemed to know what to say.

My mother couldn't bear the loss. At night I would lie in bed in the front of that house, listening to her talk to my dead father, and watching the rectangles of light race around the walls when a car passed in the street.

There were pictures pinned on a display board next to John's coffin, speckles of life, frozen moments. There was John in black and white with a mischievous grin as if he had just pulled a joke. He was wearing a work shirt with his name in an oval on the right front and a pocket with a small

metal ruler on the left. Taken in one of the machine shops he worked in. He was a machinist and was always able to get a job. He said he was in demand. And he used that, quitting jobs and switching shops pretty much as the mood struck. Never staying very long at any one place and never becoming any more than a machinist.

There was another black-and-white photo of John holding the waist of a woman I suppose was his wife. That marriage lasted long enough to produce two children and not much longer. I don't know if I ever met John's wife. After that he seemed to have nothing to do with women. I never knew him to talk about a girlfriend. There were two older women he did talk about. They went places, he said, drove around and talked dirty. They were his traveling companions, he said. There was a picture of John with his brothers, the three with their arms around each other. With his brothers and his two sisters. With his parents. There was the high-school graduation picture and one of him in his Army uniform. One of him standing outside the Polish-American Club.

"Ruthie, why do you always have to ruin everything," my uncle had said.

She drank more in that house. She had gone through the Bible in her grief and found no comfort, gone to the priest and found nothing. The beer worked best for her. And as she drank to deal she grieved more and slipped into dementia. "Where's my tin box?" she asked, looking for the box that held her bills and receipts. Pacing the floor, wringing her hands, looking frightened, smelling like spoiled meat, with wide hazel eyes that never blinked. "Where's my tin box? Where's my tin box?" I'd take her into the bedroom and show her the box was where it always was in the bottom of her dresser.

I'd close the dresser and she would ask, "Where's my tin box?"

I was fifteen then.

I never saw John much after college and Vietnam. It was only in the few years before he died that we came into contact again. We talked sometimes. He told me about the reunions of his branch of the family "out at Lou's place."

"We shoot skeet," he said, "and there's a pool."

But he didn't seem very enthusiastic. He told me about his jobs and about how valuable he was in his trade, how in demand he was.

He came to my own son's wedding.

He spent his nights at the Polish-American Club and some of the smaller bars just north of the city, spent his days working in the machine shops, went places with his "old ladies," and died. That was that.

"Ruthie, why do you do that?" her brother had said.

She began lighting her hair on fire and sticking her head in the oven. I slapped out the flames in her thin graying hair and turned off the gas. If I came home from school and she was gone, I would search the house expecting to find that she had hanged herself in a closet or some corner of the cellar.

I never did.

I did come home from school one afternoon and found them there—two of her brothers. They were sitting in the living room on the couch with her, talking seriously. Then she went away. They took her to the psychiatric hospital, and I was alone in the house.

I was seventeen then.

They never talked to me about her. I barely saw any of them again until her funeral, when I was supposed to have them all over to the house to drink beer and eat sandwiches, but I refused.

Before she died I visited her every Sunday at the hospital, and listened to her worry aloud about her tin box and beg me to get her out of "this place." Then I got married myself, moved my wife into that little house, and had a child. Went to school, got a job, and grew older.

John had done the same—gotten married, gotten a job, had children. Now John was in his suit in his coffin with a red and white pin in his left lapel.

I left the funeral home, went outside into the snow that was blowing horizontally across Hudson Avenue and the small parking lot of the funeral home, hitting against the side of the building that had been Wojacski's Bakery and against the front of the Polish-American Club.

And I went home. ◥

Chuck Lyons

ON FRIEDERICH PARK

The two steeples of Holy Redeemer Church cast long shadows over the neighborhood.

I remember those shadows, the streets and houses, the cracks in the sidewalk in front of our house, and the places you could get through fences, but I also remember John, and I remember Mr. Kneel. The others have faded in memory: the neighbors, the boys I played softball with in the street, even the dogs that ran with us after the balls that got away.

I remember the church, the shadows, John, and Mr. Kneel.

And, I remember Jimmy.

John, who lived next door to us on Friederich Park in the '60s, was from the Ukraine. He had been born there, he said in his accented English, and had worked on a small farm outside a small village. He hated the Communists, and he told me about the mounds of dirt that served as fences between the Ukrainian wheat fields. The Communists used those mounds, John said, to bury the bodies of people they had killed when they came through his village.

He had fled his village in the forties, John said, to join Hitler's invading army and fight the Communists. His son, who was still in the Ukraine then, was a Communist, and John was angry with him for it.

John had come to Rochester in the early sixties, but Mr. Kneel had been on the street all my life.

The only black man to own a house on Friederich Park, he had been there before I was born. He worked for Eastman Kodak, people said, and had won a large incentive award. With the money from that award he had bought the large brick house at the Hudson Avenue corner of the street.

In the beginning, my mother said, people had objected to him moving there and had tried to get up a petition to keep him off the street, but it had come to nothing. He bought the house, and rented out two or three apartments to other black families. They were always good people, and there was never any trouble at Mr. Kneel's house.

"He's a good one," my mother said.

In those days, Friederich Park was a stew of languages and cultures. Wedged between Rochester's black neighborhood to the south and the smaller ethnic "Polish Town" to the north, Friederich Park and the surrounding streets had attracted East Europeans displaced by the war.

That's why John had come there.

Officially, they were called Displaced Persons, but we always knew them as "DPs." There was prejudice against them, more than I ever saw toward the blacks who lived to the south. DPs would work for less money and take jobs away from Americans, my mother, herself the daughter of immigrants, complained. They would live without the luxuries we took for granted, she said, and eat only potatoes to save money and buy homes and businesses. Two or three families would live in the same house and sleep two or three to a bed, she would say, talking to her sister who lived across the street or to a neighbor while sitting at a table in Wissman's drinking a draft Genny.

Feeling threatened, we disliked the DPs and talked about them. Mr. Kneel we accepted; he was one of us.

Mr. Kneel and his wife had one child, Jimmy, who was a year older than I was. We played ball together, and I took over Jimmy's paper route when he gave it up. Jimmy was just another kid in the neighborhood to us. I never heard him talk about the DPs.

It was when I was learning his paper route one wintry day that Jimmy told me his mother had died the night before. It was late afternoon, but the darkness was already settling over Friederich Park. We could still see OK, but the streetlights had come on and the light reflected on the snow banks alongside the street and the ice. We were delivering the papers from an old wooden sled we pulled along on the hard-packed ice and snow. She had cancer, he said. Then we went on and finished the route.

Jimmy eventually went off to the University of Michigan and got a master's degree in finance. He always liked money, and while I dreamed of being a baseball player, he dreamed of making a lot of money as a plastic surgeon or a real estate lawyer. He got married when he got back from Michigan, had a child, and moved into one of the apartments in his father's big brick house.

Jimmy was the only black kid I knew back then. I grew up in those days with Lithuanians, Ukrainians, Estonians, and Latvians, and with the sound of accordion music floating from secret places on Sunday mornings. I grew up hearing languages I didn't understand and seeing people who looked like me and yet were different.

There was a Lithuanian Church on Hudson Avenue where the priests went back and forth through a golden screen and the Mass seemed endless. For a while there was a Ukrainian store with a window display of white tablecloths edged with orderly red patterns like Mozart's music. Those windows also held record album covers printed in a language I couldn't read

and in an alphabet I didn't know and posters of dancers in strange costumes. There was a Lithuanian jewelry store and Latvian real estate agents, and I went to school with boys who dreamed of liberating their homeland.

That was John's world.

For a while an old man lived with John. He would wear a red smoking jacket with a black velvet collar and walk on the broken cement driveway next to John's house and on the lawn where John's pink peony bushes dropped their petals. He had white hair and a small white beard, and people said he was a priest.

It seemed everyone spoke with an accent then.

Years after I had left Friederich Park, part of the "white flight" to the suburbs, I read in the paper that Jimmy had been found shot to death behind a bar near North and Hudson. No one was ever caught, and it was never clear what had happened. Was Jimmy involved in something that went awfully wrong, I wondered, or was he simply an innocent person who was in the wrong place at the wrong time? Had his love of money killed him?

Mr. Kneel had lost his wife and his only son, and the big brick house must have echoed with the silence. After feeling bad for him for a few days, I decided to drive by the old street to see if he was there. He was sitting on the steps of his brick house. The grass in his small lawn was long, and the rose bushes that had always been so well trimmed were scraggly. The street was different too, with some boarded-up houses and the burned skeleton of a house three doors away from Mr. Kneel's place. There was broken glass in the street and a black-and-tan German Shepherd barked at me from behind a patched fence next door.

Mr. Kneel looked drunk, and stumbled when he tried to get up from the steps. As I approached him, I noticed the front of his pants was wet. He didn't seem to know me. I left as quickly as I could.

As I drove away from the neighborhood, I saw John waiting for the bus in front of Wissman's in the shadow of the church's steeples. I offered him a lift, and we talked of the neighborhood as we rode together downtown.

We stopped for a red light at North Street and Hudson Avenue, which was then a crossroads of the black community, and near the place where Jimmy had been shot. We could see the people on the street going to the Marine Midland Bank that was there, coming out of the diner and the other small shops, standing together talking.

We talked about Mr. Kneel for awhile and then fell silent.

Just as the light changed, John spoke.

"When I was in the Ukraine" he said, "the circus came to town one year, and I paid a ruble to see a black man. Now I see them all the time." ⧫

Cecil Abrahams

ALEX LA GUMA AND BESSIE HEAD: BEARING WITNESS
IN SOUTH AFRICA

Despite colonialism, Apartheid, and censorship that plagued South Africa during the 20th century, South African writing grew significantly. In a country with four recognized and segregated color communities and with several European, African, and Asian languages, writing appeared in many books and journals. While English became the dominant language of expression for three of the color communities, Afrikaans, derived from Dutch descendants and their mixed-race slaves and indentured workers, also occupied a powerful position in the world of literature. Today, South Africa boasts one of the most lively literary environments in Africa and internationally. Not only have two of South Africa's writers, Nadine Gordimer and J.M. Coetzee, won the Nobel Prize for Literature, but South African writers of all colors have also won major international plaudits for their work. Furthermore, as the recent Cape Town Book Fair has shown, not only can South African writing attract book critics and sellers from across the world, but the event attracted many new South African writers and their writing to the competitions held at the Book Fair.

While writers among the white descendants of the Dutch and English occupiers of South Africa have actively involved themselves in writing since the early 19th century, it was not until the early 20th century that the first significant writings by black South Africans Sol Plaatje *(Mhudi)* and Peter Abrahams *(Mine Boy)* were published. This promise was soon squelched with the introduction of Apartheid and the racist authorities' determination to eradicate all writings that were critical of the rulers and their ideology. Many writers were banned, arrested, and imprisoned, and some of them left South Africa clandestinely or voluntarily. Among these writers were Alex La Guma and Bessie Head, whose writings were to become internationally known and recognized.

Alex La Guma came from Cape Town and belonged to the mixed race or cape colored community. He was born into a family where there was active opposition to the twin evils of colonialism and Apartheid. His working-class parents were among the first black South Africans to join the newly formed Communist Party which had been founded by Jewish immigrants from Eastern Europe. Thus, early in his life La Guma learned to despise injustice to the poor and the downtrodden people of color. The young La Guma

learned how to organize the poor in his community and he soon found school-going to be less relevant than trying to go to Spain and World War II to fight the fascist regimes of Europe. Only his underage and slight physique thwarted his determination to fight in the wars.

Having left school before completing his matriculation, La Guma worked in a metal-box factory, where he helped workers to unionize. He was sacked, but went on to employment as an office worker and bookkeeper while he organized the mixed-race community to oppose the injustices of Apartheid. The Communist Party of South Africa was banned in 1950 and La Guma was listed as an "opponent of the state." He became a leader of the South African Colored Peoples Organization and led a delegation to Kliptown, Johannesburg, to be part of the convention that drew up the South African Freedom Charter on which most of South Africa's democratic constitution is based. Although he and his delegation were prevented from attending the event, La Guma was arrested with notable South Africans such as Nelson Mandela, Walter Sisulu, and Oliver Tambo, and charged with treason against the state. The trial lasted for four years, but the state failed to prove its case. It is during this period that La Guma worked as a journalist and soon thereafter began to write creatively.

From 1960 to 1966, until he left South Africa on an exit permit for the United Kingdom, La Guma spent much time in detention. He was also placed under house arrest. But this did not stop him from publishing many short stories and publishing his first three novels. La Guma's writing has both a diagnostic and a visionary quality about it. In his work as a political activist, La Guma did not only point to the faults of the Apartheid regime, but he also urged the downtrodden populace to resist and eventually to overthrow their oppressors. In so doing he envisioned a South Africa free of oppression where democracy flourished and where all residents of South Africa, regardless of race, economic class, and gender, would enjoy freedom and equality. This same quality of not merely lamenting the injustices of South Africa, but actively creating characters and situations where resistance and hope abound is prevalent in La Guma's work. While his first three novels depict the cruelties of Apartheid, La Guma also creates characters who are willing to defend humanity under severe restrictions. As La Guma's work and life became more certain that Apartheid, with all of its injustices, can be defeated by the oppressed, his last two published novels and his unfinished final one are filled with characters who go beyond mere civil protest and who are actually willing to meet the violence of the state with their own militant responses.

In La Guma's first short novel, *A Walk in the Night* (1962), he deals with the famous District Six in Cape Town. La Guma's journal columns dealt mainly with the lives of the colored community who lived in places like District Six. As an activist fighting for justice for his own community, La Guma would enumerate the many incidents of injustice that plagued the community. In his first novel, La Guma continues his role of reporter, entering the tenements and alleys of the inner city suburb and reporting on the down-and-out lives of the inhabitants of this run-down district. As in his newspaper columns, La Guma revels in setting the scenes for the stories he tells and being meticulous in capturing both the myriad characters who frequent the area and giving realistic details of the environment. While La Guma vehemently opposes the oppression of the slum dwellers of District Six, he is, however, unwilling to accept the mindless criminality and hapless behavior of the inhabitants of the community. Therefore, he revels in the characters who defy oppression and who are willing to remove the yoke of poverty from their backs.

La Guma completed the writing of *A Walk in the Night* while he was in a Cape Town prison. His second novel, *And a Threefold Cord,* which was published in 1964, was written entirely while he was in the Cape Town jail on Roeland Street. In this novel La Guma recreates the experience of living in a slum; his main emphasis is on the mind-numbing poverty that surrounds and destroys the people who live there. The reader can practically smell the devastating effects of poverty. While La Guma observes ruefully how poverty creates hopelessness, he still takes a positive view by creating the main character as one who defies the circumstances and is willing to challenge those who created the awful conditions. As in his first novel, La Guma ends the second one on a note of optimism, certain that with determined resistance by all of the oppressed, the day of reckoning for the oppressor would come.

La Guma's third novel, *The Stone Country,* was published in 1967, when he had left South Africa on an exit permit and was now working actively in London for the banned African National Congress of South Africa. The book deals with prison life in South Africa. It captures the lives of those who live in detention. For much of the book, it is difficult to distinguish between life in detention and the restrictive and oppressive society that black South Africans live in outside detention. While many of the hard-core criminals have little respect for human life and are unconcerned about the sociopolitical conditions of South Africa, even here La Guma's message is one of defying evil and transforming the prisoners so that they can respect themselves and others and become a force for good.

Once La Guma left South Africa, he added a further dimension to his opposition to injustice. He recognized that peaceful protest that exposes the protesters to violent attack and imprisonment by those that oppress them will not bring about justice. In his next novel, *In the Fog of the Seasons' End* (1972), La Guma carefully describes the socioeconomic conditions of oppressed South Africans, and he concentrates on those who work both above and under ground to end oppression. He now foresees the possibility of committed protesters being trained in a militant way to challenge the Apartheid state. Thus this novel envisions a time in the very near future when protest will go beyond civil disobedience and lead to armed clashes between the oppressed and the oppressor.

La Guma's last novel, *Time of the Butcherbird,* which was published in London in 1979, predicts that the time for avenging the crimes of the oppressor had, indeed, arrived. In this novel he develops the story of Shilling Murile, who had been sent to jail for violently reacting to the cruel and unnecessary death of his brother at the hands of Hannes Meulen, a powerful farm owner and politician. After serving his long prison sentence for having attacked and injured the farm supervisor Dawie Opperman, who had been instrumental in his brother's death, Murile sets out single-mindedly to seek revenge on Meulen and Opperman. When he finally catches up with Meulen he discovers that Opperman has died; he kills Meulen. While La Guma recognizes this act of revenge, he argues, however, that personal violence does not resolve the injustices suffered by the majority of South Africans. Murile is then persuaded to place his strong feelings behind a collective movement that seeks freedom for all South Africans.

• • •

Bessie Head has been embraced strongly in the United States as a feminist writer who describes "the female condition in a very powerful and truthful manner." She is without doubt the most important black female writer in southern Africa. Head was born illegitimately in a mental asylum in Pietermaritzburg, South Africa. Her mother was a white woman of English-settler descent; her father was a Zulu stable boy who worked for the woman's family. Racist South Africa and the woman's family could not tolerate such a pregnancy and after failing to persuade the young woman to have an abortion, she was forcibly admitted to an asylum where Head was born and where she lived with her mother until the latter's death two years later.

For a period of time the two-year-old was shunted around foster homes until she finally found a home with a mixed-race family. Every effort was made to shield the identity of her mother's family and no trace of her father has as yet been found. Her grandmother would visit occasionally, but disguised as "a kindly old white woman." Head's mother had left some money in her will to be used for her education and she was sent off to a convent school where she obtained her teacher's certificate. Head taught briefly but then left for Johannesburg and Cape Town, becoming a newspaper reporter. She married a fellow reporter and gave birth to her only child. Head, who was trying desperately to establish an identity, found South Africa's racism stifling and decided to leave South Africa as a voluntary exile for neighboring Botswana. Here Head taught school for two years in the village of Serowe, the home of the paramount chief of the Batswana tribe. She then became a refugee in Botswana, living off United Nations assistance. Head supplemented her small allowance by developing a garden and selling produce from it and by writing fiction, short stories, and a history of the Batswana people.

For much of the 20th century, South African writers made heavy use of autobiography and biography in their fiction. Often, as participants in the daily drama of South African life, many writers reported their own involvement in South African society. As we have seen, much of Alex La Guma's fiction deals with his own political activism and his experiences in prison. For Bessie Head, almost all of her work is based on the unusual circumstances of her birth and the struggles she must endure that emanate from her illegitimate and racially forbidden conception. The main theme of Head's work can be described as a search for personal identity. Once she is made aware of her birth circumstances, Head begins to search for a place in herself and in South Africa where she can feel at home. Her restless travels inside South Africa and her quick changes of jobs are all dedicated to finding a home. When she fails to find such a home in a country so beriddled by racism, Head departs from South Africa for rural Botswana, where she imagines a homogenous society of peace and harmony prevail. This objective inspires Head's first novel, *When Rain Clouds Gather,* which was published in 1969.

In the novel Head deals with a South African protagonist, Makhaya, who has left South Africa involuntarily after having spent time in prison for opposing Apartheid. Like Head, he sees Botswana as a place of escape and the hope of starting a new life free of racism. However, Makhaya soon runs into the prejudices of the Batswana and realizes that his black skin does not

exempt him from being ill treated by the black people of Botswana. Indeed, here he discovers that Gilbert, an English agricultural specialist who has left England in disillusion, is a kinder friend to him than the black-skinned people he prefers. The village of Golema Mmidi soon becomes a haven for all those in Botswana who are victims of race or tribal discrimination; here together they build an ideal living place. It is also the kind of place Head had been searching for.

However, in Bessie Head's second novel, *Maru*, published in 1971, she examines the place of the Masarwa people, who are pejoratively referred to as "the Bushmen" and considered to be "filthy, uncivilized children" by the majority Batswana tribe. In this novel Head tries to discover the roots of racism by pitting the Masarwa school teacher, Margaret Cadmore, against the prejudices of the larger society. Unlike the other Masarwa, who are illiterate and who are employed as servants of the Batswana people, Margaret had been rescued at birth by an English aid worker who had brought her up to prove to the Batswana people that the Masarwa were quite capable of intellectual development. Margaret's presence in the village of Dilepe becomes a major concern for Maru, the paramount chief-in-waiting, and the tribal people in general. The idea of a Masarwa teaching the "superior" Batswana is considered to be outrageous and the children are instructed by their parents to treat her in a contemptuous manner. Maru sees in Margaret the opportunity to create equality among the Batswana and the smaller despised groups such as the Masarwa by marrying her. In all of her work Head considers the questions of prejudice, whether it be of a racial nature or of any other form. Indeed, in *Maru*, Head argues that discrimination existed in Africa long before "the white man became universally disliked for his mental outlook." She notes how prejudice has existed among the various peoples of Africa regardless of their race. Her novel ends, therefore, in the hope that if enlightened people of the various groups were to marry among themselves, this might trigger a change in the positions held by the groups.

Bessie Head's most powerful novel, *A Question of Power,* which has endeared her to the feminist movement, was published in 1974. In this very personal novel, Head uses all the details of her life, beginning with her conception and covering her life in the asylum, her estranged white family, her internal demons, and her views on good and evil as these phenomena are practiced on the African continent. In all of these themes Head demonstrates the immense presence of power and how this overwhelming

phenomenon influences all human action. The chief character, Elizabeth, lives her life in the seeable world of daily hope and despair; she lives for days and nights at a time completely removed from the outside world, grappling with the demons that live within her. When the pressures grow to be too much, Elizabeth suffers nervous breakdowns and is admitted to a mental hospital. In some ways Elizabeth is mimicking Head's own mother, who had to endure great external opposition to her pregnancy; in her defiance she was admitted to an asylum. In her battles with her demons, Elizabeth comes to grips with the monsters of racism, war, and human hatred and folly that plagued the world of Botswana and southern Africa. In this novel Head demonstrates a quality of writing that elevates her to an important place in world literature.

The Collector of Treasures (1977), brings together thirteen stories of history and life in Botswana. Here Head is able to deal with portraits of various people who live in this country. She covers stories of migration, of a village saint, a faith-healing priest, witchcraft, the Rain God, a wedding, hunting, and the title story of the collector of treasures. The stories had been written over a period of time and thus we take away various portraits of the writer as she shows her interest and involvement in the community that she lived in. Although Bessie Head was never fully accepted into the Serowe village community where she lived, she was respected and thus was able to come close to observe the community. The collection of stories provides us with a more relaxed writer who truly loves the people of the village.

In her book, *Serowe Village of the Rain Wind,* which was published in 1981, Head makes a close study of the Khama family. By looking at this family that formed the leadership of the Batswana tribe, Head shows how through a benevolent line of chiefs the Batswana have managed to preserve their customs and to ensure that they would never be colonized. In a rather idealized version of the greatness of the Khama family, she provides many kindly portraits of the development of the tribe and the reasons for Botswana's prosperity.

Alex la Guma and Bessie Head saw the solution to the racial problems of southern Africa differently, but in the end both their contributions have been appreciated in today's South Africa. While La Guma placed his faith in oppressed human beings rising up against their oppressors and overthrowing them, Head believed that human oppression will end only on a person-to-person basis and in a non-violent fashion. The end to Apartheid came when

the militancy in South Africa had made the Apartheid state ungovernable, but the final solution became one of reconciliation. If for these visions alone, Alex La Guma and Bessie Head have established for themselves major positions in the southern African world of literature. But their work embraces universal themes making them relevant to all of us. ≋

Eric Gansworth

BENEATH THE CONSTELLATIONS, THE SMOKE MOVES HOME

Before the moon rises and
Before the hunters chase the bear and
Before the starlight dippers tip and
Before the Old Men teach and
Before the Young Men learn and
Before they both chase a ball of flames and

After the Breakfast and
After the Run through Dog Street and
After the Princess is crowned and
After the last cornsoup bowl is scraped clean and
After the stands have closed up shop and
After we laugh with old friends

We gather to watch Smoke
Dancers anticipate the fireball
as shadows fill the grove
with lateness and urgency
and every other movement
in the wind, shifting
with the drum and the song

And this boy, like his father
before him on a lacrosse field
moves like dance is as natural
as breathing, confident
with each turn and jump
that he is taking us home

Carrying us until the next year
when our friends are older and slower
and someone new steps forward and
joins in the dance that binds us
together beneath the constellations.

My Mother Delivers a Quick Lesson in Survival and History

The other day I was
talking about my uncle
and his house
with fondness to her,
a mistake, I know,
and she lit a cigarette
because I disapprove
blew the darkened air out
surrounding us and said
"I never went there, you know

that, and you should not have
either. He only smiled
for you kids because years before
you were born, he threatened
the older kids when I wouldn't
do something for him,
and I took that baseball
bat the boys had and beat
him to the point that he could not
walk for a week after, and no matter
what, he knew what was
an arm's length away
for the rest of his life."

David Eye

*IN MEDIA RES**

for John

We stayed that way all afternoon.
Me in one end of our apartment,
he in the other. Poles of a magnet.
I could hear him. His silence.
Dust swarming around the tall palm.
I watched twin trapezoids slide
across the wide floorboards, merge,
crawl up the wall, fading.
I stood, then, and pushed through
the heavy air, the waning light.
Leaning in the bedroom doorway.
He sat cross-legged on the bed,
the balled tissues around him
a flock of sleeping doves.
Dusk smearing the room gray.
I'm sorry—the best I could do. *Are you all right?*
He should have spit or hit me or yelled.
Instead: *I have less than 50 T-cells.*

HIV, I'd known—four years.
(No symptoms, so far.)
But 50 meant AIDS. "Full blown."
He hadn't wanted to worry me.

Then he said *Now my disease is all I have.*

He asked me, told me, once
he wanted me to help him die
when it got bad. Take his life
if it came to that. I told him then
I wish he'd known
I couldn't make that promise.

*Latin, "in the middle of things"

Ed Taylor

NYS Permitted Discharge Point: Outfall No. 058

Max Excitement—read the casino billboard the first thing she saw, waking under the 198 skyway, but different that morning: tagged the previous night with a silver-sprayed "ATAK." She stretched, pink arms tendon and bone, hair thin and shimmery black, face like a pale fox; the rest in the army-colored mummy bag. The bag somebody else's who was gone, but she'd forgotten his name.

Marnie, 15, woke up in green weeds and plastic trash and warm July dirt. She sneezed, the air pollen and dust and exhaust. Early cars hummed and thumped over.

Max Excitement: the sickest, for shore; it was all so fucking something. She could die happy or hate it or be dead already. Whatever. She was a little hungry.

She sat up in the bag, reaching for her pants, her shoes there like pets. She got up and peed behind a concrete pillar, watching the sky. Hazy toward the lake but uncloudy, it was just a day. She wore a stopped watch.

Then, voices. She stayed crouched, finishing and dropping tissue, putting the pocket pack back. Workers: away under the raised highway, men with machines, long-necked diggers and lifters with baskets. They jackhammered, punching big holes in old cement until corroded iron showed. To do what? She didn't care, wasn't interested in the fixing.

Marnie loped from the pillar toward the asphalt bike path through reedy weeds tall as she was. From the path she bent through an oval rip in a chain-link fence into a parking lot broken up by waist-high geysers of fern. She scuffed toward a small white runabout, its stern bitten looking, broken in a chewed arc, and the fiberglass frayed: *Killin' Time* on the hull, but today "ATAK" sprayed over it, the boat aground against a reef of rusty machinery, refrigerators, scaffolding, built-in-stove-and-oven fronts, black-bagged garbage.

"Hey Baby? Hey Mike?"

She stood with a hand on the transom. She didn't like getting any closer; under the deck was dark and stank.

"Baby? Mike?"

She heard rustling. Baby's big soft body filled the rectangular hole where a small hatch had been, his slick head short haired, skin shining, today in

his welder's glasses and black cape. Already dressed. That was not good. Crawling out and over the side.

She took it slowly. "Hey. You look ready for school. Wanna play?"

"Yeah, alright. Sure. Alright. Why not. He's not here."

He looked wet, dark shirt and pants wrinkled and stuck to him as he circled to the other side of the trash dike. She heard piss on the ground, like at the stable where she'd worked as part of her therapy. So she looked around for something new to play with. She didn't want to go back to her sleep spot for her stick. Once she started moving it was bad luck to backtrack.

She yanked a two-by-four from the junk. She heard Baby banging around. When she looked he had a golf club. She whirled and started walking, back to the path.

Baby bowed and forced himself through the fence behind her and followed. She spoke over her shoulder at him. "You see Mike last night?"

"No. I didn't see anyfuckingthing."

She left the path after ten yards and cut right to the overpass and the creek lacing in and out of shade, the water green under brown foam. At the bank she knelt at the dry runoff pipe with the 58 sign and bent over to look in. Her head reeled. She had to close her eyes, then opened them. The money they'd left was gone; another loaded baggy was there. She pinched it up and sat on her heels with closed eyes.

"Yo. Any mail for me."

She jumped, eyes open, him over her now. "Shit, Baby. You scared me." She stood too fast but forced down the nausea and dizziness and made sure to face him. She shook the baggy.

"Marry me. Take the dog for a walk." His face glistened around the goggles.

She split the baggy lips and held them out at him. He dropped the club and lowered his big head warily, like a horse, to pimp white powder from a yellow fingernail up his long nose.

"Fuck. It's coke, it's fucking *coke."* He jerked his head back and stomped, raising a little dust, swinging at the air with his empty hand.

TT left crank when Seneca Mike left him money, except this time. TT came on a bike, skinny with a backpack and a goatee. Marnie saw him at sunrise once in a red Reebok suit. Red bike. His brakes squeaked.

Marnie waited. Baby stared at her, a foot taller than her. She knew she should speak fast. "Come on man, we can sell it. Let's play first and then find Mike and sell it. Okay?"

She sealed the bag as he bent to grab his club and backed away, still looking at her.

Baby on the path swung hard at the air. She rolled the baggy into a pocket and moved after him. They could sell but they had to find Seneca Mike. It was his money, his shit.

At another rip in the fence, Baby first, they waded into thigh-high weeds rippling under a breeze of smoke and old skunk. She had a ball, a silver truck bearing the size of a mare's eye. She dropped it and they were off, on rotted green carpet and concrete beside a brothy stagnant pool: working hole to hole on a miniature golf course left for dead so the grass and crap took over.

Windmill, clown, dinosaur, pirate; stolen, stored, sold, and everything left was flat and hard and low with a hole in it. Baby went first. They played, chasing the ball with their sticks and beating it until it hid in the ground, trapped with nothing to do but wait and then look up at them bending over and reaching in with their claws; she looked up at herself reaching down; weird shit. The hole holding a little water, the ball wet. Somebody won, they guessed.

Marnie smelled wet fabric and cars and felt the sun through her shirt. Baby was a shadow moving, in the light always dark; scary. What then? She was with him. They walked, ahead Baby breaking the ice, cutting the thick air. She smelled herself.

On the asphalt path by the dusty glass of the dead creek under the legs of highway beside the white chickens; some poem, school like a sickness coming back. She thought of school, how it felt and smelled. Like being inside a carcass. She shook her head to stop.

They kept going. Going. Everything as it was except it was light again, so sun trees weeds shit old buildings new noise the path; walking and at the Tops dumpster, Baby already pulling the black bags out.

She liked the cheese: cut off any colored spots and the rest was sweet. She had a knife with a cross on it, small and folded in her pocket. Past expiration sounded immortal and she liked that and ate of the immortal. Bless me father and me mother for they have sinned, she went all Irish or something what was that about she shook her head to stir it up.

A shopping cart: off the path half in the creek. She walked through nettles and old snow fence to where its nose dipped into water and pulled. She pushed hard to get it through the trashy weeds back to the path, her arms ropey and lips tight. She pushed it to the white wall at the store's rear away from everything, and left it. One alone or lost or with a wheel off or bent she would move. Seneca Mike laughed, but fuck him; she moved them.

Baby ate soft things: his teeth hurt. Sliced bread yogurt. The parking lot guard walked at them and waved them away like flies. She thought about putting one foot in front of the other, felt stuck, moving through the blackness like the day was a tunnel. Money and shit: sell the shit buy other shit. Tell Mike.

"Baby, maybe Seneca Mike's at Front Park, he stays there sometimes right? Let's go there. Okay?" He lifted his head like a deer. She laughed.

Baby took Marnie to the railroad bridge and over the water one night. Baby'd crossed back and forth from a low rez facility in Canada, everybody asleep, but then the planes flew into the buildings in New York and now most of the time Border Patrol watched, ate pistachios and threw shells on the ground in little piles you could track by. But that night no one watched. She could walk and see the water between her feet and the rust. Ghosts of cold strung up through the girders. If there was a train you had to really run. Some people jumped, the water fast and freezing always, even in August. Runaway. Run away.

Suddenly: her mother, flat and no sound, just a picture; then, turned off. Bye bye. Marnie and Baby walked down the path leaving the store guard behind yelling. Clean your plate she told herself, clean up after yourself clean up kick and let Jesus into your. Look at yourself you're disgusting. Tough love scared straight counselor talk. Squawk. It was a game, cowboys and indians. She heard birds when they talked, she heard radios and bees. La la la la la la. Fuck that. She was just bored. She figured she'd be bored with Baby for a while and then after that who gave a shit. Too far away to even see, and she got a headache trying. Three tardies equals one absence and that affected your grade. A blue ribbon lamb. Get a scholarship and study to be a vet or a.

What was all that, where did that come from. She shook her head as they walked. They needed Mike and money. They needed some shit.

On the path the old trolls awake, three drunks, two men and a woman who stayed under the Grant Street bridge. Ancient fucks all leathery red skin, pop eyes, smelly, animal hair, one carried a wooden bat, sneakers without laces, long sleeves in the heat, yelling like we're on their lawn, Marnie thought, the woman worst: Marnie was jangly, ready to be angry. Baby swung his club and piece, his cape shiny like oil. They didn't know how fucking crazy he was. He was sweating.

"Got a cigarette? Hey, got a smoke?"

The woman talked. Marnie laughed at her lighting-a-match motions, as if Marnie and Baby didn't speak English. The woman's two men squatted,

heads down. Marnie didn't trust them, one suddenly looking and grinning or something, no front teeth, the other with a big purple sore on a cheek. Boy never, I'd die first, Marnie decided.

"Hey. What's wrong with him. Fuck you." Baby'd just swung at her and them grinning, with metal in his hands, playing, Marnie could tell; he was a baby. The men stood up pulling shit from pocket and boot, a knife and a something. Sharp; Marnie danced a little, all wire.

"Baby come on man. He's kidding, he's okay. We don't smoke. You want some blow?" To give them a taste, sell it for what? One of the men emptied a nostril.

"Shit. Fuck that powder. Walk on by, walk your crazy asses on."

Okay old troll, wine drunks the worst: Marnie breathed through her mouth, a little gaggy. Smell bugged her more; she must be getting close to her period. Great. The men stood, the woman stood, on opposite sides of the path, Baby having cut the ice and moved along, swinging ahead like he's cutting grass. Marnie sped up looking to both sides and not turning her back, then turning and skipping after Baby, la la, seizure. Saluting.

She and Baby walked, heat down on them already. Baby had a watch and it was nine o'clock, he'd boosted the watch from this guy. Marnie shivered. Breathed deeply. Deeper. She felt like a fish.

One of her teachers told her she had weird ideas. She spat at him but he didn't get the joke. If she was not in her RIGHT mind then she should be LEFT alone, but nobody got it.

Baby stopped. He put his hand out. He touched her. Nobody touched her. She pushed his hand off and he raised the other one. Baby no.

Humming all around, snakes in the air. There was a rabbit. Bunny bunny. Her mother was a whore. Why bother, she couldn't wait to get away. Her mother. Everybody, Baby, back off. Please.

"Where are we going, man? Let's find Mike."

Where could they get paid? The plants all mowed in that part since last week so everything naked: county came once a summer; she could see too much, everything low and flat like a cemetery. Marnie panted; they'd hid some shit there and would it still be there did it get. Fuck. Gone tee shirts pants soap toothbrushes hard candy gone.

She stayed low to sniff the air: Baby called over his shoulder, "I'm going to walk to the lake and get a drink." To the watering hole where all the creatures meet. She remembered on TV deer at some water getting pulled in by the nose.

A trash bag full of rolls where the path curved up toward the light again, there every day, a woman in a van left them. Please feed the animals. Baby reached in to grab two fistfuls and now Marnie was there and taking out a roll, cold and chewy. Tearing into it with teeth.

"Which part of the lake?" She wanted to know, she decided, now measuring, how many steps how many minutes till time with Baby was fucking up.

Baby huge, wet and smelling, and he wouldn't go away now. He turned to her in his goggles. He saw her, she was in his eyes and he would not let go. She was scared a little but she could deal, she could run, she could do something. But she didn't want to take any chances and needed Mike. Mike could control him, get him off her.

She needed to move. This was the day. She had been in plays in school, she was different people and if she could get to that not have to go back to counseling outpatient the cottage occupational therapy to Rita and Ruth and John Boy and Doctor X and Y. There was an ant she swatted she hated them shook out her hair. A quest. She remembered King Arthur from a book.

To find Mike. To sell the powder buy ice then something. She'd like to hear music, she missed it. But fuck it.

Sun flat and white tortilla. She rode up and down escalators all day at the mall and then at the subway station all day onandoff by herself up and down that was home a big oval always turning left never right bad luck. She did the airport too, the moving walkways shooting old people toward planes beep beep she hated old. Her stomach hurt.

Marnie wanted to keep flowing but not on the black asphalt there. She saw the river cold and clean like hard and clear and thick under the bridge clean and cool. Her mother stayed in one place and fell apart let everything wear her away. Marnie would keep moving; if you were in it, it couldn't wear you away. She used to take pills from a paper cup like you put mustard and ketchup in at the zoo she liked the otters but not the seals like ratty coats although in the water they flew.

She flew too, they were walking now green on both sides and heat. To the lake. To the sea. Was anyone looking for them? Was Mike? Mike had a temper. He was smart.

Baby ahead swayed side to side the path got longer and ahead she saw nothing. She counted steps snapped her fingers.

Something weird happened ahead; noises like the ocean. In her head jets left silk in the sky until it was all white, a web. Baby with a finger at his lips: he was pointing.

A man in a hat with a feather, legs in tights, lady with her breasts pushed up like cake in a hot dress dragging the ground another man in tights and slippers and they saw Baby and Marnie and one man bowed, smiling.

"Good day, m'lady and fair knight, and well met," he swept the ground with his hat, the feather bent. The lady and other man smiled and bowed. "Prithee, can'st thou offer a taste of Raleigh's burning leaf?"

Baby stared. The lady turned away saying "it's time."

Yes it was time, Baby still staring and now grinning, and Marnie watching the three walk off the path toward a little building on another path through the wall of trees and weeds toward flat grass. Other people dressed like them in bright light. Where was she, sun or moon a poker chip cookie Oxycontin. Ladder and a man with headphones. A clipboard.

Baby looked at her now nervous, hopping a little. He spotted a bottle in the jungle and wound up and it broke against the little building and the people scattered like roaches some yelling and two men jogging their way looking behind to see if anyone else was coming. One big one was. Police someone said. Shakespeare. He ran she ran.

Starting to sweat, it was hot, but she was not sure of the month. She remembered July in the counseling sessions in a circle somebody crying somebody making fun of her the doctor tranked too eyes like a lizard lids that took hours to go up and down. That was like a hundred years ago the big wooden house on a steep street.

Did they escape was it over they ran now not sure why Baby thumping ahead the cape like smoke. Were they going in the right direction. Just follow the little road, the path: should have been doll houses on it: she wished she'd grabbed a handful of rolls fuck it.

Nobody behind them right then. Maybe somebody ahead a trap the police waiting back to juvey. Her dad was in Florida. She got a card from him once, a bikini woman and an alligator. *Florida scenery is nice. See you soon. Your dad.* Mom was like a cat. Grandma had tried but hit her, and nobody hit Marnie.

Baby walked now there was shade he wouldn't walk with her, fine. She sped up he did she slowed down he. Fine.

Just get Mike she was sick of that shit all that. She pushed sticky hair from her eyes. A playground opened in the trees and Baby went for the swings. "Come on man, let's keep going, I want to find Mike."

Him in a swing and swinging slow to get going but black in his black and like a black knife cutting back and forth. He was not listening he was somewhere but looking at her. Could they please just motherfucking do something. She wasn't going to wait she was not going to wait she was tired of waiting. "See you man I'm going to find Mike and sell this shit and get some money and get out of this." He was looking but not stopping they were in a place the backs of old buildings windows all broken. People lived there 4000 years ago probably pharaohs or Romans or now him digging at the ground under the swing kicking big clumps of dirt out.

Marnie spun and walked off her hair flared around her it was too open there anyway: first place five-oh'd look. "See ya, man, later dawg."

Would he follow sniff her out follow the trail. Hunt. Shit she stopped and took a hit of the blow what the fuck. Kill the hunger stay strong and happy happy. Whew she was getting too weird so just follow the path what else was there.

Down the path then a stone lantern a scummy pond with bushes and a fake bridge in the middle between two fake islands, let's sit and watch the moon Romeo or something, signs of life. What was this place she didn't know didn't care where was Mike where was her ticket. Was that Baby she saw or a shadow. If he was hiding that was bad. Her heart flipped.

She was not illegal she was a fucking American she could just walk onto any street and be home. So. So so so so so so. Why not. Could she get there?

Scavengers nosed and poked under bushes bottles and cans putting them in bags like they were picking fruit. Animals like they smelled her and stopped to watch she knew she made her face stone and stared back hard one smiled a gold tooth they were giants they smelled like pee she hated them.

The arms of trees curved up over her. Emeralds in the path if she squinted. Four little school boys ahead there smoking a joint all clean and skateboardy. Petting zoo. She swayed and swung a little without thinking about it but didn't bother to look, whatever.

Path black and empty, creek back on the right cloudy and lots of floating green a dead fish no eyes. Something rustled and the weeds shook down to the water. Rat.

Now she heard it, flapping thumping shoes running at her back closing so she turned. She rolled her eyes, Baby just leave me alone. She smelled smoke. The wind was behind them. "Something's burning, it smells nasty, like plastic or something."

Baby shiny from running and mouth open under black eyes his face three black circles, his teeth yellow. She thought Baby was in his twenties. He looked bigger in this shade. He was carrying the golf club. Where was Mike.

"Where'd you get that club anyway?"

"At the country club."

Ha ha. This was so funny. She opened the blow again, not caring. There wouldn't be anything to sell. Whatever. Fairy tale and the magic beans, they lived happily ever. After. Baby behind her breathing. She offered he didn't speak.

Another cart, beside the path. Upside down. All dusty and gray no shine. The plastic seat melted weird, black. Some waldo tried to burn it. She walked up kicked it over with a foot then wrestled for a minute with her spider arms until it was upright again. Baby walked on, her pushing the cart for a minute, wheels chattering stuck, dust on her hands and shirt. She strained to push it to a clear space and parked it. Baby out of sight again as the path snaked.

Cars but she couldn't see them. Just a sound. Baby had been a sherm head; Marnie knew that stuff stayed in you like a pesticide; her mom said cops were scared of PCP, because it made you an animal. So pretend you're sherming: thanks mom, I'm glad we had this talk. Just like a fairy tale. Her mom the junkie nurse at some bar selling stuff she stole from the hospital. That was fine she didn't care. Her mother didn't care. Nobody. Nothing to care about it was all fine. Zippidee doodah.

Fuck coke you couldn't get spun. She snorted more and rubbed it on her gum. Her teeth hurt but that stopped. It was so hot. Baby was a black wall. Blocking the path. He was looking at something.

She turned around and began walking back away from Baby, toward the morning away from the afternoon.

Smoke in the air. And onions from restaurants. She wasn't hungry anymore. She was going to the river. Back that way, not to the lake but to the fast river and the bridge. She wanted to feel cool and see the clean water. She'd be in school except they laid off her teacher and put her in a regular class and she couldn't swim so she stopped going. Mom didn't notice. Her brother was in a foster home. Sometimes Marnie thought about him.

She thought she saw a fox, something red with a bushy tail just the back of it. Marnie heard a guy say he saw a coyote near the water. She walked

fast now, bumping up the blow as she walked, rubbing it on her gums, spilling a little on her shirt.

Baby somewhere. He hurt somebody bad once with a piece of wood. There's a star man waiting in the sky, old song from somewhere. Who knows where anything comes from, it pours on you from everywhere all the time like a shower sometimes it's hard to stand up in it. Not hard for her but for some of the others. She remembered other kids in school. Was it fall yet? Walking faster. Running.

Running. Slap slap run on her toes she used to run all the time it felt good her hair held by the air touching her shoulders watching everything move faster, a way to speed things up, when she was little she ran when her dad was around, mom and dad would get into it and she'd run in circles then out on the sidewalk through the little front yards when she was eight she went with her class to the circus everybody bought something but her on the bus they were all playing with their souvenir shit and Marnie watched: they told you to bring money but my mom wasn't awake when I left I got my own pop tart and dressed in the dark and waited for the bus while all the cars drove past looking at me faces like in an aquarium she got really mad when I woke her up one time I tried and she wouldn't wake up I thought she was dead I ran when I came back she was gone. Happily ever after. Little princess.

Marnie running, and she heard voices and stopped. People in olden clothes, they fought with swords and there was a girl looking nervous at the boys talking and what they said came out like German birds words with shapes like stars and edges she told herself she was nuts. Shakespeare in the park. Laughed and ground her teeth at the morning it was still morning. It was all stuck kick it loose. She ran.

She realized she'd lost track which way. There was that smell burning something and ahead there was something on fire boat shape smoldering not really fire just red edges somebody'd torched it. Baby's boat. How long did she run? Why it smelled weird and gaggy, fiberglass looked like gray hair, or like fish scales, all woven like knights, chain mail. No more sleeping there. Who would do it. Things in the forest. Dark up in there. Don't think. Run and run.

She ran following a silver wire in the air her heart hooked on it. Above the trees the highway on legs. And then it turned away and there was water and there was a bridge. There was a little house on top where somebody worked. Metal, but with green weeds growing up in the air, on the rusty beams. A cottage in the air.

And Mike and Baby. There they were. How? How. How. Where was she? Baby had a golf club Mike had an aluminum bat. Mike.

"Mike." She saw him sweaty. Blood on his face little crumbs.

"Where's my shit. Where's my shit, Marnie? Fuck that TT mother-fucker."

Gone. It was all gone man in the wind. She stood now she could feel her heart opening and closing like birdwings. She saw little brighter parts in the light like white cuts bleeding white. Running and stopping now. Oh god.

She couldn't talk shaken by her heart. Should she run.

"You either have the shit or my money." Somebody scratched his face fingers nails. "You have one or the other. Bitch."

Her mind fluttered. She saw something from the morning she'd forgotten, at the mini-golf course, a dead pool. Bad olive-colored like soup frog eggs algae stuff like hair and out in the middle three rusty wheels sticking up. A drowned grocery cart. Upside down tilted. One that she couldn't save. ◤

Cynthia Day

The Orchard

...There are great differences in lands immediately adjoining that none but orchardists who are experienced in that particular locality can detect. There are differences in climate at short distances vital to the growth and bearing qualities of orchards of which only local experience can know.

W.W. Smith, Orchardist

An overcast day in September. So many days here are dark—it's called Lake Effect, masses of cold air moving over the warmer waters of the Great Lakes, creating clouds and precipitation. We had gone to Twin Orchards on Middle Settlement Road to buy apples and cider. Ray stayed in the car, as usual, having learned that a single purchase didn't exist in the female vocabulary of consumerism and entering the store meant long minutes of standing around. He stayed in the car, listening to a ball game on AM radio.

As long as I've lived in Utica, New York, Twin Orchards has been a familiar landmark. When I was a Connecticut girl of 23, I married a man from Utica and we moved here when I was 28. The marriage ended a few years later and I found myself alone with a three-year-old child in a strange country. Let's just say that landmarks were important to me. Twin Orchards was well established on a hill overlooking what was then open fields and marshland.

In autumn the parking lot was always full, but Twin Orchards sold apples into late spring, as well as cabbage, squash, syrup, and honey. The store looked like a garage, a large, unadorned, open room with an island of counters and cash registers in the middle and a cider bar in the corner. Along the perimeter, the shelves were loaded with bushels of fancy or utility apples: McIntosh, Cortland, Macoun, Jonathans, Northern Spy. Apple selecting wasn't allowed. You took a number, waited in line and a hearty looking woman, flushed from constant activity, filled the five or ten pound bags or bushel boxes for you.

Such places are familiar here and everywhere, farmer's stands or small markets, most of them on the outskirts of town, an area we used to call "country;" now built-up, developed, surrounded. In Syracuse, smack dab on the busy intersection of Route 5 and Route 92, is an ancient stand called

Rosa's. The paint peels off of it; the black lettering is chipped and faded; its foundations sag. I used to go there in the 1980s for corn and tomatoes and it remains there, the ghosts of pink and yellow gladiolas standing in white plastic buckets.

Twin Orchards no longer looks out on marshland. Twenty-some years ago the mall rose up out of the grasses. Coming up the hill is a new east-west interstate and with it a Cineplex with its complementary stores and restaurant franchises

On this day in 2006, however, I wasn't fully present, which became painfully clear to me. I had tunnel vision, and my thoughts teemed with apples. I assumed my surroundings were the same; the store was there, therefore the orchard behind it was there, the parking lot, the sky…I had a right to assume this. Or to put it differently, I can't help needing for things to stay the same; otherwise I might fall off the edge of the world. Change is inevitable, but man-made change isn't always for the best—an almost subversive statement to make in the United States these days, and in an international community heavily influenced by American pragmatism and propaganda, where a continuous flow of disposable products, from buildings to cameras, is necessary even when the newest product doesn't work as well.

Ray and I were astounded to discover after we downsized and bought a bungalow in South Utica that ice trays were more efficient than the ice maker we got with the beautiful, stainless steel GE refrigerator included in the price of our old house. The ice maker worked for a year; then it slowed down; then it broke altogether and ice backed up into the depths of the freezer. Our new-old crappy refrigerator that came with the bungalow makes ice the old-fashioned way in ice trays that you fill, freeze, crack open, and dump into a container.

The Macouns, my favorites, were gone, but the fancy Empires looked good. Maybe I'd get some Cortlands as well. Ten pounds, five of each. I placed my order, and the clerk brought two paper bags overflowing with apples to the counter. I looked at the washed Empires, their golden red skins still glistening with beads of water. I could feel the bite to come, the pungent skin, the crisp sweet flesh. Apple pie and crisp, apples with walnuts and cheddar cheese, with peanut butter. And for a pittance, under ten dollars!

Carrying my bags, I pushed out the door, lifted my head, and saw a landscape from a video game in hell; an earth-moving machine with the face and claws of a raptor taking down the orchard that stretched across and over the sloping hill behind the store. I stared as the black claw clanked and grabbed hold of the gnarled trunk of an apple tree. With a loud crack like a scream I hope never to hear again, it broke the tree and tore it from the earth. Behind it lay a row of decimated trees, once full of blossoms, bees, fruit.

I looked over at the car and saw Ray slumped back in the driver's seat, shaking his head at me. While I had been oblivious in the store, he had been watching the execution of tree after tree.

I guess there isn't a lot of money in apples. Unless of course you grow them in huge quantities, like corn in Iowa. Unless you form an apple corporation with an apple CEO. Unless you plant, prune, harvest them on an assembly line and slap a sticker on each and every one. Twin Orchards was a family business created in 1962. This is a surprise to me when I look it up—the landmark isn't as ancient as I thought. Is anything in the United States? On the other hand, John Kennedy hadn't been shot in 1962; it was a different world.

Twin Orchards represents almost fifty years in the life of one family of planting, irrigating, battling cold, frost, worms and other disease, packing and marketing. Fifty years before that, the families of orchardists grew up packing apples in cold sheds and drying them on the roof for winter use. Sometimes in desperation they put wooden boxes in irrigation ditches to direct water to the trees. And here is the undeniable benefit of progress, or change: the work itself gets easier, less physically demanding. Although in most cases, the hours don't seem to have gotten shorter. People aren't any less stressed or worried about business. And the product, the apple in this case, isn't any better. Oftentimes it's worse.

Maybe Twin Orchards was losing money. Perhaps the younger generation decided they didn't want to grow apples in Utica for the rest of their lives. Who could blame them? So when Lowes offered them a fortune to build their giant hardware store in the middle of the orchard, Twin Orchards had no choice.

It's possible to follow this story all the way back to Adam and Eve and their particular apple tree. Mine is just another description of homes lost,

animals becoming extinct, processed versus organic. What does this story teach us over and over again? That everyone sells out—not just out there in Washington, D.C., or Madison Avenue, but right here in your community, at Twin Orchards, at small groceries, book stores, schools, and hospitals. The schools consolidate. The hospital is transformed into Urgent Care. The funky, dusty book store goes Mega.

It teaches that everything changes, not just once in awhile but all the time. What was yesterday an orchard is today a man-made monumental monument of gypsum, engineered wood, and fiber cement.

And if you work out the logic, as so many of us have, sometimes without knowing it, individual life is of little significance. Your past disappears before your eyes, your house, your store. Nothing small and private matters to the CEOs and their earth machines. They have to think of the bottom line, they will tell you—not to mention population and demographics. They have become *They* and *The System*. They can't spend their time, which is money, on individuals. They gave, they insist, Twin Orchards a lot of money, and if money isn't apples or the smell of a room full of them on a fall day—hey look, their lab can concoct the smell and taste of apples and sell you apple candles, or apple flavored muffins and cereal!

To Ms. Stein I say that an apple is not an apple is not an apple. I don't know who or what to trust besides my husband and family (and I am fortunate in that). We live in a bungalow in an old residential neighborhood in the city, as close as we can get to a sense of sameness, ordinariness. Neighbors still talk over the fence here. Kids play ball and ride their bikes. Dogs get loose and run through the back yards. But we know we live in a backwater. We know that the war is going on. We know or sense an environmental upheaval. We know our children and our grandchildren are in danger of terrorist attacks and global warming. What we don't know is what to do except auto-fill our names to another Internet petition and cast our lonely vote. ≋

Elisa Leiva

THE GLOVE COMPARTMENT

I believe in cluttered desks
and open minds. I believe in
random acts of kindness
and crowded subways.
I believe in quotes
that haven't been said
people that haven't been met.
I believe that not everyone belongs somewhere
not everyone can wrap up
their identity in a tidy
little box. I believe in cities
and nightlife but more importantly
in social justice
and that protests
do bring about change. I believe crying
over spilled milk is useless.
I don't believe in fate
or karma because of the
corrupt white men
swimming in cash
while the working class
with gnarled hands and broken backs
remain ignored. I believe that memories
and sleeping pills
are the only things that get me through
the night. I believe in the women
who held me tight
when I found out we were moving
again. I believe in the long
string bean country where I was born
and the state of the thousand lakes
where I once lived.
I believe in the wrinkles
on my grandmother's face

are tragic stories
that will never be told. I believe
that I will never fully understand
my father or the reason why
he moved us to suburbia
or drives a mini van
and keeps his memories
of being a revolutionary locked up
in the glove department

Stephen Lewandowski

Here Be

Casting lures from
a water-washed
gravel point
on the lake shore

Fishermen break
forked willow and
poplar sticks and
push the sharp end
deep into the gravel
for pole holders

Bait flutters as
lines drop into
deep, clear water

When fishermen pack up
at dusk
sticks are left behind
sculptures and markers

Dowsing wands
divining water
not water
here be fish

A month later
roots push out the end
and from nodes on the stem
the first few green
leaves appear

 -on Canadice Lake

Donna Steiner

STILL LIFE

The old paper mill burned down last
night. Floor by floor collapsed on
itself while a crowd collected. Some
remembered summer jobs at the factory,
or their fathers' long careers. The plant's
been closed for years, half-gutted, still full
of scrap, combustibles. Embers drifted up
and landed in the river—small flaring boats—
echoes of cut timber floating to the mill.

October's over, the maples stubborn-
yellow and flaming along the ridge.
This morning a deer lay as though
asleep in the front yard of the gray
house down the road. Big doe,
white-bellied, hit in the night by some
pickup that left no sign—no broken
glass, no skid marks. Peace and
violence, violence and indifference;
small town life complicates and
settles, settles and rattles.

Last winter, same road, snow like
a bunched skirt around bare trees; I
walked our pup on a long leash. She'd
stop and sniff and sniff and pee and
I mostly daydreamed, hunched inside
my coat. Twenty yards away I swore
I saw a deer head lying in the snow.

The mind has trouble at a moment
like that, having no history of images
that might offer context. We don't
grow up glimpsing the heads of men or
beast collected in drifts on sidewalks
or beaches; I'd seen no pictures captioned
Still Life with Snow and Deer Head.

But out in the middle of nowhere,
resting near the old lightning-struck
tree where the road curves, where I hit
a squirrel last month and didn't turn back,
where I hit a blue jay last month and didn't
turn back, a deer head cut clean at the neck.
We're pretty cavalier about beauty,
we're pretty stoic about death; nobody
breaks a sweat out here over killing
anything not human. If a deer
slips in and out of tender maples on a
brisk autumn morning, *why not* shoot
the thing, gut it, lop off its useless head?

Small town life won't let you
turn away. We watch the fire,
the flesh, we witness what happens
when something happens.
In this way we marvel, in this way
we mark time, make history of
fire, of work and cold;
a history of fleet creatures
navigating a forest of shotgun
and cherry, a forest of bow
and arrow and aim, a dense
and blazing forest of pine
and birch and birth and shade,

cut and cleared for homes
of children whose fathers
labored at the mill, coaxed deer
into the cross hairs, drank into the
darkness as yellow
yellow leaves collected
on their rooftops.

Facts accumulate like ash; we write them down
on paper made from northern hardwoods.

This is our education; this is our art.

Linda Allardt

AGAINST PLOWING

Left to itself the field will say grass,
 will say mustard and mullein,
 chicory, bladder campion,
 milkweed and mallow and Queen Anne's lace,

 will hide foot-twisting furrows
 and woodchuck holes,
 spill springs down the slope,

left to itself, will say evening primrose,
 clover and daisies, dock,
 will say color and pollen—
 goldenrod, aster and paintbrush,
 coltsfoot and blue vervain,

will say nightshade, hawkweed and bramble
and sharp Scottish thistle.
Left to itself, to freeze and thaw,
the field will say stone.

GRACE HEDLUND, *Harris Farm,* oil on canvas, 21"x14", 2006

Lindsay Glover, *Hollowed Out #1,* ink jet print, 47"x35", 2005

Lindsay Glover, *Hollowed Out #3,* ink jet print, 47"x35", 2005

LINDSAY GLOVER, *Hollowed Out #6,* ink jet print, 47"x35", 2005

LINDSAY GLOVER, *Hollowed Out #7,* ink jet print, 47"x35", 2005

SARAH McCOUBREY, *Save White Lake,* oil on wood, 8"x7.5", 1999

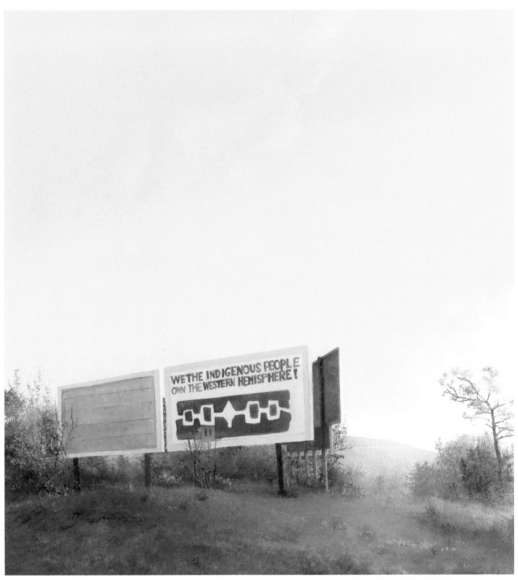

Sᴀʀᴀʜ McCᴏᴜʙʀᴇʏ, *We the Indigenous People,* oil on wood, 16"x15", 2005

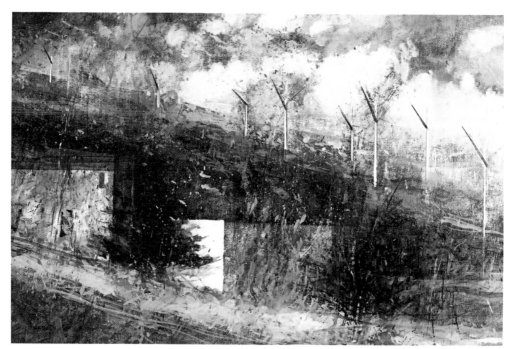

BRUCE MUIRHEAD, *Wind Farm on the Tug Hill Plateau,* detail, oil on canvas, 36"x24", 2005

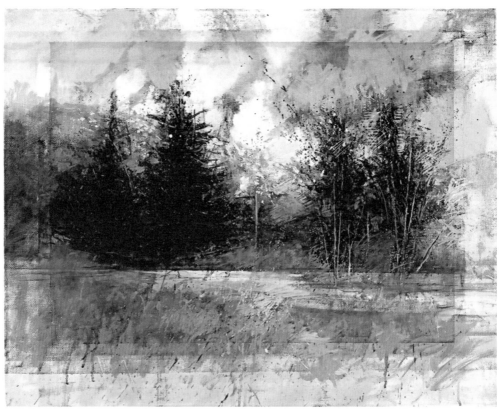

BRUCE MUIRHEAD, *The Oriskany,* oil on canvas, 24"x18", 2006

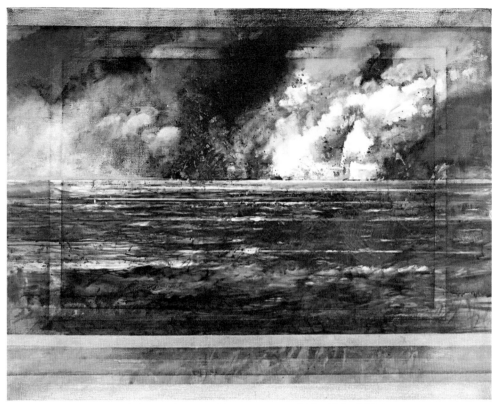

BRUCE MUIRHEAD, *Atlantic Storm,* oil on canvas, 30"x28", 2006

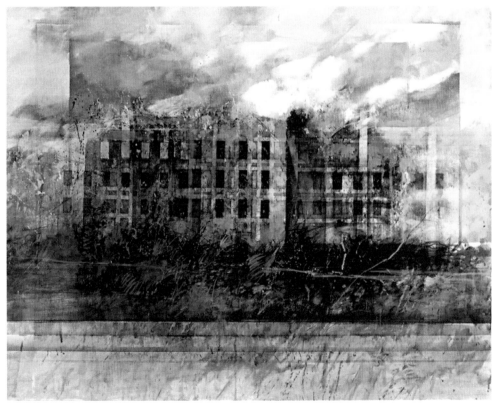

BRUCE MUIRHEAD, *Abandoned Factory at Richfield Springs,* oil on canvas,
32"x30", 2007

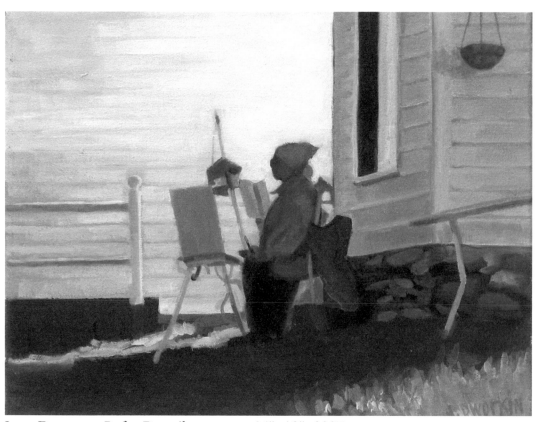

Joan Dworkin, *Perfect Day,* oil on canvas, 16"x12", 2007

Rick Henry

PRIVIES

[FROM A NOVEL-IN-PROGRESS]

The *Homer Ode* was an odd compendium of bits and snippets governed by the fancies of its editor and the boundaries suggested by its title. The name itself was the original whim of its founding editor, a man who sensed a divinely ordered Cosmos, a man who knew something of the Classics, a man given to reading the Bible in Greek, but a man who remained muddled and muddied in everything he did. Witness the incomplete definition in the upper left corner of the *Ode's* front page: "Ode: a lyric poem that praises in exalted style." The *Ode* was not, of course, lyric, nor did it approximate poetry even in its most florid days. It had long since ceased to be a broadside in praise of "all that is simple and delightful in the faire towne of Homer" (the orthographic rendition "faire towne" being a-historically mannered as well as one reason why so many of its denizens left the University in Rome bare-headed and mortal-bored. That many actually pronounced the finale e's assured University officials that they were dealing with rubes in the rough). On occasion, however, the newspaper's style could be considered exalted, if not sublime, in the editor's continued efforts to the refinement of the population. On occasion, the population was refined.

The upper right corner offered a second definition, this time as suffix: "-ode: way or path." Visitors to Homer should not be dismissed for their occasional complaints of the broken type and misspelling—mistaking the hyphen for a broken "R" and the "ode" for "oad," they quite naturally expect the upper right corner to read "Road: way or path" (why visitors might expect such a thing is beyond the grasp of most Homerians). Nor, given the proximity of Cooperstown and baseball's Hall of Fame, should such visitors be banished from the faire towne for suggesting that the original intent of *The Homer Ode* was to celebrate the home run. They are simply expressing their unfamiliarity with the early game of baseball, as well as a substantial gap in their education, a gap which, if filled, would have had at the ready the knowledge that the *Ode* was going to press on a regular basis before A. Doubleday was born. No, banishment is too strong. There was a time when being unfamiliar and being dumb were cardinal virtues.

As a point of fact, the paper announced the break between the Colonies and the Queen. *Worker Bees to Begin a New Hive,* waxed the metaphoric headline, presaging such Marxist slogans by nearly one hundred years; Tories insisted they simply *Buzz Off,* and grew red, stung by their own embarrassment as they realized their snappy comeback was about as clever as the Whiggish *Sayeth Thou So?* Upon reflection, they puzzled. Was this reference to the Queen meant to emasculate the third George, or did the editor mean to pay homage to the powers of Charlotte? Or, and this was a serious contender, was the editor simply an idiot? Unhorsed by the possibilities, they tipped their ales and burped, "Long Live the King!" Had they so erected in England, their onioned and malted desecration would have cost them their offending throats.

The fact was, the editor was neither idiot nor wit. He was, however, decidedly for the break with the ruling Isle and argued against conciliation of any kind. The *Ode* celebrated the military exploits of Homer's favorite sons by publishing their letters home. Skirmishes with the British army describing the fallen, arms and legs ajumble with exhaustion, eyes forever turned to heaven, mouths opened, sudden and curious "ohs" on their lips, all these details were duly presented by the editor. Skirmishes with the not-yet daughters of the revolution were excised; cantations exorcised from the young soldiers' narratives by the prudent and prudish blue-penciled hand. He hesitated over professions of undying love for the daughters of Homer, inclined as he was to print such homages until he discovered quite by accident that one of Homer's favorite sons favored the editor's only daughter. Favored? The villain had successfully mounted a private's campaign of his own. The editor would have preferred professions of dying love.

Hardly an event of world importance escaped unwitnessed by an Homerian. When the market crashed on that blackest of Mondays in '29, the *Ode* crowed metaphoric:

"They sold the hay before it hit the barn. Now the cows will starve, to be sure."

More than a few scratched their heads over that little gem, but it caught on, much to the chagrin of Allan Dumfries, defender of the Queen's English (though he fancied the Scottish Mary, who gave herself to each of four husbands, but lost her head to the jealous (and virgin?) 'Lizbeth). Dumfries' eye naturally scanned the lines as he read them and was surprised to find

the lilting iambic pentameter of the first careen out of time in the second. He did remark (to himself) upon the sharpish violence of the consonant it/hit and the lamentable howling of the vowelled now/cow. Lost in rhyme, he returned to the opening syllables to discover a nasalled braying, and so was lost in time, transported to battles and axes and bridled asses, to damsels spread on dampened grasses, winning and winnowed.... Oh, Homer never knew.

The *Ode* ran a small piece on the price of apples in New York City in which it quickly editorialized the Edenic nature of Homer, where one could pluck an apple "fresh and worm-free" which would "sate the devil himself and inspire the erection of the eighth Wonder of the World with its flavor." Readers will not find in the *Ode* mention of the fact that a full seventy-five percent of the town's orchard stock originated some miles up the road in Rome. Visitors will, no doubt, forgive this editorial omission. The Fall, they would be reminded, was not an act of omission, but of commission. The question of who sanctioned that eating, it will be remembered, has muddled more minds than the apple itself. Ah, most hideous Worm!

Marguerite Rischel sits in the office of the Ode, awaiting her father while eating just such an apple. It is a New York Rome from Ernst Gros' orchard by way of his son, a schoolmate of Marguerite's. The apple is perfectly round, exquisitely green, and voluminous—it fills Marguerite's hands, hands small for her age. She is small for her age—fourteen-years-old, four-feet-ten inches, and finished growing. A catastrophic completion. Her mother, quick to see the good in the bad, has reminded her that her dress, measured carefully to mid-calf last season, won't need hemming until the styles change.

"Just watch Melissa Albert's knock-knees running from out under her dress," her mother said only yesterday, as if they were cucumber vines escaping the garden fence. "She's growing so fast she'll need new material sooner than yesterday."

Marguerite was not comforted by the fate awaiting Melissa Albert. New material? A new dress? Her lips curled consonants and wounded vowels in insinuated sarcasm. "A new wardrobe! Oh horrors! Anything but!" Well, attempted sarcasm. Though she willed its tortuous passage through her speech canals, the sound came out straight enough. It sounded better when her brother George dribbled such things out of the side of his mouth. George. "Now there is a *dangerous* boy," her teacher said one day. Marguerite hadn't thought her teacher ought to be saying such things. Neither had her brother Charles when she told him. Charles wrote a letter issuing the teacher

a warning and signed it as the head of the State Department of Education. Then he faked an official-looking seal by pressing the paper against the lid of a Mason jar. "Pfth," he said as he licked the envelope. "I'll show her who's dangerous."

Marguerite sits on the edge of her father's desk, eating her apple while contemplating her feet, her own knees safely imprisoned in the material she will have for life. The print, a rose-brown yarrow with its thousands of petals, bothers her immensely. Sneezeweed. Her grandmother, so taken with its delicacy, sowed and sowed the tiny seeds until the weed crept from every crack within a mile of the farm. Had she ever left the farm, historians might have christened her Hazel-Sneezeweed-Seed. Fortunately for the world, Hazel was a homebody. Unfortunately for Marguerite, the same. Everywhere she went, everywhere she played, she crushed the weed beneath her feet and breathed its ascendant scent. She snuffles. She sneezes. Beneath those petals—her feet. Left foot. Right foot. They are not too big, how could they be? She sniffles. But she worries Robert O will think so. Or would if he ever took a peek. A convulsive expulsion of fine mist settles on tiny petals.

Pa Rischel pays no attention to his daughter. He has fifteen lines of type to set and is working quickly so to be finished by sunset. He works under an electric bulb. Natural light, moody and fickle with the wind and the clouds and the transit of the sun and the translucent-but-imperfect glass, is a strain on his eyes. He prefers the constant lumination of the 25W incandescent. So the shade is drawn and has been for fifteen years. He is rushing so that he and Marguerite can walk home in the light, so that they can make it in time for supper.

She jumps from the desk, and roots through the proofs for the current edition. The proofs are fresh, damp with the ink. Pa Rischel prints three sets for every edition. Two are for the proofing—a horrendous job the Editor-in-Chief shares with his son. The editor swears he taught his son to read at an early age with the proofs. His son's teachers (including the aforementioned Allan Dumfries) aren't so convinced. Capital H Homer comma space capital N capital Y period doublespace capital K Kliens apostrophe s capital F Farm period new line capital T The so hyphen called quote capital O Outhouse capital G Gang unquote. For years everyone thought the boy stuttered until they realized he was paid to talk that way. They never were sure if what he was doing could actually be called *reading*.

Pa Rischel delivers the third copy to Ma Rischel. She prides herself in knowing everything just one day before the rest of the town. A story catches Marguerite's eye.

Homer, NY. Klein's Farm.

The so-called "Outhouse Gang" struck again on Tuesday last when they removed John Klein's outhouse from its designated site and left it perched atop his barn. Speculation has begun over the intricacies of this engineering feat. The hooligans raised the small out-building a full forty feet in the air without damaging the barn roof. Messy Klein suspects the supernatural and has vowed never to use the structure again. John Klein has already begun installing indoor plumbing. "The crows can have it," he said.

Mrs. Klein is going to have the whole county running from fairies, thinks Marguerite, echoing what her mother will say when she reads it. Mrs. Klein never did stop believing, certain as she is that half-a-dozen of the more evil sprites crossed the Atlantic with her father just to punish him for leaving the blessed isle. More likely, the fairies were hungry too, suffering the Great Potato Famine with as much acuity as their human brethren. Blight, after all, is Blight.

Marguerite skims an editorial on the Modernization of Homer, NY advanced by their dear Editor-in-Chief. One feels the dagger thrust in a number of directions—toward Cooperstown where telephone service is limited to businesses and street lamps to Main Street; toward Homerians living outside the city limits who dared to cultivate such filthy apparatuses as outhouses with their night soil; and toward "The Outhouse Gang" itself (though here the thrust is halfhearted at best; the Editor himself lives just outside the city limits and has been pressing the municipality to extend its sewer services so that he won't have to go to the expense of putting in a septic system, especially since the city is bound to grow in the future):

Certainly the rogueries of various personages henceforth noted as "The Outhouse Gang" are not to be glorified, opines the Mayor. One must admit, however, that they do serve to highlight the Modernization of our Metropolis. City sewer, telephones, and electric street lamps are available to all living within the city limits.

"Pa?"

"Hmm?" says Pa who isn't really listening.

"When we going to finish the plumbing?"

A small "p" drops to the floor, a pinging tinkle as it dances under the desk. Pa bends to search. He has lost only four letters in all the years he has set type: o, t, e, and m in that order. He remembers MOTE or TOME, the inconsequential or the weighty depending on his mood. A little "p" would exhaust his mnemonic device. He scrapes about the floor, disturbing the dust until the fine particulates begin to fill his lungs. He coughs.

Marguerite doesn't expect an answer.

• • •

"Mrs. Klein is going to have the whole county running from fairies," says Ma Rischel as she settles to reading the paper her daughter has just dropped on her lap.

Marguerite smiles to herself on her way into the kitchen.

"Modernization Schmodernization," she mouths to George, whose fingers are deep into fresh-baked blueberry pie.

"Modernization Schmodernization," mutters Ma from the other room. "I'd pay them fairies to run Hirem out of the county." Marguerite has her hands on her hips, flapping her jaw while she wiggles her head. George snorts, a purplish blueberry stream trickles from his nose.

"Opined!" She burst. "That does it. Hirem never opined in his whole entire life!"

George unleashes a flood of blueberry filling.

Ma Rischel hears the kitchen door slam. Scuffling feet and laughter. To this point, her objections have been personal. The snorts and wheezes from the other room return her to motherhood. She begins reading aloud, to no one in particular, the specific "no ones" in question being George and Charles, the latter of whom has just come in from the barn with Lester and Warren. No one can say with any certainty that she knows of their escapades, or that she knows with any certainty what they are up to, but she has a good feeling they are the culprits, members, if not founders, of the "Outhouse Gang." She doesn't need her trick knee to tell her that. A couple of boys sneaking around in the dark. A couple of outhouses dislodged from their appointed locales. That is plenty close to certainty. Certainly enough for her. Besides, she doesn't have a trick knee (or not one that she admits to anyone). So Ma Rischel begins reading:

The mayor has every bit of confidence that the hooligans will be caught forthwith. Chief Heater, says the mayor, has assured him that an arrest is imminent. The Chief has clues, says the mayor. The perpetrators have left a paper trail a mile long. Chief Heater was out following the trail or....

Ma Rischel doesn't need a trick knee to hear the sudden silence from the kitchen, to see four sets of ears turn red, or to note the sidelong glances passing between brothers. She can hear the blood rushing to their faces, the sudden and jarring vibrations of eyes swiveling in their sockets. She enters the kitchen, leaving the *Ode* on the sofa, conveniently open to the article. The four boys look stricken. Margie is smiling, waiting for George to catch it for desecrating the pie. Ma Rischel orders them out of the kitchen to clean themselves for dinner. They bolt. Amidst the clatter of the plates, she hears the newspaper savaged. ≋

Nancy Geyer

LOOKOUT

It's a late Tuesday afternoon in September, noisy with municipal lawn mowing. The kids at the end of the block are on their skateboards, and the cat that lives across the street is chasing yet another squirrel with a nut in its jaws to the corner. After the squirrel scrambles to the uppermost reaches of a tree, where it monitors the cat waiting at the tree's base, I move to the sofa with the newspaper.

There's a section of the paper called, "The World," as if the world were a separate thing. In it, I come to a black-and-white photograph of a solitary Pakistani soldier on a lookout mountain, turned three quarters away from me. He faces a panoramic sweep of arid peaks along the Pakistan-Afghanistan border, a region the text describes as "lawless" and a "largely forgotten corner of the war on terrorism."

Shadows spill across the distant mountains, which are creased and puckered and pocked with alpine flora. In his camouflage fatigues, the soldier dissolves ever so slightly into this backdrop texture of light and shade. He is still the photo's centerpiece but fading, as if history is already beginning to claim him. As if the air is withholding its breath.

The hills are believed to be hideouts for Al Qaeda and for the Taliban. There is a tension between their jagged beauty and what they shelter, between the photograph's careful composition and its hints of a world in the unmaking.

I'm still immersed in the photo when I become aware that a helicopter has been circling "the flats"—our south-side, flood-prone neighborhood. It pauses overhead. The sound of a chopper is neither rare nor common in a city that, though recently designated a metropolitan statistical area, is still called a small town by many. To me it feels like not quite one, not quite the other. I've lived in towns and cities that are unequivocally what they are.

For a few moments the photograph and the chopper noise conflate, the sensation of each heightened by the other. I feel exposed just then, as if I'm lying on my sofa and out in the world at the same time, somewhere where the air is thin and where being safely tucked inside a house with walls is only a memory. It's an acute feeling but it disappears as soon as I try to wrestle with it.

Where I live, a man might rob a liquor store or the tiny basement shop of Tibetan knick-knacks on the Commons. He might start a fire or peep through a college student's bedroom window. Do worse. If the perpetrator is on foot, he may well head toward our edge of town, with its edge-like operations: a hilltop factory that makes gear motors and clutches; a long stretch of auto supply stores and car washes; a natural gas transfer station that is always humming. Perhaps no one is on the lam and a city engineer is up there studying traffic; it's the right time of day for it.

· · ·

Most nights, despite my neighbor's admonishments, I walk around the block alone. I perceive the city as safe while she, who has lived here much longer, feels her sense of security steadily eroding. The house on our west side hasn't been lived in for over a year, and I can see through its living room window that the caretaker has left the ceiling fan running, underlit by a cluster of bulbs in their tulip housings. After each visit, he leaves a new pattern of lights on and lights off to give the illusion of occupancy.

Many times, reading in bed, I still think of the man who once lived there. Late at night, after watching television, he would abandon his walker at the first floor landing and crawl up the stairs to his bedroom, which was a straight shot through our window. A war veteran, too old to drive by the time I met him, he once told me, "To survive you must learn to ask." He kept his shade up so we could be alerted to any mishaps.

All I ever saw of him, once he was safely in bed and under his blanket, were his hands and a book between them. The pages of the book faced me, and I would wonder where they took him: far from home? back in time? wherever the women were beautiful? Some nights he and I read so late we could have been the only ones alive. In daylight, though, we had little rapport; he felt his stories were more appropriate for my husband's ears, expected them not to travel to my own.

From the street, looking through the thin margin between drawn curtain and the top of the window frame, you can't see the fan's blades—only their shadows on the ceiling, whirring soundlessly around their axis. ≋

Marion Menna

ENGRAMS

I saw two shore birds in the doctor's parking lot
this morning, sunny morning in late April,
stalking on thin pink legs in the flower bed,
turning over pebbles brought in from Pennsylvania.
Killdeer, I thought, one of my brother's favorite birds,
black breast bands, russet back, golden orange rump
displayed in flight. Thirty years he's been gone.

My friend says he saw killdeer as a kid
in upstate New York, in the fields, near the farms.
I check the book; he's right. "Habitat: fields, airports,
lawns, river banks, shores; will nest on flat roofs."
Not a shore bird then, or only on Long Island where
we ran the beaches and the mud flats of the bay.

New green-yellow leaves droop down from each
slender branch of the willows, moving easily
in the breeze as I go by. Remember that,
with a fine brush put in darks and lights,
all connected, pulling the color down, deep
inside the structure of the tree, as he taught you,
as you remember him, and the birds.

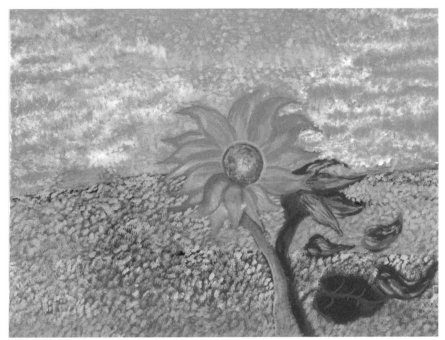

DENNIS PULLEN, *Sunflower,* acrylic and oil on canvas, 24"x18", 2007

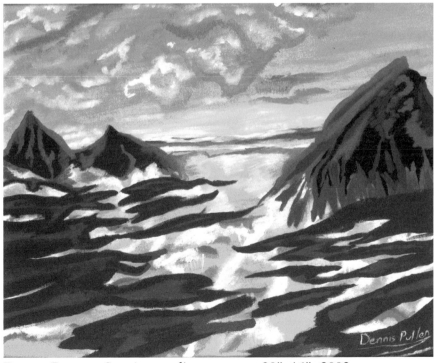

DENNIS PULLEN, *Serenity,* acrylic on canvas, 20"x16", 2002

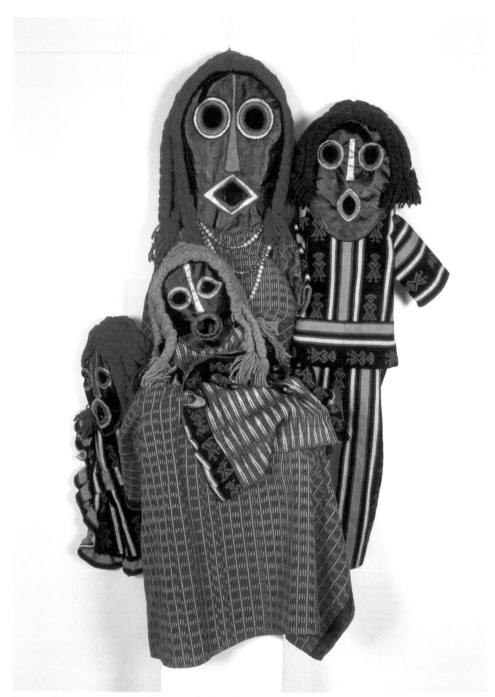

Faith Ringgold, *Mrs. Jones and Family,* mixed media, 69"x74", 1973

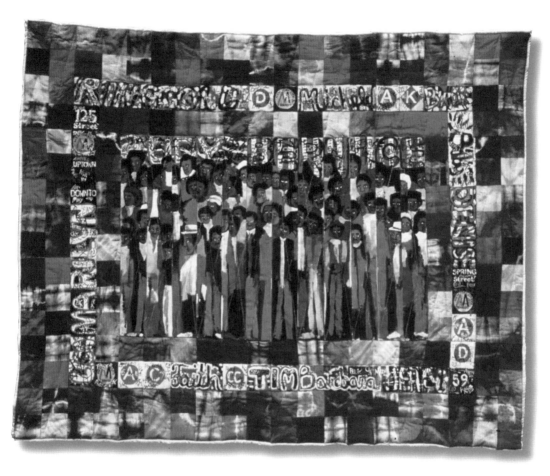

FAITH RINGGOLD, *Subway Graffiti #1,* acrylic on canvas, 62"x50.25", 1987

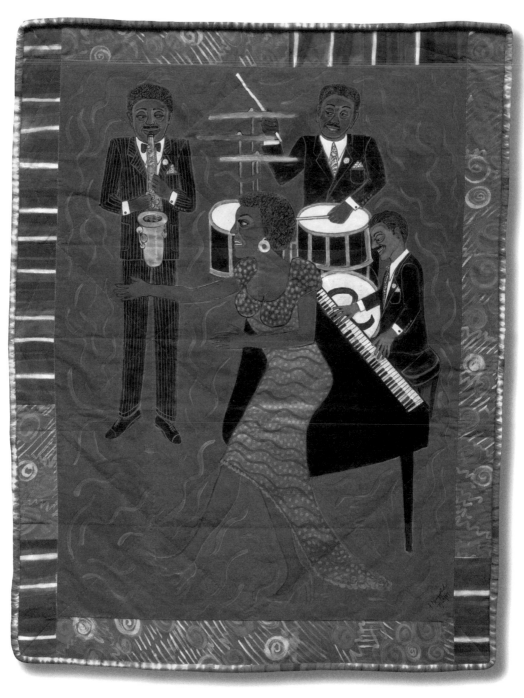

FAITH RINGGOLD, *Jazz Stories 2004: Mama Can Dance, Papa Can Blow #6:*
I'm Leavin' in the Mornin', acrylic on canvas with pieced border, 65"x82", 2004

Jason Fishel

RAINY DAY MUSIC

I believe
In the Father Almighty, maker
Of heaven and Earth,
etc.,
etc.,
ad infinitum,
sure.
But more importantly,
I believe in the needle
That burrows its way to the center
of the Earth, and I believe in the music
Of its voyage.
I believe
In wise men saying
only fools rush in,
And I believe that you may just be my candy girl,
and yeah,
you got me wanting you. I believe
In the rain outside, and I believe
It will not stop this time,
Finally.
I believe in you and you alone,
and tears,
and clowns,
and countless stills of countless nights.
In blue velvet and black vinyl
And vice versa.
And maybe,
just maybe, this time I will dare
to believe that when arms fall off,
and music turns to scratch,
scratch,
scratch,
You will still be there, singing to me
Softly.

Daniel Torday

CHARITY

Claudia's hair hadn't always been so startlingly blonde. But there was a confidence to wearing the color that sharpened her presence, and made it impossible for her friends not to equate the change in her hair with the remarkable upswing in her general disposition. She had, of course, always been a welcome presence; few of her friends would ever have considered Claudia to be anything less than a stalwart friend. But as often happens with those who easily absorb such a great deal of the pain of those around them, Claudia had found that while her temperament was measured in the face of others' adversity, when it came to dealing with her own crises, there was no way for her to be but spun as inside a chrysalis.

So it was on an exceptionally billowy night in early January, when the sun was no longer out past five in the afternoon, that Claudia found herself at the birthday party of one of her closest friends. This friend, Rachel, was a talented jeweler who lived in Dumbo, only a few blocks from the Manhattan Bridge. Claudia had always been smitten with Rachel's ability to take craft and transform it into aesthetic, as those with such deep levels of compassion often seek to match their insatiable need for people with a desire for art. She looked to her for a definite guidance, as not only did she lend the skill of her hand to precious metals and glass, but she equally molded out of her friends great sculptures of human consonance. Rachel had a self-assuredness that bordered on delusion; she had a way of effortlessly welling up inside herself every iota of confidence she possessed. She then bestowed the very same upon others, making them as sure of themselves as she seemed to be of them.

It was already late when Claudia reached the apartment, but she arrived unflustered. She'd ambled through the snowy streets that always evoked for her what old New York must have been, all cobblestone and brown around the edges. Probably the image came from a movie she had seen, since she couldn't remember having ever seen a picture of old New York. She wondered what that even meant: Old New York. Something Dutch, perhaps. Coming up the stairs now to the fourth floor door, she let herself in, hearing the noise of loud voices and music, and Claudia couldn't help but feel relieved when Rachel met her in the doorway. She was smiling widely and holding her arms out as if to be passed an infant.

"Rachel," she said.

They hugged.

"How's the party?"

Claudia followed Rachel inside without an answer, and soon she had acclimated herself to the constant lull of idle conversation. This night, Rachel had invited not only the regular friends who Claudia knew, but had also included a number of different groups. There were the glass blowers with whom she worked, a group who, through their callused, soiled hands and stained clothing took on an earthy belligerence. There were the women with whom she had once made her beaded art, a practice that had fallen off after a trend of a strong demand for beaded glass necklaces died. And of course, there were the smattering of her other friends dating back to childhood acquaintances, children of her parents' friends, elementary, high school, and college friends with whom she had kept, as was her way, in surprisingly close contact. As a result, the party took on a distinct air of what could be referred to as nothing other than Rachel-ness: Introductions were made by Rachel between friends who had not met before ("Do you know Alex? He's my *oldest* friend; we used to take baths together!"), and conversation was spurred on and engaged in, without exception, by each person's relation to Rachel herself. One's fingers and toes could not have sufficed to count the number of variations of, "How do you know Rachel?" that were employed to open a conversation throughout the evening.

This fact filled Claudia with an indefatigable pool of pride. She couldn't help but wonder if this was the common feeling that everyone at the party had. Claudia walked among clusters of Rachel's friends, at times served with a glowing introduction from the hostess herself ("You all haven't met Claudia yet? She just finished a term at Penland, in North Carolina, making stained glass—you guys will have so much to talk about"), and at times spurred on to make similarly grand introductions for herself. Claudia's head was left spinning, and it wasn't until she bumped into her close friend Philip that she noticed she was still wearing her jacket.

"And your gloves are still on, too," Philip told her, though in truth only one of them was. "I'll take this off to the bedroom for you."

"Let me do it," Claudia said, raising her voice to him in annoyed objection. "I need to catch my breath a minute."

In the bedroom, where a pile of coats was strewn across the bed, Claudia bumped into Jason. Though they'd only seen each other three or four times, Claudia had already become infatuated with him. He was her most

immediate evidence of having escaped her recent depression. Jason worked on Wall Street, trying to make his money and then get out. It wasn't a track much appreciated by Claudia or by her friends; but where most of Claudia's friends' prejudices would immediately have (or had) turned them off, Claudia had taken the time to find out about his true ambitions. He had designed gardens throughout his time in college, and had always considered getting a degree in environmental studies. He considered himself to be politically so far left he was almost a reactionary, and yet he had a pragmatism that often comes with that tag. It was just that pragmatism that led to his career. Claudia could see what she thought was the truth of his convictions in his physical appearance: His broad shoulders, his dark complexion and five o'clock shadow, his wide, rough hands.

Born a century earlier, Claudia would likely have taken to phrenology.

But perhaps her readiness to believe was hubris, and though she recognized that she was projecting much onto him, she was prepared for what she would get.

"On the train to work this morning," he was saying, "there was some black guy selling whistles. Had a big bag full of whistles—there must have been a thousand of them if there was one."

He was talking to two people Claudia didn't recognize.

The woman he was with said, "That's exactly why I don't ride the subway."

Jason continued, still unaware of Claudia's presence.

"He was rhyming, saying something like, 'Ladies and gentlemen, I'm here to sell these whistles, it sure ain't a hustle, in the train hustle bustle, I'm not lookin' for a tussle, get your whistle.' Something like that—oh, and then, 'for a big talker, a real squawker, you New Yawkers.' That one was pretty smart. He was going on and on. Selling his whistles for a dollar."

"Well," the woman said again, "that's *exactly* why I don't ride the subway."

She looked to the man that was with her. "James grew up on the Upper East Side, and he never even knew there were trains that weren't on the green line, the Four, Five, or Six."

The man nodded and smiled. He couldn't have been thirty, and yet he was already balding significantly, and wan. Claudia saw a fatigued dullness in his eyes that made him look ten years older.

"He was in college before he even knew there were other trains. And now we don't even use the Six."

"So I gave him a dollar," Jason said. "I didn't take a whistle, though. Just gave him the dollar."

"The last time I rode the subway," the woman continued, "I was sitting down when a street person came into the car I was in. I thought, 'What's the net if you have to pay a dollar fifty to get onto the train to ride? How much change must you have to collect to turn a reasonable profit?'"

She laughed.

"Well, he was—he was dark as night, skin all ashy, looked like he hadn't had a shower or a meal in weeks—he was muttering in some language that certainly didn't sound like real words. At first I couldn't quite believe what happened next. He was rubbing his hands, his cracked, diseased, ashen hands, on the walls of the train, on the handrails and the bars. Then I saw he wasn't just rubbing them. He was sticking his fingers into his ears and rubbing it on the poles, and then sticking his fingers into his nose and rubbing his hands on the poles, and under his armpits, and, oh, I can't even go on. I haven't been on a train since."

Jason shook his head and said, "Whistles for a dollar." He turned then, seeing Claudia for the first time, and touched his cheek to hers, kissing the air. "This is, uh—oh, God, I'm sorry guys, this is Claudia, and this is…"

"I'm Jenine, and this is my husband James."

"Nice to meet you," Claudia said.

She kept her hand at her side. She couldn't believe that Jason would stand by and listen to this woman talk. His acceptance of it, the way he tacitly allowed such racism and prejudice to go on and on. But what bothered her most was the way that because Jason listened, she had stood, not speaking, because she had no way into the conversation. Why hadn't he noticed her when she walked in? After hearing this tirade, she had to acknowledge her complicity. She was implicated into the bigotry of the conversation by standing there, and she couldn't help but think about it, and she couldn't help but think…there was some legitimacy. To think of some un-fed homeless man purposely spreading disease all over the subway car was unnerving.

But surely that wasn't what bothered her either. It was the woman's attitude. While there wasn't anything wrong with being disgusted by that scene on the train, one needn't speak in such callous terms.

That was it.

There was a way of approaching not only one's own personal thoughts about such a situation, but also of the decorum with which one presented

those thoughts. It wasn't for Claudia to tell anyone whether or not he or she should ride the subway; but there was something to the idea of tact, keeping up some semblance of social grace.

Claudia found herself unnecessarily bothered, and she could tell her face betrayed her. She longed to go back into the happiness of the scene outside.

"Let me help you with that," Jason said, realizing Claudia hadn't put her things down. He placed her jacket on a hook, away from the heap of coats on the bed.

• • •

Jason had been at the party for almost an hour before Claudia arrived. Although he'd moved to New York only three months prior, he still hadn't adjusted to keeping city time. In Michigan, if an event was called for seven, you got there at seven. If you got there at eight fifteen, you arrived with a good excuse. Once he'd arrived at dinner at his mother's house half an hour late. "Well, the clocks in this town all do read the same, except for yours," she'd quipped, and turned back to her gentle dinner conversation. She was like a guard at the state penitentiary, palms board-flat and straightening her jacket, returning to calm discussion after disciplining a prisoner with fist and billy club.

It should have followed that Jason would embrace this new urban schedule, accepting of half-hour delays spent on subway trains whose lights flickered, the bodies of all the people pressed, sweaty and festering, against his. Riding public transportation was the populist dream, the melting pot in action; while it fit into Jason's ideals, in practice it was something very different.

He knew he had repeated the story about the man selling whistles to distance himself from his own thoughts.

It was the way he wished he'd acted.

In reality, he had passed the man a dollar, but he'd used the money as a kind of shield—he hadn't smiled or made eye contact. There was no charity in his heart.

So Jason had arrived early at the party, unable to sidestep his punctuality. Thinking he was fifteen minutes late, he found that he was one of only three people there—the other two were the hostess and her friend Gillian. He'd met Rachel once through Claudia. He'd gotten the impression she didn't like him much. It was simply snobbery, the haughtiness that artists

take against anyone they deem conformist. Jason learned long ago to slough off such pretenses; he understood the urge, and he knew if he could show people like Rachel pictures of the gardens he'd designed, they would warm up to him. He sometimes even considered carrying photos of them around, showing off his work like a proud parent.

Jason quickly shed the burden of inquiry from himself. He helped Rachel with some last-minute preparations. She was busy making a salad, and he worked happily, dicing scallions, tearing lettuce, and chopping tomatoes. He took a moment to admire the decorations on Rachel's wall and fell into conversation with Gillian. She had been Rachel's first teacher at the glass studio, and in the quiet spaces of her conversation with him, she revealed herself to be as beautiful in words as she was physically. She had high cheekbones, a small, straight nose, and perfect, soft skin.

"When I first saw glass blown," she said, "I knew that was what I had to do. They call it dancing with glass, and that's more to the point. When I started, it was like riding a horse—when you first get on, you aren't trying to get it to jump, to go where exactly you want it to go. You're just trying to stay on. Maybe later you'll want to be able to be precise. But maybe not. Maybe it always needs to have that freedom of its own to continue to be what it is, and that's always just glass."

"Or always just a horse," Jason said.

By the time people started to show up, he wished they wouldn't. He could have listened to Gillian for the rest of the night; he would let her mold him while he nodded and smiled, nodded and smiled.

As the room filled up, Jason sat on a couch in the corner of the room, no longer eager to start conversations. The guests all seemed too ready to please Rachel, their conversations punctuated by quick glances at their hostess. She obliged their insecurities, bouncing from conversation to conversation. Jason squirmed under the collar of his shirt and the belt at his waist. When finally he decided that he'd done enough listening, Jason searched the then-crowded room for Gillian's face.

Then he remembered Claudia.

He met her at a party not unlike this one. It surprised him how much like his introduction to Gillian it had been. She was everything New York to him. Beneath her bleached blonde hair was the drone of brown that told everyone she had no need to excuse herself the superficial change she'd made to her appearance. Her pants were just tight enough to draw attention to her strong, full body, and when her attention was turned toward him, he

lit up like a wick touched by a match. Listening to her, he felt something akin to what a freshman must feel the first day he hears a lecturer speak the exact words and ideas that he never even knew had been rattling around in his head for so long he assumed they were his own.

As time passed that feeling dissipated. Only his conversation with Gillian earlier that night made him remember how he could feel under the same spell. What was it that turned in him so quickly? As voices raised to a clamor, Jason's head began to throb, and while he realized that though Claudia would be upset when she arrived and he was gone, he had to leave. On his way to pick up his coat Jason encountered his conversation about the subway with James and Jenine. They were just putting down their belongings, and though Jason imagined that the look on his face must have been anything but inviting, Jenine had struck up conversation, thinking herself polite.

Still, their friendliness began to lift Jason's spirits. Jenine told him that James was also working as an investment banker, and somehow the comfort of eschewing their judgment loosened Jason's lips. They had been talking for ten minutes before Jason noticed that Claudia had finally arrived. By that time, he felt refreshed as if by a shower that begins uncomfortably hot and ends unbearably cold. Walking back to the party, Jason felt again ecstatic to be around people, living in the city.

Outside, snow fell softly to the ground, the occasional flake brushing the windows of Rachel's apartment, piling on the sill.

• • •

Back out in the living room it suddenly seemed a switch had been flipped. In the middle of the room, ten or fifteen people had started dancing, the music so loud that conversation was nearly impossible.

"I could use a drink," Claudia said.

Her own words made her shudder. She'd been drinking again only two months after three years of committed sobriety. Her world had been informed by a new coterie she'd joined at AA, but in the days since her father had died a year prior, Claudia had found herself in a strange progression.

At first she had been devastated. Months of watching her father in a hospital bed, lying in a coma and dying of a brain hemorrhage, had torn at her until her life became rote and vacuous. Claudia mourned in the time immediately after her father finally passed. But a day came when she could see that her life must again cohere, and she began to venture outside of her new routine.

The results instilled in her a new energy. She'd gone off to an elite crafts school in western North Carolina, where a new group of friends reminded her of the anodyne aesthetics could provide. When she'd gotten back, it was as if a new life was born, one that she took from a foreign place and transplanted to New York. She spoke of her new friends by name, though her old friends hadn't met them.

In this schizophrenic new social outlook, Claudia found herself happier than she could remember ever being. But the man she'd been seeing in North Carolina was a pot smoker. And though Claudia eventually broke up with him, being around the dull, citrusy smell of the smoke again, staring into his eyes with their capillaries glaring red against glassy white, she began to wonder why she'd ever become sober. Alcoholics Anonymous was an explicit misnomer for her. Her drug problems had been with psychedelics and pills. She'd smoked too much pot, eaten the occasional pill of ecstasy. But she'd never even enjoyed drinking. Looking back lucidly on the motivation for her sobriety for the first time, Claudia realized in her first weeks back from North Carolina that her real problem had been control. And not a lack of control—she'd had too much of it. Drugs had allowed her to pick a mood and live inside of it. She could crush up and snort a Xanax if she needed sleep, or find some Ritalin if she wanted to stay up all night.

So she started to drink again. It made her happy. She could smile and tip a glass to her lips with people she didn't know—and laugh a guilty laugh to herself, the personal scandal of it. Then a week ago, she'd woken up and experienced her first hangover in more than four years, and it threw her. It wasn't the headache, the flu-like symptoms. It was a nebulous haze over her general outlook that scared her. There was a feeling of jittery, anxious worthlessness, the black spots in her memory taking the presence of long awkward silences in a difficult conversation. She felt too terrestrial.

So Claudia was going to get a drink. Before she got out of reach, Jason grabbed her.

"Where are you going?" he said.

"I was gonna get us some drinks. Looks like we're about eight behind everyone else here."

Jason's innocent look turned comically heavy-lidded. He pulled her toward him. He said, "Maybe we should stay that way. I think this party's had enough of us already." Claudia couldn't help but laugh at him.

"What?" she said.

He was instantly embarrassed.

"Oh, all right, let's stay awhile. I forgot I've been here so long."

His concession made Claudia sad she'd miscommunicated so badly. She put her hand lightly against the side of his shoulder and said, "I'll get the coats. You start saying good-bye to Rachel."

When Claudia got back from the room where she and Jason had first seen each other, Jason was already caught in an extended good-bye with their hostess.

"Well, we all have to go out sometime, you and Claudia and me and William, my boyfriend. You and William would love each other. Don't you think, Claud?"

"We're headed out, Rachel," Claudia said. "Sorry to leave so early, but I have that thing in the morning."

Rachel looked at her knowingly. That indiscretion didn't bother Claudia, but Rachel whispered in Jason's ear and the two of them looked to where a beautiful woman danced with a man, rubbing up and down him, and they laughed. Jason winked at Rachel and said, "It was great making food with you. And please, tell Gillian good-bye."

· · ·

The walk away from a party always made Jason feel he was missing something. Knowing that there were still so many women flirting made him feel like the last guy cut from the baseball team. An uncomfortable air overwhelmed him on the walk from Rachel's apartment to the subway station. Though Claudia's arm was wrapped tightly in the crook of his, the two didn't speak a word.

It was bitterly cold. Jason's shoulders hunched against the biting wind, every muscle in his body taut.

He finally awoke from his fog when they got to the shelter of the subway station. Claudia unraveled her scarf and smiled.

"Cold," she said, and his eyes forced a smile back. He only then realized that she had been silent the whole way back as well. They stood on the platform waiting for a train uptown. Claudia finally tried to broach their silence.

"I hate it when she calls me Claud," she said, knowing that she was giving away the mood that the end of the party had left with her.

Jason said nothing.

"I thought that little whisper between you and Rachel was weird," Claudia said.

Jason began to feel defensive, but as he opened his mouth he realized her candor made him comfortable. He said, "We were making fun of that girl Gillian. Her friend who was dancing with those guys."

"Yeah, I saw," she said. It wasn't until he looked at Claudia then that Jason realized the indiscretion of his laugh with Rachel. It was a laugh of jealousy and desire.

"Well, look, it was just a simple laugh. We were hanging out with Gillian when I got there, and I just ended up…it was just funny."

He clicked his tongue. He looked at his feet. Cars passed loudly across the platform. A group of drunken teenagers stumbled up the stairs.

"I'm sorry," she said.

"Well, you should be," Jason said.

Before she had a chance to speak again Jason said, "Sorry. I don't know why I said that."

"No, it's not all you," Claudia said. "Maybe I'm retarded. I didn't used to drink for a long time, and I got all weird when I offered to get us drinks. I didn't want one anyway, but I was ready to get drunk and go home with you."

She felt as if she'd said too much. Then she continued.

"My father died a year ago tonight," she said.

At that moment their train began to screech through the tunnel. Jason spoke, but the noise of the train covered it. When the car finally came to a stop in front of them, they passed onto it in silence. Jason looked and saw that there were tears streaming slowly down Claudia's cheeks.

It was impossible for Jason to imagine what it was like for Claudia, losing her father when her life was just starting to seem foreign. It was like hearing thunder in the dead of winter, knowing that it should be impossible, a sound not unfamiliar in a not-unfamiliar setting, just a combination desperately out of sync.

They got on the train and it jerked to a start. Jason sat back, thinking vaguely of the person who had sat in that seat prior to him, the dirt and grease slowly soiling his cashmere hat.

• • •

Claudia couldn't help but feel embarrassed. That burden only made the tears keep coming. *Why won't you look away?* she screamed inside her head. She couldn't stop crying, and when she feared she would begin to sob, her shoulders lightened. She sat up straighter. A feeling like a force was tugging

her chest upward brought her confidence back. Jason had a grimace on his face, and she lamented the way she'd made him feel. Whose burden was the death of her father? How could she think that she could not only go out to a party that night but also drink? She sagged again and thought to make another apology.

Jason's eyes were closed. His head was back.

Claudia looked across the car, where an old man sat with a cloth sack in his lap. From his chin hung a dirty gray beard that extended down to the middle of his chest. Evidence of recent meals of something brown and chunky stained it, and something yellow and sticky that might have been tobacco spittle or bile. His forehead was high and pocked. He had a long, kind nose and equally long, oval eyes. He was homeless, yet his clothes didn't seem dirty enough to have spent many nights on park benches or worse.

Claudia's gaze turned to the parcel he held. His eyes were trained to it. Each time he glanced up and then back down at the package, his countenance softened, and he reached a finger in the bag.

Claudia looked closer. It became clear to her what was in the man's lap. He had a baby chick! Its tiny yellow head bobbed beneath his finger. Claudia nudged Jason's arm. He turned his head deliberately toward her, opening his eyes. He smiled back. She kept her hand in her lap but extended her index finger in the direction of the man and his bird, moving her arm almost undetectably from the shoulder.

It took a second for Jason to realize where she was motioning. He looked across to the homeless man. He flushed bright red with anger, removed from the safety of his thoughts and into the insecurity of the world. He thought, in the space of less than a second, that Claudia was insinuating that something in the conversation they'd had back at the party about the homeless man on the train had stoked her memory: She'd caught on to him.

Maybe she knew the details he left out when he spoke about himself.

But awake again to the world, he realized she wasn't making fun of him. He saw that her tears had already dried to glittering spots on her face. She was smiling. He, too, looked closer and saw the bird.

He thought: That man has a bird.

Then he thought: Maybe that bird's carrying the avian flu.

He smiled at Claudia. He put his head back against the seat. He closed his eyes, and he let sink into his deepest thoughts the vision of a man on a subway with a diseased bird in his lap. ≋

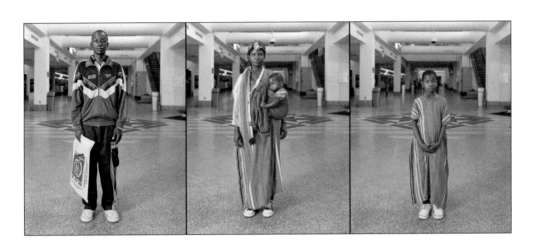

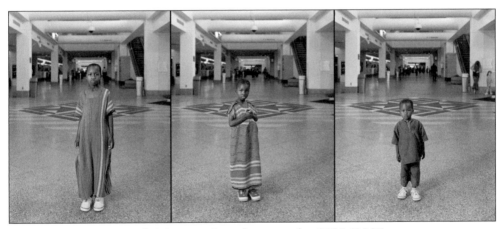

Doug DuBois, *Arrival 1 Series,* color photographs, 2003/2007

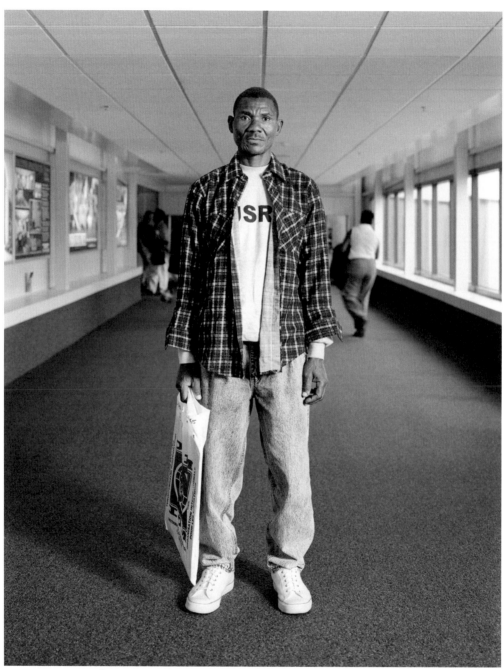

Doug DuBois, from *Arrival 2 Series,* color photograph, 2003/2007

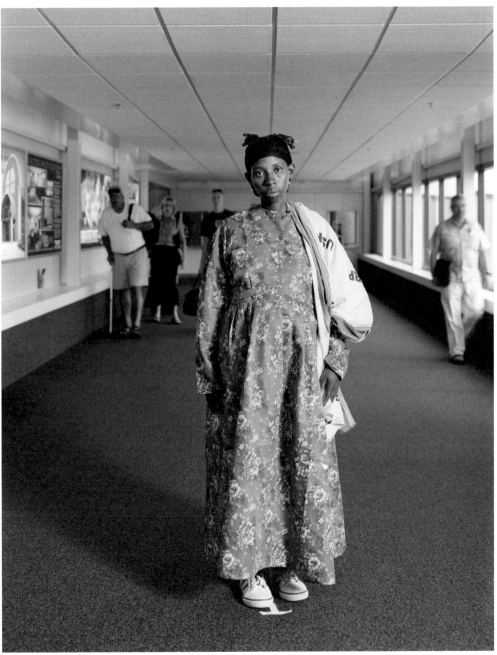

Doug DuBois, from *Arrival 2 Series,* color photograph, 2003/2007

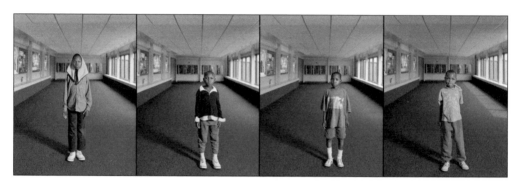

Doug DuBois, from *Arrival 2 Series,* color photographs, 2003/2007

Robert Colley

The Stone Canoe Interview: Bill Henderson and the Pushcart Prize

A critical success from its inception, the Pushcart Prize has become an increasingly significant force in the literary world since its founding 32 years ago. The *Chicago Tribune* calls the annual *Pushcart Prize, Best of the Small Presses,* distributed by W. W. Norton, "the ex-officio house organ for the American literary cosmos."

Bill Henderson, founder and publisher of Pushcart Press and creator of the *Pushcart Prize,* decided in 1975 to create a vehicle for recognizing the best writing in "small" literary journals. Started on a shoestring, the Pushcart is now widely acknowledged as one of the premier benchmarks of new writing talent, an annual publication that *Publisher's Weekly* calls "chock full of short works that make big statements." Pushcart has been credited over the years with discovering many important writers, such as Ray Carver, who taught at Syracuse University from 1980 to 1985. As Russell Banks has said, "This is the anthology that writers read, especially young writers, perhaps because it is the only collection whose contents have been selected by writers themselves."

The Pushcart Prize is often found among the list of awards in many prominent resumes today, and even a nomination for the Prize is considered a big boost for the beginning writer's career. Bill published the first *Pushcart* book in 1976, and still does it, essentially on his own. He is seen as a hero by many, an enigma to some, and a nemesis to those who feel somehow left out of the "Pushcart club."

Educated in Upstate New York at Hamilton College, Bill currently divides his time between his home in Wainscott, New York, and his summer camp, built with his own hands, in Sedgwick, Maine...where he does lots of reading! The following interview was conducted by phone from Sedgwick in August, 2007.

RC: You first conceived of the idea of the Pushcart while working in the mainstream publishing industry in New York. Can you elaborate on the story, and explain where the name came from?

BH: Well, at first I didn't expect to get a job at Doubleday. I was 29 years old and all I had ever done in publishing was start a little press in North Plainfield, New Jersey, with my uncle. One of our books was my first novel,

The Kid That Could, which I still like. Nobody else liked it but I thought it was brilliant. So I learned how to publish stuff myself, though the press eventually folded. Then I got a job with Doubleday and worked weekends on a book called *The Publish It Yourself Handbook*—the first Pushcart Press title—and just by word of mouth alone it sold out the first edition of 20,000 copies—eventually 70,000 copies. I shipped that over the weekends from my apartment with my then wife. So from that venture I had a little money in the bank, and then I got fired from Doubleday—well, fired, quit, I don't know—it was more like a mutual agreement that I wasn't right for the job. Which is absolutely correct. I was not a Doubleday sort of guy, and I wanted to do literature. So I had a little money from my book, the only money I ever had in my life, and I put it into the Pushcart Prize, which I started in 1975 by writing letters to literary sorts who might help me out. I also did a stint with Putnam for awhile to make ends meet.

As for the name, George Plimpton and some writer friends did a demonstration on Fifth Avenue called, "Project Pushcart." They sold their own books from pushcarts, in protest against the laziness and narrowness of commercial publishers. So I adopted the name.

RC: Surely it was hard to take that big step—to finally quit commercial publishing with all the perks—was it a sudden decision to go entirely on your own?

BH: Well, it happened gradually. But when the first *Pushcart Prize* reviews came out, I quit flat out. The reviews were terrific.

RC: Your list of founding editors is stunning—Paul Bowles, Ralph Ellison, Leslie Feidler, Buckminster Fuller, Ismael Reed, Anais Nin, Joyce Carol Oates, etc.

BH: Yeah. I wrote many letters to established writers all through the summer of 1975 while I was living in a rented place in Southampton.

RC: Is there a copy of that original letter around?

BH: I wish I had it. All my stuff is at the University of Indiana Lilly Library. But I never found a copy of that original letter. Anyway, some of them responded—Ralph Ellison said use my name but don't ask me to do any work. Paul Bowles said he'd help. So did many others. Joyce Carol Oates

has been terrific, one of the founding editors who didn't just let me use her name but offered great suggestions. For more than 30 years she has sent me letters with names of people and things she'd loved in little magazines. She is really a terrific person. I know she's a Syracuse grad. She gets knocked for being prolific (why is that a problem?) and for being an institution and all that, but she deserves all the praise she can get.

RC: You actually wrote to Anais Nin—that took some courage.

BH: She used to send purple postcards with the Pisces sign on the back. I have a lot of purple postcards. Some people weren't as receptive, and a lot of them just ignored me. But many were enthusiastic, because obviously I was this guy who had my heart in this thing—I was sitting there with this freaking manual typewriter, which I still have, and typing these long letters out one by one.

Then I paid for an ad in *Publisher's Weekly* with my self-publishing kitty, listed all the founding editors. We got the first edition out, and people went berserk with praise.

RC: And some of these famous writers really helped do the work?

BH: Yeah, they made suggestions, made nominations as core contributing editors, about 25 of them. We have over 200 now. You get to be a contributing editor, if you want to be, by actually having your stuff published in the *Pushcart Prize.*

RC: When did the connection with Norton start?

BH: That started over lunch with then-President of Norton, George Brockway, in 1982. I called him and asked him if he wanted to distribute it. Before that—other than a brief association with David Godine—I did it all myself, had a little studio apartment in Yonkers, wrapped them all right there, got a number 1 mail bag and literally dragged them to the Yonkers Post Office.

RC: What did you think you were going to do with your life when you were a student at Hamilton—I assume you were an English major?

BH: Yes, an English major. A horrible choice for a guy who wanted to become a novelist. English departments usually manage to make literature terribly dull. It took me years to recover as a writer. I even did graduate work at Harvard and Penn, but ultimately fled both. Then I spent the next year in Paris, living on a little pittance I had saved. I broke out in hives, was eating with a camping burner on the floor of my garret, just the old story. I lost a lot of weight and had zero money. But anyway I lasted a year and got some work done on my first book, came back, got drunk for a couple of years, got undrunk, got married, and finally joined the publishing world. You know the rest.

RC: Is Pushcart your sole professional activity now? Did you ever imagine it would get so big?

BH: No, I never dreamed the *Pushcart Prize* would catch on as it did. Yes, it is all I do. I collect no salary from it, live basically on air.

RC: The nomination and selection process is felt by some to be somewhat mysterious—someone sends your name in and then you never hear anything—unless you get in, of course. Can you shed some light on the process and how it has evolved?

BH: The nomination process has been the same since 1976. Writers are nominated by former winners, or editors of small presses. We read the nominations—between 6,000 and 8,000 pieces. Obviously since I work alone I can't reply to all nominated authors, only the winners. The grand announcement is the book itself—published every November.

Each year I ask a new poetry editor or editors to help out—distinguished people. They make the poetry picks. My long-time essays editor retired, so now I read all the prose, essays, and fiction—with lots of help from a handful of first readers. But I try to eventually read everything myself except the poetry.

By the way, we don't pay our staff editors more than a small honorarium. Believe me, if I had any money, I'd distribute it. The editors are very generous, but they do have to rotate, because they will just get burnt out otherwise.

RC: How are you funded—are you a 501c3?

BH: We are funded by sales alone. I refuse for various reasons to go after grants. I publish the book myself, and W.W. Norton is our distributor. We do have an endowment—the Pushcart Prize Fellowships—a 501c3—to help us going into the future. But, for now, I don't tap into it. Donations are very welcome. We have some large gifts, but many donations of 25 or 30 dollars, which are very important to us, to keep the project alive.

RC: How do you envision the future of the Pushcart—do you have an heir apparent?

BH: I have to admit, I never thought I'd do this for 32 years. But I may be around for awhile—after that, the endowment board will take over. I am relying on the board and Norton to keep it going after I'm out of here.

RC: Who are some of the major writers who were discovered or at least catapulted forward by their being anointed as Pushcart winners?

BH: So very many—and, I hope, hundreds more encouraged to keep on keeping on. Ray Carver,* Rick Moody, Mary Gordon,** Jayne Anne Phillips, Charles Baxter—our annual index, in the back of each edition, lists over 1,000 writers.

RC: What in your view are some of the best journals and "little" magazines now being published?

BH: I don't like to pick the "best" journal and presses. Each year we discover so many more terrific ones—for instance, for *The Pushcart Prize XXXII— Smartish Pace, The Canary, Rattle, Anhinga Press, Laurel Poetry Collective, Ocho, A Public Space, World Literature Today,* and more than forty others.

RC: How has the advent of online content figured into the constant evolution of the small presses?

*In 1976, the first *Pushcart Prize* reprinted a little-known Carver story, "So Much Water So Close to Home," from the now-vanished journal, "Spectrum." It was released as a feature film, *Jindabyne,* in 2007.

**Mary Gordon is a Syracuse alumna; she earned an M.A at SU in 1973.

BH: Lots of online stuff out there. So far, I have seen little of terrific interest. Too fast. Too easy—like all of electronic media today. A waste for writers, in many cases. We do now allow for submissions from E-journals, but they are not where the good stuff is currently coming from.

RC: How would you describe Pushcart's place in the literary world?

BH: I have no idea of Pushcart's place in the ":lit world." I work alone and pay little attention. But I am always pleased and amazed by things like the National Book Critic's Circle Lifetime Achievement Award for 2006. That was really huge. I just started laughing when they called me. It was totally unexpected and came out of nowhere. I couldn't believe it at first.

RC: Did you have to give a speech?

BH: I went to New York and gave a speech. I don't know how it was critically evaluated but they laughed a lot. It was very loose. I kind of shambled up and just said what happens at Pushcart. I don't attempt to be literary in any way.

RC: You were quoted as saying at that event that Norton has been a great partner, but never made a dime's worth of profit on *Pushcart*. A badge of honor, almost.

BH: Nobody makes any money on my books. I don't make any money on *Pushcart,* we pay the printer and that's just about it.

RC: I know you have had health issues and some operations this past year, so it was a tough year and a terrific one at the same time. Not only the National Book Critic's Circle award, but also the fundraiser for your endowment at Guild Hall, in the Hamptons.

BH: Yes, quite a year. Lots of medical challenges and also lots of recognition for the Pushcart. The fundraiser was extraordinary. Cedering Fox put that together. We had some Oscar winners reading from Pushcart Prize-winning stories, and it was great to hear great actors like Peter Boyle and David Strathairn reading really great fiction. Marcia Gay Hardin read a wonderful

Joyce Carol Oates story, for example. And then *Pushcart* was awarded the "Writers for Writers" Prize from *Poets and Writers* magazine, an annual prize for those who help other writers' careers. That was another great celebration in New York.

RC: Do you generally go to a lot of literary events or conferences?

BH: As a rule, I tend to avoid literary gatherings. If I know someone I tend to want to do them a favor. It gets a bit lonely at times, but if people do approach you, you suspect it's because they want to get in. I prefer just to have the piece of paper in front of me and read it.

RC: So the truth comes out—you are really a misanthrope at heart, preferring the woods of Maine to literary company?

BH: I like people a lot but my inclination is always to help them out and I am afraid of putting a short story in because I know the author. I will put the story down and say, well, that was pretty good, but was it good enough?

Then of course we do love it up here. We rent out our Long Island house every summer, and come up here to our very basic and rustic camp. I work out of a shed in the back of the property. And we just got an electricity pole because my wife uses a computer.

Sometimes we actually do commune with the outside world. My wife Genie and I do a radio program on the local NPR station, "Radio Pushcart," something we have been doing once a month for the last year or so. It's not a big deal but we talk about small presses and getting published. And we also run the World's Smallest Bookstore, as it is called on the sign, as a dig at Barnes & Noble. It is small, but we have over 1000 titles, all the *Pushcart* books and all the good small journals. Send us yours and we will put them out there!

RC: Thanks, we will. So you really are basically in a shack out in the woods with no power, not in a secret palatial setting, as some would suspect, with your own air strip, perpetuating the myth of the creative rustic?

BH: No luxuries, really, and it does get cold up here. I stayed under the blankets this morning to keep warm. But we live really basically and really

beautifully. I am looking right now at the ocean and Acadia National Park mountains in the distance. Spending the summer here always restores me.

RC: While there is no doubt that the *Pushcart* is generally revered, I'm sure you are aware that there has also been some criticism from various quarters. In *The American Dissident,* Tod Sloane turned the *New York Times* praise on its head, saying that if the *Pushcart* really is the "single best measure of the state of affairs in American lit today," then Emerson, Ibsen, and Orwell must be turning in their graves, given the politics of the current publishing establishment.

BH: Oh, absolutely. I am very aware that some people have started calling *Pushcart* an organ of the establishment, an establishment institution. I can understand that, but it is really run out of my back yard in a shed, by me and about 200 volunteers.

RC: The argument that you have, ironically, become a voice of the establishment seems to go like this: since editors get to nominate writers from their own magazines, and since they are anxious to get a Pushcart for their publications, will they not be tempted to nominate their most famous contributors, say someone like Joyce Carol Oates, because the odds are better that such names will impress the Pushcart editors?

BH: Yes, I agree that this would always be a worry—it is a worry I have too. But we read for really the best we can find. And also I don't even look at the author's name or the press's name. Our joy is always to find little presses that we haven't even heard of.

Or new authors. If you look at a typical edition, certainly, there are a few names that you know, but most of the people are new. And there are also entries from better-known small magazines, certainly, but this year at least eleven of the presses are new to me, out of, say, 50.

RC: Yet you do find people like John Updike and Margaret Atwood in the *Pushcart* annuals. And there is *Time* magazine's famous reaction to the first issue: "That's not small press, there's Saul Bellow in it." Actually, in looking back over some of your recent issues, I was surprised that such well-known writers still send things to small presses.

BH: Oh, it is absolutely necessary. People like Joyce Carol Oates often can't get their stuff published anywhere else but in small presses. I mean, there is maybe *Playboy* or the *New Yorker*. But the publishing venues for serious literature are more and more limited. You have to give a break to the name writers too. But again we just try to pick the best. And then if there is a tie, the new writer is always favored.

RC: Well, Howard Junker, editor of *ZYZZYVA, A Journal of West Coast Writers and Artists,* seems to agree with you there. In a piece called "Pushcart Comes to Shove," (November 21, 2006), he says: "The Pushcart winners are first nominated by former winners; litmag editors also get to nominate. For a long time, we've only nominated our unknown (and especially our first-time) writers, who have a distinctly less likely chance of being chosen than our 'famous' writers. The nomination itself means something to these writers, and, conversely, not racking up another prize means nothing to us."

BH: Well, that is encouraging. The process is not perfect, I'm sure. I assume the nominations mostly are honest and objective. And I'm sure some lit teachers who are former winners try to do favors for students. I don't know where these nominations are coming from. I don't know who is sleeping with whom or who owes money to whom. I don't even know who my contributing editors are at first, it all comes in blind, and my poetry editors and I just read on the basis of merit. There may be conspiracies all over the place, but not at Pushcart.

Pushcart is the only anthology I know of that gets nominations from over 200 contributing editors and over 500 editors of little magazines. I will agree with one observation from *The American Dissident*—that most of the work comes from professors and English departments. It is unfortunate that most of the writing we see these days comes out of creative writing departments. I have often told writers that they ought to get off their asses and go out and wash dishes or drive trucks rather than sit around and do "creative writing." I say this as a past creative writing teacher at Princeton and Columbia and Harvard, and I do still go to all kinds of places as a guest lecturer and instructor. But I always tell the students to get out in the world and don't get trapped in academia. You've got to get some knowledge and experience of the greater world. Then your writing will be better.

RC: But the Junker piece also goes on to say that all prizes and "best" lists are inherently corrupt, since Art is not a competition, and preferring apples over oranges is simply a matter of taste.

BH: Well, I have a certain skepticism about prizes myself. I should be careful to say that our picks are not really the best per se but the best we have come across in our judgment. Certainly they are our picks and editors everywhere, including Junker, pick the best that they have. It is a prize to get into any journal, though you don't call it a prize. People are making selections all the time. But I think our prize helps alert people that there are all these great presses out there, some of them doing terrific work, and I think that is a positive thing. Imagine if the commercial publishers were allowed to dominate everything. I think the Pushcart is a thumb in the eye of the commercial giants. It's called the Pushcart Prize, which sounds like the Pulitzer prize on purpose. We are still alive, damn it, and what we are doing is important, and this is as much as we can get of new stuff with 200 contributing editors—a wide-open book for anyone to send to. But I do make picks, yes, and so does everybody else by the way.

You know, I was rejected so many times when I was a young writer, and finally I published my own book. I never forgot that experience. So many people put their life into their poems and stories and then get ignored or just slapped in the face. So I have never forgotten what it means to be able to get published, or what a small press can do for people—give them heart. And that's what the Pushcart tries to do just by the nomination procedure. Somebody's noticed your stuff and liked it. I know friends probably nominate friends, but often that is not the case. It would have meant a lot to me back in the '60s to have someone I didn't know nominate me for a Pushcart Prize.

RC: Looking at the stuff that comes in, do you have any sense of whether the quality is getting better overall? Worse?

BH: Much better. In the early days I sometimes wondered if there would be enough to fill a book, but the quality now is overwhelming. It is contradictory that the publishing world is so commercialized and tawdry, and you'd think good writing would be declining, but it's not, it's blooming, and all because of the small presses. Although I shouldn't totally knock commercial presses, since occasionally they do some pretty good stuff.

RC: If you have any free time to read, what do you read—apart from *Pushcart* submissions, of course.

BH: I am so glad to stop reading. It takes me about four months to put together the *Pushcart Prize,* and all that time is spent reading. So after that I want to go outside and build things. I'm building a chapel on my land here, out of stone. My daughter and I discovered this marble ledge with two natural pews, and I've spent years building this stone chapel. So this summer I'm finishing it. I finished the roof.

RC: So you are a religious fellow?

BH: Sort of—the *Pushcart* is sort of a religious enterprise, I think. The spirit counts and the money doesn't so much. ≋

Note: In March 2008, NPR will broadcast nationally a Pushcart Prize fiction reading by actors from New York's Symphony Space. The stories will scan the entire 32-year history of the series.

Mary Lee Hodgens

DREAMS BETWEEN THE SKY AND THE EARTH:
COLLABORATIONS WITH CHILDREN AT EDWARD SMITH
ELEMENTARY SCHOOL

A few short blocks from Syracuse University's main campus sits Edward Smith Elementary School and one truly inspired and inspiring art teacher, Mary Lynn Mahan.

For the past five years, Mahan and her fifth and sixth grade students have been teaching the Syracuse University community a lot about photography, writing, and the power of art and image-making, not only to promote literacy, but also to deepen our understanding of and respect for children. The Ed Smith School has a philosophy of whole-school inclusion, which focuses on enabling every child, including those with and without disabilities, to fully participate in the arts programming and learning community. Within this lively mix of students you'll find many ethnic, cultural, and socio-economic backgrounds as well as differing learning styles.

Dreams Between the Sky and the Earth: Collaborations with Children at Edward Smith Elementary School, is the most recent exhibition of Mahan's students, who were encouraged to create photographs and written commentary about their notion of "dreams." The exhibition included eighty photographs and a video documentary on display in the Link Gallery at Syracuse University's Warehouse, a converted furniture factory at the edge of downtown Syracuse that has provided invaluable opportunities for a number of joint city/university initiatives.

This 2007 exhibition was the culmination of an innovative course, "Literacy, Community, and Photography," offered through the College of Visual and Performing Arts and taught by photographer Stephen Mahan. Created in collaboration with Ed Smith's Mary Lynn Mahan and Light Work, a Syracuse University photo and imaging center that supports emerging and under-recognized artists working in photo-based media, the course brings Syracuse University students into the elementary-school classroom as teaching artists and mentors. Inside Mahan's inclusive art room, filled with both Syracuse University students and fifth graders, something unusual happens. Mahan describes it best herself:

"Often children do not see themselves as successful. They don't feel they can articulate what is in their mind by drawing, writing, discussion, or the many standard ways we give them to express themselves. But the camera levels the playing field because each child can successfully show us what he or she sees by clicking a button. This program has proven that by giving a child a camera, a mentor, and a chance to write about the experience, we can give them an experience of success. Successful experiences raise self-esteem, which in turn encourages children to try new activities. This is exactly what we have seen at Ed Smith. Whether a child is a typical learner, learning disabled, or autistic, we have seen growth."

Light Work's facilities and equipment have enabled the course to move to a new level of adaptive sophistication, allowing for modification of camera and darkroom techniques that suit the specific needs of the individual student.

The broader inspiration for the Mahans' work has been the theoretical work of Wendy Ewald, noted author, artist, and educator whose Literacy Through Photography workshops, first conceived at Duke University in 1990, have demonstrated tremendous success in developing children's communication skills through a combination of photography and written exercises. Ewald brought a version of her workshop to Syracuse University in 2005, further galvanizing the Ed Smith/University collaborative partnership, which has now put Syracuse in the forefront of what is quickly becoming a national movement to promote literacy and community through art.

"Between the sky and the earth emerge paths to a new way of life where people journey together to a cleaner, safer, more beautiful world." This is the writing that fifth grade student Shivhari Chathrattil added below his photograph of converging train tracks, and in many ways its hopeful tone describes the shift in our community, as artists and educators work together to make a difference in the lives of our children. ≋

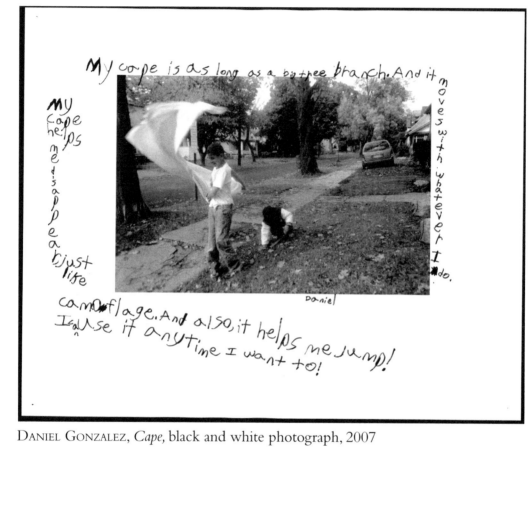

My cape is as long as a big tree branch. And it moves with whatever I do.

My cape helps me disappear a bjust like camouflage. And also, it helps me jump! I can use it anytime I want to!

Daniel

DANIEL GONZALEZ, *Cape,* black and white photograph, 2007

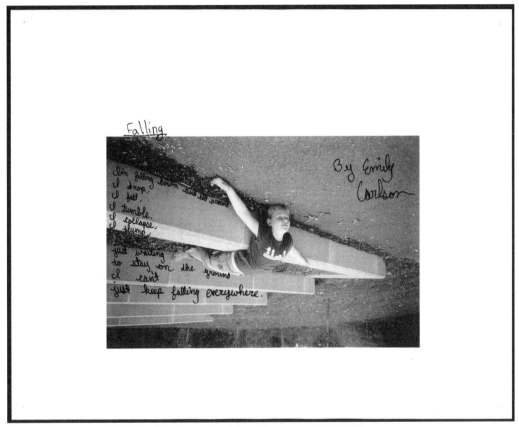

EMILY CARLSON, *Falling,* black and white photograph, 2007

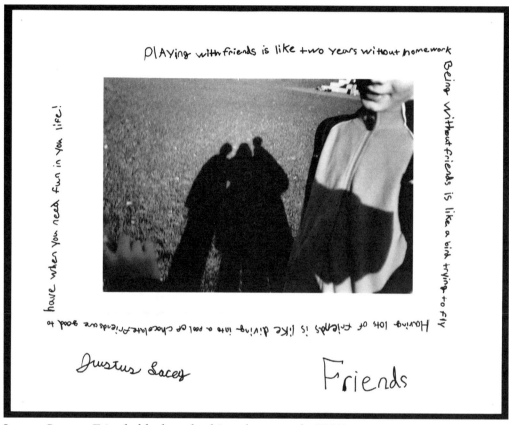

Justus Lacey, *Friends,* black and white photograph, 2007

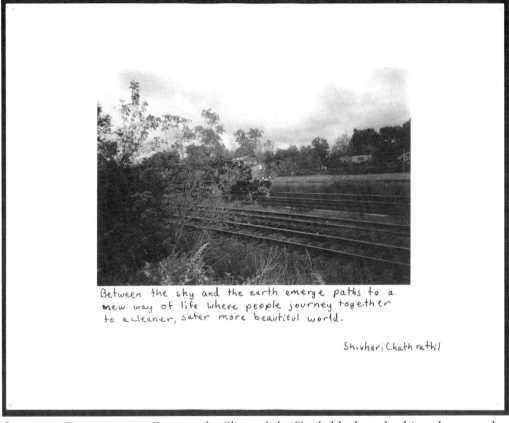

Between the sky and the earth emerge paths to a
new way of life where people journey together
to a cleaner, safer more beautiful world.

Shivhari Chathrattil

SHIVHARI CHATHRATTIL, *Between the Sky and the Earth,* black and white photograph,
2007

Maureen A. Sherbondy

CONVERSATION WITH A CAR

One cold morning, at the end of January, when Cindy Rhodes started her car, instead of the usual seatbelt reminder symbol or the 1 TIRE LOW PRESSURE (!) message flashing in green digits, the message this morning read *HI CINDY* alongside a peridot smiley face.

It was the smiley face that drew her attention. "What?" Cindy blurted aloud, her breath visible in the air of the car. Her puzzled tone the same as when her twin sons casually mentioned they were putting off college to travel through Asia for a few months. That was two years ago, around the same time that her husband, Jack, walked out after announcing he no longer loved her *that* way.

Rubbing her green eyes, trying to clear the haze of sleep, she then stared at the letters again. Still there. Had her mechanic programmed a personal greeting? Just last week the Jeep was at the dealer for its thirty-thousand-mile check-up. It had been acting up, sometimes starting on its own, sometimes refusing to turn on when she turned the key in the ignition. Once before, the car had shifted into reverse when Cindy was teaching Spanish at the high school where she worked. Her car had rolled into the principal's new Acura. No one believed her. "You probably just left it in reverse," said the mechanic.

"I have no time for this!" Cindy said, turning on the heater to eliminate the cold air.

Where are we going today? Asked the car. How did it know to ask questions? Prior to today, there had only been statements like *3,000 miles have passed, time for oil change.* Or, when the tires were low, it used an exclamation point surrounded by parenthesis. But there had never been a question before.

Suddenly, in the blank screen above the radio, a small map of Raleigh appeared. She'd never even used the navigational system that came with this car; her ex-husband had talked the dealer into throwing it in, even though she had no use for such things. Her daily trips were already mapped out in her head: grocery store, post office, high school, drycleaners, doctor offices, the vet. Where would she ever go that would require the use of this guidance system? She had absolutely no idea how to use it anyway. Maybe she'd accidentally hit a button that turned the darn thing on.

A wave of nausea hit her and she sucked in her breath, and then stuck a hand in her purse, digging out a pack of saltines. I must be imagining it,

she thought, shaking her head. Backing out of the garage, she decided to ignore the map, the smiley face, and the green messages and just go to her appointment.

Two miles into her journey, the letters began flashing and growing larger; she had a hard time ignoring the fact that the green smiley face no longer wore a smile, but a downward frown instead. Were those purple teardrops running down his digital cheeks?

DON'T DO IT!!! She had surely never seen three exclamation points displayed. Touching her belly with one hand, she pressed on the gas pedal and sped passed cars on the Beltline. For some reason she couldn't remember if this was the outer or inner Beltline and this made her think about insy and outsy belly buttons. She wondered why nearly everyone she knew was an insy. Both her sons had outsies and she began to wonder if there was a preference in other countries like China. Would Chinese girls make fun of her sons for having outsies?

Lost in her thoughts, she almost missed the next statement. *DON'T DO IT CINDY!* in thick red letters.

The clinic was just two more miles away. "I'm not keeping it!" she yelled to the car. "I'm forty years old and am done, done, done! It was a mistake! A one-night stand on Thanksgiving. I was lonely."

She caught the guy in a car next to her staring. So what! She could argue with her car if she wanted to.

It had been her second Thanksgiving alone and she had decided to attend a turkey and martini party at a local bar/restaurant. It was fun! She'd never even had a martini prior to that evening. That night she had five martinis and a man named Tommy—a thirty-year-old mechanic who had a tattoo on his right bicep. Not her type, but she was so lonely. Her ex-husband was with his new wife and her two sons were still traveling the world, eating sushi instead of turkey probably. She didn't even know the mechanic's last name.

Hitting the dashboard, hoping to silence the car's commands and judgment, her heart pounding, she pulled the car into the right lane, seeing her exit up ahead. But the steering wheel resisted turning onto the exit ramp; instead, she ended up on the shoulder, missing her turnoff.

Cindy, think about it. Keep the baby.

Cindy jammed her car into park, pulled out the keys. She kicked her car bumper over and over again, and then, her right foot throbbing, she began to walk to the clinic, four blocks away. On the icy walk, there were

no digital messages stopping her. Instead she heard the voice of her twenty-year-old sons when they were toddlers. *Mama, mama.* With each step, voices of children reached her ears. First, she heard her own boys, then the distant playful voices of children in a schoolyard at recess. A mother pushing a baby in a stroller passed her on the sidewalk and smiled.

Cindy held a hand to her stomach. This is not life. This is not a baby yet, she told herself. I'm forty years old, I have no husband.

She reached the small brick building and walked in, the guilt following her with each step and each cold breath taken. ≋

CONTRIBUTORS

ARLENE ABEND is a sculptor who graduated from The Cooper Union in Manhattan, moved to Syracuse, New York, forty-seven years ago, and graduated from Syracuse University in 1970. Her work has been featured in a variety of galleries and museums, and in various publications, including *Women Artists in America II*. Her work is in the collection of Merck Corporation, The Pioneer Group, Ebasco Services, and many other private and corporate collections. She has received, among other honors, an "International Women's Year award, *The Post-Standard* "Women of Achievement" award, and a "Certificate of Recognition" from the Town of Dewitt 9/11 Memorial Committee. Arlene continues to take courses at Syracuse University's University College, and maintains a full working metal studio in Syracuse.

CECIL ABRAHAMS, currently a visiting University Professor at Syracuse University, is a world-renowned scholar in African studies and African literature, a former president of the University of the Western Cape in South Africa, and former chair of the South African Presidents' Association. Exiled from his South African homeland for his work with the African National Congress, Abrahams studied and taught in Canada and then returned home at Nelson Mandela's request after the apartheid government was overthrown. He has worked closely with Mandela—who Abrahams has known since he "was in short pants"—and with Archbishop Tutu, to create a high-quality educational system for all South Africans.

JOY ADAMS experienced Hitler's bombs as a child in London, and as a child entertainer, recorded with George Martin in the Abbey Road studios. She immigrated to the United States as a G.I. bride in 1963, eventually earned an M.F.A. at the Maryland Institute College of Art, and has taught painting and drawing at SUNY Brockport, SUNY Potsdam, and Ithaca College. Her paintings have been exhibited at major galleries throughout New York State. She is currently retired from academia, lives in Trumansburg, New York, and paints in her studio/home in a renovated 19th-century barn.

LINDA ALLARDT is a poet and small-press editor who lives in Pittsford, New York, where many of her poems are set. She has published four books of poems, including *Accused of Wisdom* (Foothills Publishing, 2004). She teaches advanced poetry writing at Writers & Books of Rochester, and has also taught at St. John Fisher College, the University of Rochester, and the Eastman School. She has a bachelor's degree from Alfred University and a Ph.D. from University of Rochester.

HENRY ALLEN has won awards ranging from the Academy of American Poets' Prize at Hamilton College to the Pulitzer Prize for photography criticism as a staff writer for *The Washington Post*. His poetry has appeared in *The New York Review of Books, Poet Lore,* and *Gargoyle,* and has been read on National Public Radio (NPR) by Garrison Keillor. He has published a poetry chapbook, *Museum of Lost Air,* at Dryad Press; a novel, *Fool's Mercy,* at Houghton Mifflin; a collection of feature journalism, *Going To Far Enough,* at Smithsonian; and an evocation of the 20th century, *What It Felt Like,* at Pantheon. He has also written criticism for *The New Yorker, The New York Review of Books, The Paris Review, Vogue, Smithsonian,* and *The Wilson Quarterly*.

KATH M. ANDERSON attended St. Lawrence University, lived in Rochester, New York, for eighteen years, and completed an M.F.A. in creative writing from Syracuse University. Her grandfather was the mayor of Governeur, New York, from 1943 to 1951. She has published in *Poetry, Quarterly West, Sonora Review,* and other journals. She now lives in Austin, Texas, and buys cheddar at the grocery store only if she can find Herkimer.

JANET BIGGS' epic video installations have been exhibited at such institutions as Cornell University's Herbert F. Johnson Museum of Art, Syracuse's Everson Museum of Art, Rhode Island School of Design Museum, Finland's Vantaa Art Museum, and Austria's Oberoster-reichisches Landesmuseum. She is the recipient of numerous grants, including a National Endowment for the Arts (NEA) Fellowship and Anonymous Was a Woman Award. Her work is in public collections including the Herbert F. Johnson Museum of Art, Ithaca, New York; the Gibbes Museum of Art, Charleston, South Carolina; and the New Britain Museum of American Art, New Britain, Connecticut. Biggs lives and works in New York City.

PHILIP BOOTH (1925-2007) was a founder of Syracuse University's graduate program in creative writing. He studied poetry with Robert Frost at Dartmouth College, completed an M.A. in English from Columbia University, and taught at Wellesley College before coming to teach at Syracuse. Author of 10 books of poetry and recipient of numerous awards, such as the Lamont Prize from the American Academy of Poets and the Theodore Roethke Memorial Poetry Prize, Booth was born and raised in Maine, and this setting served as a place of primary symbolic importance in his work.

MARK BUDMAN was born and raised in the former Soviet Union and trained as an engineer. Currently, in addition to a career in translation and web design, he is the editor of *Vestal Review,* a flash fiction magazine featured on NPR. His poems and stories have appeared in a variety of publications, and he has been a finalist in several *Writer's Digest* fiction competitions. He lives with his wife and two daughters in Upstate New York.

EMILY CARLSON is a sixth-grade student at Syracuse's Edward Smith School, and a participant in the *Dreams Between the Sky and the Earth* project.

BRANTLEY CARROLL is a self-taught photographer residing in Syracuse, New York, and a 2007 Light Work grant recipient.

SHIVHARI CHATHRATTIL is a sixth-grade student at Syracuse's Edward Smith School, and participant in the *Dreams Between the Sky and the Earth* project, which was named after the caption of her photograph in the show.

SUSAN DEER CLOUD is a poet and fiction writer of Blackfoot, Mohawk, and Seneca heritage (Metis) who grew up in the Catskills but has sojourned in many places. She is an alumna of Binghamton University, where she has occasionally taught creative writing. She has published three books of poetry and has published poems and essays in many journals. She is editor of the multicultural anthology *Confluence,* and current guest editor of *Yellow Medicine Review.* Deer Cloud was awarded the NEA Literature Fellowship in Poetry for 2007.

RANDY COHEN'S first professional work was writing humor pieces for newspaper and magazines *(The New Yorker, The Atlantic, Young Love Comics).* His first television work was writing for "Late Night with David Letterman," for which he won three Emmy awards.

His fourth Emmy was for his work on "TV Nation." He received a fifth Emmy as a result of a clerical error, and kept it. Currently, he writes "The Ethicist," a weekly column for *The New York Times Magazine,* syndicated throughout the U.S. and Canada.

DANNER DARCLEIGHT is currently serving time in a maximum security prison in Upstate New York. *Metered Time* is his first published essay.

CYNTHIA DAY (winner of *Stone Canoe's* 2008 Bea González Prize for Poetry) has published in the *Denver Quarterly, The Literary Review,* and the *Southern Poetry Review,* among other literary magazines. Four of her poems appeared in *Last Call: Poems of Alcoholism, Addiction and Deliverance,* from Sarabande Books. Her first novel, *Last House,* was serialized online at Big Tree Press, and she is now working on a second, *The Janeville Murders.* A native of Hartford, Connecticut, she has lived and worked most of her life in Central New York.

SARA DI DONATO was born in Naples, Italy, and moved to New Rochelle, New York, as a young child. She received her B.F.A. from the University of Iowa and her M.F.A. in painting from SUNY Albany. She is currently assistant professor in the art department at SUNY Brockport. She has exhibited widely in both regional and national ventures, and her work was recently featured in the Northeastern edition of *New American Paintings.*

MI DITMAR is a research project coordinator in the Center for Health and Behavior at Syracuse University, where she is also a student in the M.F.A. program in creative writing. She received the M.F.A. program's 2007 Delmore Schwartz Award for best poem by a graduate student.

DANIEL DONAGHY holds a B.A. from Kutztown University of Pennsylvania, an M.A. from Hollins College, and an M.F.A. in creative writing from Cornell University. He is currently completing a Ph.D. at the University of Rochester. His poems have appeared in many journals, and his book, *Streetfighting,* based on his boyhood in Philadelphia, was a Paterson Poetry Prize finalist and was featured on "The Writer's Almanac" with Garrison Keillor. Donaghy has won fellowships from NEH, the Cornell Council for the Arts, and the Constance Saltonstall Foundation for the Arts. He currently lives in Willington, Connecticut.

DOUGLAS DUBOIS is a photographer and videographer who teaches in the Department of Transmedia in the Syracuse University College of Visual and Performing Arts. He has exhibited at The Museum of Modern Art in New York, New Langton Arts in San Francisco, and PARCO Gallery in Tokyo, Japan. His work is in various museum collections, and has been featured in several books, such as *The New Earth Reader* (MIT, 1999) and *The Spirit of Family* (Holt, 2002). He also does editorial assignments for such publications as *The New York Times Magazine, Details Magazine, Double Take,* and *The Black Book.* DuBois is a recipient of an NEA Visual Arts Fellowship, an Elliott Porter Fellowship, a Light Work grant, and residencies at The MacDowell Colony and Yaddo.

STEPHEN DUNN is a graduate of Syracuse University's master's program in creative writing, where he studied with Philip Booth, Donald Justice, and W.D. Snodgrass. He is the author of fourteen books of poetry, including *Different Hours,* which won the Pulitzer Prize in 2001. His latest book of poems, *Everything Else in the World,* was issued by Norton in 2006. He is currently Distinguished Professor of creative writing at The Richard Stockton College of New Jersey, but spends much of his time in Frostburg, Maryland, with his wife, writer Barbara Hurd.

Joan Dworkin has been a graphic designer and art director at *New York Magazine, House and Garden*, and many other publications. A New York City resident and weekend painter throughout her professional career, she now lives in Treadwell, New York, and devotes full time to painting. She has recently exhibited at The Roxbury Arts Group, the Cooperstown Regional Show, and the Bright Hill Gallery in Treadwell, New York. She was educated at Pratt Institute, The Art Student's League, and Parsons School of Design.

Sara Eichner lives and works in Brooklyn, New York. She received an M.F.A. in painting from Syracuse University in 1998 and is currently represented by Sears-Peyton Gallery in New York City. She has received a New York Foundation for the Arts painting grant, participated in the Bronx Museum's Artist in the Marketplace program, and attended residencies at the Millay Colony for the Arts and the Saltonstall Arts Colony. Most recently her work was exhibited in *Sight Lines;* a solo exhibition at Sears-Peyton Gallery (2006) and *Interior/Exterior* at the McDonough Museum of Art in Youngstown, Ohio. She has participated in various group shows in New York City, Earlville, New York, New Haven, Connecticut, and Glassboro, New Jersey. She also collaborated with Tom Krueger on an exhibition called *Wedgewood Rundown* in the spring of 2007 in Brooklyn, an exploration of decorative domestic patterns under the influence of entropy and displacement.

David Eye is currently pursuing his M.F.A. in poetry at Syracuse University, after a 17-year career in the New York theatre. He also works at BOA Editions, Ltd., in Rochester, as the Larry Levis Memorial graduate student intern. In 2007, David received two university teaching awards. His poetry last appeared in the inaugural issues of *Stone Canoe* and *roger* (Roger Williams University), and has work forthcoming in *Critical Encounters,* published by Syracuse's writing program.

Chelsea Lemon Fetzer is a creative writer, video artist, and art educator. A native of Minnesota, she studied at Sarah Lawrence College and will earn her M.F.A. in creative writing at Syracuse University this spring. She also teaches writing and literature to Syracuse University undergraduate students, and teaches poetry to Syracuse elementary and high school students. She is currently working on her first novel, *Rivermaps,* while pursuing her master's degree.

Jason Fishel was born in Syracuse, New York, and currently resides in the Albany area. He became interested in writing in high school, and subsequently attended the New York State Summer Young Writers Institute at Silver Bay, New York. Jason is currently a student at Carnegie Mellon University in Pittsburgh, and despite his most fervent objections, may end up going to medical school like his dad after all.

Maureen Foster, a Syracuse, New York, native, received an A.A.S. degree in art from Onondaga Community College and a B.F.A. in Studio Arts from Cazenovia College. She currently works as a tutor in the visual arts, a studio assistant to a local artist, and serves as a volunteer at the Everson Museum of Art. She has exhibited her work throughout Central New York.

Nicora Gangi was born in Indiana, and was educated at the University of Hartford Art School, Montclair State College, and Syracuse University. She currently teaches as an adjunct at Syracuse University and conducts private lessons for adults in her home studio. She lectures regionally and exhibits her work regionally and nationally, in galleries and juried exhibitions. She is married to Bruce Manwaring and resides in Syracuse, New York.

Eric Gansworth, a member of the Onondaga Nation, is Lowery *Writer-in-Residence* and professor of English at Canisius College in Buffalo, New York. Born and raised at Tuscarora Nation in Western New York, he is the author of six books, one of which, *Mending Skins,* won the 2006 PEN Oakland Award. His fiction, creative nonfiction, poetry, and visual art have recently appeared in *The Kenyon Review, Cold Mountain Review, The Boston Review, Shenandoah,* and *The American Indian Quarterly.* He has won grants from the Constance Saltonstall Foundation for the Arts and The Seaside Institute.

Eric Geissinger works in Watkins Glen, New York, as a technical writer. His fiction has appeared in *The William and Mary Review, the Owen Wister Review,* and *The Barbaric Yawp.*

Nancy Geyer is a graduate of Wells College in Aurora, New York, and currently resides in Ithaca, after an extended period in Washington, D.C. She has had work published in the *Alaska Quarterly Review* and *The Healing Muse.* In addition to writing poetry and creative nonfiction, she contributes art criticism and cultural reportage to the *Ithaca Times.*

Lindsay Glover has a B.F.A. with a concentration in printmaking and new media from Alfred University, where she studied with Joseph Scheer, Andrew Deutch, and Peer Bode. She has worked at the Women's Studio Workshop in Rosendale, New York, collaborating with artists in residence on limited-edition art books. She exhibits her work locally and internationally, and is currently completing an M.F.A. at Cornell University.

Diana Godfrey has resided in Syracuse for over twenty years, and has exhibited and sold her work in Upstate New York in one-person, group, and juried shows, such as Cazenovia Counterpoint, "Structure, Surface, and Subtext" at Cazenovia College, and the National Collage Society Postcard Exhibition in Buffalo, New York. Her work is also currently represented in galleries in Connecticut and along the Maine coast, and has been featured on record and CD covers for the Society of New Music. She has co-curated a number of area art exhibits, and is a juror for *Scholastic ART.* She has a B.F.A. in painting from the University of Connecticut, and an M.A. and M.F.A. in painting from the University of Iowa.

Daniel Gonzalez is a sixth-grade student at Syracuse's Edward Smith School and a participant in the *Dreams Between the Sky and the Earth* project.

Ronald Gonzalez lives and works in his native Binghamton, New York, and is a professor of art at Binghamton University. Over the past thirty years, he has produced thousands of figures, from the tiny to the monumental in scale. His numerous awards include two Pollock-Krasner Foundation artist's grants and multiple grants from the New York Foundation for the Arts. He is widely represented in both public and private collections through the U.S., and has exhibited in many galleries and museums, including the Corcoran Gallery of Art in Washington, D.C., the Everson Museum in Syracuse, the Allan Stone Gallery in New York, and the Berta Walker Gallery in Provincetown, Massachusetts.

Holly Greenberg is an associate professor of printmaking in the Art Department at Syracuse University. She received her M.F.A. in printmaking from the School of the Art Institute of Chicago, after completing her B.F.A. in studio arts at the University of Michigan. She currently lives in Fayetteville, New York, where she and her husband, sculptor Timothy Brewer, are renovating an early-19th-century church for their living and studio spaces.

Samantha Harmon (winner of *Stone Canoe's* 2008 Michael Fawcett Prize for Visual Arts) was raised in Utica, New York, and wrote in her *My Book About Me* at age seven that she wanted to be an artist. In 2005, she entered Syracuse University, where she is currently pursuing a B.F.A. in Sculpture. In 2007, Samantha was awarded the Mark and Pearl Clements Internship Scholarship, which funded her summer internship at Sculpture Space in Utica, New York. Harmon has worked a variety of food service, clerical, retail, and maintenance jobs—experiences that she feels have informed her unique approach to art. During the academic year, she works as a clerical assistant in the office of the Syracuse University athletic director. Harmon is spending the spring 2008 semester at Syracuse's center in Florence, Italy.

Brooks Haxton lives in Syracuse, New York, and teaches at Syracuse University. His next book, *They Lift Their Wings to Cry,* will be published by Knopf in the summer of 2008.

Grace Hedlund is a painter with a home studio and gallery in Cortlandville, New York. Her work has recently been exhibited at the Lucas Gallery in Skaneateles, New York; The Corners Gallery in Ithaca, New York; the Cortland Picture Frame Company; and The Bird's Nest in Groton, New York. Since becoming disabled several years ago, she finds painting to be very enjoyable and therapeutic.

Bill Henderson is the founder of the *Pushcart Prize* annual and publisher of the Pushcart Press, currently celebrating its 32nd year. The annual *Pushcart Prize* publication is considered by many to be the authoritative documentation of the best quality writing from the small presses and literary magazines. He graduated from Hamilton College, taught at several colleges, and currently divides his time between his Long Island home and his Maine camp. He is interviewed in this issue about his life's work and its place in the literary landscape.

Tyler Hendry is a recent graduate of Le Moyne College in Syracuse, New York, and is currently attending law school at the University of Buffalo. He was raised in Phoenix, New York, where the human population is strongly outnumbered by livestock. He began writing stories in the first grade, and selling them to family and friends for fifty cents, including illustrations. This is his first story published in a journal, with no illustrations.

Rick Henry is an associate professor and director of graduate studies in the Department of English and Communications at SUNY Potsdam. He has published numerous short stories in *The Connection Review, Between C & D, Short Story,* and other literary journals. He is the editor of *The Blueline Anthology* and the author of *Lucy's Eggs,* both published by Syracuse University Press.

Elana Herzog lives and works in Walton, New York, and New York City. She has a B.A. from Bennington College and an M.F.A. from Alfred University. She has been the recipient of a New York Foundation for the Arts Fellowship in Sculpture (twice), the Joan Mitchell Award, the Lambert Fund Fellowship, and the Lillian Elliott Award. Her work has been exhibited in major venues throughout the world, including a solo show at Smack Mellon in Brooklyn, New York; participation in "Studio in the Park" in Manhattan's Riverside Park; a collaboration with sound artist Michael Schumacher at The Aldrich Contemporary Art Museum in Ridgefield, Connecticut; and a site-specific project at K-3 in Zurich, Switzerland in 2007. She has lectured at Colgate, Cornell, Hartwick, SUNY Albany, and Syracuse University.

Mary Lee Hodgens is the program manager at Light Work, a nonprofit photo and imaging center at Syracuse University that has been supporting emerging and under-recognized artists for over 30 years. She is a graduate of Syracuse University's College of Visual and Performing Arts with an M.F.A. from the School of Art and Design, and has also worked as an instructor of design and drawing.

Ada Jacques (Onondaga, Turtle Clan), was born and continues to reside on the Onondaga Nation Territory. At age sixty-seven, she took up pottery when her daughter bought her a ceramics class at Onondaga Community College as a Mother's Day present. She turned a part of her husband's lacrosse factory into a studio, and began working in stoneware, porcelain, terra cotta, and raku. She exhibits her work regularly throughout the state, at both native celebrations and museums such as the Iroquois Indian Museum at Howes Cave, New York; Colgate University; Syracuse University; and the Schweinfurth Memorial Art Center in Auburn. Among her awards is "Best of Show" at the 2004 Ostingo Powwow.

Christopher Kennedy is the author of three full-length collections of poetry, and three chapbooks. His latest book, *Encouragement for a Man Falling to His Death,* from BOA Editions, Ltd., won The Isabella Gardner Poetry Award for 2007. Born and raised in Syracuse, New York, Kennedy has worked at a variety of jobs, including his current one as director of the Syracuse University M.F.A. program in creative writing. He is also a founding editor of the literary journal *3rd bed*.

Aida Khalil, Palestinian-born, immigrated to the United States in 1979 and has lived in Syracuse, New York, ever since. Her artwork encompasses mixed-media assemblage, collage, and painting. She has exhibited her work in several local and regional art shows, and has been the recipient of various artist grants and awards, including an artist residency at Stone Quarry Hill Art Park. She is currently an assistant professor of Landscape Architecture at Morrisville State College.

Jonathan Kirk came to the United States from Great Britain in 1978 to study sculpture with Rodger Mack at Syracuse University. He then joined the fledgling Sculpture Space in Utica, New York, and served as its studio manager for twenty years. Since 2000 Kirk has been pursuing sculpture-making full time, in a large studio in the industrial section of Utica. Currently represented by the Robert Steele Gallery in New York City, he has received grants from the New York Foundation for the Arts, the Pollock-Krasner Foundation, and the Adolph and Esther Gottlieb Foundation. Within New York State, his large metal work has been exhibited in Kingston, Plattsburg, and Purchase, and on display on the campuses of Colgate University and Cazenovia College.

Tom Krueger lives and works in Brooklyn, New York. He received his M.F.A. from Syracuse University in painting in 1999. He has created paper installations in places like Earlville, New York, Youngstown, Ohio, New Haven, Connecticut, and New York City. He also collaborated with Sara Eichner on an exhibition called "Wedgewood Rundown" in the spring of 2007 in Brooklyn, an exploration of decorative domestic patterns under the influence of entropy and displacement.

Justus Lacey is a sixth-grade student at Syracuse's Edward Smith School and participant in the *Dreams Between the Sky and the Earth* project.

DORAN LARSON'S stories have appeared in such publications as *The Iowa Review, Boulevard,* and *The Best American Short Stories.* His novel, *Marginalia,* was published by Permanent Press in 1997. He is an associate professor of English and creative writing at Hamilton College.

JOSEPH LEE was born in Toronto, Canada, earned a business degree from the University of Texas, taught English in Japan, and is now pursuing a master's degree at Le Moyne College in Syracuse, New York. This is his first published story, which grew out of a workshop in his graduate program.

ELISA LEIVA was born in Santiago, Chile, and moved to the U.S. when she was six. She is currently a sophomore at Guilderland High School in Guilderland Center, New York, but dreams of moving back to Chile. Last summer, she participated in the New York State Summer Young Writers Institute at Silver Bay, New York.

STEPHEN LEWANDOWSKI has published eight books of poetry, his most recent being *One Life,* from Wood Thrush Books. His work has appeared in a number of literary journals. He is a graduate of Hamilton College, and later did graduate work with Louis Jones in The Cooperstown Graduate Program in American Folk Culture, and with Howard Nemerov and William Gass at Washington University in St. Louis. Lewandowski has worked as an environmental educator and consultant in the western Finger Lakes for thirty years, and has won environmental awards from Finger Lakes Community College, Canandaigua Lake Pure Waters, and the Finger Lakes Land Trust. He lives in Canandaigua, New York.

CHUCK LYONS is retired in Rochester, New York, with his wife Brenda and Gus, his beagle, after a career editing community newspapers in the Finger Lakes Region. He has published numerous magazine articles, won a short story and a play competition, edited a couple of books, wrote one, won a national award for "an outstanding article on colonial American history," and admits to spending a lot of time cutting grass and shoveling snow, with Gus's help.

MICHAEL MARTONE is a professor of English and director of the creative writing program at the University of Alabama, where he has been teaching since 1996. Before that, he taught at Syracuse University (1991-96), Iowa State, and Harvard. He is the author of five books of fiction, as well as countless pieces of short fiction in journals and books. *The Flatness and Other Landscapes,* a collection of his essays about the Midwest, won The Association of Writers & Writing Programs Prize for Creative Nonfiction in 1998. Michael lives in Tuscaloosa, Alabama, with the poet Theresa Pappas and their sons Sam and Nick.

FRANK MATZKE is writing a series of nonfiction pieces about the experience of recovering from brain trauma after war. He is a veteran of the first Gulf War who served with the Eleventh Armored Cavalry Regiment. Matzke was born and raised in Fulton, New York, and moved to Florida after the war to receive treatment at the VA's premier brain injury unit. He stayed in Florida to complete his degree in communications and creative writing from Flagler College in St. Augustine, and currently covers city and county beats as a journalist for the *St. Petersburg Times.*

SCOTT MCCARNEY was born in Troy, New York, and spent the 50s and 60s in the Capital region. The 70s took him to Virginia, where he earned an undergraduate degree and had his first museum exhibition. The 80s drew him back to Upstate New York for graduate work at the Visual Studies Workshop in Rochester, New York, and he has been there ever since. He is involved in regional arts activities as well as the LGBT and labor communities. He is currently an adjunct faculty member at the Rochester Institute of Technology and teaches in the Summer Institute program of Visual Studies Workshop in Rochester.

SARAH MCCOUBREY is a landscape painter and associate professor at the College of Visual and Performing Arts at Syracuse University. Her numerous honors include a New York Foundation for the Arts Fellowship, an NYFA Special Opportunity Stipend, a Ballinglen Arts Foundation Residency-in-Ireland Fellowship, the Milton Avery Foundation Fellowship, a MacDowell Colony Fellowship, two Constance Saltonstall Foundation grants, and an NEA grant. McCoubrey has an M.F.A. and a B.F.A. in painting, as well as a B.A. in English, from the University of Pennsylvania. She lives in Fayetteville, New York, with her husband and three daughters.

JOHN "JAWS" MCGRATH is a lifelong resident of Syracuse, New York. A self-taught artist in the medium of pen and ink, he takes much of his inspiration from the natural beauty seen from traveling many miles on his Harley. His work has been exhibited throughout the East Coast and most recently at the Delavan Art Gallery in Syracuse. He works exclusively with a single #102 nib and a top-grade watercolor paper to add texture and depth to each piece. See more of John's work at *suitable4framing.org.*

MARION MENNA is a former special education teacher for Nassau BOCES who after retirement taught creative writing for Taproots at SUNY Stony Brook and facilitated writing groups for the disabled for an agency called THAW. She moved to Glenmont, New York, two years ago, and is a founding member of the Delmar Writing Group and recording secretary for the Hudson Valley Writers Guild. She has had poems published in the *Long Island Quarterly, the West Hills Review, Xanadu, Quill, Parchment,* and *Women's Synergy.*

BRUCE MUIRHEAD is a professor of art at Hamilton College, and has, over the course of an illustrious career, had his etchings and paintings included in many exhibitions and private collections. He has a B.F.A. from the Rhode Island School of Design and an M.F.A. from the Boston University College of Fine Arts. *Robert Bruce Muirhead, Prints 1969-2006, A Catalogue Raisonne,* was published in 2007 by the Amity Art Foundation of Connecticut.

JAKE MUIRHEAD is associate printmaker at Pyramid Atlantic Art Center in Silver Spring, Maryland, and teaches art at Montgomery College and The Waldorf School. He has recently won awards at several major print exhibitions, including Purdue University's annual *60 Square Inches* International Print Exhibition, and Artlinks 26th National Print Exhibition. Jake grew up in Clinton, New York, graduated from Hamilton College, and earned an M.F.A. in printmaking from George Mason University.

PETER MCKEE OLDS taught college English for thirty years and, in addition to writing, works as a metal sculptor in the Catskills. He recently built a sculpture garden for the Town of Mountaindale, in Sullivan County, which is undergoing a renaissance. Peter has a Ph.D. from Columbia University.

FRED MURATORI has published two books of poetry, *The Possible* and *Despite Repeated Warnings,* and has had poems and prose-poems published in a variety of magazines and journals. He also regularly contributes criticism to such publications as *American Book Review, Boston Review,* and *The Manhattan Review.* He is a graduate of the Syracuse University M.F.A. program, and currently works at the Cornell University Library as the bibliographer for English-language literature, theater, and film.

JENNIFER PASHLEY lives in Central New York with her husband and two sons. She is a fiction instructor at the YMCA's Downtown Writer's Center in Syracuse, New York, and an adjunct instructor at Le Moyne College. Her book of short fiction, *States,* was published in 2007. She is currently at work on a novel.

DONALEE PEDEN-WESLEY has a B.F.A. and an M.F.A. from Syracuse University, and currently teaches at Syracuse University and Onondaga Community College. She has shown her work internationally from England to Germany to Australia and throughout the United States. Her work is featured in multiple books, such as *The Sculptor Reference Book,* and is included in public museum collections, such as the Munson-Williams-Proctor Arts Institute and the Everson Museum, as well as in many private collections.

LINDA TOMOL PENNISI is the author of two volumes of poetry, *Seamless* (2003) and *Suddenly, Fruit* (2006), which was chosen by William Pitt Root as winner of the Carolina Wren Press chapbook prize. Her poems have appeared in such journals as *McSweeney's, Hunger Mountain, Lyric Poetry Review,* and *Faultline.* She has been a recipient of grants from the Constance Saltonstall Foundation for the Arts and the Academy of American Poets. She is director of the creative writing program at Le Moyne College in Syracuse.

THOMAS PICHÉ JR. is director of the Roland Gibson Gallery, the art museum of SUNY Potsdam. He was previously assistant director and senior director at the Everson Museum of Art in Syracuse. Exhibitions organized by Piché include, "Only an Artist: Adelaide Alsop Robineau, American Studio Potter" (2006), "Some Assembly Required: Collage Culture in Postwar America" (2003), and "Carrie Mae Weems: Recent Work, 1992-98" (1998). Art criticism by Piché has appeared in *Sculpture, NY Arts, American Craft, American Ceramics,* and *I.D., The International Design Magazine.*

JO PITKIN has a B.A. in creative writing from Kirkland College in Clinton, New York, where she studied with Michael Burkard and Tess Gallagher, and an M.F.A. in poetry from the Writers' Workshop at the University of Iowa, where she studied with Donald Justice, Larry Levis, Sandra McPherson, and Jane Cooper. Her poems have been published in *Dark Horse, Lyra, Ironwood, Quarterly West, Nimrod,* and many other magazines. Among other prizes, she has won Kirkland's Eighth Annual Watrous Poetry Prize, the First Annual Hudson Valley Poetry Contest, and *Lyra* magazine's Fourth Annual Poetry Prize. Her chapbook, *The Measure,* was published in 2007. For more than twenty years, Jo has worked as a freelance educational writer for major textbook publishers. She lives in the Hudson River Valley in a 175-year-old house that was once a public school.

Linda Price has a B.F.A. from Ithaca College and an M.F.A. in painting from Bard College. She has worked as an educator at Cornell University/Herbert F. Johnson Museum of Art, and currently teaches painting and drawing at Ithaca College. Originally from the Midwest, she traveled to Upstate New York in her early twenties, was "smitten by the hills in the Finger Lakes region," and settled in a small town by Cayuga Lake, where she still lives with her family.

Dennis Pullen (winner of *Stone Canoe's* 2008 Burton Blatt Institute Arts Leadership Prize), is a painter and writer who lives in Oswego, New York. At age seven, he sustained injuries from a truck accident that resulted in quadriplegia and ventilator-dependency. He lives in his own apartment, has twenty-four-hour nursing care, and considers his nurses his friends. He creates his paintings by holding his paintbrushes in his mouth, and depends on others to mix his paints for him. He has benefited from professional mentoring by fellow Oswego artist and friend, Norm Roth. Dennis spends much of his time volunteering to speak at local schools and universities. His primary areas of interest and expertise include the promotion of disability awareness, rights of the disabled, and self-advocacy. He is a graduate of AmeriCorps and a member of the Self-Advocacy Association of New York State.

Beatrix Reinhardt was born in Wolgograd, Russia, and grew up in East Germany. She resides in New York City, where she works as an assistant professor of photography at the College of Staten Island/CUNY. She received her M.F.A. in photography from Illinois State University, her M.A. in Media Studies from the New School for Social Research, and her B.A. in New German Literature from the Freie Universitat Berlin. Her work has been exhibited nationally and internationally, most recently in Madrid, Spain; London, England; and Syracuse, New York, at Light Work. She is represented by the Romo Gallery in Atlanta, Georgia, and her work is included in many public collections, including The New York Public Library, Old Parliament House in Canberra, Australia, and the Light Work collection.

Faith Ringgold is a distinguished American artist whose impressive body of work continuously casts new light on issues of race, gender, and social justice. She has produced award-winning work in every conceivable artistic medium, and written several books which have won awards, such as *The New York Times* Best Children's Book Award, the Caldecott Medal, the Coretta Scott King Award for best illustrated book by an African American, and the 31st NAACP Image Award for Best Children's Book, *If a Bus Could Talk: The Story of Rosa Parks*. She has received numerous grants, awards, and fellowships through her illustrious career, including 16 honorary doctorates. The Community Folk Art Center first invited Ringgold to Syracuse in 1973 to participate in a Syracuse City Schools art program, for which she produced her first series of dolls. In the fall of 2007, the CFAC hosted a major retrospective of her work at their Syracuse gallery.

Susan Robinson (winner of *Stone Canoe's* 2008 Allen and Nirelle Galson Prize for Fiction) recently graduated from Le Moyne College with a degree in creative writing and film, having completed the degree over six years while working full time and helping to raise her granddaughter. Susan lives in Liverpool, New York. This is her first published story.

Ralph James Savarese is the author of *Reasonable People: A Memoir of Autism and Adoption* (Other Press, 2007), which *Newsweek* called "a real life love story and an urgent manifesto for the rights of people with neurological disabilities." He teaches American literature, creative writing, and disability studies at Grinnell College, and is a frequent guest lecturer at Syracuse University.

Stephen Shaner, a native of Skaneateles, New York, is a journalist and photographer who has traveled eight times to the Middle East, and spent more than a year in Israel and the Occupied Territories. He received his B.F.A. from the Rochester Institute of Technology and spent several years as chief photographer at the *Troy Daily News* in Troy, Ohio, before returning to New York to pursue freelance work and devote time to documentary work. When not traveling in the desert, he can be found sailing on Skaneateles Lake.

Maureen A. Sherbondy is a poet and fiction writer who grew up in New Jersey and spent summers with family in Upstate New York, where she wrote her first book at age eight, *From Ground to Sky,* for which her grandfather paid her five dollars. She now resides in Raleigh, North Carolina, with her husband and three sons. Her poetry and fiction have appeared in many anthologies, and her book of poems *After the Fairy Tale* was published in 2006. She was awarded the 2007 Hart Crane Memorial Award by ICON, the literary journal of Kent State University. Her second poetry book, *Praying at Coffee Shops,* was published in March 2007 by Main Street Rag.

Ryan Skrabalak was born in Binghamton, New York, and grew up in the Albany area. While in high school, he attended two sessions of the New York State Summer Young Writers Institute at Silver Bay, New York. Ryan has fled the frigid and desolate winters of Upstate New York and now attends the University of Delaware, where he is majoring in English.

Donna Steiner's essays and poems have been published in literary magazines including *Utne Reader, The Sun, The Bellington Review,* and *Isotope.* She's been twice nominated for a Pushcart Prize and has won the Annie Dillard Award for creative nonfiction. Her work has been included in college textbooks, and can be found in the anthologies *Women on the Verge* and *Under the Influence.* She teaches writing at SUNY Oswego.

Lynette K. Stephenson is associate professor of art at Colgate University in Hamilton, New York, and has exhibited actively in the region, and also in Texas and Ghana. Her work is found in many private collections. She has a B.S. from Northwestern State University in Natchitoches, Louisiana, and an M.F.A. from Georgia State University in Atlanta. Her work is often inspired by uncontrollable tragedies, such as Hurricane Katrina, that are an aspect of the uncertainty of life.

Sylvia de Swann is a Romanian-born photographer who has lived, worked, and taught in Mexico, Europe, and the United States. Her work has been exhibited through the world and is included in the collections of the Corcoran Gallery of Art, The Museum of Modern Art, the Munson-Williams-Proctor Arts Institute, and Light Work. She has published five books and her work has been included in many others. Regionally, she has taught at Colgate University, Cornell University, Onondaga Community College, SUNY Oswego, and Hamilton College. She is a Saltonstall Fellow and co-founder of Sculpture Space in Utica.

BRUCE SWEET has over a long career published many poems, short stories, essays, reviews, and has had twenty-six of his plays produced. His poetry books include *Archaeology, This Is a Good Thing,* and *A Dream of Animals,* an illustrated book for children. He currently teaches writing at Roberts Wesleyan College in Upstate New York, and his "What's the Word?" program celebrating local, national, and international poets can be heard on NPR station WXXI in Rochester, New York. He published his first poem, for which he received $16, in the fourth grade.

ED TAYLOR is a Saltonstall Fellow whose poetry and fiction have appeared in such print and online magazines as *Ontario Review, Southwest Review, Swink, Sentence, New Writing* (UK), *Nth Position* (UK), *River Styx, Slope, Slipstream, Suspect Thoughts, Washington Review,* and *PP/FF: An Anthology.* He currently resides in Buffalo, New York.

MICHAEL PAUL THOMAS received an M.F.A. from Syracuse University, where he was founding editor of *Salt Hill,* and winner of the Raymond Carver Prize for Poetry. His poems have appeared in a variety of literary magazines, such as *Hayden's Ferry Review, The Plum Review,* and *Boston Literary Review.* He has been assistant director of the Catskill Poetry Workshop at Hartwick College since 1996, and, since 1997, has taught literature and creative writing at Monmouth University in West Long Branch, New Jersey, where he is also assistant dean of the School of Humanities and Social Sciences.

DANIEL TORDAY currently teaches fiction writing at Bryn Mawr College in Pennsylvania. From 2000 to 2005 he served as an editor at *Esquire* Magazine, and, more recently, while completing his M.F.A. at Syracuse, he served as editor of the literary journal *Salt Hill,* and fiction editor of *Stone Canoe.* His short stories and nonfiction have appeared in *Esquire* Magazine, *The Kenyon Review, The New York Times,* and *Interview Magazine.* Torday is a Pushcart Prize nominee, and winner of the 2006 Peter Neagoe Short Story Award at Syracuse University. He recently completed his first novel.

JILLIAN TOWNE is currently a senior at Greenwich Central High School in Greenwich, New York. Jillian attended the New York State Summer Young Writers Institute at Silver Bay, New York, in 2007. She has had poetry, prose, and artwork published in the regional literary magazine *Talent Unlimited.* She is currently applying to colleges and intends to major in creative writing or a related field.

BRIAN TURNER earned an M.F.A. from the University of Oregon before serving for seven years in the U.S. Army. He was an infantry team leader in Iraq with the 3rd Stryker Brigade Combat Team, 2nd Infantry Division, and before that served in Bosnia-Herzegovina with the 10th Mountain Division of Upstate New York. His poetry has been published in *Poetry Daily, The Georgia Review, American War Poetry: An Anthology,* and in the *Voices in Wartime Anthology,* published in conjunction with a documentary of the same name. His book of poems on Iraq, *Here, Bullet,* won the 2005 Beatrice Hawley Award.

ELIZABETH TWIDDY has an M.F.A. in poetry from Syracuse University, and currently teaches at The Downtown Writer's Center in Syracuse, New York, SUNY College of Environmental Science and Forestry, and Le Moyne College. She is also involved in various elementary and middle school initiatives, including the U.S. Poet Laureate Project, *Literacy Through Creative Expression.* Working with a science teacher at Shea Middle School in Syracuse, she helps students explore the connections between poetry and science, and compose their own poems. Her chapbook is forthcoming from Turtle Ink Press.

LANE TWITCHELL was born in Salt Lake City, Utah, studied graphic arts at the University of Utah, then moved to Manhattan in 1993 to pursue an M.F.A. at the School of Visual Arts. His ancestors were among the early pioneers who followed Brigham Young from the Finger Lakes region of New York to the desert of Utah, and his paintings often draw their inspiration from the mythology of that experience. His work has been exhibited primarily in New York City, but a show organized by the Schweinfurth Memorial Art Center in Auburn will introduce his work to a broader upstate audience. The exhibition will travel to the University Art Museum at SUNY Albany and the Roland Gibson Gallery at SUNY Potsdam through February 2008.

KEN VICTOR has been published in journals in both Canada and the U.S., including the *Beloit Poetry Journal, Grain* magazine, *The Malahat Review,* and the *Queen's Quarterly.* He received a National Magazine Award for poetry from the Canadian Council for the Arts. Ken completed his M.A. in creative writing at Syracuse University, and now makes his home in Chelsea, Quebec.

MARY L. WHITE grew up in Kansas in the 1950s but has lived and worked in Upstate New York since 1978. She has worked at many jobs, including raising goats, milking cows, and assisting the incarcerated. She currently works as a public historian and archivist at The History Center in Tompkins County, lives with her partner in Ithaca, and writes and paints in her spare time.

LEAH ZAZULYER is a poet, Yiddish translator, and former school psychologist. She grew up in California but has lived in Rochester, New York, since 1968. Her parents came from Belarus. She has received grants from the Constance Saltonstall Foundation for the Arts, the New York State Council on the Arts, and the National Yiddish Book Center. She has published three volumes of poetry. Her current project, excerpted in this issue, involves creating dramatic monologues from her interviews with Holocaust survivors, building on her work with the Speilberg Foundation.

DEBORAH ZLOTSKY teaches painting and drawing at The College of St. Rose in Albany, New York. She has had multiple one-person exhibitions throughout the country, and been included in group shows at The Tang Teaching Museum and Art Gallery and the Schick Art Gallery at Skidmore College; The William Benton Museum of Art in Storrs, Connecticut; The Alternative Museum in New York City; the Munson-Williams-Proctor Arts Institute in Utica, New York, and the Fine Arts Building Gallery in Chicago. She has had residencies at the Ragdale Foundation, the Millay Colony for the Arts, and the Virginia Center for the Creative Arts. Zlotsky has a B.A. in art history from Yale University and an M.F.A. from the University of Connecticut.

EDITORS

PAUL AVILES is a poet, translator, essayist, and professor of English at Onondaga Community College in Syracuse. He has a B.A. from St. Lawrence University and an M.F.A. from Syracuse University. Paul has received grants from the Constance Saltonstall Foundation for the Arts, the New York Foundation for the Arts (NYFA), and the National Endowment for the Humanities. He is currently completing a book of poems entitled *Funeral Tunes.*

MICHAEL BURKARD has taught in the M.F.A. Program in Creative Writing at Syracuse University since 1997. His latest book, *Envelope of Night* (Selected and Uncollected Poems, 1966-1990) will be published by Nightboat Books in January 2008. His poems have appeared in *APR, Bat City Review, Verse, Caketrain, McSweeney's,* and many other journals and magazines. He has previously taught at New York University, Hamilton College, Sarah Lawrence, and the University of Louisville. Among his other published books are *Entire Dilemma* (Sarabande, 1997), *Unsleeping* (Sarabande, 2001), *My Secret Boat* (a notebook of prose and poems) (W.W. Norton , 1990), and *Pennsylvania Collection Agency* (New Issues Press, 2001). In 2007, Michael was given a Jerome Shestack Prize from *The American Poetry Review.* He has degrees from Hobart College and the University of Iowa. A former editor at *Iowa Review,* this is his second year as a *Stone Canoe* poetry editor.

DAVID T. LLOYD teaches for the creative writing program at Le Moyne College. His articles, interviews, poems, and stories have appeared in the U.S., Canada, and Britain, including *Crab Orchard Review, Denver Quarterly, DoubleTake/Points of Entry,* and TriQuarterly Books. His poetry collection, *The Everyday Apocalypse,* won the 2002 Maryland State Poetry and Literary Society's chapbook contest. His poem sequence, *The Gospel according to Frank* appeared in 2003 (New American Press). In 2000, he received the Poetry Society of America's Robert H. Winner Memorial Award, judged by W.D. Snodgrass. He is the editor of *The Urgency of Identity: Contemporary English-Language Poetry from Wales* and the author of *Writing on the Edge: Interviews with Writers and Editors of Wales,* and a fiction collection, *Boys: Stories and a Novella* (Syracuse University Press, 2004). From 2005-07, he was poetry editor for *DoubleTake/Points of Entry.* He has a B.A. from St. Lawrence University, and an M.A. and Ph.D. from Brown University.

MARION WILSON has had exhibitions at the Dorsky Gallery in Long Island City, New York, New Museum of Contemporary Art in New York City; Schroeder Romero Gallery and Exit Art in New York City, SculptureCenter in Long Island City, New York; Hallwalls Contemporary Arts Center, Buffalo New York; SPACES, Cleveland, Ohio; Everson Museum of Art, Syracuse; and SCOPE Miami/Art Basel Miami Beach and SCOPE New York. She has been awarded funded residencies at the International Studio Program; the Millay Colony for the Arts; and Sculpture Space. She has received grants from the Gunk Foundation Artists in the PublicArena; NYFA artists in the school, and the Constance Saltonstall Foundation for the Arts. She is a graduate of Wesleyan University (B.A. '83), Columbia University (M.A. '90), and The University of Cincinnati (M.F.A. '93). Wilson is the Director of Community Initiatives in the Visual Arts at Syracuse University, and teaches in the Sculpture Department. She started MLAB, a collaborative design team of art and architecture students at Syracuse, as a result of her belief in the revitalization of urban life through the arts. She lives and works in Syracuse and maintains a studio in New York City.

EDITORS' COMMENTS

In *Drawings and Observations,* the artist Louise Bourgeois wrote the following: "At one point I stopped making self-portraits, and I included the people that lived with me. I would say that it had to do with the problem of the *toi* and the *moi,* of the you and the me. Life is not worth living if you talk only about the *moi.* Life is interesting in terms of others." The wonderful diversity of others' poems made my task as poetry editor rewarding and various. I thank all the poets for being *toi.*

Michael Burkard
Poetry Editor, *Stone Canoe 2*

It has become a cliché for an editor to say that he or she has read many more publishable submissions than there is room for in a given issue. But this has in fact been true for me while reading fiction for *Stone Canoe.* We're a big magazine, encompassing multiple genres, open to various creative expressions, but still there isn't enough room. I read through close to 70 short stories, hundreds of pages, an astonishing variety of forms and voices. One of the things I want to experience while reading fiction is *revelation* (to put a complex experience into a single word)— to feel, when I put the story down, that in some way I've had a new experience, a surprise in language. That was the effect on me, in different ways, with the stories I accepted for this second issue of *Stone Canoe.* In Ed Taylor's otherworldly and discomforting "NYS Permitted"; in Susan Robinson's tragic-comic meditation on loss and death, "The Year that Everything Died"; in Michael Martone's subtle and complexly interwoven "Board Games"(excerpted from a larger project, "Four for a Quarter")—to cite a few examples—I found myself in unfamiliar territory, which is exactly where I like to be.

David Lloyd
Fiction Editor, *Stone Canoe 2*

Being interested in space, I at first tried to "curate" the art in this book as though it were art in a physical space. That led me toward artwork in series, narratives, images in sequence, and multiples. I was also intrigued by work that revealed something new about familiar experiences in our shared community: refugees arriving at the airport, highway road signs, swimmers underwater, or pools and tree houses in our backyards. And finally I chose work that I just loved, and that expanded the geographical boundaries of our region a bit.

Marion Wilson
Visual Arts Editor, *Stone Canoe 2*

LEAVE A LEGACY OF LEARNING

Invest in the educators of tomorrow by
making a gift that offers a financially
secure future for yourself *and* the
School of Education. You can realize
a level of giving you never thought
possible and receive dividends
throughout your lifetime. Every financial
commitment—no matter how large or
small—provides the gift of knowledge
for generations to come.

WE SHAPE
TOMORROW'S CHILDREN BY
WHAT WE DO TODAY

SYRACUSE UNIVERSITY
SCHOOL OF EDUCATION

For information about a full range of life
income gift options contact: Victoria F. Kohl,
Syracuse University School of Education
315-443-7773, *vfkohl@syr.edu*

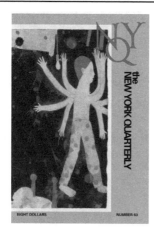

Whitman
SCHOOL *of* MANAGEMENT
SYRACUSE UNIVERSITY

The Whitman School
continues to support

Stone Canoe

an award-winning example of
Syracuse University's "Scholarship in Action"

The **College of Human Ecology**

supports the Stone
Canoe and its
promotion of
arts & ideas
of Upstate
New York.

The College of Human Ecology is comprised of the following academic units:

Department of Child and Family Studies
Department of Health and Wellness
Department of Hospitality Management
Department of Marriage and Family Therapy
Department of Nutrition Science and Dietetics
Department of Sport Management
School of Social Work

The College of Human Ecology | Syracuse University | 119 Euclid Avenue | Syracuse, NY 13244
Visit us on the web at: http://hshp.syr.edu

COLLEGE OF VISUAL AND PERFORMING ARTS
SYRACUSE UNIVERSITY

vpa.syr.edu

Congratulations on **Stone Canoe** Number 2
from the **School of Architecture**

HumanitiesCorridor

CENTRAL NEW YORK

Like *Stone Canoe*, the Central New York Humanities Corridor is committed to celebrating arts and ideas. Since its inception in 2006, hundreds of scholars from Syracuse and Cornell universities and the University of Rochester have collaborated on projects spanning music, religion, philosophy, linguistics, the visual arts, and science and technology. To find out more about this large-scale partnership, generously supported by The Andrew W. Mellon Foundation, please visit *TheCollege.syr.edu*

The Harlem Quartet performing at the Music, Justice, and Gender conference at Syracuse University, presented by the Central New York Humanities Corridor.

Burton Blatt Institute
SYRACUSE UNIVERSITY

Working Toward a World Where Every Person is Valued

The Burton Blatt Institute was established to open the world to the enormous potential of people with disabilities. It starts with building an understanding of the challenges they face each and every day.

Our mission is to build upon that understanding—creating inclusive environments in schools, the workplace, and the community—through research, education, training, policy, technical assistance, outreach, and fundraising. Our ultimate goal: To create a world where every person is valued.

"We can change the world. The first step is to change ourselves!"
—Burton Blatt

The Goldring Arts Journalism Program

The Tully Center for Free Speech

and

The S.I. Newhouse School of Public Communications

support

Stone Canoe

A welcome literary and artistic contribution to our community

IT'S YOUR FIRST

CONGRESS SHALL MAKE NO LAW RESPECTING
AN ESTABLISHMENT OF RELIGION, OR
PROHIBITING THE FREE EXERCISE THEROF;
OR ABRIDGING THE FREEDOM OF SPEECH
OR OF THE PRESS; OR THE RIGHT OF THE
PEOPLE PEACEABLY TO ASSEMBLE,
AND TO PETITION THE GOVERNMENT
FOR A REDRESS OF GRIEVANCES.

S.I. Newhouse School of Public Communications, Syracuse University

Photo of Newhouse III courtesy of Hans Walter/Polshek Partnership LLP

the creative *mind*

Le Moyne College is proud of its reputation as a center for creative writing and literature. We're excited about the strong lineup of upcoming talks and hope to see you on campus for these events scheduled during the spring 2008 semester.

LE MOYNE

SPIRIT. INQUIRY. LEADERSHIP. *JESUIT.*

WWW.LEMOYNE.EDU

February 11, 7 p.m. | Grewen Aud. "The Edge of Each Other's Battles: A Vision of Audre Lorde" is a powerful documentary about the life and work of the legendary black lesbian feminist poet Audre Lorde (1934-1992).

February 14, 7:30 p.m. | Piano in the Panasci Chapel. "All You Need is Love," a Valentine's Day performance by Le Moyne's Grammy-nominated artist-in-residence Andrew Russo.

February 15, 16, 21, 22 and 23, 8 p.m. | W. Carroll Coyne Center for the Performing Arts. "Anton in Show Business." Boot and Buskin Theater Troupe presents this savvy comedy, which skewers idiot directors, surgically beautified actors and self-important critics, and satirizes, celebrates and challenges theatre today.

February 20, 7 p.m. | Reilley Room, Reilly Hall. Fiction reading featuring Le Moyne adjunct English professor Jennifer Pashley, from her collection of stories, "States" (2007, Lewis Clark Press.)

March 13, 6:30 p.m. | Reilley Room, Reilly Hall. Poet and memoirist A.J. Krivak will read from his memoir, "A Long Retreat: In Search of a Religious Life."

March 14, 3:30 p.m. | Special activities room of the Noreen Reale Falcone Library. "Historical Research Applied to Education Through Storytelling," by Vanessa Johnson, a community historian and storyteller.

April 3, 5:30 p.m. | Reilley Room, Reilly Hall. Poetry reading featuring Argentinian-born poet Noni Benegas, author of five books of poetry including "La balsa de la Medusa" (Miguel Hernández Prize) and "Cartografía ardiente."

April 4 and 5 | Religion and Literature Forum at Le Moyne College. Plenary speakers will be Amy Hollywood, of the Harvard University Divinity School, and Karmen MacKendrick, Le Moyne professor of philosophy. The forum will explore contemporary culture through the category of the grotesque and its convergence with the sublime.

April 8, 5:30 p.m. | Reilley Room, Reilly Hall. Poetry reading by Spanish poet Aurora Luque, who will present the first U.S. reading from her most recent book, "La siesta de Epicuro."

April 14, 7:30 p.m. | W. Carroll Coyne Center for the Performing Arts. Inaugural concert of the Le Moyne College Community Chamber Orchestra, comprised of Le Moyne students and professionals from the CNY community. Excerpts from Mozart's "Requiem" highlight performance.

April 15, 7:30 p.m. | Piano in the Panasci Chapel. The Boccaccio Trio: Fred Karpoff, Jeremy Mastrangelo and David LeDoux, perform works by Schubert and Brahms.

April 19, 9 a.m. to 3 p.m. | Sixth Annual Undergraduate Literature and Culture Conference, a scholarly literature conference.

April 25 to May 4 | Various activities associated with the Syracuse International Film and Video Festival. Highlights at Le Moyne include an education forum and a sidebar panel. Learn more at http://www.syrfilmfest.com.

Syracuse University Library's Biblio Gallery

Syracuse University Library is pleased to present the Biblio Gallery. This Library gallery space contributes to the cultural life of the Library and University by offering students a venue for exposing their creative work to a wider audience.

Located on the 4th floor of E.S. Bird Library, the Biblio Gallery provides space for displaying two-dimensional works and smaller three-dimensional works.

General Information for Submission

Contributors of artwork will be selected from proposals received from under-graduate and graduate students at Syracuse University. For more information, visit *http://bibliogallery.syr.edu.*

The Downtown Writer's Center
of the YMCA of Greater Syracuse
& Onondaga Community College
present an evening with

Charles
Simic

Poet Laureate
of the United States

Friday, October 3rd, 2008
7:00 p.m.
at OCC's Storer Auditorium

TICKETS

$15 for YMCA/DWC members
(on sale January 1st, 2008)
$20 for non-members
(on sale March 1st, 2008)

To order, contact the DWC
at (315) 474-6851 x328.

The YMCA's **Downtown Writer's Center**

The Arts Branch of the YMCA
www.ymcaarts.org

CHARLES SIMIC was born in Yugoslavia on May 9, 1938. He is the author of 18 books of poetry, including the new collection *That Little Something* and *The World Doesn't End*, winner of the Pulitzer Prize. He is also an acclaimed essayist, translator, and editor. His many awards and honors include fellowships from the NEA, the MacArthur Foundation, and the Wallace Stevens Award from the Academy of American Poets for "outstanding and proven mastery in the art of poetry."

Onondaga Community College
presents

arts across campus

The Constance Saltonstall Foundation for the Arts

is committed to serving the individual NYS artist (especially in the Finger Lakes region) through all stages of the creative process. We serve NYS artists and writers with summer fellowships, grants, seminars and access to studio space. Learn more about our programs and how you can get involved at www.saltonstall.org

CONSTANCE SALTONSTALL
Foundation for the Arts

Art
Literature
Journals

follett's Orange
Bookstore

Marshall Square Mall
720 University Avenue
Syracuse, NY 13210
(315)478-6821
efollett.com

Serving the Syracuse University Community for 41 Years

fig. A

[crafting theatre from well-crafted words]

www.SyracuseStage.org

SYRACUSE UNIVERSITY BOOKSTORE

YOUR CAMPUS SOURCE FOR THE FINEST IN READING AND LITERATURE

THE UNIVERSITY
BOOKSTORE
Owned and Operated by Syracuse University

Schine Student Center
303 University Place
Syracuse, NY 13244
(315) 443-9900
www.syr.edu/bkst

the partnership
for better education

Congratulations to *Stone Canoe,*
the award-winning community arts journal,
from
the Partnership for Better Education

The Partnership for Better Education provides opportunities
for students from the Syracuse City School District to
achieve success at the following institutions of higher
education: Le Moyne College, Onondaga Community College,
Syracuse University, SUNY College of Environmental Science
and Forestry, and SUNY Upstate Medical University.

Vestal Review. The magazine dedicated to flash fiction

Since March 2000

Brevity is the soul of wit.
William Shakespeare

Submission Guidelines on the website: www.vestalreview.net
All stories 500 words or less

Featured on NPR

Coalition of Museum and Art Centers
350 West Fayette Street, Syracuse, NY 13202
315/443-6450, 315/443-6494 fax
http://cmac.syr.edu

Formed in September 2005 by Syracuse University President and Chancellor Nancy Cantor, the Coalition of Museum and Art Centers (CMAC) brings together the programs, services, and projects of several different campus art centers and affiliated non-profit art organizations in the campus community in a collaborative effort to expand the public's awareness, understanding, appreciation, and involvement in the visual and electronic arts. The mission of CMAC is to celebrate and explore the visual and electronic arts through exhibitions, publications, public presentations, education, and scholarship.

THE WAREHOUSE GALLERY
Coalition of Museum and Art Centers
350 W. Fayette Street, Syracuse, NY 13202
315/443-6450, 315/443-6494 fax
www.thewarehousegallery.org

LIGHT WORK
Robert B. Menschel Media Center
316 Waverly Avenue, Syracuse, NY 13244
315/443-1300, 315/443-9516 fax
www.lightwork.org

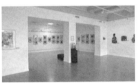

COMMUNITY FOLK ART CENTER
805 E. Genesee Street, Syracuse, NY 13210
315/442-2230
315/442-2972 fax
www.communityfolkartcenter.org

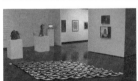

SUART GALLERIES
Shaffer Art Building on the Syracuse University Quad
Syracuse, NY 13210-1230
315/443-4097, 315/443-9225 fax
http://suart.syr.edu/index.html

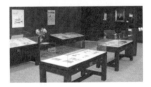

SPECIAL COLLECTIONS RESEARCH CENTER
600 E. S. Bird Library, Syracuse, NY 13244
315/443-2697
315/443-2671 fax
http://scrc.syr.edu

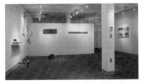

POINT OF CONTACT GALLERY
914 E. Genesee Street, Syracuse, NY 13210
315/443-2169
315/443-5376 fax
www.pointcontact.org

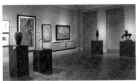

LOUISE AND BERNARD PALITZ GALLERY
Syracuse University Joseph I. Lubin House
11 E. 61st Street, New York, NY 10021
212/826-0320, 212/826-0331 fax
http://lubinhouse.syr.edu/gallery/current.html

SYNERGETIC
productions

is a Syracuse, New York based
film, video, special effects
and computer animation
production company.
We shoot high definition and
standard definition video,
35mm and 16mm film.
We put it all together in
state-of-the-art edit suites
for TV commercials and
non-broadcast programs,
for delivery on TV, cable,
the internet, CD, DVD,
videotape and video iPod....
whatever floats your ~~boat~~
canoe - Stone or otherwise.

MISSED OUR AWARD-WINNING FIRST ISSUE?

There are still copies of *Stone Canoe* Number 1 available through our office. Make checks for $18 payable to Syracuse University and mail to Stone Canoe, 700 University Avenue, Syracuse, New York, 13244. Or order through Syracuse University Press, *www.SyracuseUniversityPress.syr.edu* or Amazon.com.

Fiction by:
Thomas Glave, Elaine Handley, Carly June L'Ecuyer, E.C. Osondu, and Michael Petrosillo

Nonfiction by:
Mary Gaitskill, David Hajdu, Robin Wall Kimmerer, Monk Rowe, and Laurie Stone

Poetry by:
Omanii Abdullah-Grace, Paul Aviles, Stephen Dunn, Rhina P. Espaillat, David Eye, Jakk Glen III, Wendy Gonyea, Kelle Groom, Duriel E. Harris, Lucy Harrison, Sarah C. Harwell, Michael Jennings, Evalena Aisha Johnson, Christopher Kennedy, JoEllen Kwiatek, David Lloyd, Charles Martin, Philip Memmer, William Neumire, Victor Oshel, Robert Phillips, Georgia Popoff, Minnie Bruce Pratt, Paul B. Roth, W.D. Snodgrass, Thom Ward, and Leah Zazulyer

Visual art by:
Mark Bender, Douglas Biklen, Larry Bissonnette, Stephen Carlson, John Bul Dau, LaToya Ruby Frazier, Bob Gates, Mary Giehl, Lewraine Graham, Christopher Gray, Wendy Harris, Gail Hoffman, Tom Huff, Mario Javier, Hugh Jones, Bryan McGrath, Wendy Moleski, Anne Novado Cappuccilli, Elena Peteva, Joseph Scheer, Luvon Sheppard, S. Ann Skiold, John Thompson John von Bergen, Carrie Mae Weems, Jack White, Diana Whiting, Errol Willett, and Marion Wilson

PLUS:
A one-act play by Kyle Bass
A conversation between George Saunders and Jhumpa Lahiri
An interview with Diana Abu Jaber

Visit *stonecanoejournal.org* for updates on our contributors and other *Stone Canoe* news.

THE 2008 STONE CANOE PRIZES

The Allen and Nirelle Galson Prize for Fiction is awarded annually to an Upstate New York writer who has not yet published a book of fiction with a nationally distributed press.

The 2008 Allen and Nirelle Galson Prize for Fiction is awarded to **Susan Robinson.**

The Bea González Prize for Poetry is awarded annually to an Upstate New York poet who has not yet published a book of poems with a nationally distributed press.

The 2008 Bea González Prize for Poetry is awarded to **Cynthia Day.**

The Michael Fawcett Prize for Visual Arts is awarded annually to an Upstate New York artist who has not yet had a solo show in, or been represented by, a major gallery.

The 2008 Michael Fawcett Prize for Visual Arts is awarded to **Samantha Harmon.**

The Burton Blatt Institute (BBI) Arts Leadership Prize is awarded annually to an artist or individual whose work promotes or exemplifies the value of inclusiveness within the arts community.

The 2008 Burton Blatt Institute Arts Leadership Prize is awarded to **Dennis Pullen.**

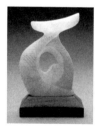

TOM HUFF
Stone Canoe, white alabaster, 2006

All prize winners receive $500 and a bronze replica of the original stone canoe carving by Tom Huff.

The prizes in fiction, poetry, and visual arts are selected each year by the *Stone Canoe* editors from exemplary work submitted to the journal by emerging artists and writers. Submission of a single work of short fiction, a minimum of three poems, or a minimum of three works of visual art in any medium will qualify for consideration in the respective categories. No additional application or fee is required. The Burton Blatt Institute Arts Leadership Prize is an unsolicited award, and the selection is made by the *Stone Canoe* editors in consultation with Burton Blatt Institute staff.